DRAWINGS
BY RAPHAEL

DRAWINGS BY RAPHAEL

*from the Royal Library,
the Ashmolean, the British Museum,
Chatsworth and other English collections*

J. A. Gere and Nicholas Turner

Published for the
Trustees of the British Museum by
British Museum Publications Limited

Reprinted 1984

Published by British Museum Publications Ltd,
46 Bloomsbury Street, London WC1B 3QQ

British Library Cataloguing in Publication Data
Gere, J. A.
 Drawings by Raphael.
 1. Raphael–Catalogs 2. Paintings, Italian–
 Catalogs
 I. Title II. Turner, Nicholas
 759.5 ND623.R2

 ISBN 0–7141–0794–8

Set in VIP Bembo
and printed in Great Britain by
W. S. Cowell Ltd, Ipswich, Suffolk.

Front cover: *A combat of nude men.* Study for the
 feigned relief in the *School of Athens* in
 the Stanza della Segnatura
 (cat. no. 102).

Back cover: Study for *'Theology'* on the vault of the
 Stanza della Segnatura (cat. no. 109).

CONTENTS

INTRODUCTION

In 1975 the British Museum celebrated the quincentenary of the birth of Michelangelo by bringing together all the drawings by him in English collections. Eight years later it is the turn of his younger contemporary and rival, Raphael. The names of Michelangelo and Raphael are sometimes coupled, as if they formed one of those contrasting pairs of contemporaries like Rubens and Poussin or Ingres and Delacroix, who have come to be regarded as the focal points of opposing styles. But the main difference between them is less one of style than of personality and temperament. Michelangelo was a solitary genius, whose inspiration came from within himself, from the deepest levels of his own consciousness. Raphael, by contrast, was sociable, highly receptive to the stimulus of the work of other artists, and to a great degree the product of his environment. Michelangelo was largely responsible for the traditional image of the 'poor, lonely, and independent old artist-man'; Raphael, according to Vasari, 'lived more like a prince than a painter'.

Michelangelo's essentially solitary temperament and the incommunicable nature of his genius meant that he had no master, and founded no school. His relation to Domenico Ghirlandaio is quite unlike that of Raphael to his early masters, Perugino and Pintoricchio; and his relation to Sebastiano del Piombo and Daniele da Volterra, or even Marcello Venusti (the three artists who have perhaps the best claim to be considered his followers), is equally unlike that of Raphael to his principal studio assistants Giulio Romano and Giovanni Francesco Penni.

The paradox of Raphael was summarised by Reynolds in his Sixth Discourse: 'it is from his having taken so many models, that he became himself a model for all succeeding painters; always imitating, and always original'. The aspect of his genius that has always been particularly remarked upon is his ability to pick out whatever for him was significant in the work of his contemporaries and absorb it into his own creative imagination. No less remarkable was his power of formulating universal artistic concepts communicable not only to his own followers and contemporaries but to artists of later generations. His intellectual and conceptual cast of mind seems to have come eventually to attach more importance to invention than to execution; and his lucidly analytical intelligence enabled him to rationalise his working methods by 'breaking down' the elements of the creative process in such a way that much of the preliminary labour involved in a large-scale commission could be delegated to a well-organised team of studio assistants. It would be an anachronism, and also an injustice, to describe Raphael as an 'academic' artist; but it is he more than any other who stands behind all later academic art, and the principles of composition deduced from his work formed the basis of the 'Grand Style' that dominates European art until nearly the end of the eighteenth century.

The drawings of Raphael's Umbrian period are superficially dependent on Perugino's, but even at this early stage his ability to simplify and harmonise forms and express himself in terms of vigorous outline rather than by painstaking attention to tone is already manifest. A power of analysis tending towards abstraction distinguishes his personality as a draughtsman alike from Leonardo's particularised attention to detail and Michelangelo's sculptural rendering of form by means of subtle tonal variation. His approach to drawing

was essentially utilitarian. He seems never to have made a drawing without some definite purpose in mind, and he regarded a working study as only a means to an end. He showed no self-conscious regard for the final appearance of the sheet, and when the drawing had served its purpose it was either abandoned, sometimes even before it was finished, or used as the basis for another. In the drawings of no other painter of the period do we find so complex a procedure of transferring figures or groups of figures from one sheet to another by tracing through the outlines with a stylus or by pricking; equally, no other artist availed himself as extensively of the time-saving use of the stylus for roughly sketching in the outline of a drawing.

The variety of Raphael's drawings reflects the methodical approach to the building up of a composition that he had learnt in Perugino's studio. They include the first rough compositional sketches and more finished drafts; studies for separate groups in a composition (as in the case of the *Disputa*, these could be numerous); studies for individual figures, from models in the studio, sometimes to fix the pose and sometimes to study the drapery; further studies of separate figures, sometimes squared for enlargement; for a complex composition, there must have been a *modello* from which the full-scale cartoon was enlarged; and even after the cartoon Raphael introduced the additional refinement of the 'auxiliary cartoon' (see no. 25).

The quincentenary has provided a convenient pretext for a re-examination of Raphael's drawings in the light of recent research. We have tried to assess each one as if looking at it for the first time, as far as possible without being influenced by preconceived ideas. Unlike Michelangelo, Raphael cannot properly be studied in isolation. There are two 'grey areas' where the connoisseurship of his drawings presents particular problems: at the start of his career when he was a pupil in Perugino's studio, and towards the end when he himself was at the head of a busy studio and dependent on the help of assistants. At the beginning of the exhibition we have therefore included a number of Peruginesque drawings, many of them traditionally given to Raphael but taken from him by modern criticism, that seemed to us in need of reassessment; at the other extreme will be found some drawings that undoubtedly are productions of the studio, together with a few borderline cases connected with commissions carried out with studio assistance. One of the main purposes of an exhibition of this kind is to facilitate such juxtapositions and comparisons. By no means every controversial drawing has been included, and one drawing undoubtedly by Raphael himself, the study at Oxford for the Prado *Holy Family with the Lamb* (KTP 520), has been omitted because of its ruined condition. The exhibition also includes two paintings. As well as the cartoon for '*The Knight's Dream*', the Trustees of the National Gallery have generously lent the painting itself so that the two can be shown alongside, and thanks to the kindness of the late Lord Clark we are able to exhibit for the first time the miniature portrait of Valerio Belli.

The present exhibition is drawn almost entirely from four collections, Chatsworth, Windsor, the British Museum and the Ashmolean Museum in Oxford. The Chatsworth Collection, as a whole, is the oldest, having been formed by the second Duke of Devonshire

(1665–1729). Raphael's earliest phase is not represented at all, and there are only one or two drawings from his Florentine period; but the Roman period is very well represented, with studies for the tapestry cartoons, the never-executed *Resurrection*, the Farnesina Loggia and the *Transfiguration*. In the early eighteenth century collectors' marks were not yet in general use, but twelve of the Chatsworth Raphaels have the initials *P. L* stamped in black on the *recto*, indicating that they passed through the sale of Sir Peter Lely's collection in 1680.

Information about the earlier history of the Raphael drawings in the Royal Library is no less scanty. Most of the Royal collection was acquired for King George III in Italy in the 1760s and 1770s, but at least one of the Raphaels – and one of the most beautiful, the study for the figure of *Poetry* (no. 110) – had belonged to Charles II or even Charles I; two others, the studies for the *Massacre of the Innocents* (no. 123) and for the *Madonna dell' Impannata* (no. 135), can be identified in the old inventory as having come, via Consul Smith, from the Bonfiglioli Collection in Bologna. It may be significant that the auxiliary cartoon for the Vatican *Coronation* (no. 24) had until the 1930s lain unnoticed among the very large group of drawings by Carlo Maratta, the contents of whose studio, including drawings by other masters, were part of the Albani Collection purchased *en bloc* in 1762. Maratta, who was the leader of the High Baroque classicising school in Rome in the late seventeenth century and an avowed admirer and emulator of Raphael, may well have owned this drawing and possibly others by him.

The collections at Chatsworth and Windsor are of the old traditional type; those in the British Museum and at Oxford reflect the new phase of collecting that began at the turn of the eighteenth century as a result of the French Revolution and the ensuing wars (especially Napoleon's invasion of Italy in 1796), which brought about the dispersal of many old collections. The works of art thus thrown on the market mostly found their way sooner or later to this country; and, as Robinson put it, 'the harvest, as regards ancient drawings, was, in the long run, mainly reaped by Sir Thomas Lawrence'. Lawrence, the most fashionable portrait painter of the time and President of the Royal Academy, was a passionate collector, who took advantage of the disturbed condition of continental Europe to bring together the finest assemblage of drawings by the Old Masters ever formed by a single individual. It is unnecessary to recount once again the story of his unavailing attempt to ensure that his collections should be preserved intact. After his death in 1830 his drawings were eventually returned to the art dealer Samuel Woodburn from whom most of them had been bought and who was the principal creditor of his estate. In 1836 Woodburn organised a series of exhibitions of the pick of the collection in the hope of disposing of the principal sections separately. The ninth exhibition was devoted to Raphael and consisted of 100 drawings, chosen from a total of about 180 which were offered for sale *en bloc* for £15,000. Unfortunately there is no detailed inventory of the Lawrence Collection, but the final total of Raphael drawings must have been well over 200. They included a high proportion of copies and studio drawings and even some not by Raphael at all, such as the group of landscape sketches by Fra Bartolommeo now at Oxford (P II 106–109). On the other hand, the hundred drawings selected by Woodburn for exhibition are, with hardly an exception,

of indisputable authenticity and the highest quality, and represent every phase of Raphael's activity.

In 1838 the Prince of Orange, later King William II of Holland, bought fifty-two of the hundred drawings in Woodburn's exhibition. The remainder were left on Woodburn's hands, but in 1845 he had the satisfaction of seeing Lawrence's wishes at least in part fulfilled, when the University of Oxford was, with some reluctance, persuaded to accept, as a gift paid for by public subscription and thanks to Woodburn's generosity at a much reduced price, more than eighty of the Michelangelo drawings (of which fifty-two are catalogued by Parker as authentic) and as many as 150 or so attributed to Raphael. Of these last, about seventy are now accepted as authentic, the rest being either studio drawings or copies. The seventy or so original drawings in effect constitute the Oxford Raphael Collection, with the addition of two (nos. 27 and 61) included in the Chambers Hall gift of 1855 (one of which had come from the Lawrence Collection via the King of Holland) and three or four acquired in recent years, notably nos. 112 (also a stray from the Lawrence Collection) and 148. All but two of the drawings presented to the University in 1845 came from Lawrence, the exceptions being the early head and shoulders of a boy once believed to be a self-portrait (no. 34) and the magnificent study for the heads and hands of two of the apostles in the *Transfiguration* (no. 180), both acquired by Woodburn from the collection of Jeremiah Harman.

The gift to Oxford had by no means exhausted the resources of the Lawrence drawings. In 1850, when the King of Holland's collections were sold at auction, Woodburn was able to buy back most of what he had sold twelve years before. In 1853 Woodburn died, but it was not until 1860 that the residue of the Lawrence Collection was finally dispersed. The sale catalogue shows that many of the finest Raphael drawings had either remained in, or had returned to, Woodburn's possession. Of the forty-one drawings by Raphael in the British Museum, two came with the Cracherode Bequest in 1799 and nine with that of Richard Payne Knight in 1824. Of the remaining thirty, no fewer than seventeen had been in the Lawrence Collection; of those seventeen, no fewer than eleven had passed through the collection of the King of Holland; and no fewer than ten of them, together with four others, were part of the Malcolm Collection which the Museum acquired *en bloc* in 1895.

It would be beyond the scope of this introduction to go into the question of where Lawrence and his agents found the drawings, but one of his sources should be mentioned. Among Samuel Woodburn's most spectacular coups was the purchase in 1823 of the remaining part of the collection which had been formed by Raphael's older contemporary, fellow-citizen of Urbino, fellow-artist and occasional associate, Timoteo Viti (1469/70–1523), and which was then in the possession of his descendants, the Antaldi family of Pesaro. Some drawings from this collection had already been acquired in 1714 by the French collector Pierre Crozat (nos. 60 and 77 in the present exhibition are two of these), and others may have already come to Lawrence via J. B. J. Wicar, another French collector active in the Napoleonic period, and the English *marchand amateur* William Young Ottley who seems to have acted as Lawrence's expert adviser (see *British Museum Quarterly*, xviii

(1953), pp. 46 f.). But even if a drawing can be traced directly back to the Antaldi Collection, this is not an infallible guarantee of authenticity. Provenance is a fascinating byway in the study of drawings, but only very rarely is it relevant to their critical assessment. We have not therefore thought it necessary to encumber the present catalogue with such details, which can be found in the catalogues by Parker, Pouncey and Gere, and Popham. The visitor to the exhibition may nevertheless like to be reminded that the Antaldi drawings are usually inscribed in pen and brown ink with the initials *R. V.* (standing for *Raffaello da Urbino*), and that those from the Lawrence Collection bear the small blind-stamped initials *TL* in the lower left-hand corner.

It is fitting that Raphael, who was destined to become the exemplar of the academic in art, should have been the first artist to be the subject of modern academic study. J. D. Passavant's *Raphael von Urbino und sein Vater Giovanni Santi*, published in Leipzig in 1839, is the earliest example of a scientific monograph, in the modern sense, on an individual artist. Previous artistic biographers had followed the narrative pattern established by Vasari in the sixteenth century. Passavant was the first to grasp the fact that the essential history of an artist is not that of the events of his life but of his stylistic development as reflected in his works, and to attempt a systematic definition of his subject's *oeuvre* by compiling a *catalogue raisonné* – and, moreover, one in which drawings are regarded as documents no less significant than paintings. (References in the present catalogue are to Passavant's second edition, published in French in 1860, which included a revised and greatly enlarged catalogue of drawings.)

Passavant's achievement in laying the foundation of later Raphael studies is all the greater for having been carried out in the period immediately before the revolution in art-historical method brought about by the use of photography. The facsimile publications of drawings listed in Rudolph Weigel's *Die Werke der Maler in ihren Handzeichnungen*, published in 1865, are almost all engraved or lithographed. Only about twenty are reproduced by photography, and the earliest of these, the Thurston Thompson publication of the Raphael drawings in the Royal Library at Windsor, appeared in 1857. Passavant's preface to his second edition is dated October 1856.

The Thurston Thompson publication owed its origin to the initiative of the Prince Consort, who in the early 1850s was contemplating a methodical rearrangement on scientific lines of the drawings and prints in the Royal Library 'to render them available for a thorough and critical illustration of the history of painting'. He decided to initiate this scheme by systematically bringing together the complete work of one great master. Raphael would in any case have been the obvious choice, but the existence of Passavant's *catalogue raisonné* was an additional, and conclusive, argument.

After the Prince's death in 1861 the Windsor Raphael Collection was carried on by Carl Ruland, whose catalogue of it appeared in 1876. This privately printed and now very rare volume is less well known than it deserves. Ostensibly nothing more than a summary handlist, its scope is so wide and its arrangement so well thought out that it still constitutes

the most complete skeleton catalogue of Raphael's entire work – comprising as it does paintings, all the related engravings, and a very high proportion of the surviving drawings. Its highly condensed form gave Ruland no scope for critical discussion: his opinion of a drawing's authenticity is implied by his classification of it either as by Raphael himself or in the apocryphal section headed 'ascribed to Raphael'.

The usefulness of Ruland's catalogue, and even more that of the collection itself, is due to the clear-headedness with which the Prince Consort devised the organisation of this great mass of material. The principles that guided him are explained in Ruland's preface, which could still be read with profit by anyone confronted with a similar task. Passavant had listed in chronological order Raphael's paintings and whatever drawings were in his opinion related to them, following these with a general catalogue of drawings arranged by location. His not altogether satisfactory compromise was abandoned by the Prince Consort in favour of a strict classification by subject, and the scope of the collection was also enlarged 'to admit every work of art to which Raphael's name had ever been attached by any definite authority'. This apocryphal section gives the collection its unique value, for it includes much little-known material that has proved to be of greater interest than Ruland supposed; and the advantage can hardly be exaggerated of being able to study all representations of any subject, whether in the form of original paintings and drawings, copies whether painted, engraved or drawn, and paintings and drawings once attributed to Raphael.

The Prince was quick to appreciate the potential usefulness of photography in the study of the history of art. After the appearance of his Thurston Thompson publication in 1857, 'other proprietors of drawings were induced to follow his example, and frequently the impulse given by His Royal Highness's request for photographic copies, led to the publication of such copies, which thus became a boon to amateurs in general. When the owner did not render such assistance, the photographs had to be taken at the Prince's own expense and for his collection only; but it is pleasant to record that with one single exception, no owner ever refused to allow the faithful reproductions of his treasures to be deposited in the Prince's portfolios'. Every subsequent student of Raphael has paid eloquent tribute to the value of the Windsor Raphael Collection, and to the foresight of the Prince Consort. Since 1973, through the generosity of Her Majesty The Queen, the collection has been deposited on indefinite loan in the Department of Prints and Drawings of the British Museum.

In the 1860s photography became widely used. Its value as an instrument of research was emphasised by Sir Charles Robinson in his *Critical Account of the Drawings by Michel Angelo and Raffaello in the University Galleries, Oxford*, published in 1879, which is one of the classics of art criticism and a pioneer work in the detailed study of an artist's drawings. Robinson was above all a great 'practical' connoisseur. Between 1852 and 1869 Curator of the South Kensington (Victoria and Albert) Museum, his fine taste and flair for acquisition had, almost surreptitiously, transformed a Museum of Industrial Design and Ornament into one of the great European collections of sculpture and decorative art. A very high proportion of the finest objects in the Primary Galleries were acquired in the period of his

curatorship, and it is hardly an exaggeration to claim that Robinson was to the Victoria and Albert what Bode later in the century was to be to the Kaiser Friedrich Museum in Berlin. His own personal interest, however, was in Old Master drawings of which he himself was a collector (see no. 121); his most notable achievement in that field was the part he played as expert adviser in the formation of the Malcolm Collection, acquired *en bloc* by the British Museum in 1895. He alludes to this personal enthusiasm in the preface to his *Critical Account*, which he begins with an apologia for treating at such length a subject likely to appeal only to a few specialists; but 'as in literature Dante and Shakespeare have justly merited and received the homage of innumerable critics and commentators, a similar devotion is the proper meed of Michelangelo and Raffaello'. The principles on which his catalogue was written are still valid today: ' . . . it was essential to arrive at definite conclusions as to the authenticity of the several specimens; to determine, if possible, the approximate date, the intention and ultimate destination of each drawing; and also, in the case of preparatory studies for known works, to give some account of the finished productions. To do this thoroughly called for careful and laborious research and comparison; and to have given, in a succinct and authoritative form, the results of such investigations, whilst withholding the evidence on which those results were founded, especially when it was necessary to modify or reverse the conclusions of previous authorities, would have been very unsatisfactory.'

Crowe and Cavalcaselle's *Raphael: his Life and Work*, published in 1882, though inevitably superseded in points of detail by Fischel and by the specialised publications of recent years, remains the standard biography. The authors take fully into account such drawings as seemed to them connected with paintings, and in their critical commentary they are often at variance with Passavant and Robinson, but there is no attempt at a complete catalogue of drawings: the arrangement of the material in the form of a chronological narrative made it necessary to put references to them into footnotes.

After the empirical and essentially common-sense approach of Robinson and Crowe and Cavalcaselle came the phase of so-called scientific connoisseurship associated above all with the name of Giovanni Morelli. It is undeniable that Morelli made a historic contribution to the history of Italian painting; but in the aspect of their work that particularly concerns us here, namely the attempt to distinguish between Raphael's late Roman drawings and those of his studio, he and his disciples Dollmayr and Wickhoff fell into the error of theorising far ahead of their data by freely bandying about the names of Peruzzi, Giulio Romano, Perino del Vaga and Giovanni Francesco Penni without having made any serious attempt to form a positive conception of them as individual artistic personalities.

The extent to which Morelli's authority was once accepted is revealed in the foreword to the first book by Oskar Fischel on the subject that he was to make his own, *Raffaels Zeichnungen: Versuch einer Kritik der bisher veröffentlichen Blätter*, Strasburg, 1898. The present-day student who has come to admire and value J. C. Robinson's combination of width of reference, critical acumen, sensitivity and common sense, is surprised to be told that 'with the exception of some valuable occasional remarks by Morelli, the author has

derived no enlightenment from his predecessors'. Fischel's *Versuch* consists of a clearly tabulated list of Raphael's drawings with a brief summary of previous critical opinions, culminating in the author's own view sometimes expressed in only two or three words – an example of the laconic style of criticism described by Robinson as 'succinct and authoritative' but 'very unsatisfactory', which was much favoured by Morelli and his followers, who seem to have taken the view that their opinions were so self-evidently correct that no amplification or explanation of them was necessary.

Fischel's *Versuch* did not, as has been claimed, 'transform' the study of Raphael. His comments on individual drawings and his discussion in the preface of some of the more general problems raised by them show that at this early stage of his career he was a faithful adherent of the then dominant Morellian school and that he followed it in all its restrictive hypercriticism and centrifugal tendency to remove drawings arbitrarily from the master and to assign them, no less arbitrarily, to a number of associates and pupils. The statement that no more than six drawings in red chalk and only about seven studies in black chalk can be attributed to Raphael's own hand is characteristic of this phase of Fischel's thought; so too is his enlargement of Peruzzi's *oeuvre* at the expense of Raphael's by giving him – to mention only drawings in the present exhibition – nos. 38, 39, 42, 45, 47, 49, 50, 51, 67, 75, 77, 78, 79 and 145.

Fischel certainly did transform the study of Raphael, and especially of his drawings, but it was not until 1913 that the first fascicule of his *corpus* of drawings appeared. In the intervening fifteen years he had divested himself of his Morellian notions, which he explicitly and formally recanted in the preface to the *corpus*: 'no more than Wickhoff, nor indeed than anyone else who has written on Raphael's drawings, was Morelli able to establish a sure basis for criticism; the author now regrets having followed these two great luminaries also in their errors.'

In 1917 he published his *Zeichnungen der Umbrer* in an attempt to clear the ground for the study of the youthful Raphael by defining the drawing-style of his Umbrian associates Perugino and Pintoricchio. Meanwhile his *corpus* continued. The eighth fascicule appeared in 1941, two years after his death, bringing the number of drawings reproduced to 395; the ninth, with a commentary by Konrad Oberhuber, in 1972; and at least one more is promised. His latest thoughts on questions of attribution are summarised, briefly and not always quite clearly, in the list of works compiled from his notes by the late Otto Kurz and appended to his monograph on Raphael posthumously published in English in 1948.

Fischel's *corpus* will remain the foundation for all subsequent work on the subject. His life-long familiarity with the material and his absorption with the personality of Raphael had given him a remarkable insight into the working of the artist's mind. His instinct is always to be respected, once due allowance is made for certain *idées fixes*. His penchant for reconstituting hypothetical dismembered sketchbooks (see nos. 20 and 37) is relatively harmless, for since the drawings thus grouped together are entirely homogeneous in style it is of only academic interest whether they were originally bound up between two covers. On the other hand, his insistence that some of Raphael's pen drawings have been 'ruined by

later retouching' is a vestige of the old Morellian hypercriticism. 'Reworking' is all too often invoked by critics as a facile way of explaining any feature of a drawing that does not conform to their *a priori* conception of the artist's drawing style; and Fischel's belief, stated in *Versuch* in the form of an axiom, that 'in every drawing by Raphael the shading takes the form of a single series of strokes evenly disposed at an angle of about 45 degrees', led him even in his *corpus*, quite mistakenly as it now seems, to see the intervention of later hands in drawings of the Florentine or early Roman period in which forms or areas of tone are rendered by a system of cross-hatching.

Fischel's readers, even those whose mother tongue is German, sometimes find it difficult to be absolutely certain of his exact meaning; but it is fair to say that his over-subtle ambiguities seem to have been caused not so much by a desire to 'have it both ways' as by the dialectical habit of thought prevalent in Germany in the nineteenth century which tended to see the truth as the outcome of two apparent contradictions.

The knowledge that Fischel's *corpus* was in progress had for some time the effect of discouraging others from working on Raphael's drawings, but the years after the Second World War saw the appearance of catalogues of three of the principal English collections: A. E. Popham's catalogue of the fifteenth- and sixteenth-century drawings at Windsor appeared in 1948, followed in 1956 by Sir Karl Parker's volume dealing with the Italian drawings in the Ashmolean Museum and in 1962 by the catalogue of drawings by Raphael and his Circle in the British Museum by Philip Pouncey and J. A. Gere. To these publications, as also to the notes made by visiting critics, especially Popham, in the typescript handlist of the Chatsworth drawings, we are much indebted. In the quarter of a century or so that has elapsed since their appearance, a number of valuable detailed studies of particular aspects of Raphael's activity have appeared, notably those by Konrad Oberhuber, John Shearman, Michael Hirst and Sylvia Ferino Pagden. Other publications that we have found of especial use are Luitpold Dussler's *Raphael: a Critical Catalogue of his Pictures, Wall-Paintings and Tapestries* of 1971 (German ed. 1966), a methodical compilation of all the ascertainable facts about the artist's works, together with a summary of critical opinion; and – invaluable in quite a different way – the brilliant and stimulating general study of Raphael by John Pope-Hennessy.

As we have sought to simplify the catalogue by omitting references to provenance, so we have restricted the bibliography of a drawing to the standard catalogues: Passavant's second (1860) edition, Robinson's *Critical Account*, Popham's Windsor catalogue, Parker's Ashmolean catalogue, the British Museum catalogue by Pouncey and Gere, Crowe and Cavalcaselle's *Life of Raphael*, and Fischel's *corpus* and his *Zeichnungen der Umbrer*. Other references that seemed worth quoting are cited in the text as and when they occur. Dr Paul Joannides's *The Drawings of Raphael* did not appear until after the present catalogue had gone to press.

The Trustees of the British Museum wish to express their thanks to those whose generous willingness to lend has made possible this exhibition: Her Majesty The Queen, the Duke of

Devonshire and the Trustees of the Chatsworth Settlement, the Earl of Pembroke and Montgomery, Viscount Coke, the Hon. Alan Clark, M.P., Mr Christopher Loyd, and three private collectors who wish to remain anonymous; also the Visitors and Director of the Ashmolean Museum, the Governing Body of Christ Church, the Syndics and Director of the Fitzwilliam Museum, the Trustees and Director of the National Gallery, and the President and Council of the Royal Institute of British Architects.

We also thank the Hon. Mrs Roberts and Lady Iona Mackworth-Young of the Royal Library; the Duke and Duchess of Devonshire, Mr Peter Day, the Keeper of the Collections at Chatsworth and Mr Michael Pearman, the Librarian; Mr F. C. Jolly, of the Holkham Estate Office; Miss Elizabeth Johnston, secretary to the late Lord Clark; Dr Kenneth Garlick, Keeper of Western Art at the Ashmolean Museum, and Mr Ian Lowe and Mr David Brown; Miss Joanna Woodall, Assistant Curator of Pictures at Christ Church; Mr David Scrase, Keeper of Paintings and Drawings at the Fitzwilliam Museum; Mr Alan Braham and Mr Christopher Brown of the National Gallery; and Mr John Harris and Miss Jane Preger of the Drawings Collection of the Royal Institute of British Architects.

We are grateful to Mr John Rowlands, Keeper of the Department of Prints and Drawings, and Mr Antony Griffiths, Deputy Keeper, for continuous encouragement and support; and, for practical assistance of various kinds, to Mr Martyn Tillier, Miss Jenny Bell and Miss Caroline Andrewes. Dr Paul Joannides, Professor Konrad Oberhuber and Mr Philip Pouncey were kind enough to give advice on specific points.

J. A. G.
N. T.

LIST OF WORKS REFERRED TO
IN ABBREVIATED FORM

AEP A. E. Popham and Johannes Wilde, *The Italian Drawings of the XV and XVI Centuries in the Collection of His Majesty the King at Windsor Castle*, London, 1949

B Adam Bartsch, *Le Peintre Graveur* (21 vols.), Vienna, 1803–21

Bean 1982 Jacob Bean, with the assistance of Lawrence Turčić, *15th and 16th Century Italian Drawings in the Metropolitan Musem of Art*, New York, 1982

Beckerath 1907 A. von Beckerath, 'Über einige Zeichnungen alter Meister in Oxford', *Repertorium für Kunstwissenschaft*, xxx (1907), pp. 291 ff.

Brown 1983 David Alan Brown, *Raphael and America*, exhibition catalogue, National Gallery of Art, Washington, 1983

C&C J. A. Crowe and G. B. Cavalcaselle, *Raphael: his Life and Works with particular reference to recently discovered records and an exhaustive study of extant drawings and pictures* (2 vols.), London, 1882

Colvin Sidney Colvin, *Drawings of the Old Masters in the University Galleries and in the Library of Christ Church, Oxford* (3 vols.), Oxford, 1907

Dussler Luitpold Dussler, *Raphael: a Critical Catalogue of his Pictures, Wall-Paintings and Tapestries*, London and New York, 1971

F Oskar Fischel, *Raphaels Zeichnungen* (8 parts), Berlin, from 1913 to 1941 (referred to also as *corpus*). For part 9, see F–O

F–O *Raphaels Zeichnungen*, begründet von Oskar Fischel, fortegeführt von Konrad Oberhuber, part 9: *Entwürfe zu Werken Raphaels und seiner Schule im Vatican 1511/12 bis 1520*, Berlin, 1972

F, ZdU Oskar Fischel, *Die Zeichnungen der Umbrer*, Berlin, 1917

Fischel 1898 Oskar Fischel, *Raphaels Zeichnungen: Versuch einer Kritik der bisher veröffentlichten Blätter*, Strasburg, 1898

Fischel 1912 Oskar Fischel, 'Some Lost Drawings by or near to Raphael', *Burlington Magazine*, xx (1911–12), pp. 294 ff.

Fischel 1925 (A) Oskar Fischel, 'Raphaels Auferstehung Christi', *Jahrb. Preussischen Kunstsammlungen*, xlvi (1925), pp. 191 ff.

Fischel 1925 (B) Oskar Fischel, 'An unknown Drawing for Raphael's *Disputa*', *Burlington Magazine*, xlvii (1925), pp. 175 f.

Fischel 1937 Oskar Fischel, 'Raphael's Auxiliary Cartoons', *Burlington Magazine*, lxxi (1937), pp. 167 f.

Fischel 1948 Oskar Fischel, *Raphael*, translated from the German by Bernard Rackham (2 vols.), London, 1948

Ferino Pagden Sylvia Ferino Pagden, 'Raphael's Activity in Perugia as reflected in a Drawing in the Ashmolean Museum, Oxford', *Mitteilungen des Kunsthistorischen Institutes in Florenz*, xxv (1981), pp. 231 ff.

Freedberg S. J. Freedberg, *Painting of the High Renaissance in Rome and Florence* (2 vols.), Cambridge (Mass.), 1961

Frommel Christoph Luitpold Frommel, *Baldassare Peruzzi als Maler und Zeichner* (Beiheft zum *Römischen Jarhbuch für Kunstgeschichte*, ii), Vienna and Munich, 1967–8

Gernsheim Walter Gernsheim, *Corpus Photographicum*. Photographs of drawings in public and private collections, in progress

Golzio Vincenzo Golzio, *Raffaello nei documenti, nelle testimonianze dei contemporanei e nella letteratura del suo secolo*, Rome, Vatican City, 1936

Gronau Georg Gronau, *Aus Raphaels Florentiner Tagen*, Berlin, 1902

Gronau, KdK Georg Gronau, *Raffael, des Meisters Gemälde in 274 Abbildungen*, Stuttgart, Berlin and Leipzig, 1923

Hartt Frederick Hartt, *Giulio Romano* (2 vols.), New Haven, 1958

Hirst 1961 Michael Hirst, 'The Chigi Chapel in S. Maria della Pace', *Journal of the Warburg and Courtauld Institutes*, xxiv (1961), pp. 161 ff.

Hirst 1981 Michael Hirst, *Sebastiano del Piombo*, Oxford, 1981

KTP K. T. Parker, *Catalogue of the Collection of Drawings in the Ashmolean Museum*, vol. ii, *The Italian Schools*, Oxford, 1956

Lawrence Gallery *The Lawrence Gallery, Ninth Exhibition. A Catalogue of One Hundred Original Drawings by Raffaelle, collected by Sir Thomas Lawrence. At Messrs. Woodburn's Gallery, No. 112, St. Martin's Lane*, London, 1836 (Plate references are to: *Lawrence Gallery. A Series of Fac-similes of Original Drawings, by Raffaelle da Urbino, selected from the Matchless Collection formed by Sir Thomas Lawrence*, London, 1841)

Macandrew, Suppl. Hugh Macandrew, *Catalogue of the Collection of Drawings in the Ashmolean Museum*, vol. iii, *The Italian Schools: Supplement*, Oxford, 1980

MD *Master Drawings*, New York, from 1963

Morelli 1887 'Ivan Lermolieff' (Giovanni Morelli), 'Noch einmal das venezianische Skizzenbuch', *Zeitschrift für bildenden Kunst*, xxii (1887), pp. 111 ff. and 143 ff.

Morelli, Rome or Berlin	'Ivan Lermolieff' (Giovanni Morelli), *Kunstkritische Studien über italienische Malerei. Die Galerien Borghese und Doria Panfili in Rom*, Leipzig, 1890; *Die Galerien zu Berlin*, 1893
Müntz	Eugène Müntz, *Raphaël. Sa vie, son oeuvre et son temps*, Paris, 1882
Oberhuber	*see* F–O
Oberhuber 1962 (A)	Konrad Oberhuber, 'Die Fresken der Stanza dell'Incendio im Werk Raffaels', *Jahrb. der Kunsthistorischen Sammlungen in Wien*, N.F., xxii (1962), pp. 23 ff.
Oberhuber 1962 (B)	Konrad Oberhuber, 'Vorzeichnungen zu Raffaels Transfiguration', *Jahrb. der Preussischen Kunstsammlungen*, N.F., iv (1962), pp. 116 ff.
Oberhuber 1963	Konrad Oberhuber, Review of P&G, *MD*, i, 3 (1963), pp. 44 ff.
Oberhuber 1978	Konrad Oberhuber, 'The Colonna Altarpiece in the Metropolitan Museum and Problems of the Early Style of Raphael', *Metropolitan Museum Journal*, xii (1978), pp. 55 ff.
OMD	*Old Master Drawings, a quarterly Magazine for Students and Collectors*, vols. i–xiv, London, 1926–40
P	J.–D. Passavant, *Raphael d'Urbin et son père Giovanni Santi*, édition française refaite corrigée et considérablement augmentée par l'auteur . . . revue et annotée par M. Paul Lacroix (2 vols.), Paris, 1860. Unless otherwise stated references are to the catalogue of drawings in vol. ii, pp. 399 ff.
P&G	Philip Pouncey and J. A. Gere, *Italian Drawings in the Department of Prints and Drawings in the British Museum: Raphael and his Circle* (2 vols.), London, 1962
P&P	A. E. Popham and Philip Pouncey, *Italian Drawings in the Department of Prints and Drawings in the British Museum: the Fourteenth and Fifteenth Centuries* (2 vols.), London, 1950
Parker 1939–40	K. T. Parker, 'Some observations on the Oxford Raphaels', in *OMD*, xiv (1939–40), pp. 34 ff.
Pope-Hennessy	John Pope-Hennessy, *Raphael*, London, n.d. [1970]
Popham, 1930	A. E. Popham, *Italian Drawings exhibited at the Royal Academy, Burlington House, London, 1930*, London, 1931
R	J. C. Robinson, *A Critical Account of the Drawings by Michel Angelo and Raffaello in the University Galleries, Oxford*, Oxford, 1870
Ruland	[C. Ruland], *The Works of Raphael Santi da Urbino as represented in The Raphael Collection in the Royal Library at Windsor Castle, formed by H.R.H. The Prince Consort, 1853–1861, and completed by Her Majesty Queen Victoria*, privately printed, 1876
Shearman 1961	John Shearman, 'The Chigi Chapel in S. Maria del Popolo', *Journal of the Warburg and Courtauld Institutes*, xxiv (1961), pp. 129 ff.
Shearman 1964	John Shearman, 'Die Loggia der Psyche in der Villa Farnesina und die Probleme der letzen Phase von Raffaels graphischem Stil', *Jahrb. der Kunsthistorischen Sammlungen in Wien*, lx (1964), pp. 59 ff.
Shearman 1965	John Shearman, 'Raphaels's Unexecuted Projects for the Stanze', in *Walter Friedländer zum 90. Geburtstag*, Berlin, 1965, pp. 158 ff.
Shearman 1967	John Shearman, 'Raphael . . . fa il Bramante', in *Studies in Renaissance and Baroque Art presented to Anthony Blunt on his 60th Birthday*, 1967, pp. 12 ff.
Shearman 1971	John Shearman, 'The Vatican Stanze: Functions and Decoration', *Proceedings of the British Academy*, London, 1971
Shearman 1972	John Shearman, *Raphael's Cartoons in the Collection of Her Majesty the Queen, and the Tapestries for the Sistine Chapel*, London, 1972
Shearman 1977	'Raphael, Rome and the Codex Escurialensis', *MD*, xv (1977), pp. 107 ff.
Stix-Bum cat. iii	Alfred Stix and Lili Fröhlich-Bum, *Beschreibender Katalog der Handzeichnungen in der Graphischen Sammlung Albertina: iii, toskanischen, umbrischen und römischen Schulen*, Vienna, 1932
Venturi	A. Venturi, *Storia dell'arte italiana* (11 vols.; from vol. vi subdivided into parts), Milan, 1901–39

1 UMBRIAN PERIOD, c. 1497 to 1503–4
Nos. 1–33

There is some doubt about the exact date of Raphael's birth. Vasari says that he was born in Urbino on Good Friday 1483 (i.e. 28 March) and that he died in 1520 'on the very day on which he was born, that is, Good Friday' (i.e. 6 April). On the other hand, the epitaph over his grave in the Pantheon makes no reference to Good Friday, but simply says that he died on his thirty-seventh birthday, on 'VIII. ID. APRILIS' (i.e. 6 April).

He received his first lessons from his father, Giovanni Santi, a minor painter attached to the court of Urbino. It seems to have been soon after his father's death in 1494 that Raphael entered the studio of Perugino, then the leading painter of the Umbrian School, who between the years 1495 and 1500 was chiefly active in his native city of Perugia. It is clear that Raphael was a prodigy. The reference to him as 'magister' in the contract of 10 December 1500 for the altarpiece of the *Coronation of St Nicholas of Tolentino* (see no. 11) shows that by the age of seventeen he had already achieved the status of an independent master. The votive banner for Città di Castello datable on external evidence 1499 (see no. 9), is his earliest known independent work. The preponderating influence on him at this period was that of his master, Perugino, whose graceful, but limited and *retardataire* style he developed to the utmost limit of refinement. He was also affected by Pintoricchio, whom he assisted by making designs for the decoration of the Piccolomini Library in Siena (see no. 29), and by Signorelli (see no. 9), while his technique of oil-painting must owe something to the study of near-contemporary Flemish paintings, which were collected and commissioned at the court of Urbino (see Brown 1983, pp. 153 ff.). The most ambitious work of his Umbrian period is the *Coronation of the Virgin*, now in the Vatican Gallery, which was probably commissioned in 1503 (see no. 20). Enough studies for this picture have survived to show that Raphael's highly organised preparatory method was already fully developed.

Vasari's observation, that already in his day it was almost impossible to distinguish Perugino's paintings from Raphael's, still applies to the drawings datable in the early years of Raphael's Umbrian period when he was under the tutelage of Perugino. We have taken the opportunity of including a number of drawings the traditional attribution of which to Raphael was challenged by Fischel in his *Zeichnungen der Umbrer* (1917), in the hope that direct comparison with others demonstrably by Raphael may throw fresh light on the problem.

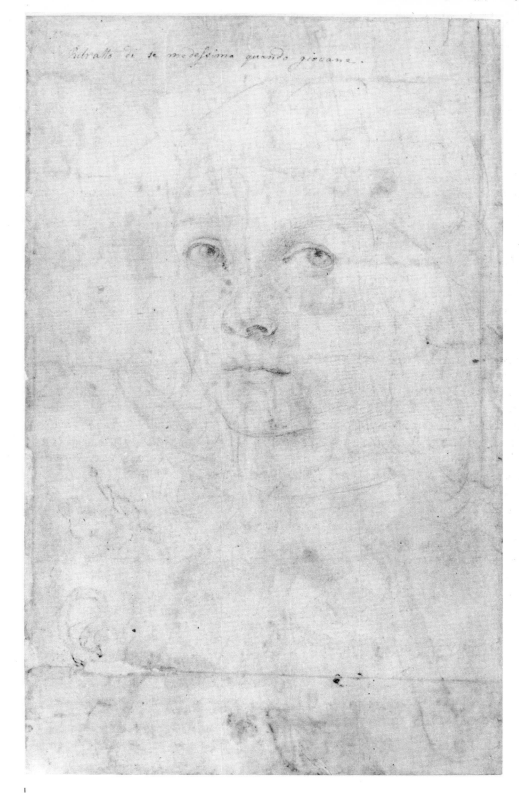

Ritratto di se medesimo quando giovane.

1. Head of a boy (self-portrait?)

British Museum 1860–6–16–94 *verso*
Black chalk. Some stylus underdrawing, e.g. in the nose.
314 × 190 mm
Literature: P & G 1; P, p. 542, *kkk*; Ruland, p. 3, ii, 1;
C & C, i, p. 282; F 38.

A round brimless cap is very faintly indicated, as is the hair hanging down to the right shoulder.

Inscribed in ink in a late eighteenth- or early nineteenth-century hand: *Ritratto di se medessimo quando giovane*. This claim that the drawing is a youthful self-portrait must be considered in the light of the identical inscription in the same hand on no. 34. Though there are some points of similarity between the two heads, they do not necessarily represent the same person – a fact that reduces the evidential value of either inscription. On the other hand, the intent stare in no. 1 is characteristic of a self-portrait, especially of one by an inexperienced hand, and the features are not incompatible with those of the adult Raphael (e.g. in self-portraits in the Uffizi and in the group on the extreme right of the *School of Athens*) and even closer to those of the head of a young man at Hampton Court (278; E. Law cat., 1881, no. 710) traditionally, and perhaps rightly, said to be a youthful self-portrait of Raphael. The boy in this painting, as in the drawing, can hardly be more than sixteen or seventeen years old, so if no. 1 is a self-portrait it could date from *c.* 1500, a dating borne out by the style of the sketches on the *recto* (F 4): a pen and ink back view of a standing nude man, with the lower part of the right leg and most of the back *écorché* to show the musculature, and five separate studies of arms.

2. Studies of a left hand and of a boy's head

Ashmolean Museum P II 32
Pen and blackish-brown ink and light brown wash,
 over lead point and/or black chalk, with the outlines
 apparently scratched in places with a stylus and the cuff
 indicated in leadpoint only (the hand); pen and light
 brown ink, over some stylus underdrawing (the head).
 212 × 245 mm
Literature: KTP 32; P, p. 513, *jj*; R 36; Ruland, p. 335,
 xxii, 1; F, *ZdU* 8.

One of Lawrence's Raphael drawings, said by Woodburn to have come from the Antaldi Collection. Passavant rejected the traditional attribution, but it was emphatically defended by Robinson: 'the writer is convinced that it is an original work of Raffaello. No doubt in the touch and style of execution a certain want of accordance with Raffaello's usual characteristics may be perceived; but, on the other hand, the purity and grace displayed in every line could have been achieved by no-one else. It would be difficult indeed, in the whole work of the great master, to select a more beautiful typical face than the beaming countenance here pourtrayed.'

Fischel, though he excluded no. 2 from his Raphael *corpus*, shared Robinson's high opinion, going so far as to describe it as 'one of the most beautiful drawings of the *quattrocento*'. It seemed to him to reflect some influence of Verrocchio, and he classified it in his *Zeichnungen der Umbrer* under the heading 'the so-called Fiorenzo group'. The reference is to the Umbrian painter Fiorenzo di Lorenzo who, like Perugino, had been a pupil of Verrocchio in Florence. But he still thought that Robinson's arguments in favour of Raphael's authorship could not be ignored, and that the drawing might well be a copy by the young Raphael of an early, Verrocchiesque drawing by Perugino, if not an original study by him in the same old-fashioned style; and he ended his comments by comparing the lively expression and treatment of the face with Raphael's somewhat later, but still Umbrian, drawing of a boy's head, at Lille (F 20).

The other critical opinions summarised by Parker are unusually varied: 'R. van Marle pronounces it to be *not* by the Master of 1473; G. M. Richter attributes it to Bramante; an even stranger opinion was that expressed by Morelli, according to whom it is a copy after Raphael by a German artist, perhaps Holbein'. Parker himself did not follow up the fairly broad hint with which Fischel concluded his remarks on no. 2, but contented himself with cataloguing it, without comment, as 'Circle of Perugino'.

We agree with Robinson that the drawing, especially the study of the head, is of exceptional

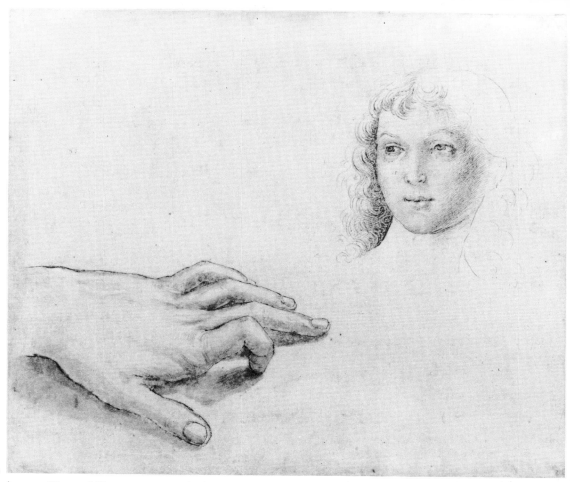

2

beauty. The unfailing exact control of the pen, the unlaboured precision with which the eyes and mouth are rendered, the rhythmic pattern of the curls and the subtle indication of reflected light along the line of the cheek, all point to Raphael. Such a drawing is surely far beyond the scope of any other *quattrocento* Umbrian, Perugino included. The study of a hand makes a less favourable first impression, but it reveals the same degree of searching observation in the rendering of such details as the wrinkled skin round the knuckles and the base of the forefinger. Three very similar 'close-up' studies of left hands are in the Venice Sketchbook (*ZdU*, figs. 181, 231 and 251), a collection of studies some or all of which seem to have been copied from Peruginesque originals, including a number by the youthful Raphael. For any draughtsman – especially a young one still trying to master anatomy – one of the most convenient exercises is the study of his own left

hand. If no. 2 is by Raphael, as we believe, it can only be a very early work, datable in the 1490s; the much later dating of 1506 or shortly afterwards proposed by Robinson is based on a false premise and is quite out of the question.

Fischel was surely right in detecting a Florentine flavour in the drawing, but the hand-study suggests not so much Verrocchio as the group of Pollaiuolo studio drawings in the Uffizi which include studies of young artists drawing and also of hands, executed – though very much more crudely – in the same technique of light brown wash bounded by an emphatic unbroken contour in a much darker ink (cf. especially Uffizi 83F, 84F, 86F and 94F). In the head-study the stylised but not conventionalised pattern to which the curls of hair are reduced even has something of Leonardo – also one of Verrocchio's pupils.

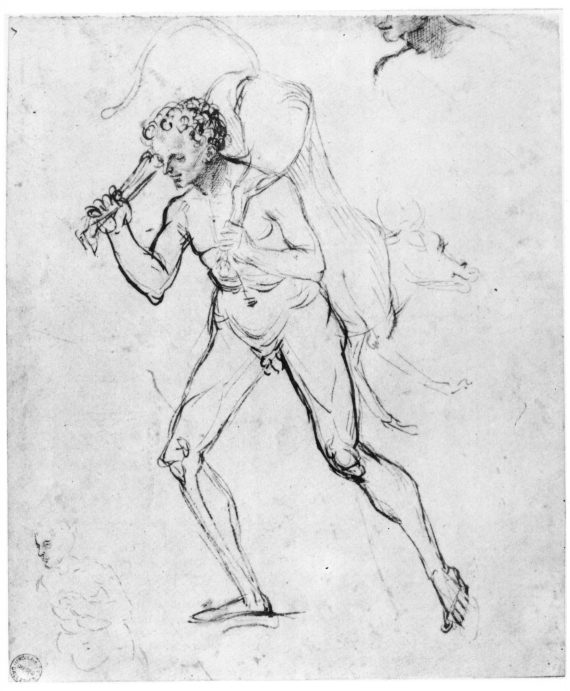

3

3. Milon of Crotona

Ashmolean Museum P II 33
Pen and brown ink. 226 × 183 mm.
Literature: KTP 33; P 529 *d*; R 18; Ruland, p. 348, iv, 1;
F, *ZdU* 72.

Milon was a Greek athlete of the sixth century BC, famous for his physical strength. Among the feats recorded by Pausanias was the carrying of a four-year-old heifer through the stadium at Olympia, and afterwards eating the whole animal in one day.

Passavant, who classified the drawing among 'copies after Antique statues', rejected the attribution to Raphael, first published by Woodburn but no doubt traditional. Robinson returned to the attribution to Raphael. Fischel included the drawing, not in his Raphael *corpus* but in *Zeichnungen der Umbrer* in the section of drawings that seemed to him products of Perugino's studio in the period of his collaboration with Raphael. He did not exclude the attribution to Raphael, but thought it could not be proved. Parker's position is much the same. He catalogued the drawing as Perugino, though with some hesitation, pointing out its resemblance to nos. 4, 6 and 9. At the same time he noted the resemblance between the head of the figure and a large-scale chalk study of a head in the British Museum (P & P 190), catalogued under the name of Perugino. Raphael and Perugino were working in the same studio and could have used the same model, so that the resemblance is irrelevant to the question of authorship. As Robinson was the first to point out, the same model appears to have been used in no. 4. We agree with him that nos. 3 and 4 are by Raphael, a conclusion independently arrived at by Pouncey (orally) as long ago as 1954.

4. A seated man; an acanthus scroll

Ashmolean Museum P II 503
Pen and brown ink (the figure) and black chalk (the
scroll). 219 × 377 mm (size of whole sheet:
the acanthus scroll not reproduced).
Literature: KTP 503; R 19; F, *ZdU* 73.

Raphael's authorship was accepted by Robinson. Fischel did not include the drawing in his *corpus* but published it in *Zeichnungen der Umbrer* with a strong hint that it might be by Raphael. The discrepancy between what he saw as the old-fashioned conception of the figure and the more developed execution of the drawing he explained on the somewhat far-fetched theory of this being a copy by one of Perugino's pupils of a much earlier drawing by the master. He acutely noticed the resemblance between the foreshortened legs and those of the angel on the step of the throne in Signorelli's *Virgin and Child with Saints*, dated 1484, in the Cathedral at Perugia. Parker did not whole-heartedly accept the attribution to Raphael but catalogued the drawing under his name. It seems to us that the drawing is certainly by Raphael, and that it could be as early as *c.* 1500, the probable date of no. 1, on the *verso* of which is a study of a man with one arm abbreviated in exactly the same way.

Robinson's contention that the figure is drawn from life is supported by the *pentimenti* for both arms and the left knee. The position of the left foot suggests that the figure was meant to be seen from below. This may account for the awkward transition, masked by the drapery, between legs and body. Robinson was surely right in his suggestion that this drawing and no. 3 are after the same model. Fischel noted that a similar figure is represented on the keystone above the *Repulse of Attila* in the Stanza d'Eliodoro, a work datable *c.* 1511–13 (see Dussler, fig. 138); he considered it part of the earlier, pre-Raphael, decoration, and was reminded by it of Bramantino. The resemblance is of the most general kind and the nature of the connexion, if any, between the keystone figure and no. 4 remains to be clarified.

On the *verso* of no. 4 are sketches of architectural ornament, *putti*, etc. Shearman (*MD*, xv (1977), p. 132 and pl. 7), who dated the drawing *c.* 1502–3, suggested that these are copied from the stucco framework surrounding Filippino Lippi's altarpiece in the Caraffa Chapel in S. Maria sopra Minerva in Rome. He used this possibility in support of his argument that Raphael may have visited Rome long before his presence is recorded there. We find obscure the hint apparently implied in his description of the figure on the *recto* as 'a copy after an unknown but impressive seated nude of very recent date'.

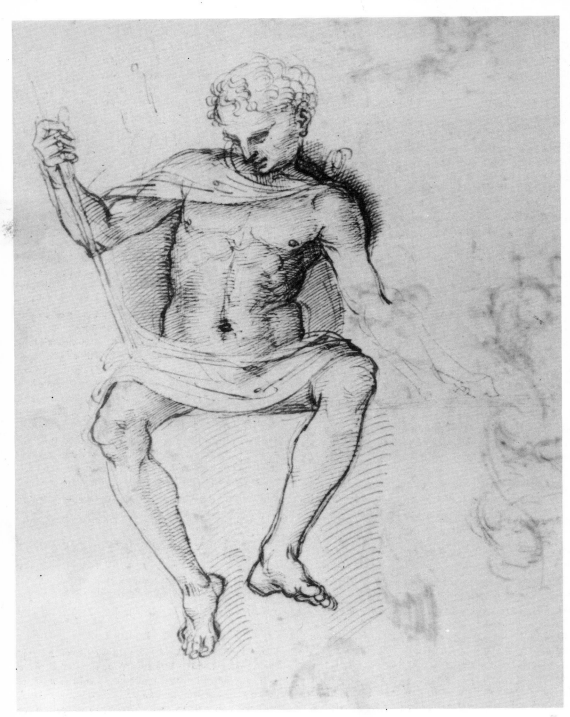

4 (Detail)

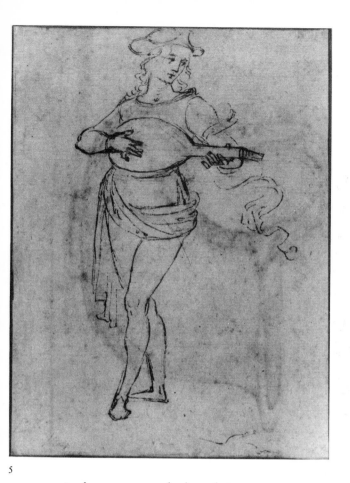

5

5. A young man playing a lute

Ashmolean Museum P II 30
Pen and ink over black chalk. 149 × 104 mm.
Literature: KTP 30; P 536; R 1; Ruland, p. 42, xviii, 1;
 C & C, i, p. 64; F, *ZdU* 80.

On the *verso* (F, *ZdU* fig. 149) is a pen drawing of a two-handled Antique drinking vessel, an *askos* of Hellenistic type.

One of Lawrence's Raphael drawings said by Woodburn to have come from the Antaldi Collection. The traditional attribution has been doubted. Passavant, for example, says of the *recto* 'il est douteux s'il soit de Raphaël'. Robinson did not share this unfavourable view, but dilated upon the freedom of handling of this figure, which he saw as 'distinctly characteristic of Raffaello in his earliest period'. Crowe and Cavalcaselle, on the other hand, dismissed it with the comment 'if genuine . . . a feeble effort'. Fischel included it in the section of drawings made by Perugino in his old age, but captioned the illustration of the *recto* 'Circle of

Perugino'. He claimed that a vessel of the same peculiar shape as the one copied on the *verso* occurs in a painting by Perugino of *The Marriage at Cana* in the Perugia Gallery, and suggested that the *recto* drawing might have been a study for a figure in a composition of that subject.

It is impossible to see any such vessel in the indistinct and fuzzy plate in W. Bombe's monograph on Perugino in the *Klassiker der Kunst* series (1914), the only reproduction of this small and apparently somewhat damaged predella panel that we have been able to find; and in any case the argument, so far as it concerns the *recto* study, seems far-fetched.

Fischel, ever on the look-out for evidence of retouching, described the pen-work on the *recto* as a later disfigurement ('mit der Feder verdorben') – a view that Parker was inclined to share, as he also followed the attribution to Perugino. In our opinion the underdrawing and the pen-work are entirely homogeneous; nor do we see that any convincing argument has yet been put forward for abandoning the traditional attribution. The handling of the pen may be compared with that in the study for the Vatican *Presentation in the Temple*, from the predella of the *Coronation of the Virgin* of *c.* 1503 (no. 27). The formula for representing the figure's right foot – long and narrow, and attached to the leg at a sharp angle with no attempt to suggest either ankle or instep – is characteristic of Raphael and often found in his drawings. Also characteristic of him, and uncharacteristic of Perugino, is the stance of the figure, with both feet planted firmly on the ground.

6. The Virgin and Child with the Infant Baptist

Ashmolean Museum P II 502
Metalpoint on pale lavender-grey prepared paper.
 193 × 228 mm.
Literature: KTP 502; P 484; R 6; Ruland, p. 90, vii, 2;
 C & C, i, p. 117; F, p. 37.

Opinions have been divided about this drawing. The traditional attribution to Raphael was accepted by Passavant and by Robinson. Morelli (1887, pp. 148, 151), followed by Fischel (1898, no. 440) and, with some hesitation, by Colvin (no. 6) gave it to

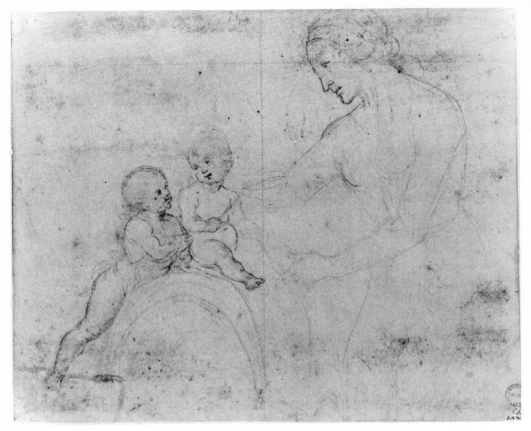

6

Pintoricchio; subsequently Fischel admitted that
Perugino and Raphael had an equal claim and finally
came down on the side of Perugino. Parker returned
to the traditional attribution.

The pack-saddle motif also occurs in no. 7, and
on 9 *verso* with the figures similarly grouped.

7. The Adoration of the Shepherds

Ashmolean Museum P II 40
Pen and brown ink over black chalk. The outlines pricked
for transfer. 183 × 262 mm.
Literature: KTP 40; P 455; R 7; Ruland, p. 34, v, 1; C & C,
i, p. 117; F, *ZdU* 78.

The drawing was accepted as Raphael by almost all
the older critics – Passavant, Ruland, Robinson and
Crowe and Cavalcaselle, and also W. Y. Ottley, who
had published it in his *Italian School of Design* in 1823
with the comment that it was close in style to the
Brera *Sposalizio* of 1504. Passavant and Robinson
remarked on the strong influence of Perugino.

Morelli (*Berlin*, p. 360) was the first to reject

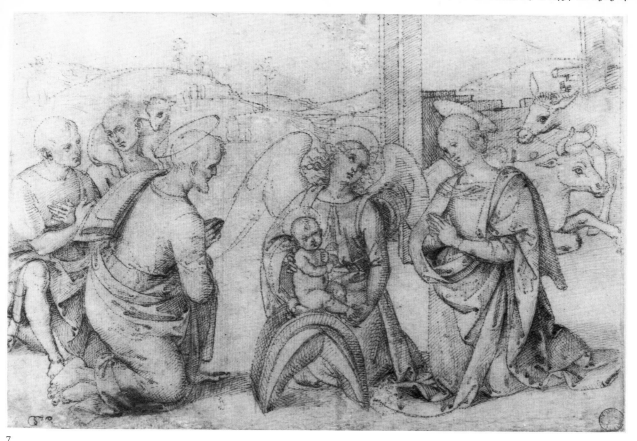

7

Raphael's authorship. His attribution to Pintoricchio was followed in 1898 (no. 374) by Fischel, who was then particularly susceptible to Morelli's authority. Fischel later changed his mind. The illustration of no. 7 in *ZdU* is captioned 'Attributed to Raphael', and in his discussion of it he stated plainly that he saw no reason to accept the attribution to Pintoricchio. He also drew attention to the resemblance, in reverse, between the St Joseph in the drawing and one of the kneeling men on the right of the *Miracle of St Cyril*, one of the panels of the predella of the Mond *Crucifixion* of 1502–3; but he also pointed out the similarity between the Madonna and some of the female types in Perugino's decoration of the Cambio at Perugia, and his doubts about Raphael's authorship evidently persisted, for the drawing is omitted from his *corpus*. Parker returned to Morelli's view and catalogued the drawing as 'very probably' by Pintoricchio.

The drawing corresponds exactly in composition with a small panel, presumably a compartment of a predella, formerly in the Connestabile collection at Perugia, of which an old photograph is in the Windsor Raphael Collection (Ruland, p. 35, v, 3). Parker's claim that it served as the cartoon may well be true, but the dimensions of the panel do not seem to be recorded.

The high quality of the drawing is noticeable in such passages as the hair of the angel and in the drapery of the Virgin. The draughtsman's individual personality is most clearly apparent in the landscape background, which is rendered with an expressive economy, amounting almost to abstraction, that seems to us positively characteristic of Raphael.

The drawing's somewhat unattractive appearance is partly due to the very high degree of finish required by its purpose as a cartoon. Its effect is further impaired by the weakening of the outlines caused by the pricking. It should be noted that the same regular hatching and cross-hatching with a fine pen occurs in cartoons by Raphael of about this period, for example, in the cartoon for the *Knight's Dream* in the National Gallery, London, (no. 15), and in that for the *St George and the Dragon* in the Uffizi (F 78).

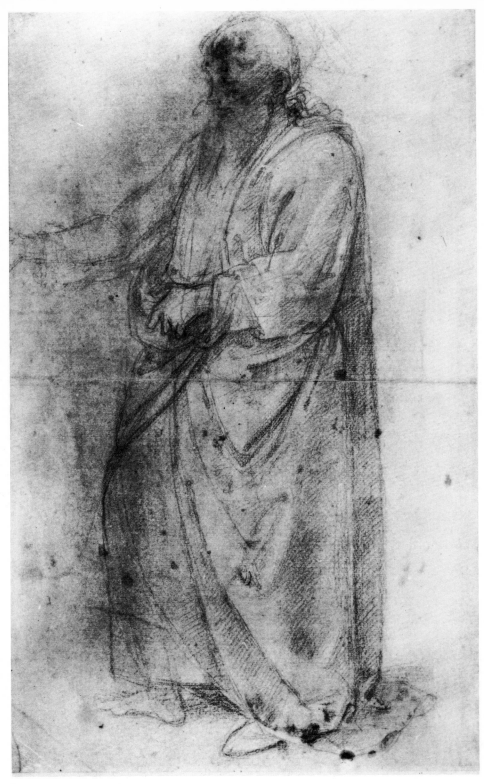

8

8. A standing bearded man

British Museum 1895–9–15–618
Black chalk. 377 × 224 mm.
Literature: P & G 2; Ruland, p. 228, lx, 5; F 11.

The head is drawn in two positions. The faint indication of a triangular halo shows that the figure is God the Father. Ruland's classification of it under the Logge as a study for Moses in *The Gathering of the Manna* is out of the question. Fischel was no doubt right in identifying this as an early idea for the figure in the *Creation of Eve* in the Città di Castello Banner of 1499 (see no. 9). The figure there is kneeling, but the position of the arms is much as in the drawing.

Oberhuber (*MD*, i (1963), 3, p. 46) was the first to point out that the drawing on the other side is a slighter alternative study for the same figure.

9. Back view of a standing man; the drapery of a kneeling figure

Ashmolean Museum P II 501
Pen and brown ink; black chalk. 254 × 216 mm.
Literature: KTP 501; P 491; R 5; Ruland, p. 313, i, 2;
 C & C, i, pp. 118 f.; F 2.

The kneeling figure corresponds in all essentials with God the Father in the *Creation of Eve* in the gallery at Città di Castello. This painting and its companion, *The Trinity adored by St Sebastian and St Roch*, are Raphael's earliest surviving independent works and were originally the back and front of a processional banner. St Sebastian and St Roch are saints especially invoked in time of plague, and the banner was evidently executed in 1499, when an outbreak of plague is recorded in Città di Castello.

The standing figure is a free copy of one of the archers in Signorelli's *Martyrdom of St Sebastian*, painted two or three years earlier for the church of S. Domenico in Città di Castello. The same figure is one of a pair painstakingly drawn in pen and ink on the *verso* of a drawing at Lille (F 50), grouped by Fischel with his 'Large Umbrian metal-point Sketchbook'. The pose of the other figure in the group is quite different from the corresponding figure in the painting, and Fischel is no doubt right in supposing that the copy is after a lost drawing. In Fischel's opinion it is by a weak Umbrian hand.

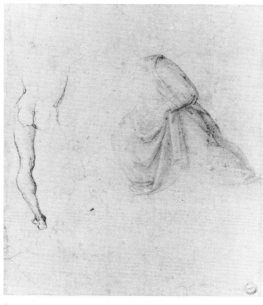

9

On the *verso* (F 3) is a drawing of a fortified town with a tall tower and several small sketches for a composition of the Virgin and Child with the Infant Baptist. In one of these the Child is shown supported by the Baptist on a pack-saddle – an unusual feature that also appears in nos. 6 and 7.

10. St John the Baptist

Ashmolean Museum P II 28
Black and red chalk, over stylus underdrawing. 311 × 198
 mm.
Literature: KTP 28; P 495; R 8; Ruland, p. 36, x, 1;
 C & C, i, p. 188; F, *ZdU,* 92.

A study from a model in contemporary dress for a figure of the saint in a *Baptism*. The lightly indicated wand in his left hand is evidently intended for the Baptist's reed cross, and in his right hand he holds the shallow cup from which the water is poured. The red chalk was used to superimpose the Baptist's garments on those of the model; according to Fischel, this is a unique instance of the use of red chalk in Umbrian drawings of the period.

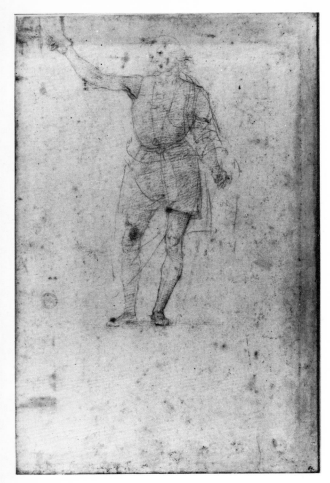

10

Robinson's suggestion that this is a study for a figure in a lost predella panel was confirmed by Fischel's observation that the Baptist occurs in an identical pose in a Peruginesque predella-shaped composition study in the Louvre (*ZdU,* fig. 157).

No. 10 was one of Lawrence's Raphael drawings, and the traditional attribution was accepted by Passavant, Robinson, Ruland and Crowe and Cavalcaselle. Fischel gave no reason for his reattribution to Perugino, and in effect begs the whole question by his comment that the old attribution to Raphael is evidence of the high quality of Perugino's draughtsmanship in his later years. In spite of Parker's agreement with Fischel's view, it seems to us that the drawing is as close to Raphael, if not

closer, and that the traditional attribution cannot lightly be dismissed. Robinson dated it *c.* 1500, and it would indeed be difficult to dissociate it from studies certainly by Raphael such as those for the *St Nicholas of Tolentino* altarpiece of *c.* 1501 (e.g. no. 11 *verso*).

11. Studies of hands, etc., for *The Coronation of St Nicholas of Tolentino*

Ashmolean Museum P II 504
Black chalk. 379 × 254 mm.
Literature: KTP 504; R 4; C & C, i, pp. 139 f.; F 8.

Robinson was the first to observe the importance of this drawing; he pointed out the studies are for the altarpiece commissioned for the church of S. Agostino in Città di Castello in December 1500 and completed by the following September. In 1789 the panel was badly damaged by an earthquake, and only four fragments have survived, two in the Vatican, one in the Pinacoteca Tosio Martinengo at Brescia, and a fourth, showing the leftmost angel in the lower register, recently discovered in France and acquired by the Louvre (S. Béguin, *La Revue du Louvre,* April (1982), pp. 99 ff.). Its original appearance has been reconstructed from these, from Raphael's drawings including a study for the whole composition at Lille (F 5) and from a late eighteenth-century copy of the lower part which replaced the damaged original in the church (see Dussler, figs. 4 – 6). In the lower part St Nicholas, treading on the demon, is flanked by standing angels; in the upper part three half-figures of God the Father, the Virgin and St Augustine are holding crowns over his head.

The principal study on no. 11 is for the right arm and hand holding the crown, of St Augustine (not of God the Father, as Parker stated); the other two hands, drawn with the sheet turned at right angles, clockwise, are those of St Nicholas, who in the painting holds in his right hand a Crucifix and in his

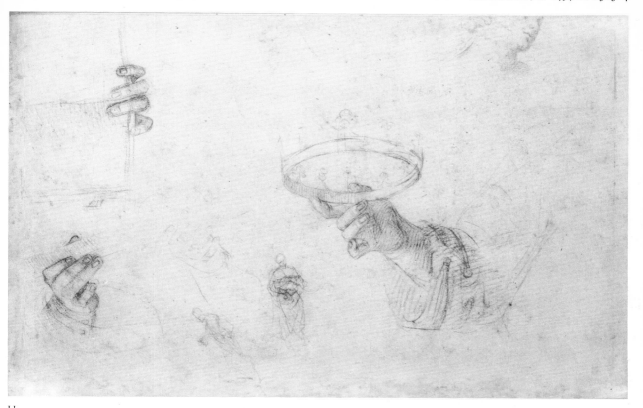

11

left an open book. The faintly drawn hand and arm between the two small standing figures lower left is another study for the right arm of St Augustine. The head partly trimmed away top right is for the angel on the left of the lower part of the altarpiece.

On the *verso* (F 7) is a full-length study for the same angel; another for the figure of St Augustine, with the right arm only summarily indicated; and a study for the left hand and forearm of God the Father.

12. A young man holding a vase

Ashmolean Museum P II 29

Black chalk with some pen and brown ink. 298 × 186 mm.

Literature: KTP 29; P 531; R 15; Ruland, p. 264, 8; C & C, i, p. 188; F, *ZdU* 86.

On the *verso*, in black chalk alone, is a study of a standing man supporting his left hand on a staff. It seems reasonable to suppose that the *recto* and *verso* studies were drawn in the same connexion. The traditional attribution to Raphael was accepted by Passavant, Robinson, Ruland and Crowe and Cavalcaselle.

Passavant considered that the *verso* drawing was used, in reverse, for a figure in Pintoricchio's *Aeneas Sylvius Piccolomini crowned by the Emperor Frederic III* in the Piccolomini Library in Siena Cathedral, one of a cycle of frescoes over the design of which Raphael is known to have helped (see no. 29). He did not mention the *recto* drawing, but Ruland includes both sides as studies for this figure. Robinson dismissed the possibility of the connexion and suggested that the *recto* drawing was a study for a king in an *Adoration of the Magi*. In this opinion he was followed by Crowe and Cavalcaselle.

Fischel, on the other hand, took no. 12 away from Raphael and gave it to Perugino on the grounds that the drawings are rejected studies for the latter's *Adoration of the Magi* in the Oratorio dei Bianchi at

Città di Pieve, a work generally dated 1504. His comment on the traditional attribution to Raphael, that the drawing is good enough to be by him but that in 1504 he was not drawing in this way, seems to us again to be begging the question.

Two studies certainly connected with the Città della Pieve *Adoration*, both for the youthful king on the extreme left of the composition, are on a sheet formerly in the Heseltine and Oppenheimer Collections (F, *ZdU*, fig. 156: better reproductions in the

13. A sleeping youth seated on a shield, and another striding forward and looking upwards to his right

Ashmolean Museum P II 505
Metalpoint, heightened with white, on buff prepared
 paper. 320 × 220 mm.
Literature: KTP 505; P 479; R 12, Ruland, p. 39, xx, 1;
 C & C, i, p. 90; F, *ZdU* 74.

See no. 14.

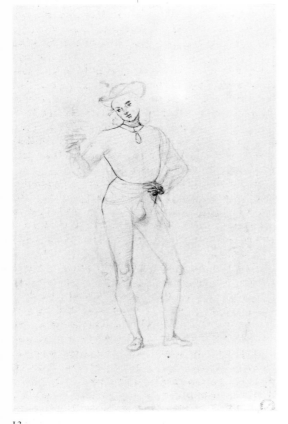

12

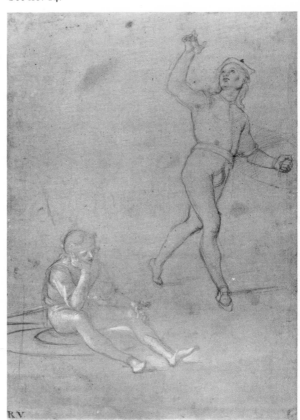

13

Oppenheimer Sale Catalogue, Christie, 1936, 10 July, lot 133, and in *Vasari Society*, 2nd series, i (1920), no. 3). Though in metalpoint and not in chalk and pen, these are comparable with the studies on no. 12; but in so far as it is possible to judge from the *Vasari Society* reproduction, Fischel's opinion that they are inferior in quality seems no more than the truth.

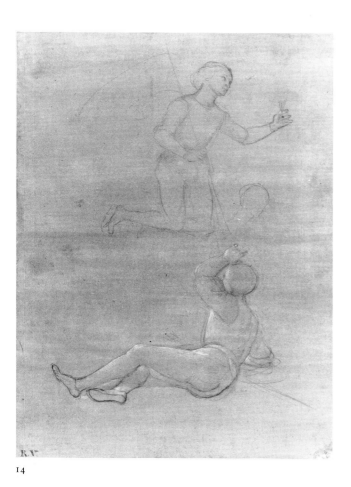

14

14. Two youths, one kneeling and one reclining

Ashmolean Museum P II 506
Metalpoint, heightened with white, on buff prepared
 paper. 327 × 236 mm.
Literature: KTP 506; P 479; R 13; Ruland, p. 39, xx, 2;
 C & C, i, p. 90; F, *ZdU* 75.

The striding figure in no. 13 and the reclining figure
in no. 14 correspond with the two soldiers on the
right-hand side of a painting of the *Resurrection*
formerly in the collection of Lord Kinnaird and now
in the Museum in São Paulo, Brazil (Dussler, fig. 7).
The painting is clearly a product of the Perugino
studio, and the attribution of the related drawings
has oscillated between Perugino and Raphael. Fis-
chel, for example, included them in his *Zeichnungen
der Umbrer* with the comment that they have an equal
claim to be by either master, but we agree with
Robinson in seeing in them 'that ineffable grace
which only Raphael's works display'. The attribu-
tion to Raphael was accepted by Popham (1930, no.
118) and by Parker.

The seated figure in no. 13 could be a discarded
idea for the soldier in the left foreground of the
picture who is likewise seated on a circular shield. In
the picture the left edge of the composition corres-
ponds with the vertical line to the left of the figure in
the drawing.

Robinson's identification of the kneeling figure
in no. 14 as a study for an angel was suggested by the
curving lines roughly indicated to the left, which he
interpreted as wings. His suggestion that the object
held in the left hand might be a 'funnel-shaped vase
or chalice' and that the angel is therefore proferring
the cup to Christ in an *Agony in the Garden* seems to
us less convincing. If Parker's suggestion is correct,
that the figure might be holding the Nails – one of
the Instruments of the Passion – the staff in the other
hand would be either the Spear or the Rod with the
Sponge. Angels holding the Instruments of the
Passion sometimes occur in a *Resurrection*. They are
usually shown flying, but if – as seems likely – this
figure was drawn at the same time and in the same
connexion as the other studies on the sheet and its
companion (no. 13), this might indicate an arrange-
ment with Christ in the upper register flanked by the
angels kneeling on clouds.

15

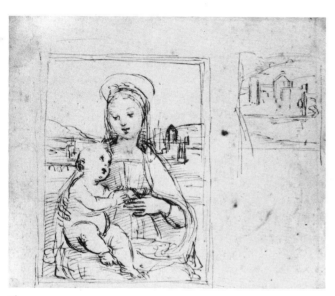

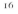
16

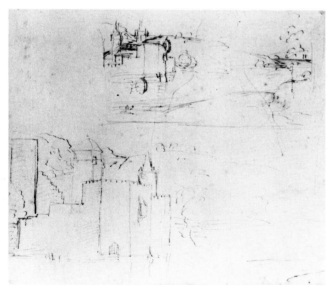
17

15. An allegory ('The Knight's Dream')

London, National Gallery 213 A
Pen and brown ink over black chalk. Pricked for transfer.
182 × 214 mm.
Literature: P 13; Ruland, p. 144, i, 2; C & C, i, pp. 201 f.; F 40.

This sheet served as the cartoon, pricked for transfer to the panel, for the painting now also in the National Gallery. When in the Borghese Collection in the seventeenth century it had for pendant a painting of the same period and exactly the same size, the *Three Graces* now at Chantilly. It seems probable that the two were originally a diptych. No. 15 and the National Gallery painting are first recorded as being together in 1833. See C. Gould, *National Gallery Catalogues; the Sixteenth-Century Italian Schools*, 1975, pp. 212 ff.

The problem of the subject has provoked a mass of exegesis as erudite as it is inconclusive, but there seems to be general agreement that this is a variation on the theme of 'Hercules at the Crossroads': a young man hesitating between two opposed abstractions such as 'Duty' and 'Pleasure'. The central figure in the painting has none of the attributes of Hercules, nor indeed anything of his appearance. E. Panofsky ingeniously suggested that Raphael's source may have been the passage in the epic poem on the Punic War by the late Latin poet Silius Italicus, in which Scipio Africanus dreams that he is the subject of a contest between *Virtus* and *Voluptas*.

The picture is generally dated in the very early years of the sixteenth century.

16. The Virgin and Child

Ashmolean Museum P II 508 (a)
Pen and brown ink over metalpoint. 114 × 130 mm.
Literature: KTP 508 (a) and Macandrew, Suppl.; P 486; R 23; Ruland, p. 90, viii, 1; C & C, i, pp. 119 ff.; F 46.

17. Studies of landscape, with a castle by a lake or river

Ashmolean Museum P II 508 (b)
Pen and brown ink over metalpoint. 116 × 132 mm.
Literature: KTP 508 (b) and Macandrew, Suppl.; P 486; R 24; Ruland, p. 342, vii, 1; C & C, i, pp. 119 ff.; F 48.

For nos. 16 and 17, see no. 18.

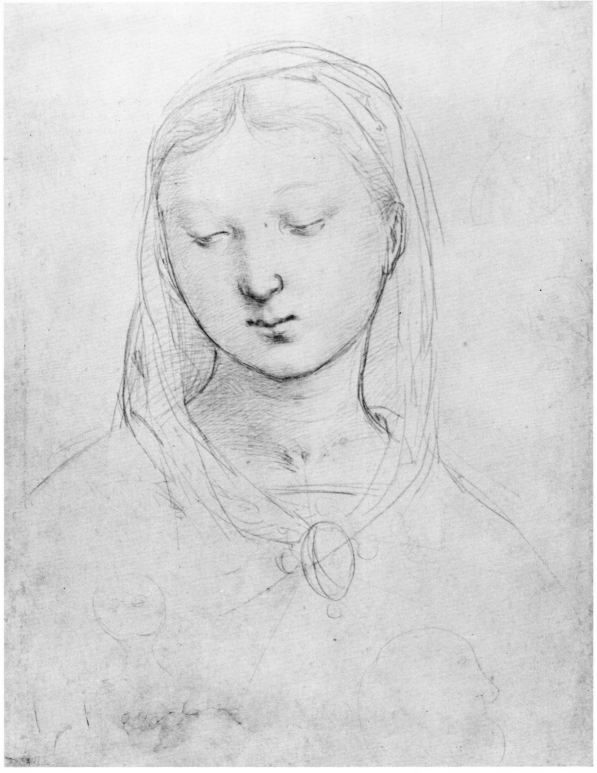

18

18. Head and shoulders of a young woman

British Museum 1895–9–15–611
Metalpoint on warm white prepared ground. Some
 childish scribbles, also in metalpoint. 258 × 191 mm.
Literature: P & G 3; P, p. 538, *gg*; Ruland, p. 98, liv, 1; F 51.

On the *verso* of no. 16 is a larger study of the Infant
Christ in the *recto* composition; and on the *verso* of
no. 17 another, more roughly drawn, sketch of a
landscape background, with the outline of the figure
of the Virgin. These drawings are intimately con-
nected, and it has been suggested by Robinson – and
by Parker stated as an established fact – that they
once formed part of the same sheet. The four sides
were reproduced together, as if all on the same side
of the same sheet, on pl. 3 of the *Lawrence Gallery*
facsimiles. Comparison with the drawings in their
present state shows that both sheets were subse-
quently trimmed. It seems to us, however, that the
actual format determined the *mise–en–page* of the
studies, and that the appearance of the hypothetical
whole sheet would be difficult to imagine.

Fischel grouped together these three drawings
and a fourth, at Lille (F 50), in which the pose of the
Virgin is studied from a studio assistant with special
emphasis on the left hand and forearm, as for a
hypothetical lost or never-executed painting which
he called *The Madonna at the Window*.

That his hypothesis was correct is established by
the subsequent discovery of a painting by Raphael
which corresponds with the composition study on
no. 16. The landscape background corresponds in all
essentials with the sketches on no. 17, the Virgin's
head with no. 18, and her left hand holding the book
with the studies on the Lille sheet.

The painting, now in the Norton Simon Founda-
tion at Pasadena, had been lost sight of in an English
country house collection. A photograph found in
the Berenson library at I Tatti had already been
reproduced as fig. 1174 of the illustrated edition of
Berenson's *Central Italian Paintings,* 1968 (better
repr. Pope-Hennessy, fig. 158; also repr. Dussler,
fig. 18; see A. van Buren, *Art Bulletin*, lvii (1975), pp.
41ff., for a discussion of the picture's iconography
etc.).

Its approximate date is established by the fact that
no. 18 and the Lille sheet form part of Fischel's
'Large Umbrian Silverpoint Sketchbook', a stylisti-
cally homogeneous group which includes studies
for the Vatican *Coronation of the Virgin*, a work
datable *c.* 1502–3 (cf. no. 20). The composition is a
variation on that of the *Solly Madonna* (Berlin), but is
probably somewhat later. Another drawing at Lille
(F 68), is of the Infant Christ holding a bird as in the
Solly Madonna, in a pose identical with that of the
figure in no. 16 but in reverse.

19. View of the city of Perugia, with the Penitent St Jerome in the foreground

Ashmolean Museum P II 34
Pen and brown ink. 244 × 203 mm.
Literature: KTP 34; P 496; R 17; Ruland, p. 119, v, 1;
 C & C, i, pp. 119 ff.; F, p. 96; F, *ZdU* 76.

The traditional attribution to Raphael was accepted
by Passavant, Ruland, Crowe and Cavalcaselle, and
Robinson, but was doubted by Fischel. He excluded
the drawing from his *corpus*, but illustrated it in the
text apropos of the study at Lille for the head of St
Jerome (F 74), with the caption 'attributed to
Raphael'. In his *Zeichnungen der Umbrer* he classified
it as a product of Perugino's studio, dating from the
period of his joint activity with Raphael. Parker
follows him in cataloguing it as 'Circle of Perugino'.

More recently Mrs Ferino Pagden (1981, pp. 231
ff.) has convincingly restated the case for Raphael,
pointing out, what had not previously been
observed, that the landscape sketch on the *verso* (her
fig. 2) is a study for the background on the right of
the *Pala Colonna* (Metropolitan Museum). Passav-
ant's identification of the city in the background of
the *recto* drawing as Perugia was rejected by Robin-
son, Crowe and Cavalcaselle, Parker and (*ex silentio*)
Fischel; but a photograph published by Mrs
Ferino Pagden (her fig. 8) opposite a reproduction
of the drawing establishes beyond question that
though the river with the mill and prominent
watergate in the nearer part of the background are
imaginary, the part beyond is a view of the Borgo S.
Angelo in Perugia: the rotunda with a pointed roof
on the far skyline is the ancient church of S. Angelo,
and the large church on the right, nearer the
foreground, is S. Agostino. The drawing is presum-
ably a study for a small devotional picture like the
one by Pintoricchio in the Perugia Gallery (Ferino-

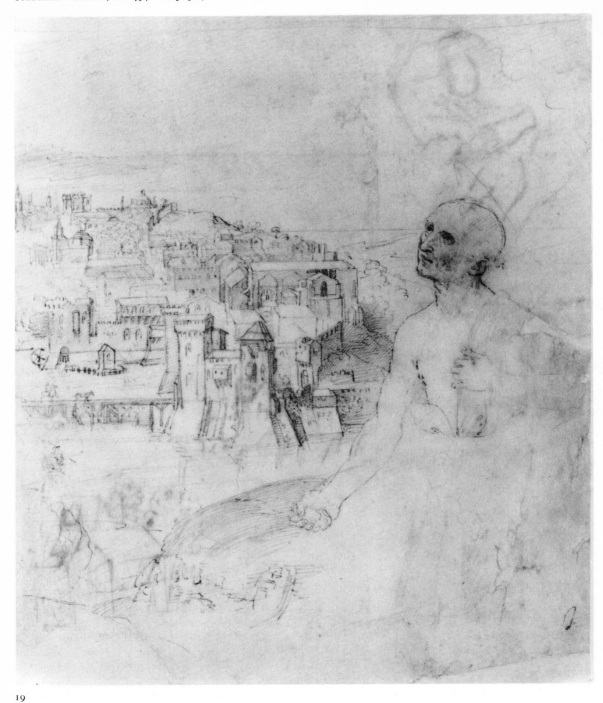

19

Pagden, fig. 10), in which St Jerome similarly occupies the right foreground in front of a landscape with a view of a city.

The *Pala Colonna* is generally dated *c.* 1504. The style and technique of the metalpoint study for the head of St Jerome, at Lille (F 74), reflects the influence of Leonardo.

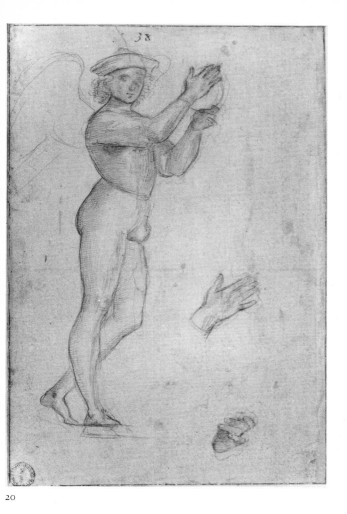

20

20. A young man playing a tambourine

Ashmolean Museum P II 511 (a)
Metalpoint on pale grey prepared paper. 191 × 127 mm.
Literature: KTP 511(a); P 493; R 9; Ruland, p. 103, i, 8;
 C & C, i, p. 145; F 18.

Nos. 20 to 27 were part of the preliminary material for the altarpiece of the *Coronation of the Virgin*, now in the Vatican Gallery, which was commissioned by Alessandra degli Oddi for her chapel in the church of S. Francesco in Perugia. The painting is not dated and the contract for the commission has never come to light, but the style points to a date towards the end of Raphael's Umbrian period and most critics have agreed in assigning it to the period 1502–3. Around the turn of the century the two leading families in Perugia, the Oddi, to which Raphael's patroness belonged, and the Baglioni, were engaged in a savage struggle for political supremacy. During the whole period of Raphael's sojourn the ascendancy of

the Baglioni was interrupted only once, between January 1503, when the Oddi were restored to power, and the beginning of the following September when they were finally ousted. It seems not unreasonable to suggest that Alessandra degli Oddi's commission may have been carried out during this eight-month interregnum.

The drawings here exhibited represent between them three distinct stages of Raphael's laborious preparatory process. The earliest, nos. 20 and 21, are studies for two of the music-making angels in the upper register, drawn from the same youthful model as in nos. 13 and 14, no doubt a studio assistant. Raphael has not troubled to vary the model's everyday dress, for his purpose in these studies was primarily to fix the pose and clarify the stance and distribution of weight, essential preliminaries if the figures were to look convincing when swathed in drapery. No. 20 is for the angel holding the tambourine, on the extreme left, and no. 21 for the one playing the rebeck (a primitive form of violin) immediately to the right of the central figure of Christ. A similar study in metalpoint, at Lille (F 21), for the angel playing the viol on the extreme right, is likewise of a model wearing everyday dress, but with the head somewhat idealised and drapery indicated round the lower part of the legs.

Nos. 20, 21 and 22 are included by Fischel in his 'Larger Umbrian Silverpoint Sketchbook' (see no. 18). He argued from the exact correspondence of the horizontal folds on nos. 20 and 21 that they originally formed one sheet, which would have been roughly the size of the others in his group. The point is an academic one, but it could be objected that the *mise-en-page* of the studies seems to fit the format of the smaller sheets. The two pairs of consecutive numbers inscribed on them in old writing establish that they were separate as early as the seventeenth, or even the sixteenth, century, but an old photograph in the Windsor Raphael Collection, taken in the 1850s, shows them joined as one. The horizontal fold is conspicuous in the photograph, and could have been made at the time when the sheet was temporarily united.

Nos. 20 and 21 and the study for the third angel at Lille (F 21) have also to be considered in relation to a lunette-shaped drawing in Budapest of the Virgin in

a *mandorla* flanked by pairs of music-making angels, which is evidently the upper part of a study for an *Assumption* or – more likely – of an old copy of a lost study (Budapest 1779; F, *ZdU* 41, fig. 299; R. Zentai, *Bulletin du Musée Hongrois des Beaux-Arts*, no. 53 (1979), pp. 69 ff., fig. 52). Though Passavant, Ruland, and Crowe and Cavalcaselle all attributed it to Raphael himself and cited it as evidence that the Oddi altarpiece was originally conceived as an *Assumption* and not as a *Coronation of the Virgin*, the Budapest drawing has been ignored in more recent Raphael literature until the publication of Zentai's article. Fischel in his 1898 volume, for example, rejected the attribution to Raphael in favour of one to Pintoricchio, and this in its turn he rejected in *Zeichnungen der Umbrer* in favour of one to Lo Spagna, without reference to the fact that of the four angels in the Budapest drawing one is in the pose of the figure in no. 20 but playing a viol and not a rebeck (the head is looking downward to the left as in no. 20, not upward to the right as in the painting); another, likewise holding up a tambourine, is in a pose very close to no. 21; and the pose of a third corresponds from the waist down with the study at Lille.

In support of his attribution of the Budapest drawing to Lo Spagna, Fischel adduced a fresco at Trevi (*ZdU*, fig. 300), in which the Virgin is closely similar but is flanked by only two angels, who are hovering in the air and not holding musical instruments. A more striking comparison is with the fresco of the subject by Pintoricchio in the Borgia Apartment in the Vatican (C. Ricci, *Pintoricchio*, London, 1902, p. 97); though the Virgin is different, she is flanked by pairs of music-making angels, the left-hand pair being so close to the corresponding pair in the drawing as to imply a direct connexion.

In 1502-3 Raphael was closely associated with Pintoricchio, whom he assisted by making drawings for the decoration of the Piccolomini Library (see no. 29) and apparently other commissions (see Oberhuber 1978, pp. 80 ff.); but he would hardly have been providing the older master with designs as early as 1492-5, when the Borgia Apartment was decorated. This would seem, on the face of it, to support Fischel's earlier attribution of the Budapest drawing to Pintoricchio. On the other hand, the composition is so much more tightly knit and

stylistically developed that it can hardly have preceded Pintoricchio's *Assumption*. The most likely explanation seems to us that the invention, though not the drawing itself, is by Raphael, who could have had access to working material and preliminary drawings preserved in Pintoricchio's studio; and that it may well represent an early stage in the evolution of the altarpiece for Alessandra degli Oddi.

21. A youth playing a rebeck

Ashmolean Museum P II 511(b)
Metalpoint on pale grey prepared paper. 189 × 126 mm.
Literature: KTP 511(b); P 493; R 9; Ruland, p. 103, i, 8; C & C, i. p. 154; F 19.

See no. 20.

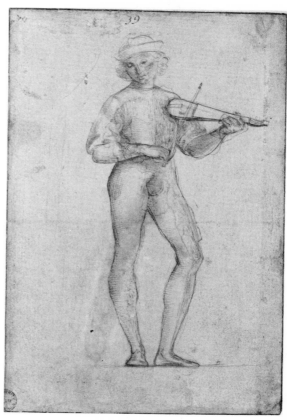

21

22. Studies of a head and of a right forearm and hand holding a violin-bow

British Museum Pp. 1–67
Metalpoint on warm white prepared paper. 276 × 196 mm.
Literature: P & G 4; P 440; Ruland, p. 104, 11; C & C, i, p. 146; F 22.

The head and arm are those of the angel playing the viol on the extreme right of the upper part of the

Vatican *Coronation of the Virgin* (see no. 20). No. 22 seems to have been drawn from a model (the roughly indicated flattened ovoid form below the wrist may represent the support on which he would have rested his arm: the angle of forearm and wrist suggests that the arm is supported at this point), but the process of idealisation has been carried further than in nos. 20 and 21.

Fischel grouped this drawing, together with no. 30 and nos. 20 and 21 (which in his view originally

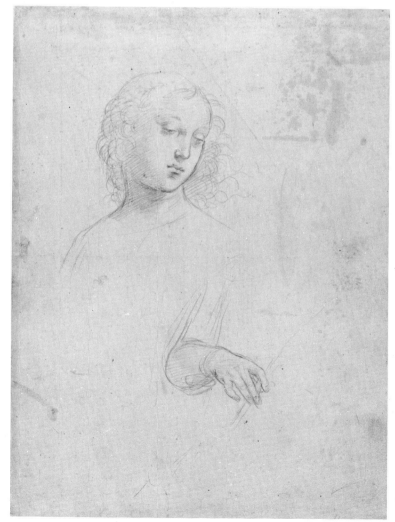

22

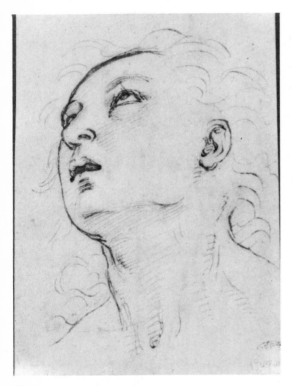

23

formed one sheet) and four other drawings, all in metalpoint on the same-coloured ground, as part of his 'Larger Umbrian Silverpoint Sketchbook'.

23. Head of a young man gazing upwards

Ashmolean Museum P II 512
Pen and brown ink over metalpoint. 89 × 62 mm.
Literature: KTP 512; P 555; R 10 (1); Ruland, p. 104, 19;
 C & C, i, p. 147; F 24.

No. 23 corresponds in all essentials with no. 25, a study for the head of St James in the right foreground of the Vatican *Coronation of the Virgin* (see no. 20). If it was drawn in this connexion (and both Fischel and Parker are reluctant to affirm positively that it was, on the grounds that the head is a stock Peruginesque motif), then it must have been a separate study like no. 22. It cannot be a fragment of a larger drawing, for the lines indicating the neck stop short of the edge of the sheet. The heavily inked contours which Parker saw as indications of later reworking could have been emphasised by the draughtsman himself in order to fix the exact position of the profile. If this was the purpose of no. 23, it would explain a certain perfunctoriness in the treatment of the hair and neck.

24. Heads of two bearded men

Windsor 4370
Black chalk over dotted (pounced through) underdrawing
 (see no. 25). 238 × 186 mm.
Literature: AEP 788.

Like no. 25 (q.v.) this is an 'auxiliary cartoon' for the heads of two of the Apostles in the lower part of the Vatican *Coronation of the Virgin*. It was not known to Fischel when he published his article on Raphael's auxiliary cartoons in the *Burlington Magazine*: Popham found and identified it shortly afterwards, misplaced among the large group of drawings by Carlo Maratta in the Royal Library (*OMD*, xii (1937-8), p. 45).

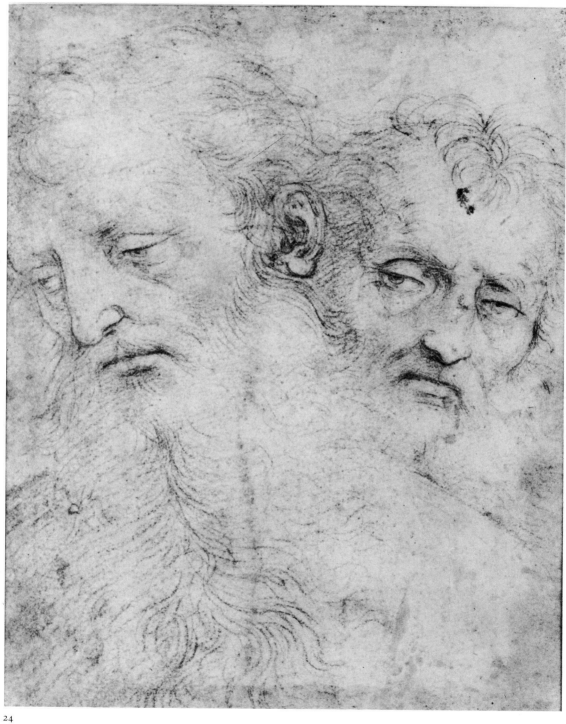

24

25. Head of a young man gazing upwards

British Museum 1895–9–15–610
Black chalk over traces of dotted underdrawing (see
 below). 274 × 216 mm.
Literature: P & G 5; P, p. 539, *mm*; Ruland, p. 104, 17; F 23.

No. 25 corresponds with the head of the Apostle
traditionally identified as St James in the right
foreground of the Vatican *Coronation of the Virgin*;
and no. 24 with those of the Apostle identified as St
Paul, who stands behind the sarcophagus to the right
of the central figure, and of the Apostle peering over
his shoulder.

Drawings of this kind represent the very last
stage of the preparatory process. They belong to a
category that Fischel was the first to identify, to
which he gave the name 'auxiliary cartoon' (1937,
pp. 167 ff.). The usual practice in a Renaissance
studio was for the final design of the entire composi-
tion to be worked out in the form of a full-size
cartoon: a drawing of the same size as the intended
painting, the outlines of which were transferred to
the surface to be painted either by tracing through
with a sharp implement, or by pricking with a series
of small holes through which a dark powder
('pounce') was brushed or blown to leave a dotted
contour on the surface beneath. (Cartoons for panel
paintings in the present exhibition are nos. 7, 15 and
119; nos. 111 and 144 are fragments of cartoons for
frescoes) Fischel's 'auxiliary cartoons', a category to
which, in addition to nos. 24 and 25, also belong no.
107 and nos. 176 to 180, which are studies of exactly
the same type respectively for the fresco of *Parnassus*
in the Stanza della Segnatura and for Raphael's last
painting of *The Transfiguration*, are all of heads, two
with the addition of hands; they agree exactly in size
with the corresponding detail of the painting; and on
all of them can be seen traces of dotted, pounced-
through underdrawing. Fischel convincingly ex-
plained them as studies worked up from outlines
traced through from the full-scale cartoon, of details
that Raphael wanted to realise as carefully as possible
before embarking on the painting itself. This prac-
tice seems to have been peculiar to him, and is
further evidence of his painstaking method.

Comparison of a tracing of no. 25 with the head
in the painting reveals that even at this very late stage
Raphael was still prepared to make subtle modi-
fications to his design: the two heads are on exactly
the same scale and the contour from forehead to
neck is identical, but the nose and eyes of the painted
head are a little higher and the mouth nearer the
contour of the cheek, with the result that the head is
tilted further back and turned slightly further away
from the spectator.

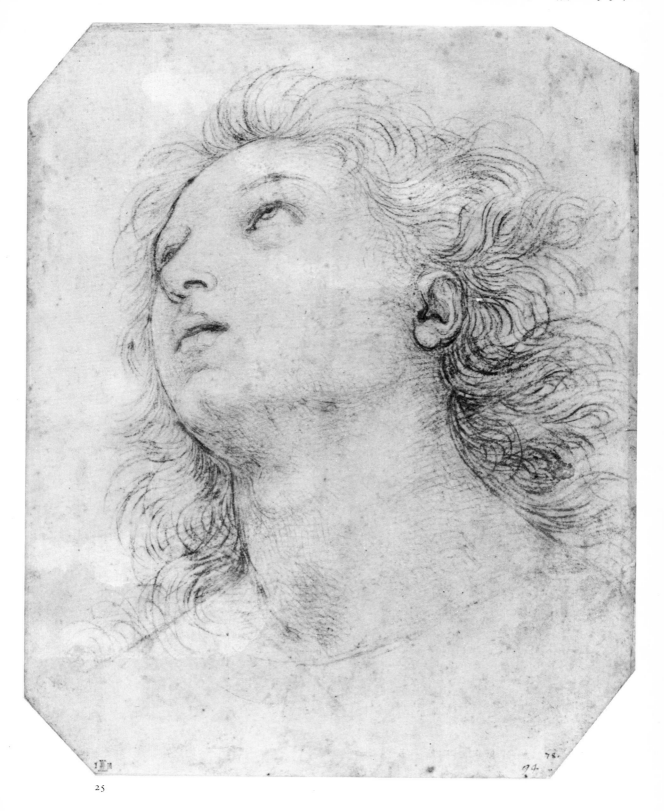

25

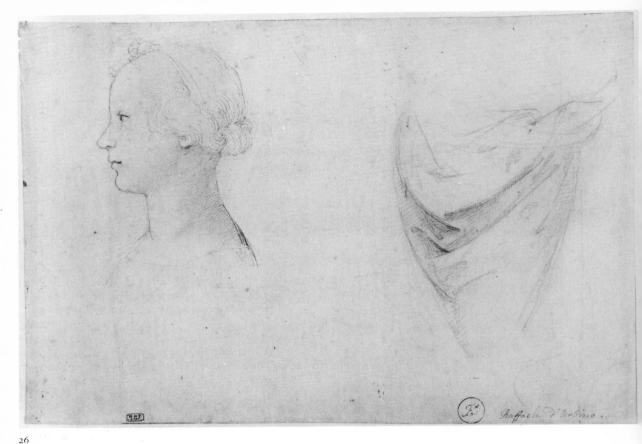

26

26. Head of a young woman and a study of drapery

British Museum 1947–10–11–19
Pen and brown wash over faint traces of black chalk (the
 head); black chalk (the drapery). 222 × 326 mm.
Literature: P & G 6; P 369; Ruland, p. 333, xxx, 1; F 31.

Inscribed lower right in ink, in a seventeenth- or
eighteenth-century hand: *Raffaele d'Urbino*. A
photograph in the Windsor Raphael Collection,
probably taken in the 1850s, shows the sheet as it
was before the present strip of paper was added to
the left edge in an ill-judged attempt to complete the
nose. Fischel knew the drawing only from this
photograph, which he used for the plate in his *corpus*.
The clumsy restoration of the nose has impinged on
the original drawing, making the contour of the
brow perceptibly more rounded: originally the nose
started on a level with the upper eyelid.

 On the *verso* is a study of drapery, for a figure
facing the spectator, with a horizontal gathering at
the waist and a big fold over the right shoulder. This
could be a study for St Thomas, who holds the
Virgin's girdle in the centre of the lower part of the
Vatican *Coronation*. The *recto* drapery study is a
standard Peruginesque formula: Fischel suggested
that it was for the woman holding the doves on the
right of the *Presentation* in the predella of the
Coronation, but it could equally well be for St James
in the right foreground of the altarpiece itself.

27. The Presentation in the Temple

Ashmolean Museum P II 513
Pen and brown ink and black chalk. 200 × 200 mm.
Literature: KTP 513; P 456; R 11; Ruland, p. 105, 34;
 C & C, i, p. 155; F 30.

A study for the group in the centre of *The Presenta-
tion in the Temple*, one of the three compartments of

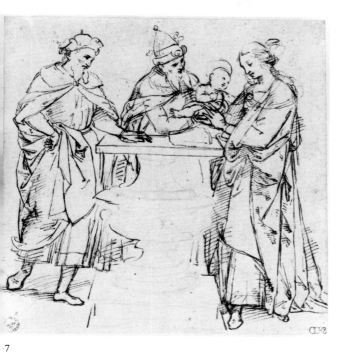

7

the predella of the altarpiece of the Vatican *Corona-tion of the Virgin* (see no. 20). The figures correspond closely in detail with those in the painting and are on the same scale, but there are a number of minor *pentimenti* and some small changes in the painting: for example, the right hand of the Virgin is not visible, and the altar is slightly higher in relation to the figures.

Robinson stated, incorrectly, that the outlines are pricked for transfer and that the drawing had therefore been used as a cartoon. Fischel denied that this had been its purpose and added, inexplicably, that there was evidence of retouching in the pen-work. It seems to us that the drawing is entirely homogeneous and entirely by Raphael.

It is possible that no. 27 was never actually intended as a cartoon, but that it was one of a series of preliminary studies from which the final cartoon was worked out. A drawing in Stockholm (F 29) for the second predella compartment, of *The Adoration of the Magi*, presents some analogies with no. 27. It is larger and contains more figures, but they are likewise on the same scale as those in the painting, and correspond with it very closely in detail and in their relation to one another. But if this explanation is correct, it is a puzzling feature of both drawings that the outlines in them are neither pricked nor, apparently, indented, since these are the two most usual ways of transferring a design from one sheet to another.

The only cartoon, in the strict sense, that has survived for any of the three predella panels is the drawing of *The Annunciation* in the Louvre (F 28). Here every detail of the composition has been carefully worked out and the contours pricked; some of the mid-tones are indicated in wash; and the figures, and particularly their draperies, are more elaborately rendered than in no. 27 or in the Stockholm drawing.

It will be noticed that the pen-work in no. 27 stops short on the edge of the altar and that that part of the drawing is rendered solely in black chalk. The artist may have already decided slightly to increase the height of the altar in the finished painting and may not have felt it necessary to elaborate this detail.

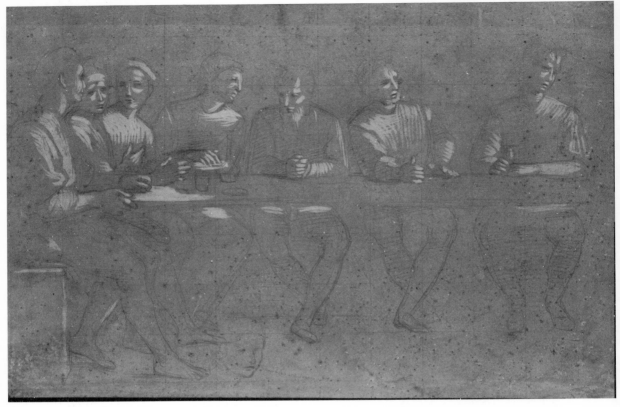

28

28. Left-hand side of a *Last Supper*

Ashmolean Museum P II 507
Metalpoint, heightened with white, on pale pink prepared
 paper 218 × 323 mm.
Literature: KTP 507; P 539; R 32; Ruland, p. 289, i, 35;
 F, p. 92, n. 1.

The old attribution to Raphael was accepted without
comment by Passavant, with enthusiasm by Robin-
son, and with hesitation by Ruland who included the
drawing in the section headed 'ascribed to Raphael'
with the remark 'perhaps by Raphael himself'; it was
rejected by Fischel, who saw the drawing as 'most
probably' an early work by Perugino, but re-
affirmed by Parker, whose suggested dating soon
after 1500 is surely correct. The somewhat loose
handling and repeated contours in the drawing of
the legs can be paralleled in the study for a group of
figures in one of the Piccolomini Library frescoes of
c. 1502–3, (no. 29).

No related work by Raphael of this period is
known or is recorded. There can hardly be any
connexion with the drawing of the same subject in
the Albertina (see no. 70) which is clearly later in
date.

29. A group of four standing youths

Ashmolean Museum P II 510
Metalpoint on bluish-grey prepared paper. 213 × 223
 mm.
Literature: KTP 510; P 530; R 17; Ruland, p. 264, iii, 4;
 C & C, i, p. 184; F, *ZdU* 119; F 63.

A figure in the pose of the one in the centre of the
group of three occurs in a group of six young men in
the middle distance of Pintoricchio's fresco of
*Frederick III bestowing the Poet's Crown on Aeneas
Sylvius Piccolomini* in the Piccolomini Library in
Siena. The figure standing with legs wide apart in
no. 29 also occurs in the painted group, but on the
right; and the one leaning on a staff with his legs
crossed, on the left. In the painting they are dressed
in 'historical' costume, but in the drawings, apart
from the suggestion of headgear, they are in con-
temporary everyday dress.

Pintoricchio received the commission in 1502
and had begun the decoration of the Library by 1503.
According to Vasari, Raphael assisted him by mak-
ing 'alcuni dei disegni e cartoni'. Only four drawings
are known that certainly belong to the preliminary
material for the Piccolomini commission: no. 29; a

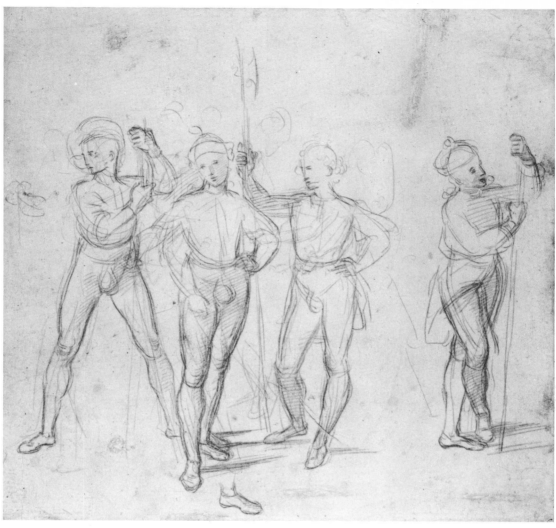

29

sheet of studies for figures in *Aeneas Sylvius Piccolo-mini's Departure for the Council of Basle* and a compos-ition study for the same fresco, both in the Uffizi (F 60/61 and 62); and a composition study for *The Betrothal of Frederick III and Eleanor of Portugal* (F 65), formerly in the Baldeschi Collection in Perugia and now on indefinite loan to the Pierpont Morgan Library. On the *verso* of no. 29 are two small pen studies of *putti* holding shields, which in the context of the *recto* drawing can reasonably be explained as studies for the similar figures holding shields em-blazoned with the Piccolomini arms, which stand at the bases of the pilasters in the Library. A similar sketch, presumably made for the same purpose, was discovered by Oberhuber in the Louvre (Oberhuber 1978, fig. 30).

The fact that these drawings are connected with a collaborative work has provoked critical argument. The attribution of no. 29 to Raphael was accepted by all the older critics, Passavant, Robinson, Ruland, and Crowe and Cavalcaselle. In the succeeding age of 'Scientific Connoisseurship' the testimony of Vasari was brushed aside. Morelli, for example, dismissed as 'absurd' (Berlin, pp. 247 ff.) the notion that a youth of only twenty could have been entrusted by an older, established master with the task of designing even a subordinate group in a composition. He nevertheless continued to believe in Raphael's authorship of this particular drawing, but the explanation that he suggested – that Raphael happened to be in Pintoricchio's studio at the moment when the older master was studying this

group of figures from a model, and amused himself by also making a drawing of it – is rightly described by Parker as 'far-fetched'. Colvin (pl. 7) accepted this explanation, and Fischel too seems at first to have been reluctant to differ from Morelli's conclusions, for in his 1898 volume (no. 41) he gave the two Uffizi drawings to Pintoricchio (he did not mention the one then in the Baldeschi Collection) but says of no. 29 that it 'seems to be by Raphael' ('schient echt'). In 1907, however, Beckerath (pp. 293 ff.) announced that no. 29 was also certainly by Pintoricchio, an opinion that Fischel seems to have followed in his *corpus*, where he rejected Raphael's authorship on the grounds that the drawing is 'careless, and in the contours repetitive' by comparison with the studies in the same technique and of the same type for the Vatican *Coronation* (nos. 20 and 21). In his *Zeichnungen der Umbrer* he attributed it without hesitation to Pintoricchio. Later, however, he seems to have changed his mind, for in the *catalogue raisonné* compiled from his notes by Otto Kurz and appended to his posthumous monograph of 1948 (p. 358), the two Uffizi drawings and the Baldeschi–Pierpont Morgan sheet are listed as studies by Raphael, together with one described as 'central group of the Coronation of Pius II'. No indication of its whereabouts is given, but it is presumably no. 29.

The attribution to Raphael was restated by Popham (1930, no. 120) and was maintained by Parker. His suggested explanation of the looser and more perfunctory handling was that the figures were not drawn from a model but 'from memory with reminiscences of Signorelli'. It is true, as Fischel pointed out, that some of the figures closely resemble soldiers in Signorelli's frescoes of *St Benedict and Totila* at Monte Oliveto; but if Raphael had drawn the group out of his head he would hardly have dwelt so carefully on details of everyday dress that have no counterparts either in Signorelli's paintings or in the painting for which the studies on the sheet were made. This is surely a rapid sketch from life made in order to fix the essentials of five different poses, three of which must later have been combined by Raphael in a further study for the group as it appears in the painting. Once allowance is made for the difference in purpose and the greater rapidity of execution, no. 29 seems to us in every way comparable, both in handling and in quality, with the more deliberate studies from the model for the Vatican *Coronation*.

30. A kneeling youth

Ashmolean Museum P II 509
Metalpoint on warm white prepared paper. 265 × 184 mm.
Literature: KTP 509; P 497; R 25; Ruland, p. 120, xii, 1; C & C, i, p. 138; F 41.

The pose and facial expression and the indication of a halo show that this is a study made from a youth in contemporary dress, no doubt a studio assistant, for the figure of a saint in an attitude of devotion. Earlier critics, no doubt influenced by the sex of the model, had suggested a variety of male saints – Stephen, Francis, Roch, Jerome. Parker was the first to observe the significance of the curved lines lightly indicated on the ground around the figure, which he suggested represent the position on the ground of a fuller drapery which the saint was to have worn. This would not necessarily exclude a male saint, but his further suggestion, that this is a study for the Magdalen in the Mond *Crucifixion* in the National Gallery, an altarpiece completed in or shortly before 1503, seems plausible, though it should be noted that the light in the drawing is from right to left whereas in the painting it falls the other way. The drawing is part of Fischel's 'Large Umbrian Silverpoint Sketchbook' group, datable *c.* 1502 (cf. no. 18).

31. Head of a young woman

Ashmolean Museum P II 514
Black chalk. 161 × 111 mm.
Literature: KTP 514; R 21; Ruland, p. 332, xxii, 1; F 35.

Though this was one of Lawrence's Raphael drawings, it is not mentioned by Passavant or by Crowe and Cavalcaselle. Robinson described it as a slighter rendering of the 'pure and beautiful ideal head' represented in nos. 22, 33 and 68; but it should be noted that these four drawings seem clearly to represent four different people. As Fischel was the first to observe, no. 31 is in fact a study for the fourth onlooker from the left in the Brera *Sposalizio*, dated 1504. On the *verso* (F 36) are studies for two other heads in the same picture.

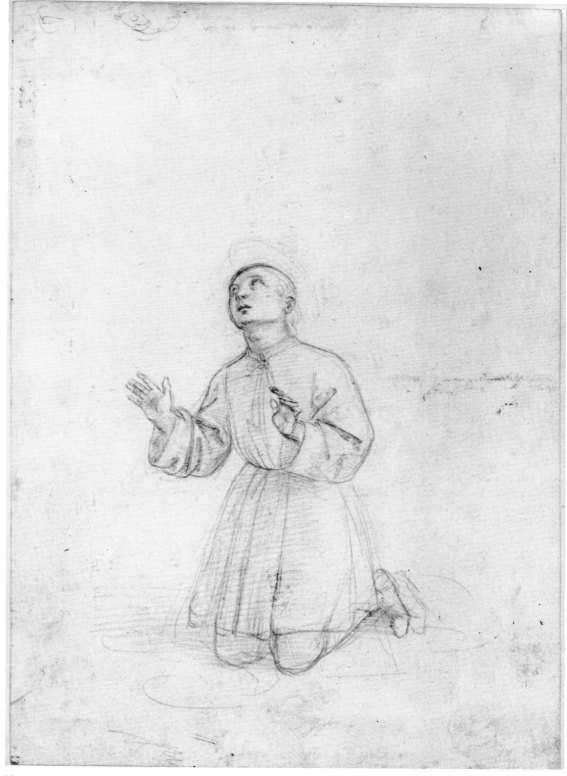

30

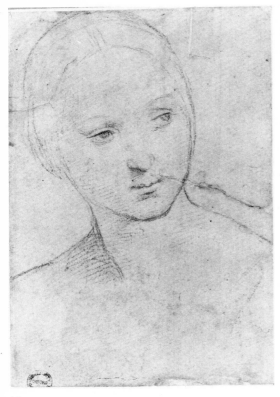

31

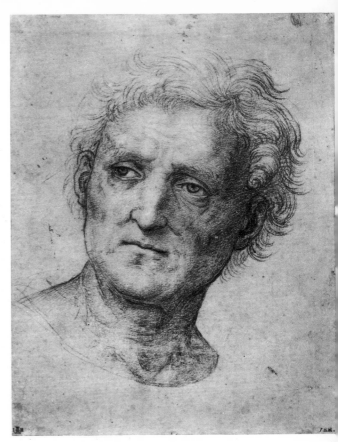

32

The landscape stated by Ruland to be drawn on the *verso* is in fact on the *verso* of KTP 107, a double-sided sheet of landscape studies by Fra Bartolommeo which had somehow found its way into Lawrence's Raphael series.

32. Head of a middle-aged man

British Museum 1895–9–15–619
Black chalk, over stylus underdrawing. 255 × 190 mm.
Literature: P & G 8; P, p. 543, *ttt*; Ruland, p. 160, vii, 1;
 F 37.

Ruland quaintly suggested that this might be a portrait of Perugino, but the features are entirely unlike those of the self-portrait in the Cambio in Perugia. Robinson saw some influence of Fra Bartolommeo in the style and technique, and accordingly dated the drawing in the Florentine period, *c.* 1508. Fischel, more acutely, observed the psychological resemblance to some of the older faces in the Brera *Sposalizio* of 1504.

33. Half-length figure of a female saint

British Museum 1895–9–15–612
Black chalk, over stylus underdrawing. 411 × 260 mm.
Literature: P & G 9; P, p. 542, *lll*; Ruland, p. 160, viii, 1;
 F 34.

Inscribed in ink in lower right corner, in an old hand: *Raffaelle d'Urbino*.

In spite of the halo, this drawing, like no. 68, was once thought to be a portrait of Raphael's sister. It must in fact be a study for a painting in the manner of one of Perugino's single half-figures of saints. The elaboration of the drapery and the facial type suggest a date in the Umbrian period, *c.* 1504.

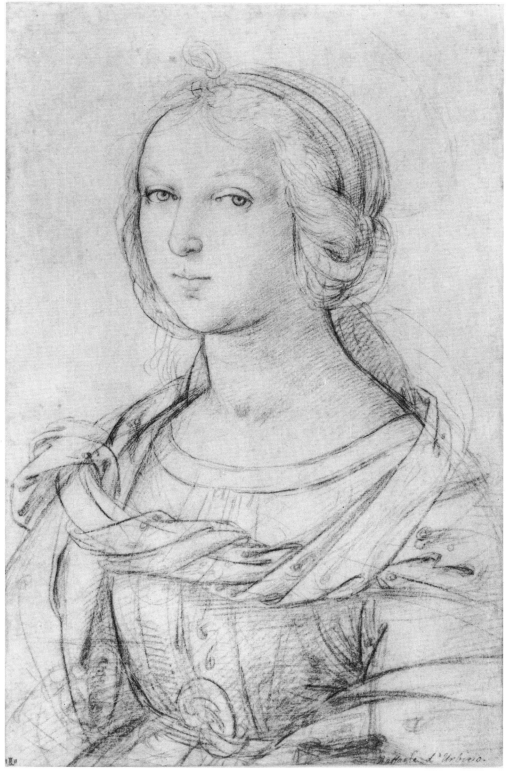

33

2 FLORENTINE PERIOD, 1504 to 1508
Nos. 34–84

Raphael's Florentine period is generally considered to cover the years 1504 to 1508. Florence was the principal centre of his activity, but he maintained his contact with Umbria, often returning to Perugia and even to his native Urbino. In the first decade of the century Florence had, not for the first time, become the focus of artistic innovation in Italy. The artistic scene was dominated by Leonardo da Vinci and Michelangelo. In 1503 Leonardo had begun the cartoon of the *Battle of Anghiari* for a proposed mural painting in the Palazzo della Signoria; in the following year Michelangelo began the cartoon known as 'The Bathers' for part of a proposed companion fresco of another episode in Florentine history, the *Battle of Cascina*. Both cartoons, and Leonardo's earlier, unfinished *Adoration of the Magi*, were to exercise a profound effect on Raphael's development, but their full impact does not become apparent until later. In the lower part of the *Disputa*, for example (see no. 85), are echoes of the *Adoration of the Magi*; the *Massacre of the Innocents* (see no. 122), another work of Raphael's early Roman period, reveals the inspiration of 'The Bathers'; and it seems unlikely that the *Battle of Constantine*, for which Raphael certainly provided the design (see no. 181), would have taken the form it did without his recollection of the *Battle of Anghiari*. Some drawings of the Florentine period reflect knowledge of Michelangelo's marble *David*, completed in March 1504 (see nos. 38 and 39), and the present exhibition also includes what may be a faithful copy of a lost drawing by Leonardo for his vanished painting of *Leda* (no. 40).

Michelangelo's cartoon illustrated an incident in the battle of Cascina in which a party of Florentine soldiers was surprised by the approach of the enemy while bathing in the river Arno – a subsidiary and irrelevant episode that Michelangelo seems to have chosen simply as a pretext for representing the nude figure in the greatest possible variety of poses. It does not immediately invite comparison with Raphael's *Massacre of the Innocents* (see no. 122) except in such a detail as the old man who stares out towards the spectator like the mother running forward in the centre of the *Massacre*. Nevertheless, there is a resemblance at a more profound level. Nothing in 'The Bathers' suggests a battle; similarly, the *Massacre of the Innocents* is formalised to the point at which it has lost all the violence and horror implied by the subject. Kenneth Clark said, of the executioners, that 'their beautiful poses bear no more relation to their brutal intentions than if they were ballet dancers'. The subordination of content to form is one of the essentials of the style that developed in the 1520s, which is known as Mannerism.

Apart from a few portraits and one or two large-scale altarpieces, most of Raphael's Florentine works are small panels of the Virgin and Child. The charm of Raphael's Madonnas has obscured the rigorous intellectual effort that underlies them: the artist is exploring the formal possibilities of the apparently simple theme of a woman with a child, and a sheet of studies like no. 84, in which Raphael is experimenting with a whole sequence of interrelated solutions, reveals the complexity of the thought that led up to the final result. An exact parallel exists in the series of studies by Leonardo for his never-executed *Virgin and Child with the Cat*. The complex pyramidal groupings of full-length figures in some of Raphael's larger-scale Madonna compositions (e.g. the *Madonna Canigiani*, the *Madonna im*

Grünen, the *Belle Jardinière*, etc.) must also derive from Leonardo. The *Madonna del Baldacchino*, on the other hand, seems, rather, to be in the line of descent, via the somewhat earlier *Ansidei Madonna*, from the still conventionally Umbrian *Pala Colonna*.

Michelangelo's emphasis on the heroic male nude in action is a product of the Florentine tradition exemplified in an earlier generation by Antonio Pollaiuolo. Both influences are reflected, not in Raphael's paintings of this period but in his pen drawings of the type associated by Fischel with the so-called 'Larger Florentine Sketchbook', most obviously in the compositions of the fighting nude men and the Labours of Hercules (nos. 50–51 and 64–67). The only fresco commission of these years, the upper part of the San Severo *Trinity* (see no. 69), was directly inspired by Fra Bartolommeo's *Last Judgement* of *c.* 1500 in the church of S. Maria Nuova in Florence.

The most ambitious work of these years is the Borghese *Entombment*, painted for a church in Perugia and inscribed with the date 1507 – that is, the year before Raphael went to Rome. The surviving drawings, most of which are exhibited here (nos. 72–80), are evidence of the trouble that he took over the working out of the composition. They illustrate its development from a static and relatively simple Peruginesque *Lamentation* to a more energetic solution in which the body is being carried: in Fischel's phrase 'the triumph of Tuscan drama over Umbrian lyricism'. The final result reveals an evident debt to the Antique and to Michelangelo (see nos. 75 and 78), but these sources seem as yet incompletely assimilated. The element of intellectual contrivance is still apparent, as it is not in the Stanza della Segnatura frescoes of only a year or so later. The *Entombment* is an example of the academic current – to define it in anachronistic terms – in the High Renaissance that had already made its appearance in Leonardo's *Last Supper* and, most conspicuously, in Michelangelo's cartoon of 'The Bathers'.

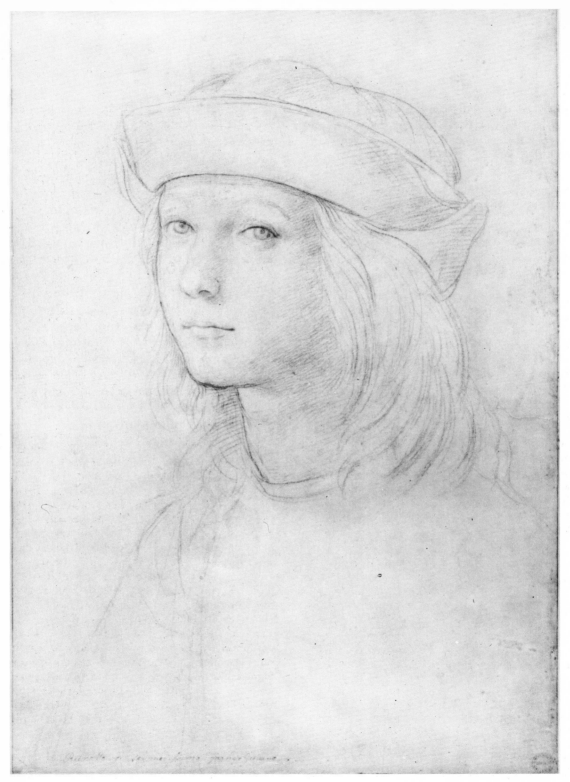

34

34. Head of a boy wearing a cap

Ashmolean Museum P II 515
Black chalk, heightened with white. 381 × 261 mm.
Literature: KTP 515; P 459; R 26; Ruland, p. 3, iii, 1;
 C & C, i, p. 282; F 1.

Inscribed in ink in a late eighteenth- or early
nineteenth-century hand: *Ritratto di se medessimo
quando Giovane*. An identical inscription in the same
hand occurs on no. 1, also a drawing of a boy's head,
but not necessarily of the same boy.

 The identification of no. 34 as a youthful self-
portrait was accepted by Passavant and by Ruland,
but rejected by Robinson and by Crowe and
Cavalcaselle. Fischel accepted it, but it was again
rejected by Parker and in the British Museum
catalogue (P & G, under no. 1). The boy represented
can hardly be more than sixteen years old, so if this
were a self-portrait it would have to date from
before *c.* 1500; and we agree with Robinson that
'from the advanced style of the drawing it seems
impossible to refer it to an earlier period than about
A.D. 1504, when Raffaello had attained his 21st year'.
The relatively late dating seems to us confirmed by
comparison with the studies for heads in the
Sposalizio (see no. 31). Like no. 68 this is a portrait
drawing, but it is executed with less assurance: the
artist seems to have made more than one attempt to
fix the line of the collar, and his final choice has
resulted in a neck unduly long for the very narrow
shoulders.

35. St George

Ashmolean Museum P II 44
Metalpoint, heightened with (oxidised) white, on
 off-white prepared paper. Badly rubbed and abraded,
 the drawing has been silhouetted and laid down on a
 sheet measuring 264 × 233 mm.
Literature: KTP 44; P 498; R 35; Ruland, p. 111, vii, 6;
 C & C, i, pp. 278 f.

One of Lawrence's Raphael drawings, the tradi-
tional attribution of which was accepted by Passav-
ant, Robinson, Ruland, and Crowe and Caval-
caselle. Robinson was the first to connect it with the
figure in the Washington picture (see no. 36), which
it resembles in all essentials except that in the

35

drawing he is carrying a small shield on his left arm
and leaning further forward in the saddle, with his
right arm extended evidently to brandish a sword
(cut away when the drawing was silhouetted). The
attribution was rejected by Fischel, who imparted to
Berenson his belief that the drawing was by Sig-
norelli. Berenson published it with that attribution
in 1933 (*Gazette des Beaux-Arts*, 6th series, x, pp. 279
f.) and in the second edition (1938) of his *Drawings of
the Florentine Painters* (no. 2509 G–1). Parker, though
he catalogued no. 35 under the name of Signorelli
qualified by a question mark, found it impossible to
overlook the connexion with Raphael's *St George*.
He was evidently very doubtful about the Signorelli
attribution, describing it as 'purely intuitive' and
unsupported by any evidence, and observing that no
other instance of such close interconnexion between
Signorelli and Raphael is known and that metalpoint
is not a medium that Signorelli was in the habit of
using. The case for Raphael's authorship has been
independently restated by D. A. Brown (1983, pp.
146 ff.) and by Shearman (*Burlington Magazine*, cxxv
(1983), p. 21).

 The condition of the drawing makes it very hard
to judge, but what can be seen of it is entirely

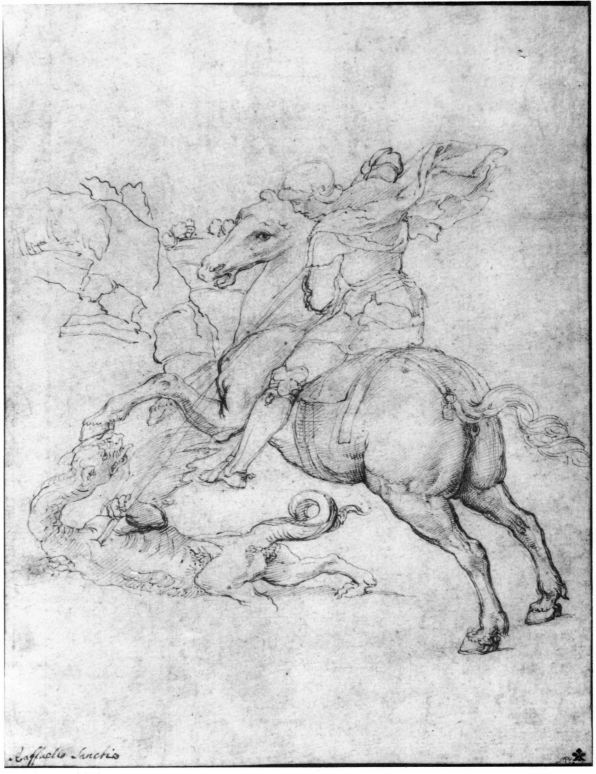

Raffaello Sanchio

36

consistent with the traditional attribution. The difficulty was increased by the laying down of the fragment with the horse at the wrong angle so that its forelegs and hindlegs were almost level, with the result that Raphael's nobly rearing animal had been transformed into a rocking-horse (cf. the reproduction in Berenson's article; the fragment is reproduced at the correct angle by Brown, fig. 82).

36. St George and the Dragon

Private collection
Pen and light brown ink over black chalk. 340 × 250 mm.

This hitherto unknown study for the painting now in the National Gallery, Washington, was recently published for the first time by Shearman (*Burlington Magazine*, cxxv (1983), pp. 15 ff.). It is closely related to a drawing also in pen and ink and (according to Shearman) on exactly the same scale, in the Uffizi (F 78), which is pricked for transfer along the outlines and seems to have served as the cartoon for the painting. The cartoon for the National Gallery *Allegory* (no. 15), like the Washington *St George* a small-scale panel painting, is pricked in the same way. Comparison with the Uffizi drawing reveals that though the horse's hindquarters and legs are in the same position in both, the angle of its body is slightly lower in no. 36 and more nearly parallel to the lower edge of the composition. Raphael presumably began no. 36 with the intention of making it the cartoon, but abandoned it when he decided to change the position of the horse. Parts of the drawing, especially the horse's hind-quarters and legs, are carried as far as possible, while other passages such as the saint's cloak and the landscape are only diagrammatically sketched in.

Shearman doubts the old tradition that the Washington painting was commissioned from Raphael by Guidobaldo da Montefeltro, Duke of Urbino, as a present for King Henry VII of England, who in 1504 had created him a Knight of the Garter (see also Helen S. Ettlinger, *Burlington Magazine*, ut cit., pp. 25 ff.). The painting is first recorded in this country in 1627, when it was in the possession of the then Earl of Pembroke; there is no record of its having been in the Royal Collection before its acquisition by Charles I. Shearman argued that

echoes of it in Italian sixteenth-century painting suggest that it remained in Italy for at least a century.

37. A youthful warrior

Ashmolean Museum P II 522
Pen and brown ink. 268 × 190 mm.
Literature: KTP 522; P 535; R 54; Ruland, p. 118, iv, 1; F 82.

The figure is a close adaptation of Michelangelo's marble *David* (see no. 39), the principal differences being the position of the left forearm and the addition of the shield and spear. On the *verso* (F 83) are some slight anatomical sketches and a more fully realised drawing of a standing nude man who holds a book in his right hand and supports his left arm on the hilt of a long sword, and is thus identifiable as St Paul. A related sheet in the British Museum (no. 38) has on the *recto* a study of a nude man in profile to

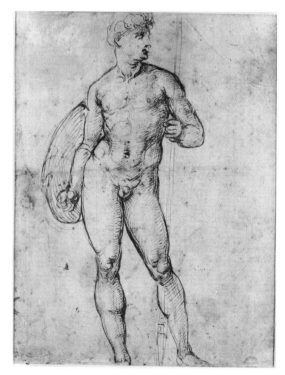

37

right in a pose identical with that of the figure on no. 37 *recto* except for the placing of the left leg, and on the *verso* a study of an elderly-faced nude man with a halo and holding what seems to be a pair of keys, which would identify him as St Peter. In view of the close relationship between nos. 37 *recto* and 38 *recto*, it seems possible that the *St Paul* and the *St Peter*, two saints frequently represented together, were designed as pendants. On the other hand, they may have been part of a whole series of saints: a nude study of exactly the same type in Budapest (F 86), of an old man with a halo, is convincingly identified by Fischel as St Jerome; and if the youthful warrior on no. 37 *recto* was also intended as a saint, he could be St George, as Ruland suggested.

This sheet is one of a number, including nos. 38, 43, 45, 46, 47, 48, 52, 81 and 83, which Fischel grouped under the heading 'The Large Florentine Sketchbook' or 'Sketchbooks' (he uses the plural in his Thieme-Becker article on Raphael). In the introduction to part ii of his *corpus* (p. 88) he enumerated the signs that revealed to him that a sheet once formed part of a sketchbook (thumbing and signs of excessive wear on the right and lower edges and especially in the lower right-hand corner, trimmed corners, drawings on both sides, and old foliation) and went on to claim that this particular sketchbook is the best preserved and easiest to reconstruct. Examination of his facsimiles of the drawings in question and of his notes on them reveals few of these indications and also some discrepancies: in the three instances where he records a watermark (his 91/2, 93/4, 97/8) these are all different, and Parker (p. 270) notes yet another on F 82/3; no signs of foliation are visible in the facsimiles, nor does he refer to any in his notes on individual drawings; of the twenty-one sheets that he includes, with varying degrees of conviction, in the sketchbook, only fifteen are double-sided; there are no evident signs of excessive wear and tear on any particular part of any sheet; and as Parker pointed out, the pricking for transfer of drawings on at least two of the sheets (nos. 46 and 47) would have served no purpose if these had been part of a bound volume. Misleading too is Fischel's description of the hypothetical sketchbook as 'the pen drawings with the Antaldi mark' (*Burlington Magazine*, lxxiv (1939), p. 182), since this collector's mark occurs on only two (F 93/4 and 110/1). But we agree with Parker that whether all or any of these sheets were bound up together when Raphael came to draw on them is a question of slight and only academic importance. What is important is Fischel's convincing recognition of them as a homogeneous group of sketches dating from Raphael's Florentine period.

38. A nude man advancing to the right

British Museum Pp. 1–65
Pen and brown ink. 279 × 169 mm.
Literature: P & G 14; P 444; Ruland, p. 319, xlv, 1; F 85.

Inscribed half-way up on the right, in black chalk: *Rafaelle*, and along lower edge *Rafaello*.

The pose is suggested by Michelangelo's marble

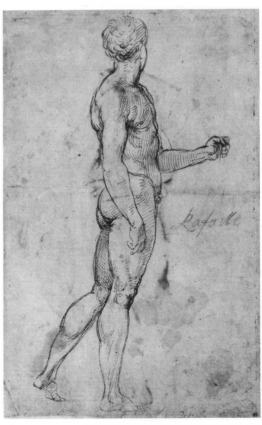

38

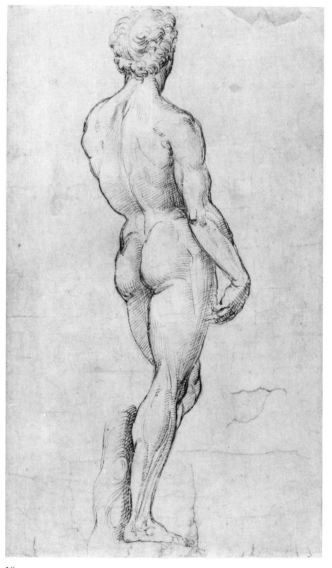

39

David (see no. 39), but the drawing seems to be a study from the life, though with the figure some-what idealised: the left hand is grasping what looks like the top of a staff, as a model would do in order to maintain his pose.

On the *verso* (F 84) is a drawing of an elderly-featured nude man, probably intended for St Peter since a halo is indicated on the head and he is holding what could be a pair of keys. This figure may be a pendant to the St Paul on the *verso* of no. 37.

We agree with the dating implied by Fischel's inclusion of this sheet in his 'Large Florentine Sketchbook' group (see no. 37).

39. Back view of Michelangelo's statue of *David*

British Museum Pp. 1–68
Pen and brown ink. Traces of black chalk underdrawing.
393 × 219 mm.
Literature: P & G 15; P 452; Ruland, p. 319, xlv, 2; F 187.

Described as a study after the Antique in the catalogue of the sale of W. Y. Ottley's collection in 1814. Michelangelo's marble statue of *David* was erected in the Piazza della Signoria in June 1504, at about the time of Raphael's arrival in Florence. Raphael's copy illustrates his bias towards idealisa-tion: he has transformed Michelangelo's adolescent with his over-large head, hands and feet into a more graceful classically proportioned figure.

40. Leda and the Swan *(after Leonardo da Vinci)*

Windsor 12759
Pen and brown ink over black chalk. 308 × 192 mm.
Literature: AEP 789; Ruland, p. 129, xiv, 1; F 79.

Traditionally attributed to Raphael, this is one of many copies of a well-known composition by Leonardo, the original of which is lost. For the most complete list see Paola della Pergola, *Galleria Bor-ghese: I Dipinti*, i, 1955, under no. 138. In addition to the Borghese Gallery copy there is one at Wilton House (K. Clark, *Leonardo da Vinci*, 1939, pl. 41). The quality of Raphael's pen-work supports Fischel's suggestion that he had before him not a painting but a drawing by Leonardo which would

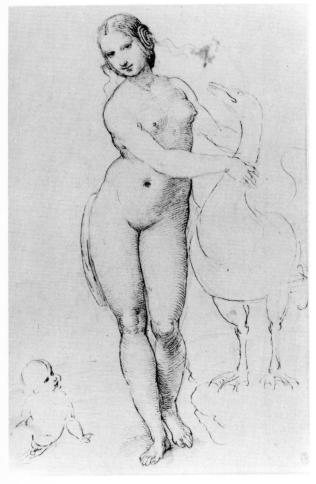

40

have resembled the pen and ink studies for Leda's head alone, also at Windsor (cf. e.g. A. E. Popham, *The Drawings of Leonardo da Vinci*, 1946, pls. 209–11). In the Borghese and Wilton copies the hair is braided in 'earphones' as in Raphael's drawing; the lines following the contour of the right thigh, which in the drawing might almost be mistaken for drapery, are clearly the edge of the bird's wing.

41. Study for a kneeling figure of St Francis receiving the Stigmata

British Museum Pp. 1–64
Pen and brown ink. A few faint red chalk strokes to
 right and left of the figure's knees indicate the ground.
 238 × 176 mm.
Literature: P & G 7; P 446; Ruland, p. 119, v, 3; F 55.

The figure's identity is established by the stigmata visible on his right side and on the back of his right hand. We agree with Fischel that this is a study from life, datable *c.* 1505.

42. A standing woman in profile to right

Ashmolean Museum P II 528
Pen and brown ink. 273 × 194 mm.
Literature: KTP 528; P 550; R 51; Ruland, p. 317, xxviii, 1;
 C & C, ii, p. 547; F 100.

The interpretation of this drawing has puzzled critics. Passavant described the figure as 'holding something in her apron'; Robinson, similarly, as 'carrying a plateau or basket, held out before her at the level of the waist, concealed beneath her dress . . . perhaps a sketch made by Raffaello to perpetuate a momentary attitude of some graceful girl which had struck his fancy'; Fischel as gathering up her dress in front of her ('Sie halt ein Bausch des Kleides vor sich'). Fischel went on to draw a parallel with the *Tempi Madonna* (Munich), a work datable towards the end of Raphael's Florentine period, in which the half-length figure of the Virgin is turning to the right and has a large fold of drapery round the waist. It seems in fact evident that the figure in the drawing is pregnant – a conclusion implied by Parker's suggestion that the artist had a *Visitation* in mind.

On the *verso* (F 101) is a drawing of children

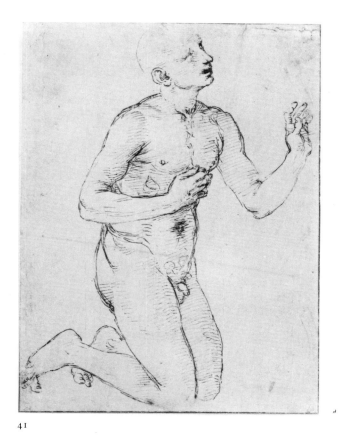

41

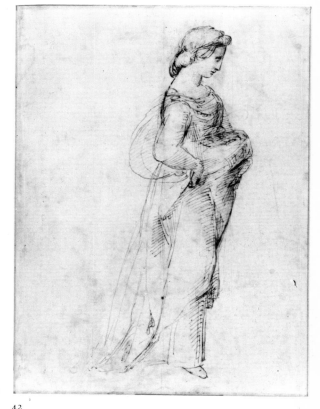

42

playing, in a pen and ink technique involving much use of tonal hatching and cross-hatching. Parker followed Fischel in explaining what he described as the 'mechanical handling' as the result of reworking. We can see no trace of another hand: the technique seems exactly comparable with that of studies for the Borghese *Entombment* (e.g. nos. 76 and 79), in which reworking has also been unjustifiably suspected. The style and handling of the *recto* study are no less characteristic of the later years of Raphael's Florentine period.

There seems to be no other evidence that Raphael was contemplating a *Visitation* at the time, but whatever the original purpose of no. 42 may have been it is possible that he made use of it some years later. An almost identical figure, likewise in profile to right, occurs in the left background of the tapestry cartoon of *The Healing of the Cripple at the Beautiful Gate*. The only differences are some simplification of the drapery and a change in the position of the right arm, which in the cartoon is held downwards, across the front of the body: a change that might be explained by the fact that the figure in the cartoon is partly obscured by another in front, in such a way that only part of the arm would have been visible if in the akimbo position as in the drawing. The tapestry cartoons date from 1515 to 1516, and the suggestion that Raphael may have made use of a study probably datable so much earlier would seem unduly far-fetched to be put forward with whatever degree of hesitation, were it not for Shearman's observation (1972, p. 99) that for the head of the woman with a baby standing behind the kneeling cripple on the right in the same cartoon Raphael had had recourse to a study for one of the Muses in the *Parnassus* (F 254).

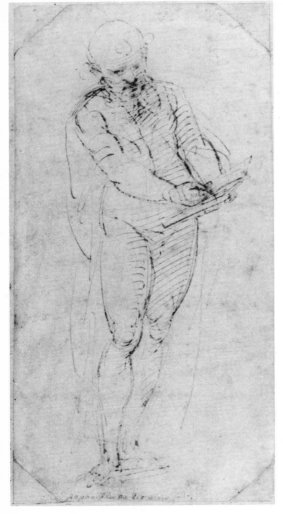

43

43. A standing man writing in a book

Ashmolean Museum P II 526
Pen and brown ink. 177 × 88mm (all four corners cut).
Literature: KTP 526; P 540; R 58; Ruland, p. 318, xxxvii, 1;
 F 310a.

Robinson dated this drawing at the beginning of the
Roman period, on the strength of the resemblance
that he saw between the figure and some of those in
The School of Athens. He was no doubt thinking of
the conspicuous standing Philosopher in the left
foreground, who holds his book against his left leg
with a not dissimilar gesture; but the pose of that
figure is altogether more complex and more
developed, and Fischel was surely right to place no.
43 in the context of his 'Larger Florentine Sketch-

book' (see no. 37). His suggestion that it might be a
study for one of the six standing Saints in the lower
part of the S. Severo *Trinity* is plausible but unverifi-
able (see no. 69): only the upper part of this fresco
was carried out by Raphael, but it seems improbable
that he never considered the problem of the lower
part, which in the end was executed by Perugino in
1520 on his own design.

44. A standing woman (St Catherine?)

Ashmolean Museum P II 527
Pen and brown ink. 259 × 171 mm.
Literature: KTP 527; P 544; R 53; Ruland, p. 397, xxix, 1;
 F 99.

Robinson argued that the resemblance between this
figure and the half-length *St Catherine* in the
National Gallery (see no. 82) is so close, 'especially in
the pose of the upper part, the costume, and
expression of the head, as to render it most probable
that it was either a preliminary study for that picture,
or else a sketch executed at the same time for some
other work, in which the standing St Catherine was
to be introduced'. In fact, the only point of resem-
blance is in the position of the left arm, which in the
painting is supported on a wheel, the Saint's attri-
bute; in the drawing the arm is also resting on a
support, but the nature of this is undefined. In the
painting the forearm is less abruptly foreshortened,
so that the hand is resting on the top of the left thigh;
the right arm is held across the body with the hand
on the breast; and the head is looking upwards and to
the right. But in spite of all these differences, the
possibility cannot be excluded that this is a study for
a *St Catherine*: it is certainly the most satisfactory
explanation of the position of the left arm.

The painting is generally dated either towards the
end of Raphael's Florentine period, *c.* 1507, or
shortly after his arrival in Rome. The drawing is
probably datable *c.* 1506–7, on the evidence of the
three roughly drawn black chalk sketches on the
verso. Two are of the head of a woman with
elaborately braided hair, once in profile looking
upwards to the right, and again three-quarter face to
left and looking slightly downwards. The third is a
very summary impression of the pose of the Virgin
in Michelangelo's Doni *tondo* in the Uffizi, datable *c.*

1504: a motif used by Raphael, in reverse, for the kneeling figure in the group of the swooning Virgin supported by the Holy Women on the right of the Borghese *Entombment* of 1507. The heads could have been sketched with the same group in mind.

Fischel did not include a facsimile of the *verso* among the plates in his *corpus*, but contented himself with reproducing it as a (full-page) illustration in his text. Whether this distinction was intended to imply some degree of doubt about Raphael's authorship of the *verso* is not clear. No such doubt was expressed in his catalogue entry relating to the *recto*, in which he associated the *verso* 'with the circle of studies for the *Entombment*' – a suggestion which Parker did not take up.

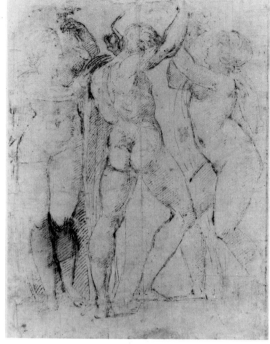

45

44

45. A group of vintagers

Ashmolean Museum P II 524
Pen and brown ink. Squared in black chalk. 280 × 205 mm.
Literature: KTP 524; P 573; R 81; F 88.

The purpose of this drawing is unknown, but the squaring suggests that the design was to have been executed on a larger scale, presumably as part of some decorative scheme. Fischel was inclined to connect it with nos. 46 and 47, compositions somewhat similar in scale and proportion and in their indeterminate subject-matter, which he thought might be designs for the decoration of a façade. It should be observed that only no. 45 is squared.

On the *verso* are pen and ink studies of the right arm and right leg of a standing child in a position resembling, as Paul Joannides pointed out (orally), that of the Infant Christ in the *Northbrook Madonna* (Worcester, Mass.), a painting which though not by Raphael's own hand seems to be based on a design by him of *c.* 1505 (Brown 1983, p. 133, pl. 11).

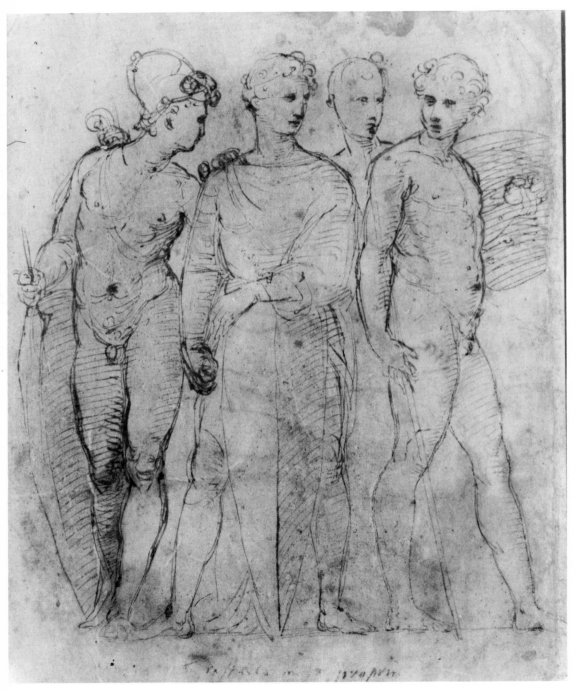

46

46. A group of four standing warriors

Ashmolean Museum P II 523
Pen and brown ink. 271 × 216 mm.
Literature: KTP 523; P 541; R 46; Ruland, p. 319, xliii, 1;
 C & C, i, p. 273; F 87.

Inscribed along lower edge in ink in an old hand: *di raffaelo mano proprio*.

In describing this drawing as 'merely a group of academy studies tastefully arranged in juxtaposition', Robinson was no doubt influenced by his inability, which we share, to explain what subject, if any, Raphael had in mind. Fischel, on the other hand, argued that this is a complete composition, carefully worked out and deliberately symmetrical, and related it to nos. 45 and 47, compositions of rather the same type and scale and similarly indeterminate subject. His suggestion that they might be studies for the decoration of a palace façade is unverifiable but not to be excluded. A somewhat similar group of standing nude men is on no. 48, and another is known from copies (e.g. F, fig. 109).

The central figure is copied from the statue of St George by Donatello which stands in a niche on the exterior of the church of Or San Michele in Florence, and the composition as a whole seems to have been inspired by Nanni di Banco's group of the *Quattro Santi Coronati* in another niche on the same wall (Venturi vi, fig. 115). Fischel pointed out the exact correspondence between the right-hand figure in no. 46 and one on a fragment of an Antique terracotta frieze in the Museo delle Terme (F, fig. 104).

On the *verso* (F, fig. 105) are figure studies, some in pen and some in black chalk. Parker follows Fischel in rejecting Raphael's authorship, but it seems to us that they could well be from his hand. The pen studies, Parker himself observed, seem to be connected with the figure on no. 38.

Also on the *verso*, on a very much larger scale, is an outline drawing of a man's head in profile with the contours pricked, identified by Parker as corresponding with one of the heads in Signorelli's fresco of *The Crowning of the Elect* in the cathedral at Orvieto. As he says, its occurrence on the sheet is 'very mysterious'.

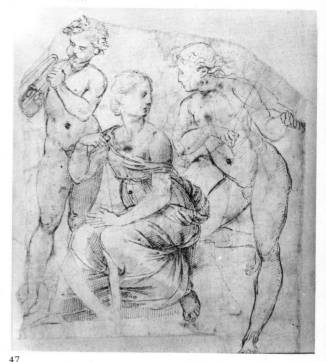

47

47. A group of musicians

Ashmolean Museum P II 525
Pen and brown ink. 232 × 185 mm.
Literature: KTP 525; P 542; R 43; Ruland, p. 169, ii, 1;
 F 89.

On the *verso* (F 174) is a study for the left-hand bearer and part of the figure of Christ in the Borghese *Entombment*, a painting dated 1507 (see nos. 72 to 80). The purpose of the *recto* drawing is unknown, but its presence on the same sheet as a pricked study for the *Entombment* suggests at least an approximate *terminus ante quem* for its date: Raphael would hardly have used a sheet already defaced by pricking for the *recto* drawing; he is more likely to have drawn the *Entombment* study on the back of a discarded drawing.

Fischel tentatively connected the *recto* with nos. 45 and 46, which he suggested might have been studies for the decoration of a palace façade.

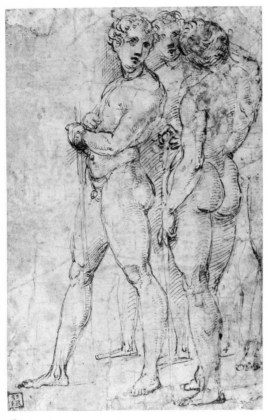

48

48. Three standing nude men

British Museum 1895–9–15–628
Pen and brown ink. 243 × 148 mm.
Literature: P & G 16; Ruland, p. 319, xlvi, 1; F 90.

Fischel hesitated about accepting Raphael's author-
ship of this drawing, but eventually came to the not
very satisfactory compromise conclusion that it is
'partly genuine'. It seems to us that the unfavourable
first impression which it makes is due largely to its
condition. Fischel includes it in his 'Large Florentine
Sketchbook' group (see no. 37).

49. Two nude men advancing to the right over the body of a third

British Museum Pp. 1–75
Pen and brown ink. Traces of black chalk underdrawing.
269 × 172 mm. Top and lower right corners made up.
Literature: P & G 17; P 447; Ruland, p. 324, xxii, 1; C & C,
ii, p. 75; F 197.

Fischel associated this drawing and the similar study
on the *verso* (F 198), of a nude man walking to the
right and looking back, shouting, over his right
shoulder, with the compositions of nude men
fighting (nos. 50 and 51). Though sketchier, they
agree with them in style and, apparently, in subject:
the left-hand figure in no. 49, seems to be holding up
a shield.

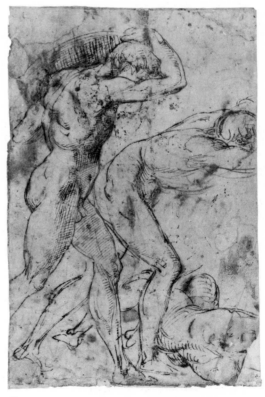

49

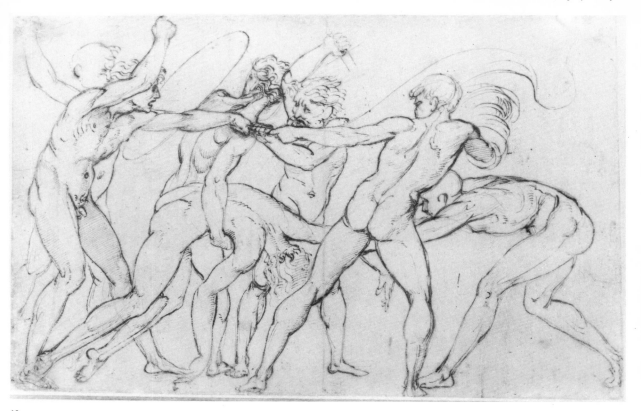

50

50. Seven nude warriors fighting for a standard

Ashmolean Museum P II 537

Pen and brown ink over black chalk. The outlines pricked
for transfer. 274 × 421 mm.

Literature: KTP 537; P 533; R 102; Ruland, p. 166, viii, 1;
C & C, ii, p. 265; F 193.

Some nineteenth-century critics, including Robin-son and Crowe and Cavalcaselle, saw in this draw-ing an early idea for the *Battle of Ostia* in the Stanza dell'Incendio in the Vatican decorated by Raphael and his assistants between 1515 and 1517. W. Y. Ottley, on the other hand, had already published it in his *Italian School of Design* (1823), with the comment that it was inspired by Leonardo da Vinci's *Battle of the Standard* and datable *c*. 1506: an opinion with which Passavant and the twentieth-century critics have concurred, though Parker follows Gronau (p. 42) and Fischel in suggesting a somewhat later date, *c*. 1508–9. Whether this drawing and the closely similar compositions on the *recto* and *verso* of no. 51 are to be assigned to the end of the Florentine or the beginning of the Roman period, the underlying inspiration is wholly Florentine. In the case of no. 50, the closest antecedent is not Leonardo's *Battle of the Standard,* in which the contestants are on horseback, nor even Michelangelo's *Bathers*, in which the figures are on foot, but the earlier (*c*. 1470) Pol-laiuolo engravings of the *Battle of Nude Men* and, even more strikingly, *Hercules and the Twelve Giants*.

The purpose of these drawings is unknown. The pricking on no. 50 suggests that Raphael intended to carry the design a stage further, and that it is more than simply an exercise in the Michelangelesque. What that further stage was to have been is a matter of conjecture. Raphael could have had a small panel painting in mind, or an engraving. The outlines are similarly pricked in nos. 122, 124 and 125, all made in connexion with engravings. It seems out of character for an artist gifted with Raphael's powers of invention to have contemplated the idea of a companion drawing of exactly the same composi-tion in reverse, as Fischel suggested in an attempt to explain the pricking.

Parker described no. 50 as 'probably a good deal retouched along its outlines', but we see no evidence of later reworking: Raphael could have strengthened the contours himself in order to emphasise the linear rhythm of his composition.

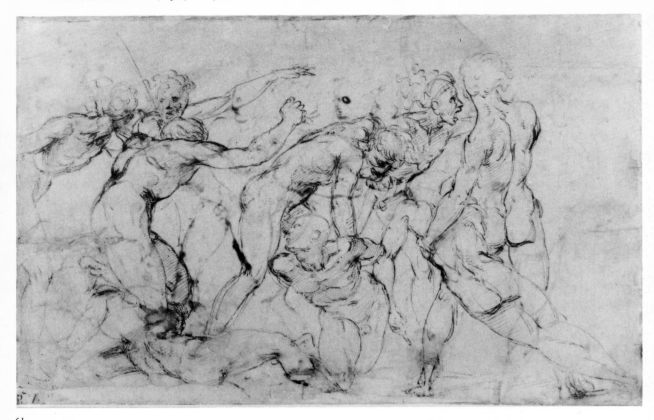

51

51. A battle of nine nude men, one of whom is being pinioned

Ashmolean Museum P II 538
Pen and brown ink. Traces of black chalk underdrawing.
 268 × 417 mm.
Literature: KTP 538; P 517; R 101; Ruland, p. 210, 10;
 C & C, ii, p. 266; F 194.

On the *verso* (F 195) is a similar composition, also of nine nude men, one of whom is being dragged along with his hands tied behind his back. On the right are the prostrate bodies of at least two others.

As with no. 50, divergent views have been expressed about the date. The critical history of the two drawings is largely parallel, except that Passavant who followed Ottley in dating no. 50 *c.* 1506, connected no. 51 with the *Battle of Ostia* in the Stanza dell'Incendio, a work of about ten years later but of which the central motif is likewise the binding of a group of prisoners. In this view he was followed by Robinson, Ruland, and Crowe and Cavalcaselle and others, some of whom put forward the same explanation for no. 50. In handling no. 51 seems less deliberate and more animated than no. 50, but it is impossible to separate them stylistically. Gronau (p. 42) was probably right in dating both in the

transition period between Florence and Rome, *c.* 1508–9. The Leonardesque character of the shouting profile on the right of the group should be noted.

52. The Virgin and Child with the Infant Baptist in an interior

Ashmolean Museum P II 519
Pen and brown ink. 163 × 118 mm.
Literature: KTP 519; P 482; R 77; Ruland, p. 96, xliv, 6;
 F 128.

The gesture of the Virgin suggests that she is on the point of depositing the Infant Christ on the floor to join the Baptist. Fischel was certainly right in placing this drawing in Raphael's Florentine period. The profile head of the Virgin with its long neck and turban-like head-dress is evidently derived from Michelangelo's Burlington House *tondo* (see nos. 84 and 121). The architectural setting is so roughly indicated as to be indecipherable. In the background is what appears to be a standing figure; if so, it would presumably be St Joseph. The object in the left foreground is probably some kind of desk, as Parker suggested, apparently one shallow from back to front and with a sloping top.

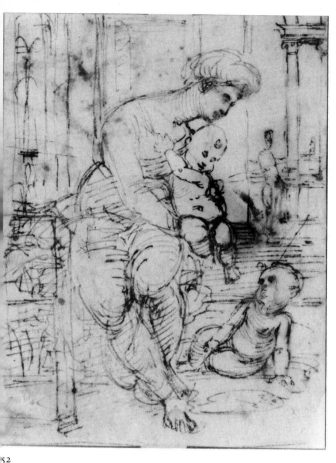

52

53. **Studies of the Virgin and Child**

Private collection
Pen and brown ink. 71 × 150 mm.
Literature: Ruland, p. 95, xlii, 2.

This fragment of a sheet of studies was listed by
Ruland as in the collection of William Russell
(1800–84). It was later lost sight of, and was included
by Fischel in his letter appealing for information on
'Some Lost Drawings by or near to Raphael' (1912,
p. 300), where it was compared to a group of slight
sketches 'in the Albertina and in the Vatican Lib-
rary'. It must date from Raphael's Florentine period.

53

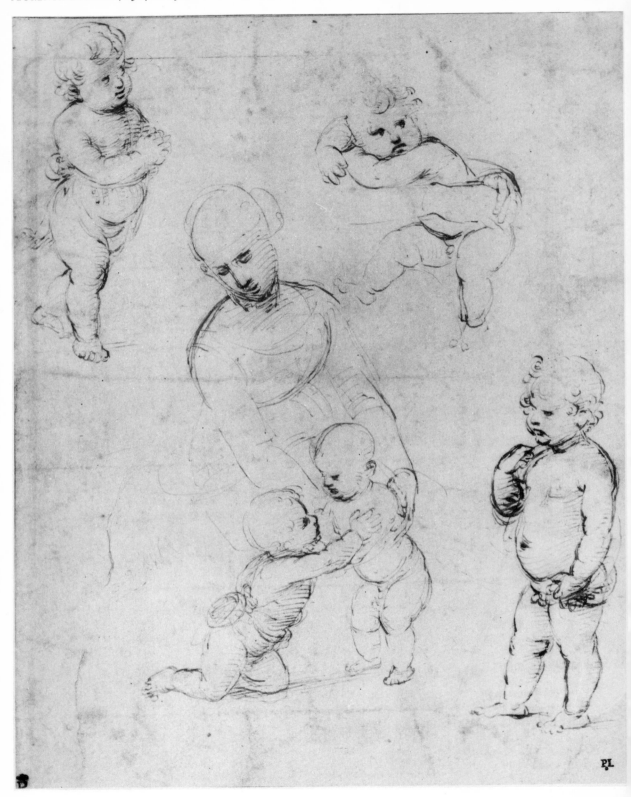

54. Studies for a group of the Virgin and Child with the Infant Baptist: *Madonna im Grünen*

Chatsworth 723
Pen and brown ink over stylus underdrawing.
 252 × 194 mm.
Literature: P 564; Ruland, p. 59, x, 10; C & C, i, p. 263;
 F 117.

Ruland was the first to connect this sheet of studies with the *Madonna im Grünen (Madonna of the Meadow)* in Vienna, a painting inscribed with a date that can be read either as 1505 or 1506. The principal study on the sheet is an early stage in the design. In the painting the Virgin is sitting upright, not leaning over to the left, but she is holding the Infant Christ as in the drawing, supported between her down-stretched hands; the Baptist is presenting his cross to Christ, who grasps it in his right hand, a motif not yet introduced in the drawing.

The child top left is for the Baptist in the same painting. He occurs in this pose in a study for the complete composition on a sheet in the Albertina (F 116). There is no counterpart to the child lower right in any of the surviving studies; though apparently older and not in need of his mother's support, he is probably intended for the Infant Christ who in the painting and all the known studies is on the right of the group, turned towards the left. It seems to us improbable that Raphael had Michelangelo's marble *David* in mind when drawing this figure, as Fischel suggested.

The sketch top right, of the Infant Christ seated on his mother's lap with his head turned towards the spectator and his body leaning against his mother who clasps him round the waist with both arms, has no counterpart in any of the Madonnas of the Florentine period. Passavant, who had not observed the connexion between the other studies on the sheet and the *Madonna im Grünen*, described this pose as that of the Infant Christ in the *Madonna della Tenda* (Munich). It seems to us that the pose resembles equally, if not more, that in the *Madonna della Sedia* (Pitti). Both pictures are so much later than the *Madonna im Grünen* – they are generally dated *c.* 1513–14 – that this sketch cannot be regarded as a preliminary study for either; but it is indicative of the working of Raphael's mind that he should have conceived the motif so many years before using it.

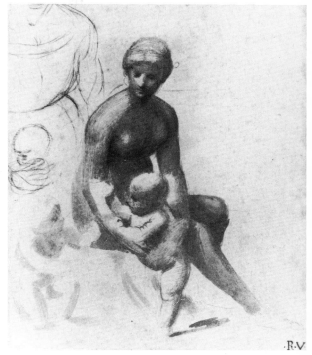

55

55. The Virgin and Child with the Infant Baptist: *Madonna im Grünen*

Ashmolean Museum P II 518
Brush drawing in brown, with touches of white body-colour and red chalk. Traces of underdrawing in lead-point. The contours indented with the stylus.
 219 × 180 mm.
Literature: KTP 518; P 481; R 33; Ruland, p. 59, x, 5;
 C & C, i, pp. 263 f.; F 118.

A study for the *Madonna im Grünen* (see no. 54), in which the placing of the figures has reached its final form. The figure of the Virgin is not clothed as in no. 54, but nor does it seem exactly to have been studied in the nude, and there are indications of drapery added with the stylus round the legs. Raphael seems here to have been concerned above all with the lighting of the figures. This is an early example of Raphael's drawing with the brush, a technique that does not lend itself easily to exact anatomical detail.

The closely related drawing which Parker referred to as lost but known from an engraving by Picart reappeared in 1964 from the same English country house collection as no. 77, and is now in the Metropolitan Museum (Bean 1982, no. 210). Like the slight sketch in the top left corner of no. 55, it is in red chalk, a very early instance of Raphael's use of the medium. The New York drawing, in which the drapery is indicated, comes even nearer to the painting than the study in Oxford. On the two sheets the main group is on exactly the same scale, and it is even possible that the outlines were traced through from one to the other.

56. Two studies of a group of the Virgin and Child with the Infant Baptist: *Madonna del Cardellino*

Ashmolean Museum P II 516
Pen and brown ink. 248 × 204 mm.
Literature: KTP 516; P 483; R 47; Ruland, p. 59, ix, 10; C & C, i, p. 262; F 112.

Studies for the *Madonna del Cardellino (Madonna of the Goldfinch)* in the Uffizi. The picture is undated, but is likely to have been painted at about the same time as the *Madonna im Grünen, c.* 1505–6 (see no. 54). The larger study on the sheet, which must have been drawn first, has no point of exact correspondence with the painting, but the group clearly evolved into the smaller and more summary sketch. In this the Infant Christ is standing, as in the painting, between his mother's knees with his right arm extended and looking upward to his right. In the painting the Baptist is also standing, with his head in the position indicated in the drawing. The painting is rectangular, but the curving line above the smaller group suggests that Raphael may at this early stage have intended to give the composition an arched top.

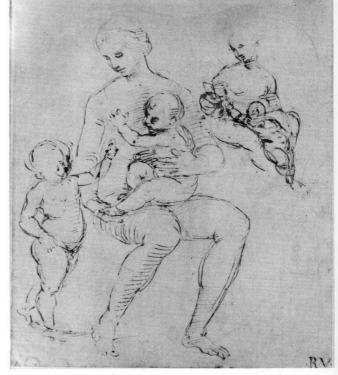

56

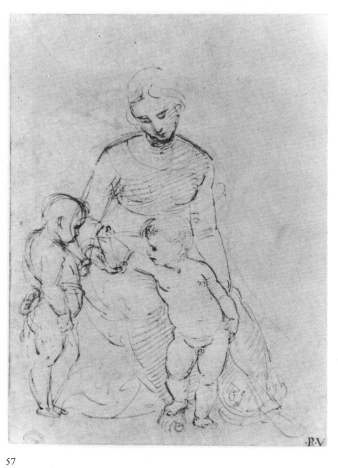

57

57. The Virgin and Child with the Infant Baptist: *Madonna del Cardellino*

Ashmolean Museum P II 517
Pen and brown ink over lead-point. 230 × 163 mm.
Literature: KTP 517; P 485; R 49; Ruland, p. 58, ix, 6;
 C & C, i, p. 262; F 114.

A study for the *Madonna del Cardellino,* later than those on no. 56. The pose of the Infant Christ is close to that in the painting, but that of the Baptist is less *mouvementé.* The chief difference is that in the painting the Baptist is holding the goldfinch from which it derives its name, and which the Infant Christ is stroking with his right hand. In the drawing this motif has not yet been introduced; instead, the Virgin is teaching Christ to read from the book held in her right hand, which is transferred to the other hand in the painting.

 The drawing is laid down and cannot safely be lifted. Some architectural sketches, apparently in black chalk, show through from the *verso* and are discussed by Shearman (1967, pp. 12 f. and fig. 1, and 1977, p. 134).

58. The Virgin and Child with St Elizabeth and the Infant Baptist

Windsor 12738
Pen and brown ink. 234 × 180 mm.
Literature: AEP 790; P 427; Ruland, p. 82, xlv,4; C & C, i,
 pp. 298 ff.; F 130.

Passavant and Ruland describe no. 58 as a study for a composition (here for convenience termed the *Drottningholm Madonna*) known from an old copy of a lost drawing by Raphael in the Louvre (F 131), a small (270 × 210 mm) panel painting attributed to Raphael in the Swedish Royal Collection at Drottningholm (Inv. Drh. 284), another painting formerly in the collection of Charles T. Yerckes in the USA (Brown 1983, fig. 19), and at least five engravings, none of which is earlier than the beginning of the seventeenth century. The Louvre drawing and the Drottningholm and ex-Yerckes paintings are in the same direction as no. 58; all the engravings are in reverse. One of them, by Jacob Matham, is dated 1609 and inscribed *M. de Boijs pinxit,* but whoever this artist was – the print in question is apparently

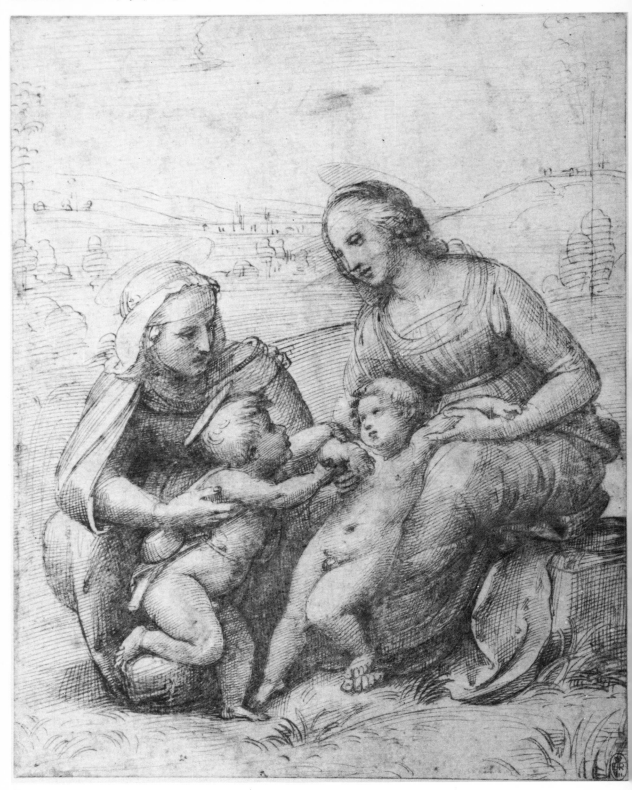

58

the only record of him – the evidence of drawings leaves no doubt that the invention of the composition was due to Raphael. It is clear, however, that neither of the paintings can be from his hand.

The *Drottningholm Madonna* resembles no. 58 very closely, except that in it the Christ Child is sitting on the Virgin's right knee, shrinking away from a bird held by the baptist in his outstretched left hand. Other differences in the figural group are in the position of the Baptist's right arm and the Virgin's left leg. The background in both paintings corresponds not with no. 58 but with the landscape in the Louvre drawing, with the addition, in the style of Raphael's Roman backgrounds rather than his Florentine, of a pyramid in the centre and on the right a group of buildings with a ruined arch, apparently part of an aqueduct.

Crowe and Cavalcaselle did not discuss the Drottningholm picture, but described no. 58 as a study for an apparently never-executed variant of the *Madonna Canigiani* (Munich), a work generally dated *c.* 1505–7. Fischel, on the other hand, followed by Popham, saw no. 58 and the lost original of the Louvre drawing as early ideas for the *Madonna Canigiani* itself. In this painting, as in no. 58 (but not in the Louvre copy), the two children are likewise standing on the ground facing one another, supported by their respective mothers; but while in no. 58 the Baptist is seizing with both hands the right arm of the Child Christ who seems to be shrinking back in alarm, in the painting the two children are more peaceably engaged in examining the banderole with the prophetic inscription *Ecce Agnus Dei*. A more radical difference is that St Elizabeth in the *Madonna Canigiani* is kneeling on both knees with her body more upright and turned to the right so that the outline of her back and upper arm balances that of the Virgin's figure and their heads are on the same level. The pyramidal contour thus imparted to the group is completed by the addition, behind and between the two kneeling women, of the standing figure of St Joseph leaning on his staff.

To us it seems an open question, whether no. 58 and the lost original of F 131 represent stages in the train of thought that led up to the *Madonna Canigiani*, or whether the *Drottningholm Madonna* was from the first conceived as an independent composition. Such a sheet of studies as no. 84 in the

present exhibition demonstrates very clearly Raphael's habit of germinating several ideas simultaneously in his mind, letting one develop from the other; and certainly there is no record of any painting by Raphael himself corresponding with the Drottningholm picture. On the other hand, the high degree of finish and absence of *pentimenti* in no. 58 might suggest that the general disposition of the figures had already crystallised in his mind beyond the point at which he would have been willing to embark on the recasting required by the *Canigiani* solution. The study at Chantilly (F 119) for the *Belle Jardinière*, showing the group in a form close to the final solution but with differences of detail, is in the same carefully finished pen and ink technique.

No. 58 is one of the drawings executed in pen in a technique involving much fine cross-hatching (e.g. nos 42 *verso* and 76), which Fischel inexplicably regarded as having been almost wholly reworked: in no. 58 he saw Raphael's hand only in the landscape background.

59. Two sketches for a *Virgin and Child*

Christ Church 0113
Pen and brown ink on pink-tinted paper. 198 × 154mm.
Literature: J. Byam Shaw, *Drawings by Old Masters at Christ Church, Oxford*, 1976, no. 363; R, p. 316, no. 3; F 157.

Inscribed on the old mount by Sir J. C. Robinson: *Raffaelle an indubitable drawing*; and by Sir Sidney Colvin: *No.*

The attribution to Raphael, first put forward by Robinson, was accepted by Fischel. He grouped the sheet with other pen and ink drawings on the same pink-tinted ground (F 150–158), in the belief that they were all once part of a sketchbook to which he gave the name 'Das gerötelte Skizzenbuch'.

Most of the studies in Fischel's 'Pink-grounded Sketchbook' group are for two closely related compositions of the Virgin and Child, in one of which she is suckling (or about to suckle) him, and in the other embracing him. No corresponding paintings are known, but what may have been the final stages of the two compositions survive in drawings in the Louvre (F 144) and at Chantilly (F 159). Both drawings are executed largely in brush with white heightening, and have the appearance of *modelli*. In

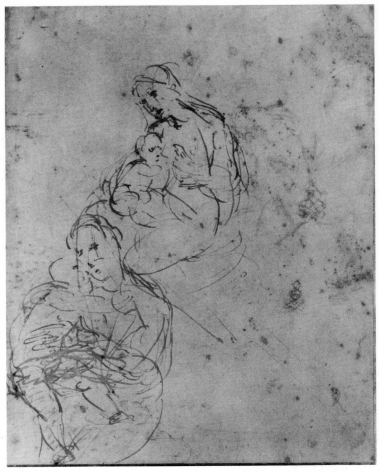

59

the Chantilly *modello* the Virgin is attended by angels; in the other she is not, but angels are included in a closely related study in the Albertina (F 150) which also belongs to the 'Pink-grounded Sketch-book' group.

No. 59, on which the two solutions seem to have been studied in rapid succession, provides a further link between them. The upper, 'suckling', solution is likely to have been drawn first: the natural instinct of any draughtsman making a study on a blank sheet of paper would be to put it near the centre. In the much corrected alternative sketch in the lower left corner, the Virgin appears to be kneeling on her left knee, embracing the Child with both hands and holding his face against hers; he supports both feet on her left thigh. On the *verso* (F 158) this solution is clarified with a masterly economy reminiscent of no. 60.

Both solutions suggest the influence of Leonardo (cf. especially F 151, at Bayonne, and the head of the Virgin in the *modello*, F 144), and the drawings are generally dated towards the end of Raphael's Floren-tine period. The small black chalk drawings on the right of the sheet in no. 59 have been explained as Leonardesque 'knot patterns'.

60. The Virgin and Child with an Angel

British Museum 1895–9–15–637
Pen and brown ink. 206 × 227 mm, excluding two strips
 of paper added to the top and bottom of the sheet,
 probably in the eighteenth century.
Literature: P & G 18; Ruland, p. 92, xxii, 1; F 134.

The composition is otherwise unknown. Fischel included this drawing with studies for the *Madonna Canigiani* (see no. 58), which it in no way resembles. He also suggested a connexion of some sort with the *Large Cowper Madonna* (Washington). Here there is some resemblance, if the group in the drawing be imagined without the angel and with the Virgin

three-quarter-length; but Raphael was in the habit of working out his Madonna compositions *pari passu*, and the resemblance is certainly not strong enough to establish a definite connexion.

We agree with Fischel's general dating. The style of the drawing points to the end of the Florentine period, as does the motif, common in Florence, of the kneeling angel supporting the Child. Less convincing is his contention that in this drawing 'Raphael took over a group from Perugino and Verrocchio and transformed it into an almost circular composition'. Nothing about the grouping of the figures suggests that Raphael had a *tondo* in mind, and the indications of framing-lines on either side establish that the composition was in fact conceived as a rectangle.

This drawing illustrates Raphael's lucidity of mind and his ability to convey all the necessary information with the utmost economy of means: slight and summary though it is, the placing of every element in the figural group is precisely defined in its spatial relation to the others.

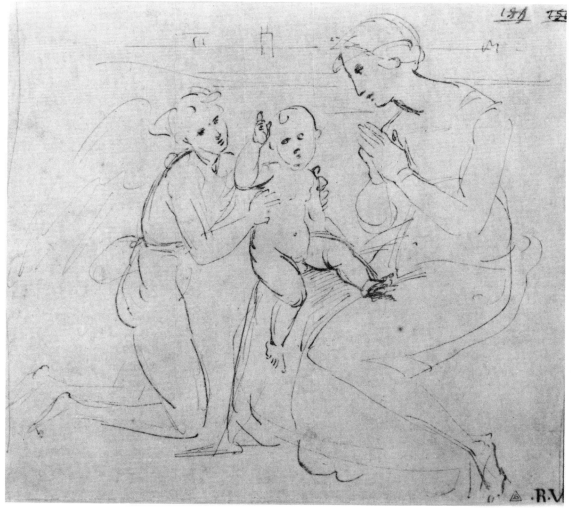

61

61. The Infant Christ and four separate studies of his left foot: study for *La Belle Jardinière*

Ashmolean Museum P II 521
Pen and brown ink, over lead-point underdrawing.
 283 × 160 mm.
Literature: KTP 521; P 457; R 50; Ruland, p. 65, xix, 6;
 C & C, i, p. 364; F 121.

A study for the Infant Christ in the *Belle Jardinière* (Louvre), which is dated 1507. So far as it goes, the drawing corresponds exactly with the final result. In the painting he supports his right hand against the Virgin's knee and extends his left arm towards the book resting on her left forearm. Pope-Hennessy (p. 200) seems to have been the first to point out the derivation of the figure from the Christ in Michelangelo's Bruges *Madonna*, a sculpture completed in Florence by August 1506.

62. The Virgin and Child with the Infant Baptist: cartoon for *La Belle Jardinière*

Viscount Coke
Black chalk, heightened with white. The contours incised.
 940 × 668 mm.
Literature: P, ii, p. 69; Ruland, p. 65, xix, 14; F 123.

For the painting known as *La Belle Jardinière* (see no. 61). The cartoon is for the group of figures only and does not include the landscape setting. Its condition makes some of the contours hard to decipher.

The figures correspond in essentials with the painting, but there are one or two *pentimenti*. The left forearm of Christ was at first so placed that the wrist and hand would have been obscured by the Virgin's left hand. In the revised solution, which corresponds with the painting, her left hand supports his left forearm, and he is holding in his left hand an open book which rests on her right arm. The Baptist's left upper arm was first drawn coming forward, but was later moved back so that the hand rests on his left thigh. In the painting he is bare-headed, whereas in the cartoon, as in the preparatory composition-study in the Louvre (F 120), he is wearing a wreath.

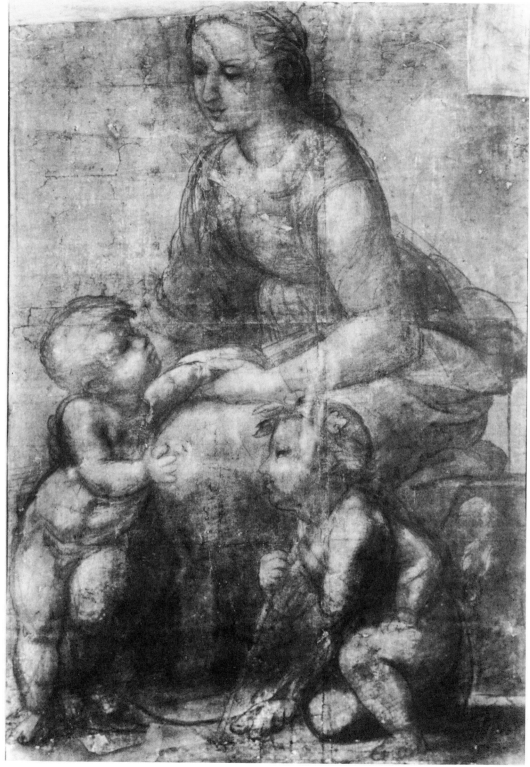

62

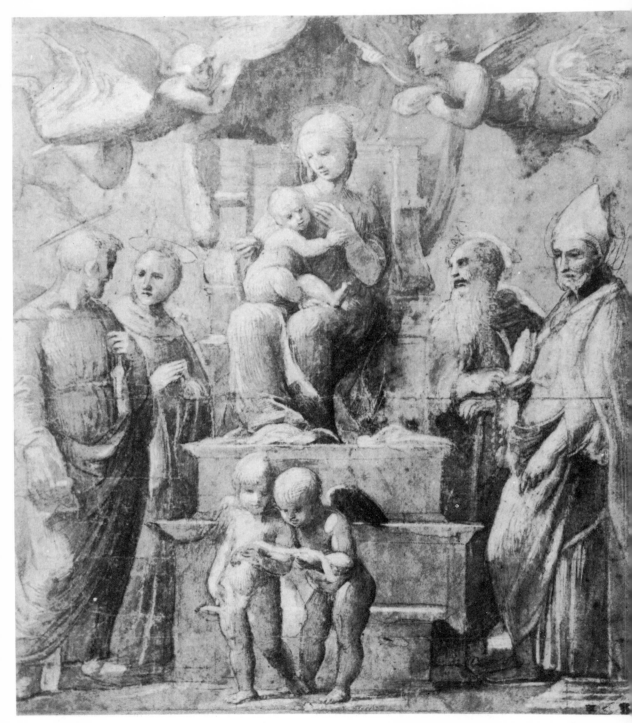

63 (From the old photograph taken *c.* 1855 in the Windsor Raphael Collection showing the drawing before the oxidisation of the white heightening)

63. The Virgin and Child enthroned between St Peter and St Bernard and a monastic saint (Anthony Abbot?) and St Augustine:

Madonna del Baldacchino

Chatsworth 733
Brush drawing in brown, with some pen, heightened
 with white. The outlines gone over with stylus.
 Squared with stylus. 265 × 228 mm.
Literature: Ruland, p. 67, xxiii, 9; C & C, i, pp. 372 ff.;
 F 143.

A study for the altarpiece, now in the Palazzo Pitti,
which according to Vasari was commissioned by the
Dei family for their chapel in the church of S. Spirito
in Florence, but was left unfinished at the time of
Raphael's departure for Rome at the end of 1508. It
must have been this picture that Ranieri di Bernardo
Dei instructed his heirs to commission in his will
dated 20 July 1506 (see *Rivista d'arte*, vi (1909),
p. 151).

In its proportion of height to width the Chats-
worth drawing corresponds fairly closely with the
painting in its original squarer format: at some time
not long after its acquisition by the Grand Duke of
Tuscany in 1697 a strip 320 mm wide was added to
the top of the panel, which had originally ended on a
level just below the upper rim of the curved base of
the canopy. Only the figure of St Peter in the left
foreground of the drawing, the pair of child-angels
in the centre foreground, and the upper part of the
Virgin's body are as in the painting. In his final form
St Bernard wears his cowl over his head and is
expounding to St Peter a passage in a book held open
on the step of the throne. An intermediate stage of
this figure is recorded in a study in the Uffizi (F 148).
The corresponding saint on the other side of the
throne in the Chatsworth drawing is probably
intended for St Anthony Abbot. He wears a monas-
tic habit with a cowl and leans on a stick, holding a
rosary in his right hand (a detail not visible in
Fischel's facsimile, but clearly to be seen in the old
photograph of *c.* 1855–60 in the Windsor Raphael
Collection from which our reproduction is taken).
In the painting he wears a cloak and clasps both
hands on a pilgrim staff, and is thus identifiable as St
James the Greater. In the drawing the other saint on
the right, St Augustine, stands stolidly motionless,
with downcast eyes; in the painting he looks out of

the picture directly at the spectator, to whom he
indicates the enthroned Virgin and Child with a
gesture of his right arm. The position of the Child's
head and arms is different in the painting, and the
Virgin's legs are crossed at the ankle, with the right
foot behind.

Vasari goes on to say that the unfinished painting
was acquired by a certain Baldassare (Turini) da
Pescia (1485–1543), an official in the Papal chancel-
lery whom Raphael was later to name as executor of
his will, who at some time after Raphael's death
placed it in his own family chapel in the cathedral at
Pescia. The readiness of the Dei family to part with
the picture suggests that it had not been carried far
enough to be placed above their altar in S. Spirito.
Turini must therefore have been responsible for
having it completed. This operation can be dated
within narrow limits. The left-hand hovering angel,
though in general disposition not unlike the one in
the Chatsworth drawing, is a repetition of one of
those in Raphael's fresco of the Sibyls in S. Maria
della Pace in Rome, a work that cannot be earlier
than *c.* 1512; and, as P. A. Riedl (op. cit. infr.) has
pointed out, a *Sacra Conversazione* by Leonardo da
Pistoia in the gallery at Volterra (repr. C. Ricci, *Italia
Artistica, 18: Volterra*, 1905, p. 95), composed partly
of elements copied from the *Madonna del Baldacchino*,
includes the two hovering angels in the revised form
in which they appear in the painting and is dated
1516.

There is no record of the state in which Raphael
left the painting, and how much of its eventual form
is due to him is a matter of argument. Riedl, after a
lengthy discussion of the question (*Mitteilungen des
Kunsthistorisches Institutes in Florenz*, viii (1957–9),
pp. 223 ff.), found it possible to accept whole-
heartedly as from Raphael's own hand only the
central group of the enthroned Virgin and Child and
the two child-angels in the foreground. He felt some
reservations about the two saints on the left, and
doubted whether Raphael had anything to do with
the execution or even the invention of the pair on the
right.

We agree that the right-hand pair of saints differs
(as do the hovering angels) in conception and,
apparently, in execution, from the central group and
from the pair of saints on the left; but not that this
difference necessarily excludes Raphael's interven-

tion. It seems to us, rather, to reflect the change in his style between 1506–8 and 1512–15. From what we know of Raphael's methods of work, the execution of the painting would have been immediately preceded by the preparation of a full-scale cartoon of the whole composition, the outlines of which would have been traced on to the panel. It would thus have been open to Turini to have the altarpiece completed according to Raphael's original design – an unexceptionable solution with the advantage that the result would have been homogeneous in style. But Turini and Raphael were close contemporaries, both living in Rome, both employed at the Papal court, and well enough acquainted for one to be named as executor of the other's will. What could be more likely than that Turini should have turned for advice to the artist himself; or that Raphael, if asked to suggest the best way of completing the right-hand side, should have proposed a solution in the more developed style that he had evolved in Rome by the middle of the second decade? (Artists, especially those whose stylistic development is rapid, do not usually pay regard to stylistic consistency when asked to complete works taken up after a long interval.) In the present condition of the picture further speculation is futile. We know nothing of the circumstances in which it was completed: nor what form Raphael's suggestions took – if indeed he made any. But whatever weaknesses of execution can be pointed to in the right-hand pair of saints, the motif of St Augustine seeming to invite the participation of the worshipper in the act of adoration occurring within the picture space is an invention of such originality that it is hard to see who other than Raphael himself could have thought of it.

Pope-Hennessey (p. 92) compares this device with one used in the foreground of the *Parnassus*; but whereas St Augustine looks outwards but gestures inwards, the figures in the *Parnassus* – notably thoseto the right of the window – involve the spectator in the picture space by gesturing outwards but are themselves all looking inwards, at one another. Other parallels are with the Baptist on the left of the Madonna di Foligno of *c*. 1511–12, and the youthful Baptist in the right foreground of the *Madonna dell'Impannata* of 1513–14.

64. Hercules and Cerberus

Ashmolean Museum P II 463
Pen and brown ink. 133 × 143 mm (top corners cut).
Literature: KTP 463; P 526; R 56; Ruland, p. 128, xi, 1; C & C, ii, p. 267.

One of Lawrence's Raphael drawings, said by Woodburn to have come from the Antaldi Collection. In spite of this distinguished provenance, the traditional attribution has been disputed. Passavant listed it under Raphael's name and described it as 'beau dessin', but went on to say 'toutefois la jambe, dessinée lourdement et sans goût, n'est pas digne de Raphaël'. His authorship was nevertheless accepted by Ruland; and Robinson, after quoting Passavant's unfavourable opinion, went on to say emphatically 'in the writer's opinion, the leg is fully equal in correctness and power of design to the rest of the figure. There can be no doubt, notwithstanding the rather unusual style of "handling" displayed, that this fine design is from the hand of Raphael'. To Crowe and Cavalcaselle, on the other hand, the drawing seemed 'less clever' than the one of 'Samson and the Lion' (no. 67): 'the contours are rapidly given, but somewhat poor. Something of the school of Lionardo in the execution, suggests the inquiry, whether Cesare da Sesto, and not Raphael, might be the author'. Thereafter, the drawing disappears completely from the Raphael literature.

Parker, following a suggestion from Pouncey, catalogued no. 64 under the name of Raphael's Sienese-born contemporary and close associate in Rome, Baldassare Peruzzi. This attribution was accepted, with some reluctance, by Frommel (p. 135, no. 97), who remarked on the difficulty of placing the drawing in Peruzzi's *oeuvre*. It seems to us (as it now does to Mr Pouncey) that the attribution to Peruzzi cannot be convincingly sustained. The drawing comes closer to Raphael and the traditional attribution deserves seriously to be reconsidered. If the drawing is by him it would seem to date from the late Florentine or early Roman period, and might be connected with the series of the *Labours of Hercules* on which he seems to have been engaged at about that time (see no. 65).

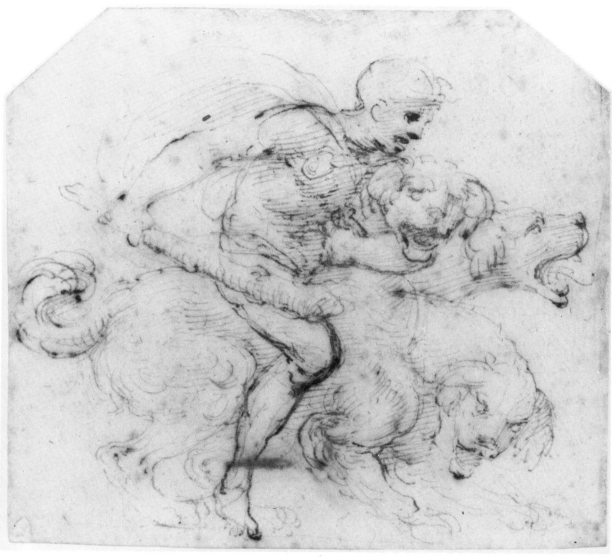

64

65. Hercules and the Centaur

British Museum 1895–9–15–631
Pen and brown ink. 400 × 244 mm. Top left corner
 made up.
Literature: P & G 22; Ruland, p. 128, x, 2; F 189.

Inscribed in the lower right corner, in a hand
probably of the sixteenth century: *Raphale Urbino*.

The drawings of *Hercules and the Hydra* at Wind-
sor (no. 66) and that of *Hercules and the Nemaean Lion*

on the *verso* of the same sheet, are on the same large
scale as no. 65 and may have formed part of a series
of the *Labours of Hercules* (see also no. 64). We agree
with Fischel's dating in the late Florentine or early
Roman period.

No. 65 has been trimmed on the right, but what is
left of the body of the creature under attack is
unmistakably equine: it is presumably one of the
Centaurs, Hercules' fight with which is not one of
the canonical Labours.

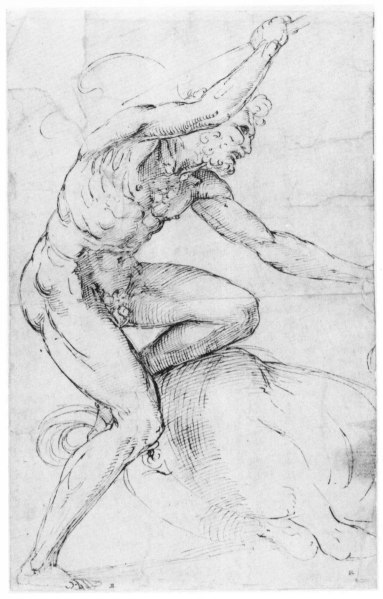

65

66. Hercules and the Hydra

Windsor 12758
Pen and brown ink over stylus underdrawing. 390 × 272 mm.
Literature: AEP 791; Ruland, p. 128, ix, 1; F 190.

This drawing resembles that of *Hercules and the Nemaean Lion* on the *verso* (AEP fig. 153), and of *Hercules and the Centaur* in the British Museum (no. 65) in being on the same large scale. All three are presumably studies for a series of the *Labours of Hercules*. The drawing of Hercules and the Lion is a close variant of one in the Ashmolean Museum (no. 67), in which Hercules is wearing a cloak, the face is less grotesquely characterised, and the right arm is so held that it appears below the left arm and not above it. Parker doubted whether the two renderings of the subject could be by the same hand. It seems to us that the unfavourable impression made by the Windsor version is due partly to its unfinished state and partly to its unusually large scale which gives it a certain appearance of emptiness, but that it is too intelligent and too vigorous not to be by Raphael.

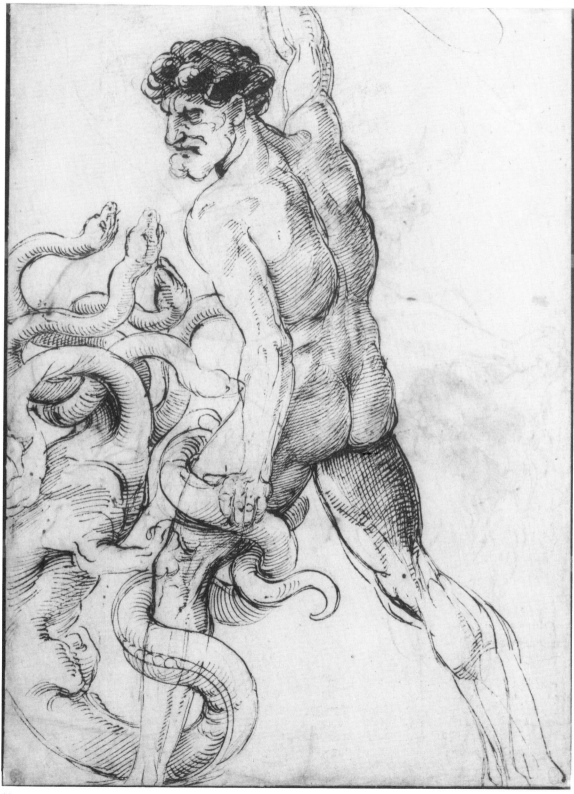

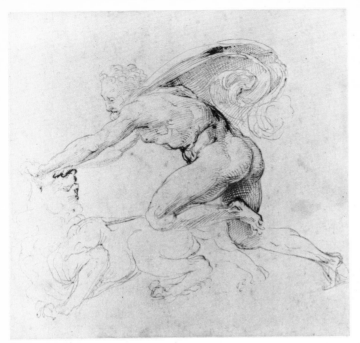

67

67. Hercules and the Nemaean Lion

Ashmolean Museum P II 540
Pen and brown ink over stylus underdrawing. 262 × 262
 mm.
Literature: KTP 540; P 567; R 55; Ruland, p. 128, viii, 1;
 C & C, ii, p. 266; F 191.

Opinions have differed whether this drawing rep-
resents the first of the Twelve Labours of Hercules
or, as Passavant, Robinson, and Crowe and Caval-
caselle maintained, Samson killing the lion in the
Vineyard of Timnath. In favour of the second
interpretation is the fact that Samson is said to have
torn his lion to pieces whereas Hercules first
attacked his with a club and then strangled it; and,
secondly, that the figure in the drawing is not
wearing the skin of the already killed Cithaeronian
lion which was the habitual garment of Hercules.
On the other hand, as Parker pointed out, not only is
there a drawing by Michelangelo at Windsor of
three exploits of Hercules, one of which shows him
as here rending the lion's jaws, but a close variant of
no. 67 is on the *verso* of Raphael's drawing of
Hercules and the Hydra (no. 66).

68. Half-length portrait of a young lady

British Museum 1895–9–15–613
Black chalk. 259 × 183 mm.
Literature: P & G 13; P, p. 542, *mmm*; Ruland, p. 159, iv, 1;
 F 33.

Like no. 33, with which it has been kept since at least
the beginning of the last century, this was at one
time thought to be a portrait of Raphael's sister; but,
as Passavant pointed out, she was not born until
1494 and died while still a child.

Fischel placed both drawings in Raphael's
Umbrian period, dating no. 68 somewhat later than
the other, *c.* 1500–3, but we agree with Passavant in
distinguishing even further between them: no. 33 is
certainly Umbrian, but the monumental simplicity
of the conception of no. 68 and the elegant plainness
of the dress indicate a date well inside the Florentine
period. A further difference between the two draw-
ings is that no. 68 is clearly a portrait drawing, not an
idealised study for a devotional painting. It can be
paralleled by such Florentine portraits of *c.* 1506 as
the *Donna Gravida* (Pitti) and the half-length female
portrait now in Urbino.

A comparable, but probably somewhat earlier
drawing in the Uffizi (F 32), also in black chalk, of a
young lady apparently seated half-length in profile
to left, is inspired by the Florentine profile portraits
of women by Pollaiuolo, Baldovinetti and others.
Fischel's suggestion, which we do not find convin-

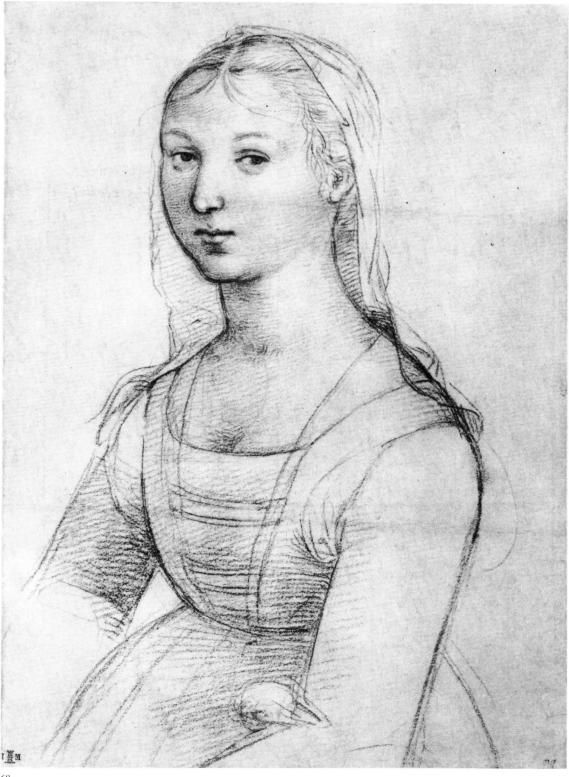

68

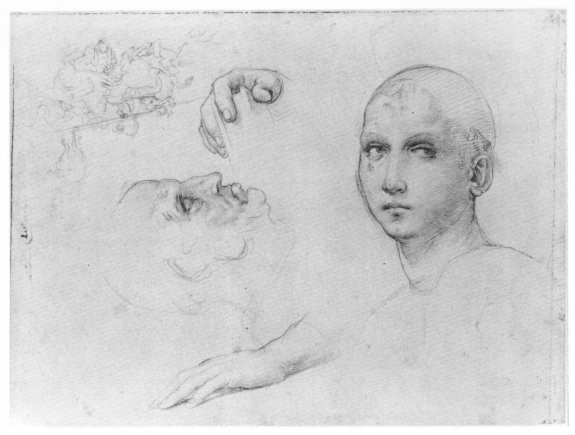

69

cing, that this second portrait study was adapted for the figure of the woman with the doves on the right of the *Presentation in the Temple* of *c.* 1502–3 (see no. 27), may have influenced his early dating of no. 68.

69. Studies of heads and hands; sketch of a cavalry skirmish (after Leonardo)

Ashmolean Museum P II 535
Silverpoint and white bodycolour on cream-coloured prepared paper. 211 × 274 mm.
Literature: KTP 535; P 532; Ruland, p. 269, 8; C & C, i, p. 274; F 210.

The hands correspond with those of the figure identified in the inscription below as S. Giovanni Gualberto, on the extreme right of the fresco of *The Trinity with Six Benedictine Saints* in the church of S. Severo in Perugia. Another inscription states that Raphael painted this fresco in 1505, but some critics, including Fischel, have argued that this records the inception of the work, which can hardly have been completed much before *c.* 1507. Certainly the painting reveals such total assimilation of the contempor-

ary Florentine style as to make it improbable that even Raphael could have carried it out within a year after his arrival in Florence.

The purpose of the studies of hands makes it reasonable to suppose that the heads were drawn in the same connexion, as Passavant had already suggested. The fresco is badly damaged and has also suffered from injudicious attempts at restoration, but Fischel was no doubt right in relating these heads to the saints on the extreme left and extreme right of the composition, which happen to be the most damaged: the older head to that of S. Maurus, on the left, whose face, apparently somewhat repainted, is likewise in exact profile to right and though more youthful is similar in proportion and type; the younger, identified as a saint by the faintly indicated halo, to that of S. Giovanni Gualberto, whose face is wholly destroyed but which is the only figure in the painting that corresponds with the drawing in the angle of the head and in the relative position of head and body. (Fischel's statement to this effect in his text is unequivocal, but his illustration (fig. 182) of a detail of the sheet, showing only the younger of the

two heads, has a caption incorrectly identifying it as a study for the head of S. Placidus, who is in the centre of the left-hand group in the fresco looking over his right shoulder: a position irreconcilable with the drawing in which the figure is turned the other way and is looking over its left shoulder.)

A significant difference between these studies and the painting is in the two left hands: the drawing is of a smooth, youthful hand, whereas the hand of S. Giovanni Gualberto in the painting has the gnarled fingers of old age and thus conforms to the usual representation of him (for example, by Raffaellino del Garbo and by Andrea del Sarto) as a middle-aged or elderly man. Parker acutely pointed out the close resemblance between the younger of the two heads on the sheet and a larger-scale drawing at Lille (F 211) of the head of an old man. 'It is hard to believe', he says, 'that the two drawings can be entirely unconnected, but their relationship, if there is one, remains problematic.' A possible solution of the problem is that in no. 69 (as in no. 22) an intermediate stage in the evolution of the head took the form of a somewhat idealised represention of a youthful model, and that this was later transformed in the Lille drawing into a head of an appropriately older and more severe aspect.

The Leonardesque derivation of the other head on the sheet hardly needs to be demonstrated: it may be compared with a closely similar profile by Leonardo in the British Museum (P & P 111). In the head of the painting, so far as this can be judged in its present condition, Raphael seems to have modified the Leonardesque character of the profile, making it younger and less caricatural. His interest in Leonardo at the time when the drawing was made is demonstrated by the sketch of a cavalry skirmish scribbled with the sheet held the other way up, in what would then have been the lower right-hand corner. This is one of the very few contemporary records of the *Battle of the Standard,* the central motif of the *Battle of Anghiari* which Leonardo intended to paint in the Sala del Gran Consiglio in the Palazzo della Signoria, and on which he was engaged at the time of Raphael's arrival in Florence. Parker pointed out that the single horse seen from behind sketched above and to the right of the main group corresponds with one in a drawing of a cavalcade of horsemen, at Windsor (12339), which has been

plausibly identified as a study for the right-hand side of the Anghiari composition. The very lightly sketched drawing of the heads of two horses biting one another, in the diagonally opposite corner of the sheet, is no doubt also derived from the same source.

70. **A young man seated facing the front, holding a book on his left knee**

Ashmolean Museum P II 533
Metalpoint on pale grey prepared paper, squared in
 metalpoint. A few strokes in red chalk, apparently
 unconnected with the drawing, to right of the head.
 203 × 140 mm.
Literature: KTP 533; P 537; R 31; Ruland, p. 120, xiii, 1;
 C & C, i, pp. 229, 329; F 67.

The style and technique point to the late Umbrian or earlier Florentine period. Though evidently for a figure in a devotional composition, this study, like

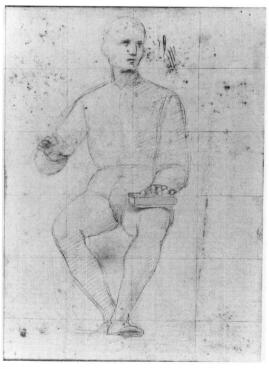

70

others of about the same time, is from a youthful model wearing contemporary everyday dress. The purpose of the drawing is unknown, but the emphatically frontal pose suggests that the figure would have occupied a central place in whatever composition was intended.

Crowe and Cavalcaselle refer to this drawing apropos of the S. Severo *Trinity with Six Benedictine Saints* (see no. 69), but admit that their suggestion is unverifiable that it may be a study for the completely destroyed figure of God the Father in the upper part of the composition. It should be added that though the area once occupied by God the Father is large enough only for a half-figure, the extent of the squaring in the drawing suggests that Raphael intended to execute the figure full-length. Fischel also saw the drawing as intended for a figure high up among clouds, but to us the intended position seems something of an open question: it is true that the perspective of the feet is that of a figure well above the spectator's viewpoint, but the left hand and the book are seen from the spectator's eye-level or even slightly higher.

Parker (1939–40, pp. 35 ff.) had suggested that the figure might be that of Christ in a *Last Supper*, perhaps the composition for which no. 28 is a study, and that the book on the left knee was used to represent the level of the table. He could have cited in support another composition-study of the subject, in the Albertina (F 220), in which the body and right arm of Christ are in exactly the same position though the head is turned the other way (the action of the left arm is obscured), but which must be considerably later in date: Fischel puts it at the beginning of the Roman period.

In his catalogue Parker returned to the possibility of a connexion with the S. Severo *Trinity*, pointing out that the youthful martyr second from right, who is identified in the inscription below as 'Benedictus', holds an unopened book flat on his left knee; but this saint could never have been intended to occupy the centre of the composition, as the pose of the figure in the drawing would seem to require. The only figure in the fresco seated facing frontwards is that of Christ; but the position of his legs is different, his right arm is uplifted in a gesture of benediction and his left hand raised to show the nail-hole, and there is no reason why he should be holding a book.

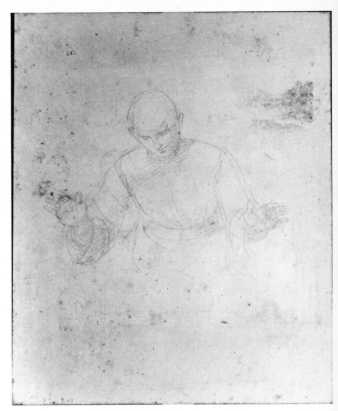

71

71. Half-length figure of a young man, looking downwards with arms outstretched

Ashmolean Museum P II 534
Metalpoint on greyish white prepared paper. 233 × 180 mm.
Literature: KTP 534; P 547; R 30; Ruland, p. 56, vi, 5; C & C, i, p. 228; F 149.

The gesture of the hands and the emergence of the figure from clouds show that this must be a study from a model in contemporary everyday dress for a figure of God the Father in the upper part of a composition. Fischel, who had identified a squared pen and ink drawing of a similar figure, at Lille (F 180), as a study for God the Father in the panel painted on Raphael's design to go above the Baglioni (Borghese) *Entombment* (Fischel, fig, 167), suggested that no. 71 was for a hypothetical lunette intended for the same position above the *Madonna del Baldacchino* (see no. 63).

That such a lunette was ever envisaged is pure conjecture; and since the *Madonna del Baldacchino* is datable at about the same time as the *Entombment*, and since Fischel was prepared to accept no. 71 and

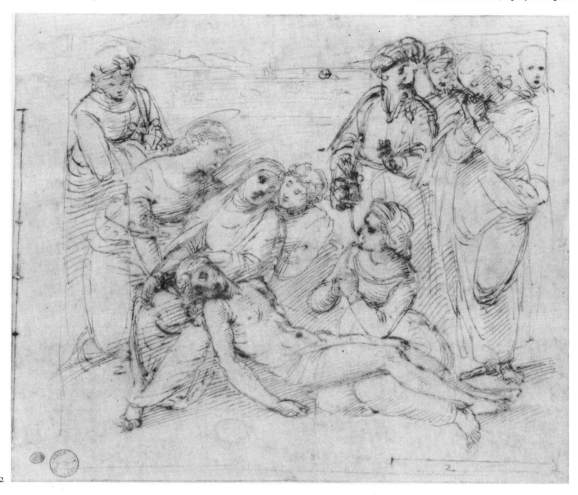

72

the Lille drawing as contemporaneous in style, it is hard to see why he should have gone out of his way to erect this complicated and unverifiable hypothesis when no. 71 could as easily be explained as an earlier study for the *Entombment* God the Father. The resemblance between no. 71 and the Lille drawing is very close. The figures are wearing the same kind of loose-sleeved tunic, and their faces and the shape of their heads are so alike as to make it probable that they were drawn from the same model at the same time. The lighting of the figures in both drawings is identical. The only substantial difference is in the angle of the head and the position and gesture of the right arm and hand.

72. The Lamentation over the Dead Christ

Ashmolean Museum P II 529
Pen and brown ink. 179 × 206 mm.
Literature: KTP 529; P 475; R 37; Ruland, p. 23, 34;
C & C, i, p. 304; F 164.

Robinson was the first critic to observe that the composition of this drawing is derived from the altarpiece by Perugino formerly in the church of S. Chiara in Florence and now in the Palazzo Pitti; and to put forward the convincing suggestion that this was Raphael's first idea for his own altarpiece, dated 1507, painted for the Baglioni Chapel in the church of S. Francesco in Perugia and now in the Borghese Gallery in Rome, which eventually took shape as the *Entombment*. A close variant of the drawing, with an elderly man substituted for the Holy Woman standing on the extreme left, is known from an engraving in the same direction by Marcantonio (B xiv, p. 43, 37); the group is set in an elaborate and unconvinc-

ing landscape unlikely to have been contributed by Raphael.

Of the fourteen known drawings connected in one way or another with the earlier and later solutions, six are in the Ashmolean Museum and five in the British Museum. These enable the development of the composition to be followed in some detail (for an analysis of this development see Pope-Hennessy, pp. 50 ff.).

Three other studies for the *Lamentation* are known. No. 73 is for the group of the Magdalen kneeling in front of St Joseph of Arimathea, St John and two other figures, on the right of the composition. No. 74 *recto* is a more carefully executed study from the nude for the standing figures in the same group; on the *verso* of the sheet is a similar study for the figure of Christ. Fischel pointed out that the figure of St John from no. 74 *recto* was traced through on to a sheet in the Louvre (F 168) and the drapery added. The Louvre drawing is carefully finished and no doubt represents the final, or near-final, form of the earlier solution. The principal group is made more compact and more sculptural than in no. 72 by the transference of St Joseph of Arimathea to a position behind the Virgin and the two Holy Women kneeling beside her, and of the standing Holy Woman from the extreme left of the group to a position behind the kneeling Magdalen, where she leans forward towards the Virgin.

73. A group of figures in a *Lamentation*

British Museum 1895–9–15–636
Pen and brown ink. 250 × 169 mm.
Literature: P & G 10; P under 475; Ruland, p. 24, 43;
 C & C, i, p. 304; F 165.

A study for the group of figures on the right of the composition of the *Lamentation* known in its most complete form from the drawing in the Ashmolean Museum (no. 72), which was Raphael's first solution for the altarpiece which eventually developed into the Borghese *Entombment*.

The Magdalen is kneeling in front. Behind her are four standing figures, including Joseph of Arimathea and St John the Evangelist.

A more carefully drawn study from the nude for the four standing figures is also in the Ashmolean

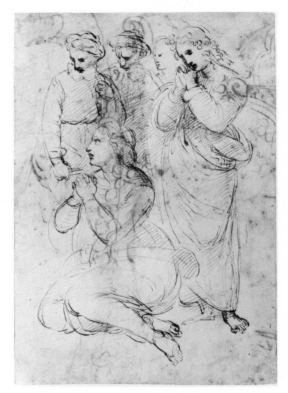

73

Museum (no. 74). In this, as in the drawing for the whole composition in the Louvre (F 168), St Joseph and St John stand closer together and one of the two background figures is moved to the extreme right of the group.

74. A group of figures in a *Lamentation*

Ashmolean Museum P II 530
Pen and brown ink over lead-point. The contours pricked
 for transfer. 322 × 198 mm.
Literature: KTP 530; P 476; R 38; Ruland, p. 24, 45; F 166.

A study from the nude for the group of standing figures on the right of the composition of the *Lamentation* (see nos 72 and 73). As Parker observed, the figure of St John, in the front of the group on the right, was traced through on to the large-scale finished drawing of the whole composition in the

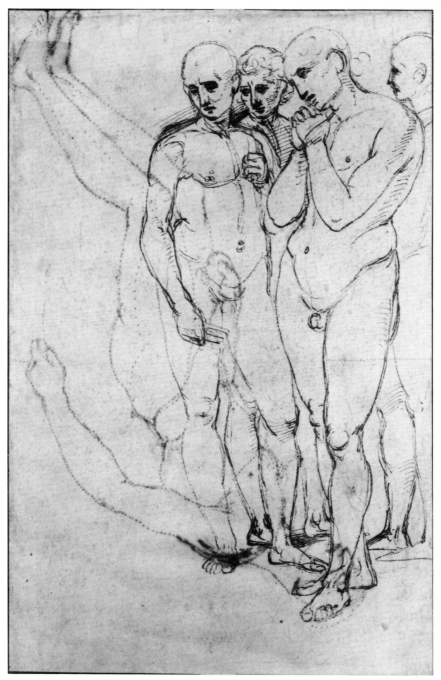

74

Louvre (F 168), where it appears in the same pose and on exactly the same scale, with the addition of drapery.

On the *verso* (F 167) is a study for the figure of the Dead Christ in a pose close to that in the composition-sketch also in the Ashmolean Museum (no. 72), with the knees of the Magdalen indicated below, supporting the body; the upper part of her body is very summarily sketched above. Though also pricked for transfer, neither this figure nor any of those on the *recto* apart from the St John correspond with figures in the Louvre drawing.

75. Study for a group in an *Entombment* ('The Death of Adonis')

Ashmolean Museum P II 539
Pen and brown ink. 265 × 330 mm.
Literature: KTP 539; P 462; R 44; Ruland, p. 22, 25;
 C & C, i, p. 316; F 200.

The composition is a free variant of a representation of an episode in the legend of Meleager which occurs in essentially the same form on Antique sarcophagi, with many variation of detail (see G. Koch, *Die antiken Sarkophagreliefs, xii, 6: Meleager*, Berlin, 1975, pls. 80 ff.). Though this Antique prototype (together with Mantegna's engraving of the *Entombment*) appears to have been one of Raphael's principal sources of inspiration in the later phase of the evolution of the Baglioni altarpiece in which the *Entombment* developed out of the *Lamentation*, the nature of the connexion between no. 75 and the painting is still a matter of dispute.

No. 75 is listed in the seventeenth-century inventory of the Antaldi Collection as 'Four Figures carrying a Dead Christ'. At some time between 1714 when it was acquired by the French collector Pierre Crozat, and 1729 when it was published in the *Cabinet Crozat* by P. J. Mariette, it was renamed 'The Death of Adonis'. Mariette himself was sceptical about this identification and thought the subject could equally well be the *Entombment*, but he dismissed the obvious explanation, that the drawing is a study for the Borghese painting, by his emphatic conclusion: 'Quoiqu'il en soit, il est postérieur à celuy dont on vient de faire la déscription' (i.e. no. 77, then also in the Crozat Collection).

Passavant described no. 75 as a study for an *Entombment*, without reference to the Borghese painting; he explained the alternative identification as a mistaken inference from the beardless face of the principal figure. Robinson considered the fact of the body being carried feet first 'alone would seem to show' that this study was not for the Borghese painting. Like Mariette he saw the drawing as too developed in style, and dated it *c*. 1509–10. 'The dead or dying figure', he continued, 'is that of a graceful young man without a beard, and the general air of antique or classical elegance which pervades the composition, lends support to the supposition that it represents the death of Adonis.' Ruland, on the other

hand, included the drawing among studies for the Borghese picture, describing it as 'The Disciples carrying the body . . . commonly called "The Death of Adonis"'.

Crowe and Cavalcaselle equally had no hesitation in connecting the drawing with the Borghese painting, but they made no reference to an Antique prototype. They saw the composition as inspired by the group of figures carrying the Dead Christ in the background of Signorelli's fresco of the *Pietà* in the Brizio Chapel in Orvieto Cathedral (F, fig. 183; better repr. E. Carli, *Gli affreschi di Luca Signorelli nel duomo di Orvieto*, n.d., pl. 70). It is not inconceivable, though perhaps somewhat unlikely, that Raphael should have paid such particular attention to a subsidiary and inconspicuous detail of a small scene which is itself one of the subsidiary and least conspicuous features of a large chapel entirely decorated by Signorelli; but Signorelli's group is also inspired, more obviously even than Raphael's drawing, by a Meleager sarcophagus – the derivation is emphasised by its being depicted as a relief on a sarcophagus-front – and the resemblance is more easily explained by their common source.

For Fischel, who likewise saw no. 75 as 'an echo from memory' of the Signorelli group, the identification of its subject as *The Death of Adonis* was a source of uncertainty. He gave the drawing the non-committal title 'A Young Man carried by his Friends' and rejected the connexion with the Borghese painting for various reasons, some more cogent than others: that the body is carried feet first; that the other figures are behaving as if in attendance on a dying rather than a dead man; and that the style and handling seem unduly developed by comparison with drawings certainly for the painting.

Parker catalogued the drawing under the title 'The Death of Adonis?', as part of a group headed by him 'Transitional Style', some of which he was inclined to date shortly before Raphael's departure from Florence and others, including no. 75, shortly after his arrival in Rome. He did not otherwise go into the question of date and abruptly closed the discussion with the statement 'there is certainly no connexion with the Borghese Entombment'. The connexion was, however, reaffirmed in the British Museum Catalogue (P & G, p. 11, n. 1).

It is surprising that so much weight should have

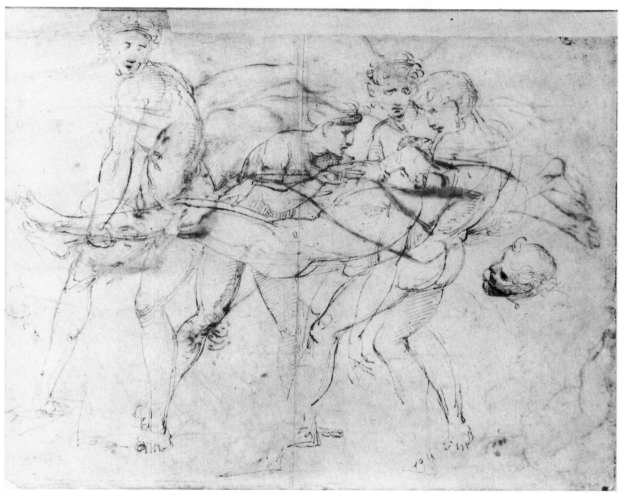

75

been attached to a 'traditional' identification of the subject that originated only in France and only in the early eighteenth century, that even at the time was doubted, and that is in any case incorrect. The legend of Adonis is often represented on Antique sarcophagi, but these never show him being carried. (The confusion between the Meleager and Adonis legends is no doubt to be explained by the prominent part played in both by a wild boar.)

Comparison of the drawing with the Antique prototypes reveals a number of differences, each in itself slight, the cumulative effect of which suggests that Raphael had an *Entombment* in mind. The

composition thus adumbrated, in so far as it can be judged from such slight and scanty indications, could have been not unlike the Borghese painting. In many of the reliefs there is a figure in the centre, on the far side of the body, who supports its further arm and leans forward to peer into its face. This figure is always a bearded man, but the corresponding one in the drawing has every appearance of being a young woman, whose action and position in relation to the other figures are those of the Magdalen in the painting. The step on the left in the drawing which supports the right foot of the left-hand bearer has no Antique counterpart, but its position corresponds

with that of the lower step of the threshold of the tomb in the painting, which likewise supports one foot of the left-hand bearer. A further detail in which the drawing resembles the painting and differs from any of its Antique prototypes is that there are indications, in the horizontal lines proceeding leftwards from the hand of the right-hand bearer and in the way the hand itself is clenched, that the body is being carried on a sheet. And though the drawing differs from the painting and resembles the Antique prototypes in showing the body carried feet first – a point to which both Robinson and Fischel attached particular significance – it agrees with the painting and differs from all the Antique reliefs in that the body is being carried from right to left, towards the position occupied by the tomb in the painting. Finally, the pose of the right-hand bearer in the drawing is identical, in reverse, with that of the left-hand bearer in the early study for the painting (no. 77).

The sheet under the body is more clearly represented in a variant of no. 75 by the 'Calligraphic Forger' (see no. 79) formerly in the Habich Collection in Cassel (repr. Morelli, Rome, opp. p. 173). The draughtsman presumably had no. 75 in front of him, for his copy includes the separate bearded head sketched to the right of the group; but it should be noted, for what it is worth, that the figure corresponding in position with the Magdalen and the one immediately to its right are clearly represented as female.

Mariette's argument, that no. 75 is more developed in style than no. 77 and that it therefore cannot be a study for the Borghese *Entombment,* would seem plausible enough if comparison were limited to those two drawings. But others connected with the *Entombment,* for example nos. 74 *recto* and *verso,* no. 47 *verso,* and the studies for the Magdalen (F 177) and for the figure of *Charity* in the predella (F 181), seem fully compatible with no. 75 in style and breadth of handling.

On the *verso* of no. 75 is a pen and ink study for the figure of Adam and (very lightly sketched) for part of Eve in the composition of the *Temptation* known in its most complete form from an engraving by Marcantonio (B xiv, p. 3, 1). Though the poses of both figures differ entirely from those in the fresco on the vault of the Stanza della Segnatura, they are placed in the same way, symmetrically on either side of the picture area; and the possibility cannot be disregarded that Marcantonio may have based his engraving on a discarded study for the Segnatura fresco. This would provide an argument for dating the *recto* drawing *c.* 1511 (see no. 109), well after the completion of the Borghese picture. On the other hand, the style of no. 75 seems to us still suggestive of Florence. It does not resemble any of the known studies certainly for the Segnatura vault, and Fischel dismissed the possibility of the connexion after comparing it with the sheet of studies in the Louvre that certainly are for the Segnatura figure of Adam (F 224).

Very close dating, so close as to permit hard and fast conclusions to be drawn from it, is not always practicable in the case of an artist like Raphael, so acutely sensitive to new developments and with his prodigious power of creative assimilation. Broad distinctions can of course be made between the well-defined phases of his activity – Umbrian, Florentine and Roman – and finer ones within those periods; but even in Raphael's development, rapid though it was, there are transitional phases when dating becomes little more than a question of intuition.

76. Two kneeling men supporting the body of a third; studies of heads, and of an arm and a hand

Ashmolean Museum P II 531
Pen and brown ink. 218 × 307 mm.
Literature: KTP 531; P 477 b; R 39; Ruland, p. 24, 48;
C & C, i, pp. 305 ff.; F 169.

Parker followed Robinson, Crowe and Cavalcaselle, and Fischel in seeing in this drawing the point of transition in Raphael's planning of the Baglioni altarpiece (see no. 72), between the initial *Lamentation* in which the body of Christ is lying on the ground, and the eventual *Entombment* in which it is being borne towards the sepulchre. Physically, the action of the two figures lifting the body just off the ground does represent a transition, but iconographically it is neither one thing nor the other; and it is doubtful whether Raphael would have envisaged either alternative with this group as its principal

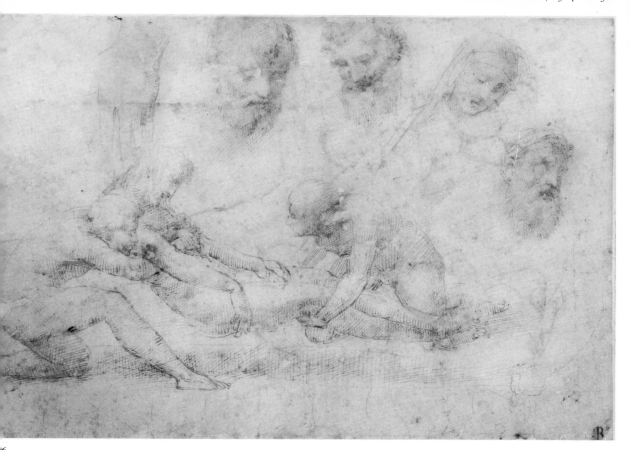

76

motif. Furthermore, an essential element in the Gospel narrative of the Resurrection is that the sepulchre should be above ground, but it is difficult to see what the neatly bounded area of shading separating the two kneeling figures in no. 76 can be if not an open grave into which the body is about to be lowered.

But that no. 76 is connected with the *Entombment* is borne out by the close resemblance in type and psychology between the separate studies of heads and some of those in the altarpiece itself. The sketches on the *verso* of no. 77 include a drawing, evidently studied from nature, of a man staggering under the weight of a corpse wrapped in a winding sheet. Raphael no doubt made other studies of the sort in the course of his preparatory work for the painting.

Fischel thought the drawing extensively reworked (a judgment with which Parker agreed) by 'a *retardataire* Umbrian Mannerist'. We see no sign of the activity of any second hand: the use of regular hatching and cross-hatching to suggest areas of tone is exactly paralleled on both sides of no. 77.

77. Study for the Borghese *Entombment*

British Museum 1963–12–16–1
Pen and brown ink. 213 × 320 mm.
Literature: J. A. Gere and Philip Pouncey, *Italian Drawings in the British Museum: Artists working in Rome c. 1550 – c. 1640*, 1983, no. 361; P 453; Ruland, p. 22, 24; C & C, i, pp. 310 f.; F 170.

This is the drawing which once belonged to the early eighteenth-century French collector Pierre Crozat, and which is referred to as 'lost' under P & G 12 (no. 78). Having been acquired by the British Museum since the publication of that volume of the catalogue of Italian drawings, it was included in the appendix of *addenda* at the end of the succeeding volume. Crowe and Cavalcaselle had seen and described it, but it was subsequently lost to sight in an English country house collection until its reappearance in the London sale-room in 1963. In his *corpus* Fischel reproduced in reverse the facsimile engraving by Caylus published in 1729 in the *Cabinet Crozat*.

No. 77 is the earliest known study definitely for the second phase of the Baglioni altarpiece, in which

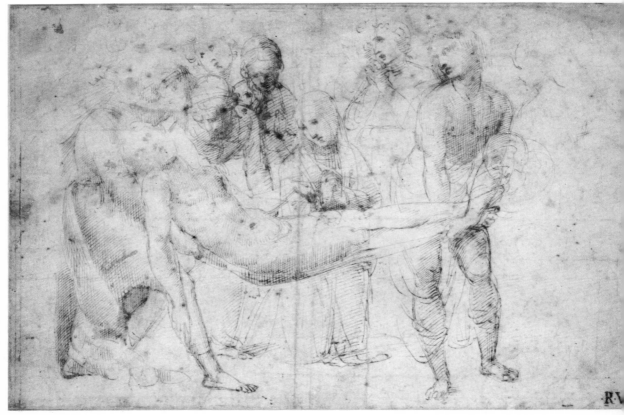

77 *recto*

an *Entombment* developed out of a *Lamentation* (see no. 72). It shows that Raphael's point of departure was a *Meleager* sarcophagus (see no. 75), and that he seems at this point to have conceived his own composition similarly in terms of a single compact group: the figures gathered immediately round the body of Christ include not only the Magdalen and St John but also the Virgin, who in the later composition-study (no. 78) and in the painting itself is the central figure of a subsidiary group. Her central position in no. 77, and her kneeling posture, are evidently vestiges of the original *Lamentation*. It is impossible to tell for certain in which direction the group of figures in no. 77 is moving: the body could be being carried feet first from left to right as in all the Meleager reliefs, or head first from right to left as in no. 78 and in the eventual painting.

On the *verso* are drawings of two corpses in winding sheets and of a man staggering under the weight of a third such corpse, all evidently studied directly from nature. These reflect the pains that Raphael must have taken to ensure verisimilitude. There is also a group of three seated naked children.

Caylus did not engrave the whole of the *verso*, but only the group of three children. Fischel, who thus knew this detail only out of context, described it in his *corpus* (p. 293, fig. 247) as a study for one of the groups of child-angels on the entablatures of the

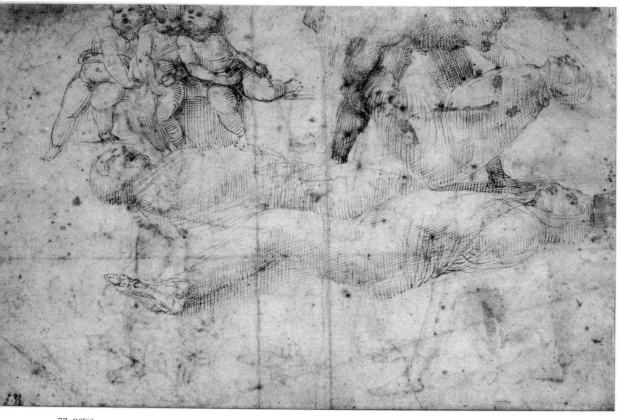

77 verso

columns in the foreground of the early design for the *Disputa* at Windsor (no. 85). He had already published the engravings in his letter appealing for information about lost Raphael drawings (1912, p. 300), where he described the child in the centre of the group as apparently 'lowering something (perhaps a crown) with a cord'. This may have later suggested to him the possibility of a connexion with the *Disputa* design, in which the two *putti* on the entablature are suspending a papal escutcheon against the column; but in his letter he went on to propose, more reasonably, that the group of children might be connected with the 'large Madonna composition' known from a drawing then also lost,

which later came to light in the museum at Orleans (F 142) and proved to be an old copy of a drawing probably connected in some way with the *Madonna del Baldacchino* (see no. 63). In the British Museum catalogue it was independently argued that the group could be imagined at the foot of the Virgin's throne in an altarpiece; and that it might, for example, have been an early idea for the similar motif in the *Madonna del Baldacchino,* a work of about the same date as the *Entombment,* in which two naked child-angels are standing in front of the high lower step of the Virgin's throne.

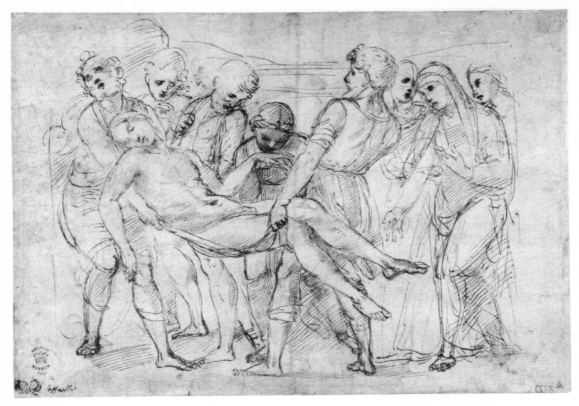

78

78. Study for the Borghese *Entombment*

British Museum 1855–2–14–1

Pen and brown ink. Traces of underdrawing in black
chalk. 230 × 319 mm.

Literature: P & G 12; P 458 and p. 536, γ; Ruland, p. 22,23;
C & C, i, p. 309; F 171.

This study comes close to the final solution. The
principal group is almost as in the painting, except
that the left-hand bearer's right foot is on the step
and his left on the ground, and that the pose of the
Magdalen is different and her figure less prominent.
The head in profile roughly sketched in black chalk
between the second and third figures from the left is
probably a *pentimento* for the head of the latter. The
right-hand group, on the other hand, differs entirely
from the painting and is less complex, consisting
simply of the Virgin advancing to the left followed
by two Holy Women.

No. 78 would have preceded the study on no. 47
verso for the left-hand bearer and part of the body of
Christ, in which the bearer's legs are as in the
painting; and also the carefully finished squared
drawing in the Uffizi (F 175), which corresponds
even more closely with the principal group in the
painting, the only differences being that the Magda-
len's head is in profile and that a woman is intro-
duced into the gap between her and the right-hand
bearer.

On the *verso* (F 172) is a drawing of a standing
bearded man. As Gronau (pp. 33 ff.) was the first to
observe, this is a free copy of Michelangelo's
unfinished statue of St Matthew, now in the
Accademia in Florence, a work datable 1504–6:
exactly when Raphael was engaged on the *Entomb-
ment*. The principal difference is in the position of the
left leg, which in the statue is bent, being supported
on a high step or plinth. The legs of the figure in the
drawing resemble those of the right-hand bearer in
the early composition-study for the *Entombment* (no.
77).

79. Three nude men carrying the body of Christ

Ashmolean Museum P II 532

Pen and brown ink over black chalk. The body of Christ
in red chalk only. The outlines of the three standing
figures pricked for transfer. 282 × 246 mm.

Literature: KTP 532; P 477; R 42; Ruland, p. 21, iii, 6;
C & C, i, p. 314 f.; F 173.

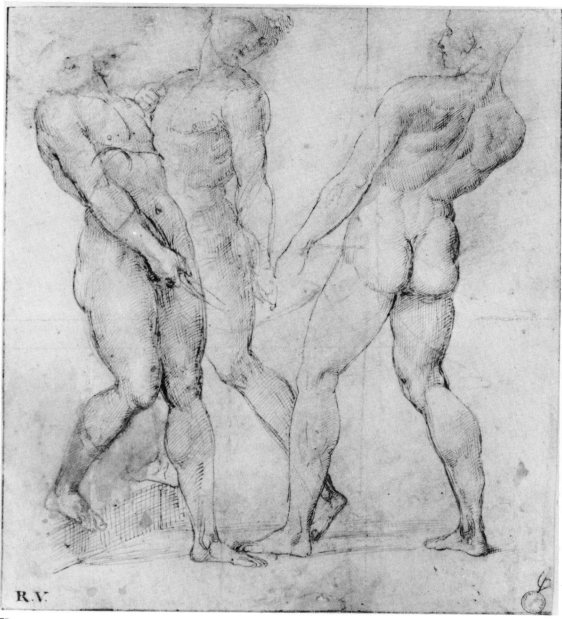

79

The left and right-hand figures correspond exactly in pose with the bearers in the Borghese *Entombment* (see no. 72), except that in the painting the left-hand bearer has his right foot on the ground and his left on the step. The third figure differs from its counterpart in that the left leg, though not the right, is in a pose that is physically feasible (in the painting it is difficult to reconcile the placing of either leg with the position of the torso), and that he is helping to carry the body by holding one end of the winding-sheet over his right shoulder and twisting it round his downstretched left arm. But the most striking difference between the drawing and the group as painted is that in the painting the right-hand bearer is more widely separated from the left-hand pair so as to leave ample space for the upper part of the figure of the Magdalen.

Crowe and Cavalcaselle described the drawings

on this sheet as 'finished academies'. Robinson, followed (with no great appearance of conviction) by Parker, sought to explain the compression of the group and the omission of the Magdalen by simply assuming that Raphael had not taken a large enough sheet of paper. But if these figures had been studied from 'the unclothed living model', as Robinson supposed, then Raphael would hardly have drawn the right leg of the central standing figure in an impossible position. In fact, the relation of this figure to its companions leaves no doubt that the grouping is deliberate.

The most likely explanation is that this is an early design for the principal group in the *Entombment* in which Raphael was emulating the heroic nudes of Michelangelo's *Bathers*. As Christopher Lloyd suggested, the immediate inspiration of the idea of a group of three figures standing close together and straining under the weight of a fourth seems to have been Mantegna's engraving of *The Bacchanal with Silenus* (see *Burlington Magazine*, cxix (1977), pp. 113 ff.). Raphael may have abandoned this more concentrated grouping because of the impossibility of combining the figure of the Dead Christ with the others in a way that would not awkwardly obscure the action of the two left-hand bearers. The virtual omission of this figure from no. 79 is surely not without significance.

The pricking of the outlines and the traces of pouncing observed by Parker show that the figures on no. 79 were transferred to another sheet or sheets. There may have been a drawing (now lost) in which the relative position of the figures was revised and which would have been an intermediate stage between no. 79 and the carefully finished study in the Uffizi (F 175) for the principal group in a form identical in all essentials with the final solution.

A tracing of no. 79 may also have been the basis of the hypothetical original of a drawing in the Louvre (3967) which shows the three standing figures in the same relative position, but with the addition of one corner of a sarcophagus in the left foreground and also the figure of the Magdalen whose head and clasped hands appear in the gap between the central and right-hand bearers. As in no. 79, the figure of Christ is barely indicated. The Louvre drawing is one of a group attributed to the so-called 'Calligraphic Forger', a would-be virtuoso

draughtsman who seems to have been an amateur, or semi-amateur, active in the seventeenth century, who had access to the Viti-Antaldi collection of drawings some of which he copied (see P & G, pp. 48 ff.). No. 79 came from that collection, and the question arises: is the Louvre drawing a copy of it with embellishments by the 'forger' or does it reproduce an amplified lost version by Raphael himself? In favour of the second alternative is the convincing way in which the figure of the Magdalen is integrated into the composition, and also the correspondence between her head and one of those sketched on no. 80, which though evidently drawn with the *Entombment* in mind does not occur either in the painting or in any of the surviving studies. It is perhaps also significant that the extreme end of a sarcophagus is indicated on the left foreground of the Uffizi drawing (F 175).

Fischel saw no. 79, as he did no. 76, as 'one of those drawings that have lost their original strength by being reworked by a backward-looking School-associate' – a view with which Parker was inclined to agree. We can see no sign of later reworking on either sheet.

80 Anatomical study of the swooning Virgin supported by two Holy Women; three female heads

British Museum 1895–9–15–617
Pen and brown ink over black chalk. The figure kneeling to right of the Virgin faintly indicated in black chalk only. 307 × 202 mm.
Literature: P & G 11; P 306; C & C, i, p. 314; Ruland, p. 22, 13; F 178.

A study for the right-hand group in the Borghese *Entombment* (see no. 72). Apart from representing the bodies of two of the figures as skeletons, it differs from the painting only in the position of the head of the standing Holy Woman and of the Virgin's left arm, and in the omission of the standing woman to the Virgin's right. An old copy of a lost study for the group, with the same differences from the painting but with the figures clothed, and completed by the addition of the second standing woman behind the Virgin, is also in the British Museum (P & G 39).

Another drawing of a skeleton with a face on the

R.V.

80

81

skull is on the *verso* of the study for the Infant Christ in the *Belle Jardinière* (no. 61), but this is of a seated figure and is not connected with any known composition.

Of the three single heads, the one top right, looking upward in *profil perdu*, must be for the figure kneeling on the right of the group; and the head top left for the figure standing behind the Virgin on the left. The one below could be for the Holy Woman who in the painting stands on the right of the group and holds the Virgin's head, but it corresponds even more closely, even to the form of the head-dress, with the head of the Magdalen in an old copy of what may have been a lost study for the principal group in the painting (see no. 79).

On the *verso* is a very faint drawing in black chalk and stylus of two standing nude men (P & G, pl. 267). In the British Museum catalogue this is said to have no evident connection with the *Entombment*, but as Martin Kisch was the first to point out, it corresponds almost exactly with the two principal figures in no. 74, and is clearly by Raphael.

81. Seven *putti* playing

Christ Church 0112
Pen and brown ink. 145 × 214 mm.
Literature: J. Byam Shaw, *Drawings by Old Masters at Christ Church*, Oxford, 1976, no. 362; P 561; R, p. 315, no. 2; Ruland, p. 141, viii, 1; C & C, ii, p. 547; F 102.

The subject, such as it is, has been interpreted in more than one way, but Byam Shaw is probably right in describing the children as playing at 'Judge and Prisoner'. The central child in the right-hand group is certainly not being 'ducked' in the vase, as Crowe and Cavalcaselle suggest.

Robinson drew attention to the very similar composition on no. 42 *verso*, the handling of which, with its fine cross-hatching, seems definitely to belong to the period of the studies for the Borghese *Entombment* of *c*. 1506–7. The technique of no. 81 is less distinctive, but Fischel was no doubt right in associating it with his 'Larger Florentine Sketchbook' group (see no. 37), and in his suggestion that Raphael may here have been inspired by the similar friezes of gambolling *putti* on Donatello's bronze pulpits in S. Lorenzo.

82

82. Five sketches of a figure of Cupid and a study for the head of St Catherine

Ashmolean Museum P II 536
Pen and brown ink. Some underdrawing in lead-point.
279 × 169 mm.
Literature: KTP 536; P 499; R 52; Ruland, p. 111, viii, 5;
C & C, i, p. 342; F 205.

The head in the centre of the sheet is a study, corresponding very closely with the final result, for the head of St Catherine in the painting now in the National Gallery, a work generally dated towards the end of Raphael's Florentine period, *c.* 1507. Pope-Hennessy has recently suggested the later date of 1509, describing the painting as a Roman epilogue to Raphael's Florentine activity.

The purpose of the other sketches is unknown. Parker did not dissent from Crowe and Cavalcaselle's suggestion that the wingless *putto* on the left of the head is riding on a dolphin, and thought that this might be a design for part of a fountain. The spherical object which the figure is bestriding was presumably identified as the dolphin's head, the snout of which is protruding below. It seems more likely that it is a globe, with which Cupid is indeed sometimes represented.

Of the four sketches on the right, the two above and below in the centre show Cupid bending his bow; in one he is using his right foot, in the other his right knee with his foot resting on his quiver. This figure is enclosed in rectangular framing-lines, over which another system of oblique lines has been drawn. The figure on the right is in much the same pose, seen from behind. (It is perhaps worth noting that a drawing in red chalk of a very similar figure of Cupid bending his Bow is in the Metropolitan Museum, Bean 1982, no. 98. The traditional attribution to Giorgione can surely be excluded: it seems to be somewhere in the neighbourhood of Parmigianino.) The pose of the Cupid on the left in no. 82 with legs crossed and the left elbow resting on a support, is of Antique derivation.

On the *verso* of the sheet (F 206) are two incomplete and very summary nude studies for the figure of St Catherine; a third rough sketch of her clothed figure holding a martyr's palm (a detail omitted in the painting) in a pose fairly close to the final result except in the angle of the head and shoulders; and a more detailed study of the neck and left shoulder on the same scale as the head on the other side.

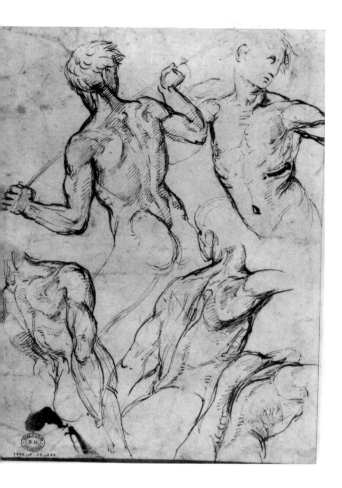

83. Five studies of a nude man

British Museum 1895–9–15–624
Pen and brown ink. Traces of underdrawing in
 lead-point. 269 × 197 mm.
Literature: P & G 20; F 91.

The pose of the figure in the centre below, of which
the torso lower right seems to be a variant, resem-
bles that of the executioner in the right background
of the *Massacre of the Innocents*, where it is similarly
offset on the left by another figure leaning the other
way. To judge from their style, however, these
studies are a good deal earlier than *c.* 1511, the
probable date of the *Massacre of the Innocents* compos-
ition (see no. 122).

Fischel did not mention the *Massacre of the
Innocents* in his note on no. 83, but described the
studies as 'variants of reminiscences' of
Michelangelo's cartoon of *The Bathers*. He pointed
out the derivation, in reverse, of the top left figure
from the man wielding a staff in the centre of the
back row of the cartoon. The drawing thus goes far
to establish a direct link between the *Bathers* and the
Massacre of the Innocents, and to support Fischel's
contention that one inspired the other. His
classification of no. 83 as part of his 'Larger Floren-
tine Sketchbook' group (see no. 37) is supported by
the Florentine character of the study in red chalk on
the *verso*, of the Virgin kneeling in adoration of the
Infant Christ (F 92), which is derived, as he
observed, from a cartoon by Fra Bartolommeo.

84. Studies of the Virgin and Child

British Museum Ff. 1–36
Pen and brown ink. Traces of red chalk underdrawing.
 254 × 184 mm.
Literature: P & G 19; C & C, i, pp. 272 and 347; Ruland,
 p. 71, 10; F 109.

The motif of the Child straddling the Virgin's knee
in the lower of the two larger studies is taken. in
reverse, from Michelangelo's circular marble relief
of the *Holy Family*, at Burlington House, a work
datable *c.* 1505. A variation of the group in the relief
is in the Louvre (F 108). This study has generally
been connected with the *Bridgewater Madonna* (Duke
of Sutherland: on loan to the National Gallery of
Scotland) which it resembles closely in the diagonal
line of the Child's body and extended left leg, and
exactly in the angle and expression of his head; but
the sketch differs in the position of the Child's right
leg, which in the painting lies along the Virgin's
thigh so that he is reclining on her lap.

 In the higher of the two larger studies the Child is
in the same pose as in the *Colonna Madonna* (Berlin).
The Virgin's legs are turned to the left in the
painting, but the angle of her head is the same.

 If analogies are to be looked for between the
other drawings on the sheet and paintings, the Child
top left bears a certain resemblance to those in the
Madonna del Granduca (Pitti) and the *Small Cowper*

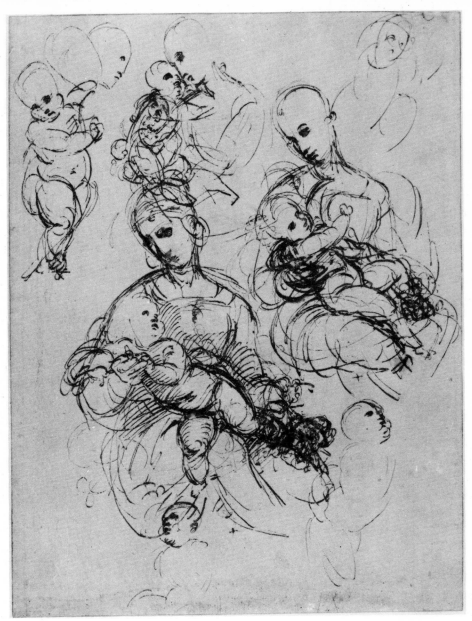

84

Madonna (Washington), while in the sketch top centre the close embrace with heads touching can be paralleled, also in reverse, in the *Tempi Madonna* (Munich). This last motif is brought to a more finished state on the sheet in the Louvre with the copy of the Michelangelo *tondo* (F 108), and also on F 107 (Albertina).

With the possible exception of the *Bridgewater Madonna*, which may be of the early Roman period (see no. 116), all these paintings are detable from the later part of Raphael's period in Florence. His late Florentine–early Roman Madonnas are a series of closely linked variations on the same theme. This sheet of studies, like nos. 54, 58 and 59, shows that he did not concentrate his attention exclusively on one composition at a time, but that his ideas took shape concurrently. Whether or not the *Bridgewater Madonna* was painted in Rome, this sheet of studies establishes that a solution very close to the final result was arrived at in Florence.

3 EARLY ROMAN PERIOD, 1508 to c. 1512
Nos. 85–134

In 1508 Raphael left Florence and went to Rome at the invitation of Pope Julius II. His name had been suggested to the Pope's chief architect, Bramante, who was already acquainted with Raphael, being also a native of Urbino. The exact date is not recorded, but it must have been between 21 April 1508, when Raphael dated a letter from Florence, and 13 January 1509, when he received a payment on account for work in the room in the Vatican now known as the Stanza della Segnatura (see Golzio, p. 370). This may not necessarily have been Raphael's first visit to Rome. Shearman (1977, pp. 132 f.) has pointed out that the Torre delle Milizie, a conspicuous Roman landmark, appears in the background of the Washington *St George*, a painting that can hardly be later than c. 1505. He also suggested that the sketches on the *verso* of an even earlier drawing (no. 4) may reflect knowledge of the Caraffa Chapel in S. Maria sopra Minerva in Rome.

In Giuliano della Rovere, who had been elected Pope in 1503 with the title Julius II, Raphael found a patron with the vision, the means and the opportunity to employ him on large decorative projects. Julius had set out to make Rome visibly the capital of Christendom. The ruthless self-confidence with which he approached this aim is shown by his proposal to demolish the ancient and historic basilica of St Peter's and to replace it with an entirely new church by Bramante, conceived on a colossal scale. Though the Pope knew that he himself could not live to see more than the foundations, he had these laid in such a way that no essential modification of the original plan was possible. By bringing Raphael from Florence and at the same time commissioning Michelangelo to decorate the ceiling of the Sistine Chapel, Julius decisively shifted the centre of the High Renaissance from Florence to Rome.

Raphael's principal work for Julius was the decoration of two rooms, the Stanza della Segnatura and the Stanza d'Eliodoro, in the apartment on the second floor of the Vatican into which the Pope had decided to move in 1507. (He decorated the third 'Stanza', the Stanza dell'Incendio, after Julius's death in 1513.) At the time of Raphael's arrival in Rome the decoration of the new apartment was well under way. A whole team of artists was working there, including Sodoma, Perugino and Peruzzi. Raphael began work at once in the Stanza della Segnatura; it is characteristic of Julius's quality as a patron that as soon as he was satisfied of Raphael's ability he had no compunction about giving him absolute responsibility for the decoration of the entire apartment with discretion to destroy as much of his predecessors' work as seemed to him necessary. It is also characteristic of Raphael's personality that he tactfully left undisturbed Perugino's ceiling in the Stanza dell'Incendio, and that the living artists portrayed in the *School of Athens* include Perugino and Sodoma.

A high proportion of the drawings in this section of the exhibition, covering Raphael's early Roman activity, are studies for the paintings in the Stanza della Segnatura (nos. 85–113). The title 'Stanza della Segnatura' implies that the room had an official function as the seat of one of the papal courts of Justice. It was so used later in the century, but all the evidence suggests that Julius himself intended it to house his private library. This purpose is reflected in the subjects of the four frescoes, three of which correspond with three of the faculties into which knowledge was then organised: Theology is represented by the

so-called *Disputa*; Philosophy, not in the restricted modern sense of metaphysics but covering all branches of humane learning, by the so-called *School of Athens*; and Jurisprudence by three *Virtues* and the smaller scenes below representing acts of Justice (see no. 113) or of law-giving. Imaginative literature is represented by the *Parnassus* on the fourth wall, an assemblage of classical and modern poets gathered round the central group of Apollo and the Muses.

Walter Pater singled out as characteristic of Raphael his power of addressing 'large theoretical conceptions to the intelligence of the eye'. In the *School of Athens* and the *Disputa* Raphael devised a pictorial formula of the utmost simplicity and effectiveness to convey a complex abstract concept. The majestic vaulted building which is the setting for the deliberations of the philosophers in the *School of Athens* is a wholly man-made space. Such decoration as there is is studiedly non-Christian, but the invention must reflect Bramante's plan for the new St Peter's. By contrast, in the *Disputa* on the wall opposite, the hemicycle of divine beings is set against the background of an infinite heaven – the ultimate expression of the 'space composition' which Raphael had learnt from Perugino. The limitations of the human intellect in attempting to comprehend the mystery of the Faith is suggested by the irregular grouping of the theologians on the ground, contrasted with the serene regularity of the figures in the upper part.

With the exception of the full-scale cartoon in the Ambrosian Library in Milan, no composition drawings for the *School of Athens* have survived. All the known studies are of single figures or groups of figures. On the other hand, there are enough drawings for the *Disputa* to enable its evolution to be followed in some detail. They reflect the painstaking process of trial and error by which Raphael achieved his final solution.

The paintings in the Pope's private rooms in the Vatican were accessible only to a small privileged circle. Raphael was quick to see the value of engraving as a means by which his work could be made more widely known, and in the Bolognese engraver Marcantonio Raimondi (1475/80? – not later than 1534), who had come to Rome at about the same time as him, he found an ideal interpreter. Marcantonio, who was one of the earliest reproductive engravers, devised an effective all-purpose technique of hatching and cross-hatching into which to translate Raphael's forms. Raphael seems mostly to have supplied him with drawings made for other purposes, and some of his prints are of great documentary interest in preserving intermediate stages in the working-out of Raphael's compositions. This was not always so, however, for some of his most celebrated and elaborate plates – for example, the *Massacre of the Innocents*, the '*Quos Ego*' and '*Il Morbetto*' – seem to have been based on designs made especially for the purpose (see nos. 122–125 and no. 139). The trouble that Raphael took with the *Massacre of the Innocents* is evident from the two drawings in the present exhibition, and demonstrates the importance he attached to his collaboration with the engraver.

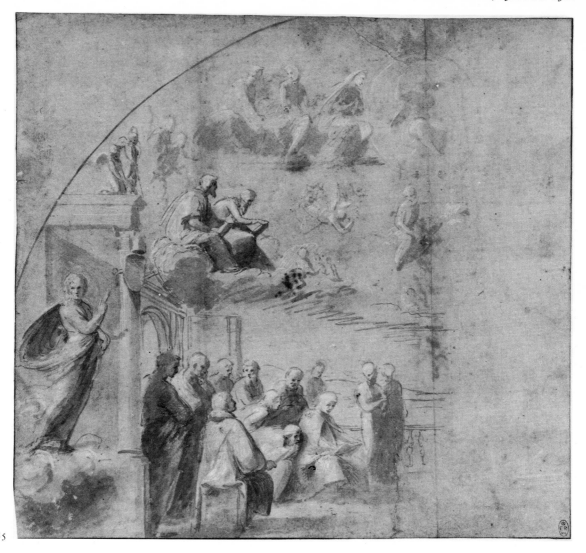

85

85. Composition-study for the left-hand side of the *Disputa*

Windsor 12732
Brush drawing in brown, heightened with white, over
 stylus underdrawing. 280 × 285 mm.
Literature: AEP 794; P 429; R, under no. 60; Ruland,
 p. 180, 69; C & C, ii, p. 29; F 258.

Nothing in Raphael's previous experience in
Perugia or Florence had prepared him for the
complexity and scale of the mural decorations he
was required to carry out in the Stanza della
Segnatura. The composition-studies for the *Disputa*
reflect the painstaking process of trial and error
which led up to the eventual solution – a solution
apparently so simple as to seem inevitable.

In the fresco the composition is divided horizon-
tally into an upper and lower zone. In the lower part
the crowd of theologians, grouped on either side of a
central altar, is separated by an uninterrupted strip of
sky from the lowest element of the upper part, a
concave cloud platform supporting on each side six
seated saints or patriarchs. Above the Holy Ghost in
the centre, raised on a smaller cloud and on a slightly
larger scale than the figures on each side, are Christ
between the Virgin and the Baptist, seen against a
circular glory. The half-figure of God the Father
appears immediately above, and on each side at this
level are three flying angels arranged in a curve
echoing that of the seated figures on the cloud
platform. The divinely ordered symmetry of the
upper part is in contrast to the scene of relative

confusion below, where the figures are disputing and gesticulating in every sort of pose, some standing, some sitting, some kneeling.

The early solution sketched in no. 85 can be elucidated with the help of nos. 86 and 87, in which the same figural elements and their counterparts on the right-hand side are drawn more explicitly. The upper part is less lucidly organized than in the final solution. The curved cloud platform is suggested, but it supports only four figures – presumably the Evangelists – in pairs at each end; in the centre, on a separate cloud is a third pair of figures, identified by their attributes as St Peter and St Paul; above them, Christ in a circular glory, with the Virgin and two seated male figures on his right, and on his left three similar figures, the nearest to him presumably being the Baptist.

In the lower part Raphael began by trying to make the picture-area more manageable by reducing its width and exactly defining its depth. He placed his figures on a terrace bounded on the far side by a low balustrade and at either end by an architectural feature consisting of an E-shaped screen, the entablature of which comes forward to be supported by single columns standing on the extremities of the high continuous base. This solution for the sides of the lunette probably began with the base: some architectural feature of the sort was needed to balance the upper part of the doorway which encroaches upon the area of the lunette on the opposite side. In his eventual solution Raphael turned the base into a waist-high balustrade, and heightened the corresponding doorway to match by superimposing a painted parapet. What may be another vestige of the early design are the two ends of the cloud platform, which occupy the same position as the entablature of the screen.

The drawings also show Raphael's difficulty in solving the problem of the centre of the lower part of the composition. The central altar on which stands the monstrance containing the Host from which the fresco derives its universally used but misleading title was not introduced until a fairly late stage in the evolution of the design (see no. 88). The isolated pair of standing figures immediately to the left of the centre line in the Windsor sketch would have been balanced by another such pair, leaving the exact centre open to reveal the balustrade. In the sketch for the lower part only, also at Windsor (no. 86), the isolated pairs of figures have been omitted from the centre with the result that the two main groups of theologians are brought closer together; that their placing here is deliberate is shown by the balustrade in the gap between them. The paired figures in the centre background nevertheless persisted beyond the experimental sketch stage, for they occur in an old copy in the Louvre (F 262–3) of a carefully worked-out study for the left-hand group with the figures nude, which in some ways comes closer to the final result.

It has often been observed (e.g. by Crowe and Cavalcaselle, ii, pp. 31 ff.) that Raphael's treatment in the lower part of the *Disputa* of two complex groups of figures pressing agitatedly forward towards a central focus, and also many of the individual figures, are inspired by Leonardo da Vinci's unfinished altarpiece of the *Adoration of the Magi* (Uffizi), which he began in 1481 for the convent of S. Donato a Scopeto in Florence. A striking feature of Leonardo's composition is the pair of mysterious personages standing aloof on either side of the foreground: on the left a brooding philosopher, and on the other side a youth who gestures towards the central group while gazing obliquely outward. From him Raphael derived the figure – supernatural, because standing on a cloud – in the left foreground of no. 85, who looks towards the spectator and points upwards in the direction of the Divine Mystery. The stance of this figure is entirely Leonardesque (cf. e.g. the well-known drawing of a standing nymph, Windsor 12581) and the upward-pointing gesture of the hand is so often used by Leonardo as to be almost a cliché. Though Raphael eventually abandoned the whole of the architectural framework, he retained the Leonardesque pose for the figure who stands in the left foreground of the fresco immediately to the right of the balustrade.

Shearman (1965, p. 158, n. 2) referred to a drawing in the Louvre (3890) as a possible copy of a 'yet earlier' (than no. 85) project for the *Disputa* wall, but did not expand this tantalising hint. The same idea had already occurred to Ruland, who accepted the traditional attribution to Raphael and placed the Louvre drawing with the studies for the *Disputa* (p. 180, no. 71). The drawing is of a lunette-shaped

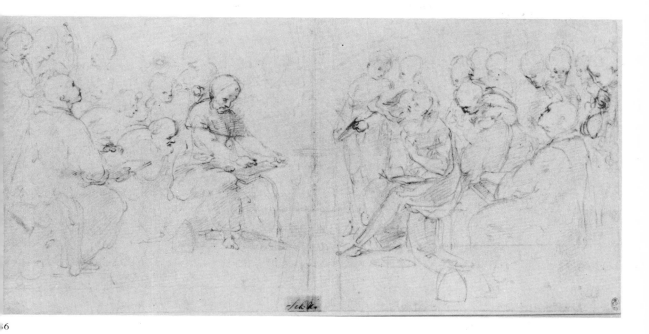

composition, having in the centre a full-length seated figure of God the Father on a cloud between groups of hovering angels, below which on either side are pairs of kneeling angels also on clouds. Though the hovering angels are very close to those in the *Disputa* itself, the absence of any such figures in the Windsor drawing must rule out the possibility of the Louvre composition being the earlier of the two. The Louvre drawing seems in fact to be no more than a clumsy pastiche of the *Disputa* composition, perhaps by some Bolognese Raphaeliser.

86. Study for the lower part of the *Disputa*

Windsor 12733
Black chalk. 204 × 410 mm.
Literature: AEP 795; Ruland, p. 182, 97; F 261.

An inscription in pen, lower centre, could be read as: *Schizzo*.

The group of figures on the left corresponds in all essentials with the lower part of no. 85, and the whole drawing with F 260 at Chantilly, which appears to be a counterpart to no. 87.

An important detail in no. 86 is the indication of

the balustrade in the centre: this establishes that the placing of the two groups in relation to one another was deliberate, and that this arrangement represents Raphael's early solution for the grouping of the figures in the lower part of the composition.

87. Study for the upper part of the *Disputa*

Ashmolean Museum P II 542
Brush drawing in brown wash, heightened with white.
 233 × 400 mm.
Literature: KTP 542; P 501; R 60; Ruland, p. 181, 73;
 C & C, ii, p. 30; F 259.

Inscribed in pen, lower centre: *Rafael*.

In this study for the upper part of the *Disputa* the groups of figures on the left and in the centre correspond with, and in some cases amplify, those in the Windsor sketch (no. 85). Those on the right must therefore represent Raphael's solution for the other side of that design. In the Windsor sketch the groups of figures are noticeably farther apart; but that their closer juxtaposition in no. 87, and the consequently larger scale of the figures, is deliberate, is suggested by the stylus-drawn semicircular curve enclosing

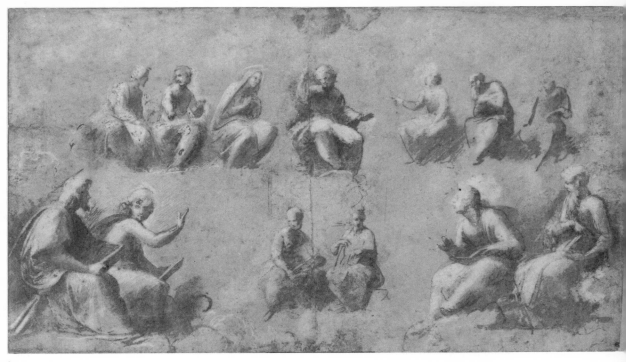

87

the composition, which Parker was the first to remark.

A drawing of the lower part of the composition, identical in technique, the left-hand side of which likewise corresponds with the principal group in the Windsor sketch though omitting the architectural structure and the pointing Leonardesque figure, is in the Musée Condé at Chantilly (F 260). Parker was inclined to doubt Fischel's suggestion that the two were originally part of the same sheet.

88. Composition-study for the left-hand side of the *Disputa*

British Museum 1900–8–24–108
Pen and brown wash over stylus underdrawing, with
 white heightening only on the figure with its back
 turned in the left foreground. 247 × 410 mm.
Literature: P & G 33; Ruland, p. 183, 109; F 267.

Raphael is here approaching the final solution for the left-hand side of the lower part of the *Disputa*. No. 88 differs from the fresco principally in the absence of the group of the so-called heretic and his companions disputing in the foreground behind the balustrade and further to the left, and also of the

conspicuous figure of the 'philosopher' who in the fresco stands with his back turned immediately to the left of the seated St Gregory. In the place of the standing figure in the left foreground of the drawing – which must have been the germ of the 'philosopher' – Raphael eventually substituted, in the same position immediately to the right of the balustrade, the 'Leonardesque youth' from the Windsor sketch (no. 85).

A more deliberately executed pen and ink drawing, with the figures nude, at Frankfurt (F 269), represents what seems to have been the next stage in the evolution of the design. The group of four figures on the extreme left in no. 88 stands out more conspicuously, and clearly marks the extremity of the composition on that side. The figure with its back to the spectator is in a more animated pose, turned round further to the right, with the left hand on the hip and the right arm extended. (No. 91 is a separate study for the upper part of this figure.) The left-hand group is also widened by the insertion of a pair of figures in the right background, between the central altar and the figure of St Jerome seated behind and to the right of St Gregory.

Of the known studies for the *Disputa*, no. 88 is the first to include the motif of the central altar. The

Host is here displayed on a chalice, but in the fresco is in a monstrance.

89. Study for a group in the *Disputa*

Mr C. L. Loyd

Pen and brown ink. 311 × 210 mm.

Literature: The Loyd Collection of Paintings and Drawings at Betterton House, near Wantage, Berkshire, London, 1967, no. 116; F 271.

No. 89 was first published by A. G. B. Russell (*Vasari Society*, 2nd series, v (1924), no. 6), who had found it, unattributed, in an album of old drawings at Lockinge House. He rightly placed it at the beginning of Raphael's Roman period, *c.* 1509–11, but it was left for Fischel, who already knew the side here exhibited from an old copy in the Louvre, to point out the connexion with the *Disputa* (1925 (B), pp. 175 ff.). The principal figure is an early idea for

the so-called 'philosopher' who stands turned away from the spectator in the centre of the group to the left of the altar. The seated figure indicated on the right corresponds in position with St Gregory, the further from the centre of the two enthroned Doctors of the Church on that side of the composition. (The curious shape of the head, suggestive of a helmet with a pointed visor, is a characteristic shorthand rendering of the outline of an upturned face and chin, and is exactly paralleled in another study for the *Disputa*, no. 90.)

In the fresco Raphael retained the standing figure in a monastic habit and his interlocutor (the latter with the addition of a mitre), but relegated them to the group of disputants in the background and further to the left; behind and immediately to the left of the 'philosopher' he substituted two bishops, both facing to the right.

On the *verso* of the sheet (F 270) are three rougher sketches, one very slight, for the 'philosopher', in

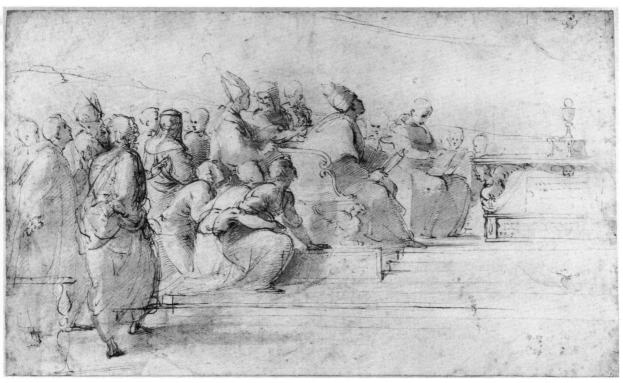

88

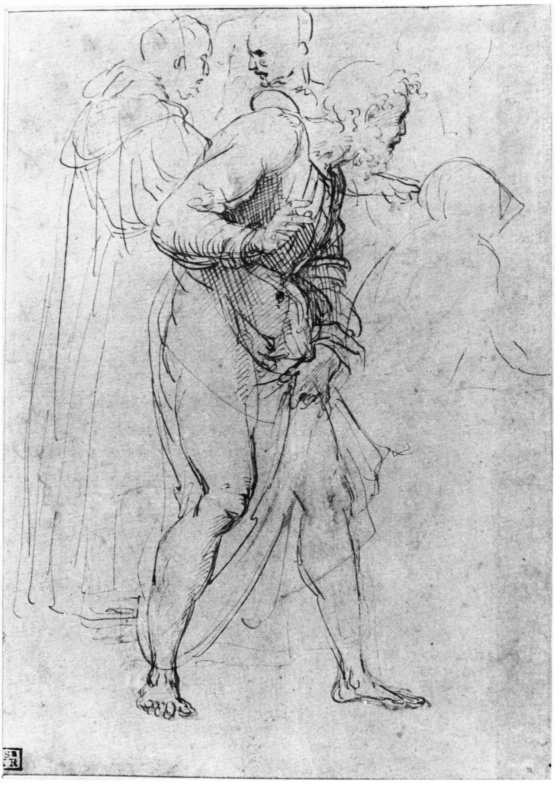

89

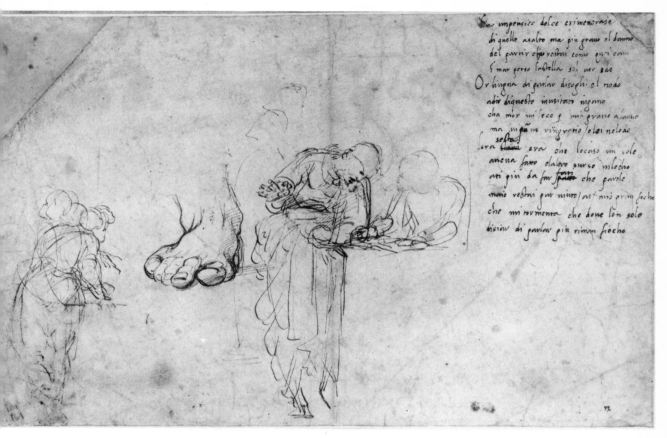

much the same pose as on the *recto* but with the legs hardly indicated. There is also a sketch for the 'Leonardesque youth' in the left foreground of the fresco, immediately to the right of the balustrade. His right arm is pointing downwards, as in the study in the Uffizi (F 264) and in the old copy of a lost study for the left-hand group in the Louvre (F 262–3). In the latter the figure corresponding in position with the 'philosopher' is in a pose less dramatic than in the sketches on no. 89 and less distinctive than in the fresco.

90. Studies for the group in the right foreground of the *Disputa*; draft of a sonnet

British Museum Ff. 1–35
Pen and brown ink. 250 × 390 mm.
Literature: P & G 32; P 449; Ruland, p. 185, 129; C & C, ii, pp. 50 f.; F 286.

Raphael has rapidly sketched two alternative solutions for the pair of figures standing by the feigned parapet which extends the height of the doorframe in the right foreground of the *Disputa* (see no. 85). In the right-hand group, which to judge from its position on the sheet was probably drawn first, the principal figure stands facing the front, leaning over to his left with his elbow resting on the parapet. His right arm is extended towards the spectator with the hand foreshortened, and he lowers his head to study a book which his companion is holding open on the parapet. In the fresco he stands upright, pointing with his right arm towards the centre of the composition, while his companion leans forward with both hands on the parapet and looks beyond him to his right.

On the left is a very slight indication of a full-length standing figure looking upwards to the left, with an alternative placing of the head at a higher level. (The notation of the head with its exaggeratedly pointed chin is exactly paralleled in the no less roughly sketched figure on the right of the group in no. 89.) This figure corresponds in position with the full-length Pope who makes a 'caesura' on the right-hand side corresponding with that made on the other by the 'philosopher'.

In the other study for the right foreground group the principal figure stands with his back turned and

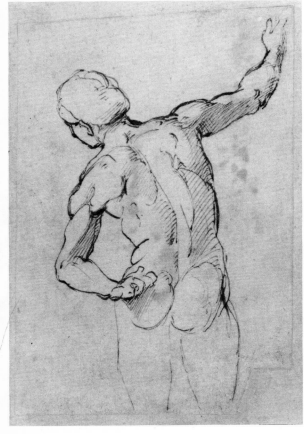

91

the upper part of his body in two positions: upright, with his body turned to the left, looking upward with his left arm by his side and his right arm raised above his head; and leaning over to the right with his right hand resting on the parapet. His weight is on his right leg, behind which the other is crossed, so that in the second position he seems about to move round the end of the parapet.

On the right of the sheet, underneath the lines of the sonnet, are some pen strokes which could be interpreted as a sketch for the second position; a very faint stylus drawing above the large-scale foot probably represents the head and right arm of the figure leaning forward behind the parapet. The foot corresponds exactly with the right foot of the figure by the parapet in the fresco.

Drafts in Raphael's hand for five sonnets are known. As a poet, he was decidedly inferior to his great rival, Michelangelo. Michelangelo's sonnets are among the minor classics of Italian literature; Raphael's are no more than curiosities. For the text of all five, and a full discussion of this aspect of Raphael's activity, see A. Zazzaretta, *L'Arte*, xxxii (1929), pp. 77 ff. and 97 ff.

91. Back of a standing nude man: study for the *Disputa*

British Museum 1948–11–18–39
Pen and brown ink. 146 × 95 mm (maximum
 measurements of irregularly trimmed sheet).
Literature: P & G 30.

A study, with the right arm held rather lower down, for the figure with its back turned to the spectator on the left-hand side of no. 88, but in the more animated pose as in the study at Frankfurt discussed under no. 88. It was omitted from the fresco itself.

92. Study for the drapery of a standing figure in the *Disputa*

Ashmolean Museum P II 545
Black chalk, heightened with white. 380 × 230 mm.
Literature: KTP 545; R 65; Ruland, p. 321, lxii, 1; C & C, ii, p. 50; F 281.

A study for the drapery of the 'philosopher' in the

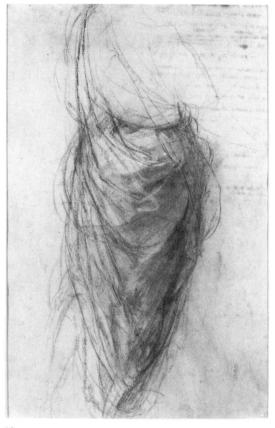

92

Disputa corresponding with the figure as painted more closely than the sketch on no. 89 or the finished composition-study for the left-hand side in the Albertina (F 273). The drapery has taken on its final disposition, hanging down on the right and exposing part of the left leg; so also has the right arm. Robinson thought that a lay figure must have been used, but a rapid sketch of this sort – in contrast to no. 94 – could equally well have been made from a living model.

On the *verso* (F 280; also repr. KTP, pl. cxxxi) is the draft of a sonnet (see no. 90) and two very rough sketches: a standing man in black chalk and a seated woman in pen and ink. Samuel Woodburn, in the hand-list of the Raphael drawings in the Lawrence Collection drawn up when they were exhibited in Oxford in 1842, thought that the two figures were

conceived in relation to one another and described the subject as the *Creation of Eve*; but Robinson was surely right in his contention that the black chalk study was drawn first, and that the other has no connexion with it.

The standing man, wearing drapery, is in profile to the right with his weight on his right leg as if walking forward. His body is turned slightly away from the spectator, so that his back is seen obliquely. His left arm hangs down and in his left hand he clutches a book; his right hand is extended, pointing with the index finger. In view of the purpose of the *recto* study, the universally-held opinion that this is a very early idea for the 'philosopher' is surely correct. Immediately to his right is an object represented by two slightly curved and roughly parallel lines the ends of which rest on the ground, and which is surmounted by a vertical tapering form culminating in a small circle or sphere. Raphael never drew anything at random or without a purpose: this mysterious form might have been intended to represent the back and leg of St Gregory's throne, which in the final solution are obscured by the figure. It should be observed, however, that whereas the 'philosopher' is conceived as an isolated figure, the man in the drawing, with his forward-jutting head and gesticulating right hand, gives the impression of being engaged in argument with a *vis-à-vis* to the right.

The female figure is seated facing the front, with her left leg drawn up and her right leg dangling. Her head is in profile to left, resting on her right shoulder. Her right arm is extended sideways and her body tilted to her left with the weight supported on the left elbow. Fischel pointed out that a pose of this kind was used by Raphael more than once in his early Roman years: in the figures of Sappho in the left foreground of the *Parnassus* and of the seated Muse to the left of Apollo, in that of *Prudentia* in the centre of the lunette on the *Jurisprudence* wall in the Stanza della Segnatura, and in the *Madonna Alba* (Washington) of *c.* 1510–11. Pope-Hennessy's assertion (p. 205) that the sketch is the germ of the *Madonna Alba* and that there is no corresponding figure in the Parnassus does not take into account the dangling right leg or the angle of the body. In the *Madonna Alba,* the pose of which is more clearly shown in the preparatory study at Lille (F 365), the

93

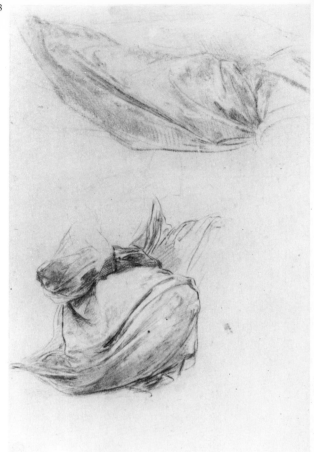

right leg is bent sharply back with the knee off the ground and the body is tilted the other way. In the sketch on no. 92 *verso* the legs in fact correspond with those of Sappho and the upper part of the figure with that of the seated Muse. The irregular curved lines below the figure have no counterpart in the *Madonna Alba,* but they could be intended to suggest the grassy mound or hummock on which each of these figures in the *Parnassus* is sitting.

93. Studies of drapery for a standing and a kneeling figure in the *Disputa*

Ashmolean Museum P II 543
Black chalk, heightened with white. 391 × 254 mm.
Literature: KTP 543; P 554; R 64; Ruland, p. 182, 94;
 C & C, ii, p. 50; F 274.

The kneeling figure is that of the youth immediately to the left of the 'philosopher' in the *Disputa* (see no. 89). The drapery of the legs is repeated almost unchanged in the painting, but the figure is leaning further forward, supporting his right forearm on his thigh and with his right hand held open in a gesture of astonishment.

Opinions have differed about the purpose of the other drawing. Robinson, followed by Crowe and Cavalcaselle, saw it as a study for the 'philosopher'; Fischel, followed by Parker, as for the 'Leonardesque youth' immediately to the right of the balustrade in the left foreground. The drapery below the waist could be for either, but the body above the waist is clearly the back view of a figure which like that of the 'philosopher' is turned slightly to the right. The correctness of Robinson's identification is further confirmed by comparison with the composition-study in the Albertina (F 273) in which the drapery of the 'philosopher', as here, hangs down on the left leaving the lower part of the right leg exposed and is gathered at the waist with the same oblique fold.

94. Study of drapery for a standing figure in the *Disputa*

Ashmolean Museum P II 544
Brush drawing in brown wash, heightened with white,
 over black chalk. 405 × 262 mm.
Literature: KTP 544; P 553; R 66; Ruland, p. 337, vi, 1;
 C & C, ii, p. 50; F 275.

Robinson was the first to observe that this is a study for the drapery of the 'Leonardesque youth' immediately to the right of the balustrade in the left foreground of the *Disputa*. The connexion is not immediately obvious, but is more easily seen if the drawing is compared with the figure as it appears in the composition-study in the Albertina (F 273).

A drawing as careful and deliberate as this could hardly have been made from a living model. Robinson was no doubt right in supposing that a lay figure was used. As Parker observed, if the drapery had been arranged on some sort of dummy this might account for the difficulty in understanding the action of the figure supposedly underneath.

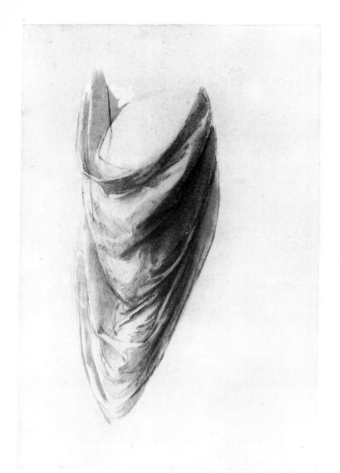

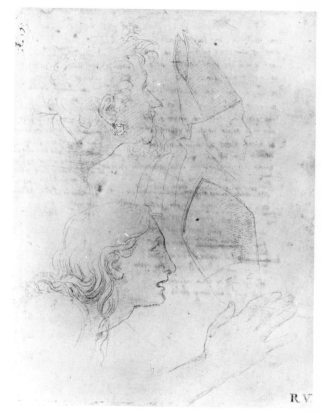

94

95

95. Four heads and a right hand: studies for the *Disputa*

Ashmolean Museum P II 546
Metalpoint on pale greenish-grey prepared paper.
 284 × 209 mm.
Literature: KTP 546; P 504(a); R 61; Ruland, p. 182, 89;
 C & C, ii, p. 50; F 278.

96. Two child-angels, two open books, two heads and a right hand: studies for the *Disputa*

Ashmolean Museum P II 547
Metalpoint on pale greenish-grey prepared paper.
 279 × 211 mm.
Literature: KTP 547; P 504(b); R 62; Ruland, p. 182, 88;
 F 276.

Nos 95 and 96 were originally one sheet. All the studies on both correspond exactly, so far as they go, with details of the *Disputa*, and must have been made at a stage when the design had reached its final form.

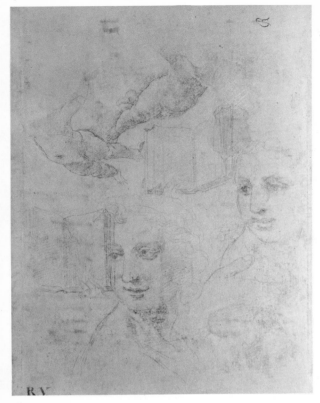

96

97. A seated man: study for a saint in the *Disputa*

Ashmolean Museum P II 548
Black chalk, partly stumped and touched with white
 chalk. 387 × 266 mm. (top corners cut)
Literature: KTP 548; P 502; R 63; Ruland, p. 182, 93;
 C & C, ii, p. 34; F 296.

The figure corresponds very closely in pose with the one on the extreme right of the semicircle of seated saints and patriarchs in the upper part of the *Disputa*, except that there the right hand is resting on a sword, the attribute of St Paul. Robinson observed that the pose is also that of the saint on the right of the right-hand pair in the lower tier of figures in the early study for the upper part of the composition (no. 87). He was no doubt correct in identifying as the four Evangelists these two conspicuous figures and their counterparts on the opposite side in no. 87, one of whom is about to write in a book while all the others hold books; but they have no specific attributes, and he gave no reason for his assertion that the rightmost figure is that of St Mark. (If no. 97 were to be considered in isolation, the winged angel to the right of the figure's legs might be interpreted as the attribute of St Matthew, but comparison with the fresco establishes that this is no more than one of the crowd of child-angels intermingled with the cloud-platform.) In the final result the only Evangelist included is St John, but St Peter and St Paul occupy either extremity of the cloud-platform. In the early composition-study they are together in the centre of the lower tier, on a smaller scale than the Evangelists on either side.

There is a *pentimento* for the head of the figure, showing it held slightly further back and looking up. This position agrees with the separate study on the left and with the head in the painting; and also with the sketch below on the left, to the right of which are two, if not three, very roughly drawn heads in profile, presumably made in the same connexion.

The two heads and the right hand on no. 96 belong to the 'Leonardesque youth' who stands by the balustrade in the left foreground. The flying angels are immediately on either side of the Holy Ghost in the centre of the composition, and the books correspond with those held by the angels to right and left of them.

The heads on no. 95 are those of the four figures immediately to the left of the 'philosopher' (see no. 89): the youth leaning forward and his kneeling companion, and the two standing bishops. In the two last studies more attention is paid to the form of the mitres than to the faces. The hand is that of the kneeling youth.

On the *verso* of the whole sheet (F 277/279) are several drafts, in Raphael's hand, of the sonnet beginning: *come non podde dir d'arcana dei* (see no. 90).

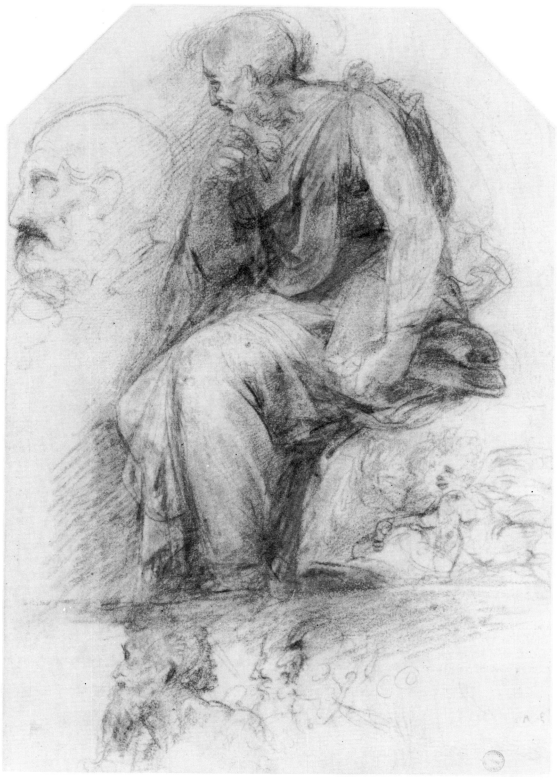

97

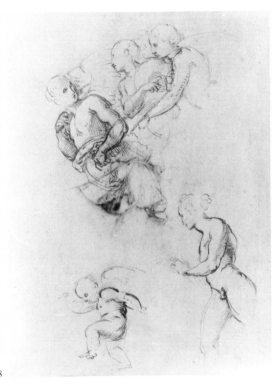

98

figures and the slight difference in scale between the one in the centre and those on either side. It seems more likely that they are three separate studies. The other two figures do not correspond with any of those in the fresco.

On the *verso* of no. 99 (F 297), is a tracing-through of one of the *recto* figures, evidently drawn by Raphael in order to judge its effect when reversed, if transferred to the left-hand group. There is also a rapid sketch for the right-hand group as a whole, disposed in a less stiff and formal way than in the final result. Robinson's comment, made apropos of no. 98, seems no less apposite to no. 99: 'in many respects the natural and spontaneous action of these most graceful figures appears to the writer more admirable than that of the corresponding ones in the finished composition. Perhaps the subject seemed to the artist to suggest more solemn and reverent gestures, and a less energetic movement in these figures; in any case much of the lifelike expression and grace of these entwined groups seems to have evaporated in the final execution'.

99. Studies for angels in the *Disputa*

British Museum 1895–9–15–621
Black chalk, with a few touches of white heightening.
 263 × 357 mm.
Literature: P & G 31; R, p. 197; Ruland, p. 181, 81; C & C, ii, p. 44; F 298.

See no. 98.

100. Two standing men in conversation on a flight of steps; a grimacing head: studies for *The School of Athens*

Ashmolean Museum P II 550
Metalpoint, heightened with white, on pink prepared paper. Somewhat disfigured by the oxidisation of the white body-colour. 278 × 200 mm.
Literature: KTP 550; P 505; R 71; Ruland, p. 192, 107; C & C, ii, p. 68; F 307.

A study for the pair of figures to the right of centre in *The School of Athens*. There are slight differences: in the fresco the upper figure is an elderly, bearded man; his left leg is more fully draped, and his other

98. Studies for angels in the *Disputa*

Ashmolean Museum P II 549
Pen and brown ink. 254 × 176 mm.
Literature: KTP 549; P 503; R 67; Ruland, p. 182, 91;
 C & C, ii, pp. 44 f.; F 299.

These studies, like those on the closely related no. 99, are for the angels in the upper part of the *Disputa*, on either side of the figure of God the Father. The figures in the group in no. 98 are drawn half-length, which prompted Robinson's convincing suggestion that at this stage the angels were envisaged as emerging from clouds.

On the *verso* of no. 98 (F 300) is a detailed study, probably from a model, for the left arm and clothed body of the leftmost angel in the right-hand group, for which the leftmost figure on no. 99 is an earlier study. This coincidence of position might seem to imply that no. 99 is a study for the group as a whole, were it is not for the disconnected placing of the

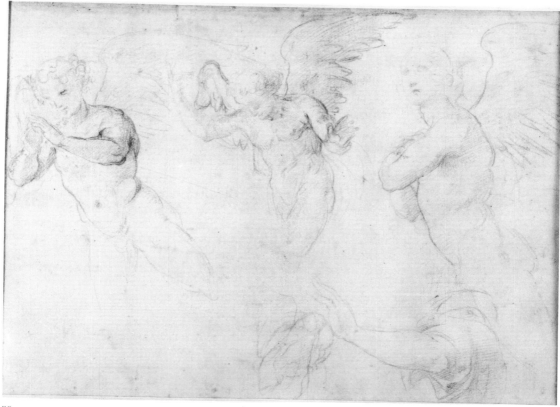

99

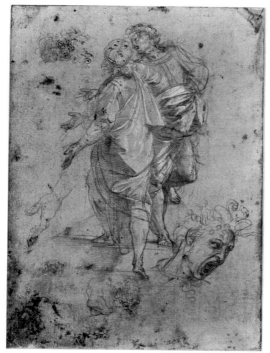

100

leg almost wholly obscured by the right leg of his companion. The separate drawing of a head is a study, apparently from a living model, for the mask of Medusa on the shield held by the figure of Minerva in the niche on the right-hand side of the composition.

101. **Studies for details of** *The School of Athens*

Ashmolean Museum P II 551
Metalpoint, heightened with white, on pink prepared
 paper. Some lines drawn with a ruler. 274 × 201 mm.
Literature: KTP 551; P 509; R 72; Ruland, p. 192, 113;
 C & C, ii, p. 72; F 308.

The figure in the niche on the left is a study for the statue of Minerva in the right background of *The School of Athens*. Two of the other three are for the statues in the niches in the sharply foreshortened wall of the central transept; the third is for the one, not foreshortened but only half visible, on the wall of the right transept on the far side of the crossing.

In the centre, drawn with the sheet the other way up, is a sketch of the head and body of a young man looking upward over his left shoulder. His tunic

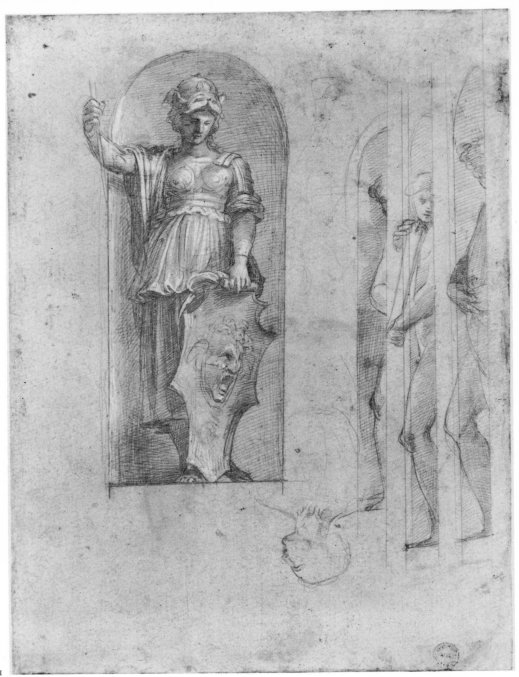

101

shows that he is a model in contemporary dress. Some very rough and almost indecipherable lines below indicate the legs of a figure descending a stair: the right leg is sharply bent, with the sole of the foot raised so that only the toe is resting on the step; the other leg is straight, with the foot on a lower level.

Though the legs are too far from the body sketched above to be anatomically feasible, Raphael presumably intended them as part of the same figure. Their position is the same, in reverse, as that of the legs of the right-hand figure of the two in no. 100, and this could be an early study for the same group.

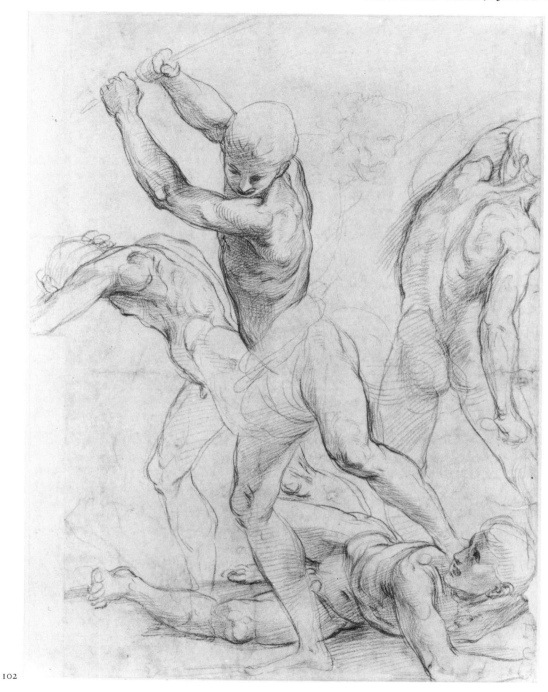

102

102. A combat of nude men

Ashmolean Musuem P II 552
Red chalk over stylus underdrawing. 379 × 281 mm.
Literature: KTP 552; P 508; R 73; Ruland, p. 193, 122;
 C & C, ii, pp. 73 ff.; F 309.

For the feigned bas-relief in *grisaille* under the statue
of Apollo on the left of *The School of Athens*. The
drapery round the loins of the central figure is less
decoratively treated than in the painting and the
drawing shows more of the man sprawling on the
ground in the right foreground, whose head and

arms are largely concealed in the painting by the beckoning philosopher on the left of the group surrounding Alcibiades.

Parker (1939–40, pl. 37) reproduced an old copy of a more highly worked-up study for the same composition which shows even more of this figure, who is seen to have his left arm bent and his hand flat on the ground as if struggling to rise; and he pointed out that a figure in the same pose occurs in reverse in the engraving of a *Bacchanal* by the Master H F E referred to under no. 167. The other figures in the engraved *Bacchanal* are copied from studies for soldiers in a *Resurrection*, for which the sprawling man's pose would also be appropriate. It seems more than likely that Raphael, whose disinclination to waste anything has often been noted, may have put to this further use the motif which the exigencies of composition had obliged him to discard from *The School of Athens*. The rough sketches for a *Resurrection* on no. 166 include two of a prostrate man in rather the same position.

103. A standing man with both arms extended to his right: study for a figure in the *Parnassus*

British Museum Pp. 1–74
Pen and brown ink. 343 × 242 mm.
Literature: P & G 29; P 443; Ruland, p. 188, 95; C & C, ii, p. 79; F 240.

Raphael omitted this figure altogether from the final stage of the composition, but a man in this pose occurs, engaged in conversation with another standing man, in the right foreground of the lost composition-study engraved by Marcantonio (B xiv, p. 200, 247; Pope-Hennessy, fig. 83) where the head is turned so that the chin is resting on the left shoulder; by itself, in the right foreground of another lost study known from an old copy (which may, however, have been trimmed) in the Ashmolean Museum (KTP 639; F, fig. 221; Pope-Hennessy, fig. 84); and with other figures in an old copy of a lost study for the right foreground group in the Louvre (F 238). It is characteristic of Raphael that he did not waste the motif: he gave the gesture, in reverse, to one of the figures immediately to the left of the altar in the *Disputa*. The separate study on

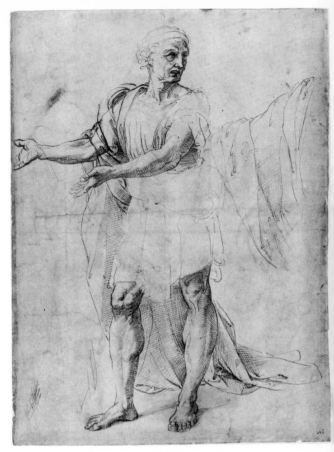

103

the right of the sheet seems to be for the drapery over the figure's right shoulder.

On the *verso* (F 241) is a study for the figure traditionally identified as Horace, which Raphael eventually placed in the extreme right foreground but which does not occur in any of the surviving composition-studies. There are also detailed studies for both his hands and for one hand of another figure in the right foreground.

104. Study for Melpomene in the *Parnassus*

Ashmolean Museum P II 541
Pen and brown ink over lead-point. 330 × 219 mm.
Literature: KTP 541; P 511; R 69; Ruland, p. 187, 76; C & C, ii, p. 86; F 249.

The figure is identified by the tragic mask in her hand as Melpomene, the Muse of Tragedy. It is a study for the figure on the left of the group of Muses surrounding Apollo in the centre background of the

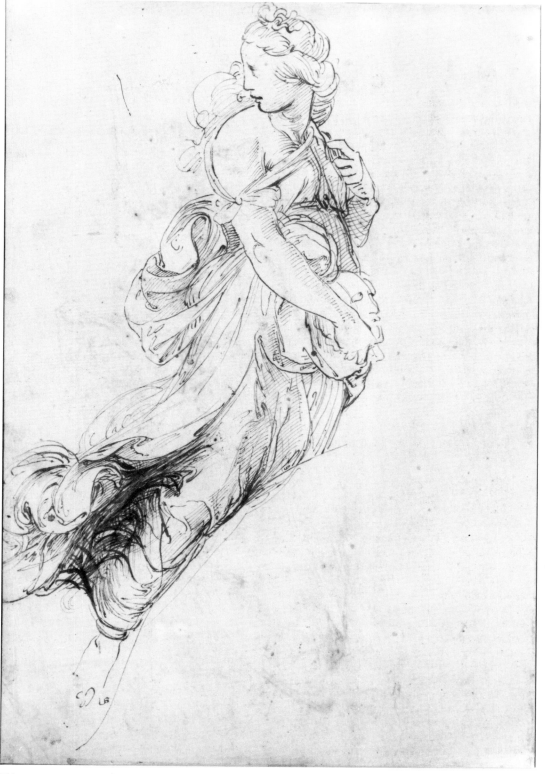

104

Parnassus. On the *verso* (F 248) is a study for the drapery of the complete figure of Virgil, who in the fresco stands to the left of Melpomene and whose body is largely obscured by her dress and by the figure of Homer.

The most obvious difference between the drawing and the figure of Melpomene in its eventual form is in the position of the head, which in the fresco is seen full-face. In the lost composition-study for the *Parnassus* engraved by Marcantonio (B xiv, p. 200, 247) she is looking backwards over her right shoulder as here, so that her face is in profile to left; in the other lost study of which there is an old copy in the Ashmolean Museum (KTP 639; F, fig. 221; Pope-Hennessy, fig. 84) her head is in an intermediate position, three-quarters to left. As Parker observed, Raphael no doubt felt obliged to abandon the first pose, beautiful though it is, when he saw that the backward turn of the head would echo too closely the position of the head of Virgil, whose traditional role as guide in the *Divina Commedia* is alluded to by the way he looks back towards Dante as if encouraging him to follow.

The action of the figure in the drawing is not clearly defined. The position of the right foot and left leg shows that her weight cannot be on either. Crowe and Cavalcaselle describe her as seeming 'hardly to touch the earth' and Parker as 'floating downwards'. The explanation is provided by the copy on the *verso* of no. 145 of a hovering figure of *Victory* in one of the spandrels of the Arch of Titus, and by an old copy, also in the Ashmolean Museum (KTP 465), of what was evidently a companion drawing of the figure in another spandrel. Raphael based his Melpomene on this Antique prototype, just as he based the seated Muse next to her on the Vatican statue of *Ariadne*. Both Fischel and Parker explain the curved outline in the lower part of no. 104 against which the figure seems to be leaning, as the contour of the seated Muse who occupies much the same relative position in the fresco; but the curve is too regular to be the outline of her legs, and must still reflect the shape of the arch which forms one side of the spandrel.

Even in the painting the Antique model is still imperfectly assimilated. Though the figure is one of a static group, her right foot is almost off the ground so that she appears to be moving – and moving rapidly, to judge from the way her draperies are fluttering out behind her. Both anomalies are vestiges of the spandrel figure. Crowe and Cavalcaselle observed the fluttering drapery, but offered no better explanation than that 'the breeze which plays with the folds of her vestment is but a flaw [i.e. a sudden gust of wind] that leaves her neighbour's tunic untouched'.

An old copy of no. 104 in the Uffizi (1220E) is inscribed, in a hand which appears to be that of the late seventeenth-century collector Padre Sebastiano Resta: *Nel Parnasso in Vaticano. era questo foglio carissimo à Monsù Nicolo Pussino. l'hebbi dal Sigr Pietro Santi scolo di Monsù Lamer suo discepolo 1699.* ('Monsù Lamer' is presumably Poussin's contemporary and studio assistant Jean Lemaire).

105. Study for the left-hand side of the *Parnassus*

British Museum Pp. 1–73
Metalpoint on pink prepared paper. 288 × 183 mm.
Literature: P & G 44; P 442; Ruland, p. 187, 86; C & C, ii, p. 87.

Accepted by Passavant and Ruland as a preparatory study for the figures above and below on the left of the *Parnassus*, but rejected, *ex silentio*, by Fischel, and also by Crowe and Cavalcaselle, who considered it 'too finished and delicate in the modulations of the shading not to be a copy of the fresco'. In the British Museum catalogue it was also dismissed as a copy, not of the fresco but of a lost study for it. The case for acceptance was convincingly restated by Oberhuber (1963, p. 47; also P & G, p. xvi). Even apart from the intelligence and high quality of the drawing itself, the use of a prepared metalpoint ground of exactly the same colour as the 'Pink Sketchbook' group, datable at the period of the Stanza della Segnatura (see no. 117), would argue a quite unusual care for verisimilitude on the part of the hypothetical copyist.

The differences between drawing and fresco are slight, but their very slightness is significant. In the painting Sappho (the figure seated in the lower right corner in the drawing) holds her left hand further from her head, with the index finger extended; and the clasp of the strap confining the upper part of her

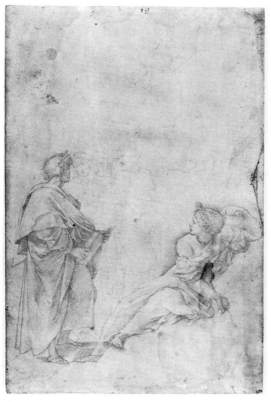

105

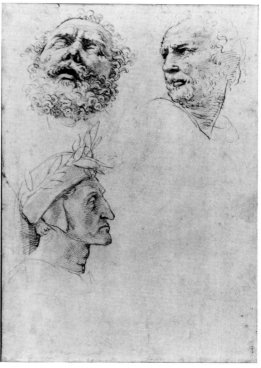

106

dress is circular, whereas in the drawing it is square. The faintly drawn group of three figures above – the seated poet, Dante and Homer – is further to the left in the drawing, so that Homer is standing immediately over Sappho.

106. Three heads in the *Parnassus*

Windsor 12760
Pen and brown ink. 265 × 182 mm.
Literature: AEP 796; P 431; Ruland, p. 186, 62; C & C, ii, p. 84; F 246.

The heads on the left of the sheet are those of Homer and his neighbour Dante in the group in the left background of the *Parnassus*. The head of Homer is copied from that of Laocoon in the then recently discovered Hellenistic marble group which had been

placed in the Belvedere courtyard of the Vatican in 1506. The third head could be that of the Poet who stands next to Sappho in the left foreground, with his back to the tree, but the angle of the neck is different and the features of the head in the painting are distinctly more idealised. The other two heads, in contrast, correspond very closely with their painted counterparts.

On the *verso* (F 247) is a study for the body of Dante. He is holding a large book against his chest, a detail which is almost invisible in the painting.

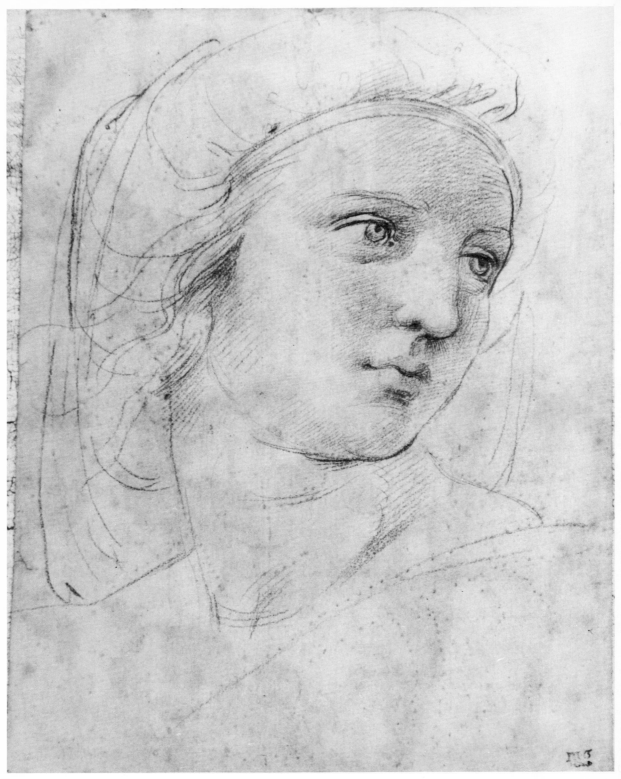

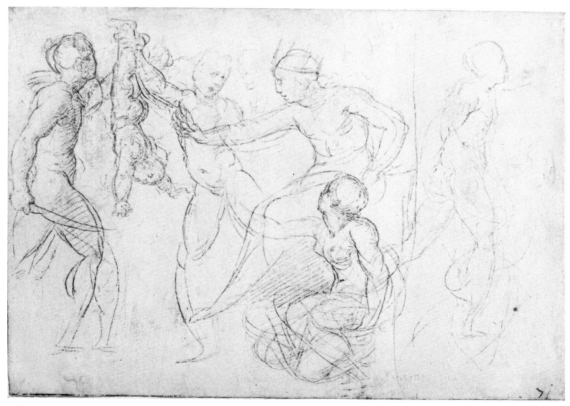

108

107. **Head of a Muse in the** *Parnassus*

Private collection
Black chalk over pounced-through underdrawing.
304 × 222 mm.
Literature: P, p. 540, *xx*; Ruland, p. 187, 82; F 253.

An auxiliary cartoon (for an explanation of the term, see no. 25) for the head of the third standing Muse from the left in the group on the right of Apollo in the background of the *Parnassus*. It was published by Fischel from the photograph in the Windsor Raphael Collection to illustrate his appeal for information about lost drawings by Raphael (1912, p. 299), and also in his *corpus*.

A lithographed facsimile of no. 107 had already appeared in *The Lawrence Gallery* (pl. 22). The description in the table of contents enables it to be identified with no. 53 in the Lawrence Gallery exhibition of 1836: 'Portrait of Raffaelle's sister – a model for the famous fresco of the Galatea . . . From the Collection of Lady Bentinck'. The connexion with the *Parnassus* was first observed by Passavant, when the drawing was in the collection of King William II of Holland.

108. **Composition-study for the** *Judgment of Solomon* **and a separate study for the executioner**

Ashmolean Museum P II 555
Metalpoint on greenish-grey prepared paper. 100 × 137 mm.
Literature: KTP 555; P 470; R 75; Ruland, p. 197, viii, 3; C & C, ii, p. 20; F 230.

For the fresco on the vault of the Stanza della Segnatura. Though the grouping of the figures is as in the painting, each individual pose is quite different. Other drawings for the Stanza della Segnatura (e.g. nos. 95 and 96) are in the same technique of metalpoint on a greenish-grey ground. 'Probably in none of Raffaello's drawings is his marvellous power of rapid conception and expression more strikingly displayed than in this slight and, at first sight, unattractive sketch. When however it is closely scanned, the vague and shadowy markings of the metal point will be found so expressive, that the imagination at once supplies the lacking forms, somewhat as the sound of well-known voices conveys to the mind a sufficient image of the unseen

speakers. The most important variation manifested in the sketch is, perhaps, in the action and general expression of the figure of Solomon on his throne. He is here represented as a young man, in an energetic momentary attitude, stretching out his right arm as if to prevent the slaying of the child; whereas in the fresco Solomon is portrayed as an old bearded man in a sedate attitude, with uplifted hands, apparently in feigned surprise at the success of his stratagem' (Robinson)

On the back of the sheet, which was uncovered only in 1953, are five pen and ink drawings of entwined and knotted ropes, justly described by Parker as 'certainly of early date, and skilfully drawn in a free style'. He remained non-committal on the question of their authorship, but observed that somewhat similar decorations are much in evidence in the *Disputa*. It seems to us that they are almost certainly by Raphael himself, but that they have little or nothing in common with the conventionally formalised arabesque decoration on the front of the altar in the *Disputa*, to which Parker was presumably alluding.

109. 'Theology': study for a detail of the vault of the Stanza della Segnatura

Ashmolean Museum P II 554
Pen and brown ink over lead-point. 201 × 143 mm.
Literature: KTP 554; P 548; R 80; Ruland, p. 195, i, 5;
 C & C, ii, p. 24; F 225.

Ruland was the first to observe that this is a rapid preliminary sketch for the figure symbolising *Theology* in one of the roundels on the vault of the Stanza della Segnatura. It would have been followed by a more careful study like the one at Windsor (no. 110) for the companion figure of *Poetry*, which represents a stage in the working out of the design immediately preceding the cartoon.

Raphael was responsible for the greater part of the painted decoration of the vault: that is, for the four roundels containing the figures symbolising *Theology, Justice, Philosophy* and *Poetry* (the subjects of the four wall frescoes), and for the four rectangular scenes of *Adam and Eve*, the *Judgment of Solomon, Astronomy* and *Apollo and Marsyas*. The *putti* in the central octagon and the pairs of small-scale composi-

tions between the roundels are vestiges of the original decoration by Sodoma, carried out shortly before Raphael's arrival in Rome.

For obvious practical reasons the ceiling of a room is usually the first part to be decorated. It is generally assumed that the vault of the Stanza della Segnatura was the earliest stage of the decoration, and that it must therefore have been undertaken by Raphael very soon after his arrival in Rome towards the end of 1508. But the studies for it (nos. 108–110) suggest a greater maturity and assurance than the earliest studies for the *Disputa* (nos. 85–87). Pope-Hennessy (p. 148) is surely right in his contention that Raphael's paintings on the vault were not carried out until later (c. 1511) when the completion of the wall frescoes would have revealed their stylistic incompatibility with Sodoma's decoration of the vault.

On the *verso* of no. 109 is a very rough composition-sketch for an *Assumption of the Virgin*. The arched top of the composition and the scale of the figures suggest that Raphael had a monumental altarpiece in mind. The incomplete arch and the off-centre placing of the Virgin show that the sheet has been trimmed away on the left. As in no. 166, the speed of Raphael's hand barely keeps pace with the rapidity and fluidity of his thought; the graphic shorthand in which he set down his ideas as soon as they occurred to him is so summary as to defy complete elucidation. Exactly what he intended to do with the sarcophagus, for example, is difficult to make out: he seems to have drawn it first with its long side parallel to the picture plane and its centre directly below the figure of the Virgin, and then to have changed his mind and drawn it end-on and considerably to the left of centre. The purpose of the two horizontal lines above the group of Apostles is not obvious: perhaps they were intended to emphasise that the upper and lower halves of the composition are studied separately, and that the interval between them would be adjusted in the final working-out.

No commission for an altarpiece of this subject is recorded. Fischel suggested that no. 109 *verso* and a more carefully worked-out drawing at Stockholm (F 351) for the upper part of the composition, were early ideas for the Monteluce altarpiece (though this in fact was to have been a *Coronation of the Virgin* and

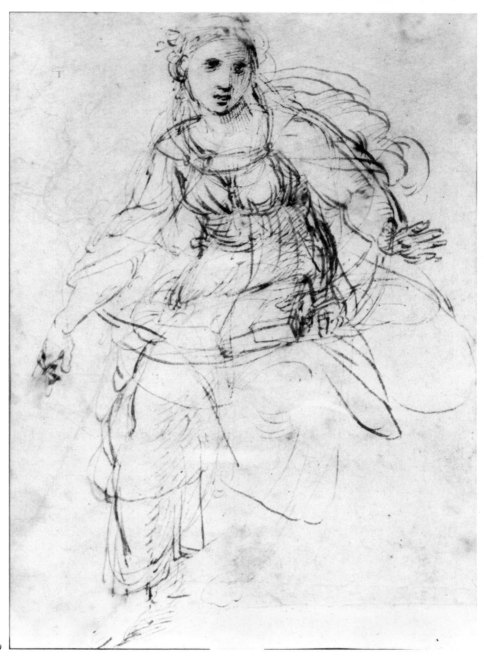

109

not an *Assumption*: see no. 133); that this evolved into the *Resurrection* (which there is now every reason to suppose was intended for the Chigi Chapel in S. Maria della Pace: see no. 167); and that it finally took shape as the *Transfiguration* commissioned by Cardinal Giulio de'Medici for his cathedral at Narbonne (see no. 174).

A more convincing alternative explanation, put forward by Shearman (1961, pp. 143 ff.) is that Raphael's *Assumption* was to have been the altarpiece of the other Chigi Chapel, in S. Maria del Popolo. The actual altarpiece of the chapel, commissioned from Sebastiano del Piombo in 1530, is of the *Birth of the Virgin*, but Shearman argued: (1) that the iconography of the rest of the decoration of the chapel illustrates the theme of Resurrection; (2) that the

principal dedication of the chapel is to the Virgin, whose Assumption is equivalent to her Resurrection; (3) that the gesture of the figure of God the Father in the centre of the cupola (see no. 154) makes sense if he is imagined as receiving a figure of the Assumed Virgin represented on the wall below; (4) that there is in the Rijksmusem an elaborately finished but unaccounted-for *modello* by Sebastiano del Piombo, datable probably *c*. 1526, for a large-scale altarpiece of the *Assumption*. Hirst (1981, p. 88) made the further point that the patron of the chapel, Agostino Chigi, was a native of Siena and very proud of his Sienese origin, and that Siena was a city where the Assumption of the Virgin inspired particular devotion.

Shearman went on to suggest that the Chigi Chapel altarpiece was carried out after Raphael's death, according to his design, by his former studio assistant and co-inheritor with Giulio Romano of the goodwill of his studio Giovanni Francesco Penni; and that in 1524–5 Penni sawed off the upper part of the panel with the figure of the Assumed Virgin in order to use the lower part to confect the altarpiece of the *Coronation of the Virgin* demanded by the nuns of Monteluce (see no. 133). This hypothesis presupposes that the Chigi family had refused to accept the altarpiece that Penni produced. One explanation, put forward by Shearman, is that the fortunes of the family had taken a turn for the worse in 1522 and that they were unable to find the money to pay for the picture. It could also have been that they simply had the good taste to prefer Sebastiano, who only a few months after Raphael's death was boasting that he expected to be given the commission for the altarpiece of the other Chigi Chapel, in S. Maria della Pace, for which Raphael seems to have left detailed drawings (see no. 167 and Hirst 1961, p. 162).

The argument that the altarpiece of the Chigi Chapel in S. Maria del Popolo was to have been an *Assumption of the Virgin* seems very convincing. The sketch on no. 109 *verso* may well have been made for this project, the inception of which is generally dated *c*. 1512–13. The presence of this sketch on the same sheet as a study for the Segnatura vault tends to support the later dating for the latter.

The resemblance between the sketch of the *Assumption* and the lower part of the Monteluce

altarpiece is of too general a nature to permit any conclusions about the authorship of the latter composition; but in view of the ineptitude of Penni's performance when left to his own devices, it does seem likely that he had recourse to a detailed drawing or even a cartoon prepared by Raphael. An essential piece of new evidence is the black chalk study for the group of Apostles in the left foreground of the picture discovered by Oberhuber in the Printroom in Berlin-Dahlem under the name of Giulio Romano and by him attributed to Raphael (F-O, fig. 68 and p. 73).

110. *Poetry:* **study for a detail of the vault of the Stanza della Segnatura**

Windsor 12734
Black chalk over stylus underdrawing. Squared in black
 chalk. 360 × 227 mm.
Literature: AEP 792; Ruland, p. 195, ii, 7; C & C, ii, pp. 22
 and 25; F 228.

A study for the figure symbolising *Poetry* in one of the roundels on the vault of the Stanza della Segnatura. It represents a later and more carefully worked out stage in the evolution of the design than does the rapid pen and ink sketch for the companion figure of *Theology* (no. 109). The pose of the figure in the drawing is exactly as painted, but the upper part of the body is naked, the shape and angle of the face are slightly different, and the head is not crowned with a wreath. If the drawing was made in preparation for the cartoon, as the squaring suggests, then these changes must have been introduced at the last moment.

Crowe and Cavalcaselle's acute observation that the face in the drawing is almost identical with that of St Catherine in the National Gallery painting (see no. 82) tends to support Pope-Hennessy's view (p. 205) that the picture was painted at the very beginning of Raphael's Roman period and not, as is generally supposed, towards the end of the Florentine period.

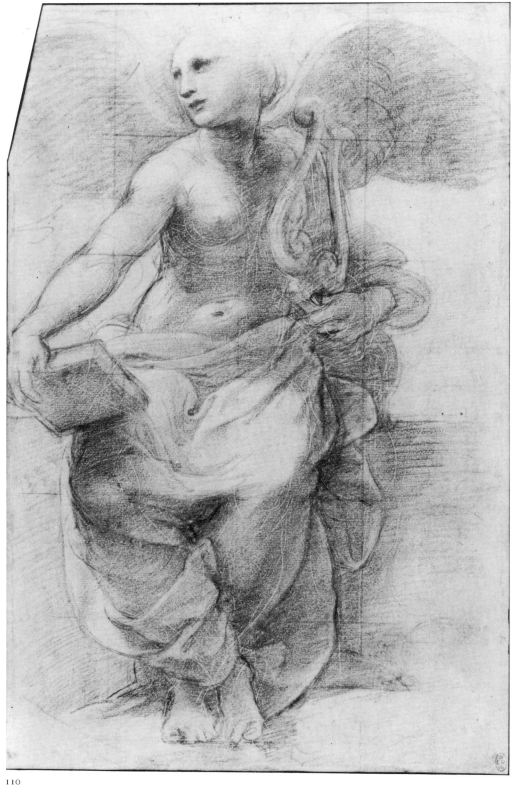

110

III. Head of a child: fragment of the cartoon for *Poetry* on the vault of the Stanza della Segnatura

British Museum Pp. 1–76
Black chalk on brownish paper. The outlines pricked for transfer. Much damaged, especially on the right. 234 × 232 mm.
Literature: P & G 28; Ruland, p. 195, ii, 9; C & C, ii, p. 374; F 229.

Inscribed along top edge, in black chalk: *RAPHAEL.*

In the old Museum inventory described as part of the cartoon for the Sistine *Madonna* (Dresden). Crowe and Cavalcaselle rightly rejected this idea, but were inclined to see the drawing as 'an independent design by Sodoma'. Ruland was the first to observe that the head corresponds with that of the *putto* on the right of the figure of *Poetry* in one of the roundels on the vault of the Stanza della Segnatura. The horizontal line across the bottom of the chin in the drawing represents the upper edge of the tablet, inscribed with the word *AFFLATVR*, held by the *putto* in the fresco.

II2. Alexander the Great depositing the manuscript of the *Iliad*

Ashmolean Museum P II 570
Red chalk, over some stylus underdrawing. 243 × 413 mm.
Literature: KTP 570; P, p. 541, γγ; Ruland, p. 189, ii, 2; F-O 417.

Though this drawing was part of the Lawrence Collection, it was not included in the series bought for the University in 1845 and is thus not in Robinson's catalogue. Parker bought it for the Ashmolean Museum in 1935.

The composition is that of the *grisaille* fresco to the left of the window below the *Parnassus* in the Stanza della Segnatura (F-O, fig. 92), which was engraved in the same direction by Marcantonio (B xiv, p. 168, 207; F-O, fig. 93).

More than one interpretation of the subject has been suggested, but as C. J. Hoogewerff demonstrated (*Bollettino d'arte,* vi (1926–7), pp. 3 ff.), the title given by Bartsch to Marcantonio's engraving,

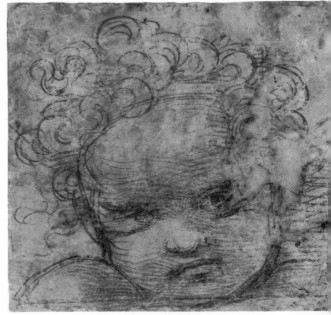

III

'Alexandre le Grand faisant mettre les livres d'Homère dans un coffre de Darius', is essentially correct. The episode illustrated comes from Plutarch's life of Alexander. After the defeat and death of Darius, a richly ornamented box was found among the spoils which Alexander took for himself and in which he decided to keep the treasured manuscript of the *Iliad* which he carried with him on his campaigns. The interpretation of the subject is made more difficult by the artistic licence taken with the story by Raphael. The box, which Plutarch clearly implies was a smallish, portable coffer, is represented in the *grisaille* as a large and unwieldy *cassone*; it is not altogether surprising that this should have been misinterpreted sometimes as the sarcophagus of Darius, and sometimes as the tomb of Achilles which Alexander is said by Plutarch to have visited (Dussler, for example, while emphasising that Hoogewerff's interpretation of the subject must be regarded as definitive, entitled it 'Alexander the Great depositing the Poems of Homer in the Tomb of Achilles'). Another confusing feature of Raphael's treatment of the subject is the action of the group of onlookers who are craning forward to peer down

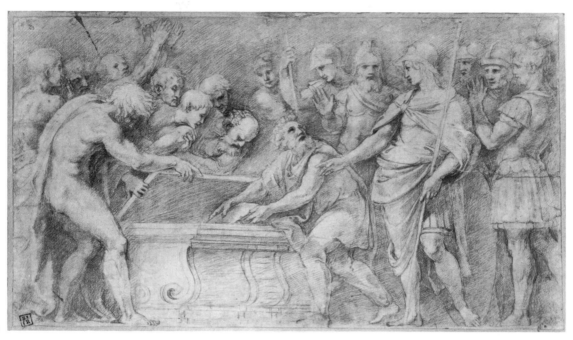

112

into the chest as if something of interest had only just been discovered in it. The figure in the centre could equally well be taking the book out of the chest, and it is easy to understand how the subject also came to be interpreted as *The Discovery of the Sibylline Books in the Tomb of Numa*. But as Hoogewerff pointed out, that subject would have been appropriate only to the *Jurisprudence* wall, whereas Alexander depositing the manuscript of the *Iliad* forms an exact pendant to the companion *grisaille* on the other side of the window, of Augustus preventing the destruction of the manuscript of the Aeneid commanded by Virgil on his deathbed (F-O, fig. 91). The two represent the preservation respectively of the principal Greek epic and the principal Latin epic, a theme appropriate only to the *Parnassus* wall.

Comparison of the three versions of the composition – the *grisaille*, the drawing, and the engraving – led Parker to the conclusion that the drawing occupies an intermediate position between the *grisaille* and the engraving, and that it was made expressly for the engraver. He catalogued it under the heading 'School of Raphael', with the suggestion that the draughtsman might have been Penni, an

opinion followed in the British Museum catalogue (P & G, p. 51). It now seems to us, however, that Oberhuber's contention that no. 112 is Raphael's preliminary study for the *grisaille* may well be correct. Comparison of the two shows that the drawing is better organised and better controlled: it is surely improbable that Penni would have been capable of so effectively rethinking the composition, or of conveying the psychological diversity of the heads of the onlookers, especially those on the extreme left and fifth from the left. Oberhuber makes the further point that the freedom of the stylus underdrawing can be paralleled in drawings undoubtedly by Raphael. No. 112 seems certainly to have been used for the engraving, but many of Marcantonio's prints after Raphael were based on drawings made for other purposes which happened to be available.

113

113. The Judgment of Zaleucus

Windsor 3720
Pen and brown ink over black chalk. 262 × 363 mm. (size
 of whole sheet; approximate size of detail reproduced
 257 × 202 mm).
Literature: AEP 797; F-O 419.

Discovered by Popham in an album of Bolognese
landscape drawings in the Royal Library, and
identified by him as a study for one of the mono-
chrome paintings (F-O, fig. 95) in the embrasure of
the window below the lunette of *Jurisprudence* in the
Stanza della Segnatura. So far as it goes, the drawing
corresponds closely with the painting, on the left-
hand side of which are the figures of Zaleucus's son
and his two guards. The drawing has been trimmed
on that side and only part of one of these figures
remains.

The subject is taken from Valerius Maximus
(*Dictorum Factorumque Memorabilium Exempla*, vi, 5)
who relates it as an example of *Justice*. Zaleucus was a
jurist who in the sixth century BC devised a strict
code of laws for the Greek city of Locris Epizephyrii
in southern Italy. His son was convicted of adultery
and condemned to the penalty laid down by his
father, of having both eyes put out. The citizens

petitioned Zaleucus to remit the penalty, but he
would only consent to a compromise by which one
of his son's eyes was put out and one of his own.

On the *verso* (AEP pl. 52; F-O 418) is a study in
red chalk for the corresponding monochrome paint-
ing on the other side of the same window-embrasure
(F-O, fig. 94). The subject is *The Doctrine of the Two
Swords*, a passage from St Luke's Gospel (xxii, 38)
interpreted as supporting the Church's claim to both
spiritual and temporal authority. In the painting the
composition has been drastically simplified by
reducing the number of figures on either side of
Christ. The drawing, on the other hand, offers a
close parallel in the frieze-like disposition of the
figures to the early study for the Chigi Chapel
Incredulity of St Thomas (no. 150), probably datable in
or not long after 1512. Oberhuber is inclined to date
the studies on no. 113 *c.* 1512–13, somewhat later
than the main part of the Stanza della Segnatura
decoration.

114. Part of a cavalry battle

Chatsworth 57
Brush drawing in brown, heightened with white. Some
 black chalk underdrawing, particularly on the right.
 244 × 358 mm.
Literature: Ruland, p. 167, vi, 2; F-O, pp. 61 f.

The black chalk underdrawing on the right of the
sheet shows an alternative position for the head of
the sitting figure; also an undulating outline which
appears to indicate the back of a third horse, riderless
and running to the left, with behind it a figure
extending its arm to seize the horse's head.

The critical history of this drawing is a remark-
able one: what is remarkable is the absence of critical
history. Since the early eighteenth century it has
been in the Devonshire Collection under the name
of Raphael. The important group of drawings by
him in that collection has been scrutinised by every
specialist, every one of whom must have looked at
this drawing and must have paused, however
briefly, to consider it in the light of the traditional
attribution. Nevertheless, until very recently the
only mention of no. 114 in the mass of critical
literature published since the time of Passavant is a
brief reference in Ruland; and Ruland too rejected

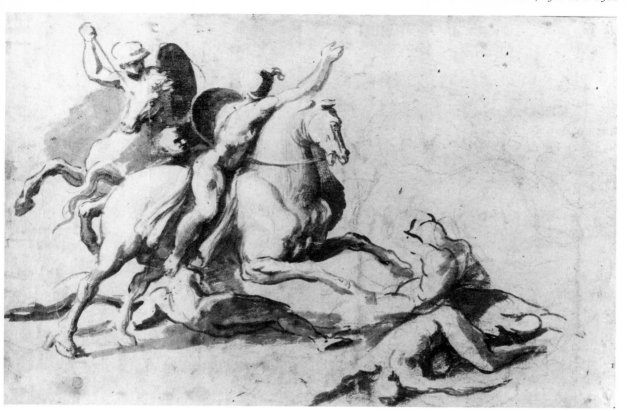

114

the attribution, listing no. 114 in the apocryphal section of his catalogue only in accordance with his principle of including everything 'to which Raphael's name had ever been attached by any definite authority'.

Only one comment, made probably in the 1930s, has been preserved in a brief annotation, 'not by Raphael'. If the annotator had been pressed to suggest an alternative attribution, he would no doubt have taken refuge in what was then the vague *terra incognita* of Mannerism. No. 114 can however, be placed with some confidence in Raphael's circle and dated not later than three years after his death, and probably within his lifetime. The group of figures occurs in reverse as part of a more complete composition engraved by Marco da Ravenna (B xiv, p. 316, 420), a pupil of Marcantonio, one of whose principal sources of subject-matter was likewise discarded studies by Raphael. His engraving is undated, but a *terminus ante quem* is established by the date 1523 inscribed on a copy of it by the German engraver Daniel Hopfer (B viii, p. 518, 46).

No. 114 is not from the hand of any artist in Raphael's immediate circle: Giulio Romano, Perino del Vaga, Polidoro da Caravaggio and Gianfran-

cesco Penni are now clearly defined stylistically and can be excluded without question. There remains Raphael himself. This aspect of his drawing style is less familiar, but the masterly use of the brush to suggest every nuance of emphasis in contour and in modelling, and the application of the white body-colour by delicate parallel hatched strokes, can be matched in the early sketch for the *Disputa* at Windsor (no. 85). No. 114 is most reasonably dated in the early years of the second decade, not long after Raphael's arrival in Rome from Florence. It is perhaps not fanciful to see a certain Leonardesque flavour in such details as the head of the man standing between the two horsemen, and to suggest that this drawing may reflect the experience of seeing the *Battle of Anghiari* (see no. 69). No. 114 was first published, and Raphael's authorship of it reaffirmed, by J. A. Gere (*I disegni dei maestri: il manierismo a Roma*, Milan, 1971, p. 81). Oberhuber accepted the traditional attribution, and pointed out analogies with the *modello* for the *Madonna del Pesce* (no. 136).

The purpose of no. 114 is a matter of conjecture. The skirmish between horsemen and foot-soldiers in the right background of the *Battle of Ostia* in the

Stanza dell'Incendio, a work datable 1514–15, strikingly resembles the group in spirit, though there is no exact correspondence and the composition engraved by Marco da Ravenna is larger and more elaborate. Such a composition might have been an early idea for part of the *Battle of Constantine* in the Sala di Costantino, the only large-scale battle-scene in Raphael's *oeuvre*, which was executed after his death but according to his design (see no. 181). Though he seems to have started work on the project only towards the end of his life, well after the apparent probable date of no. 114, the iconographic programme may well have been the subject of discussion at a much earlier stage. It is unlikely that the decoration of the largest in the whole suite of rooms, situated between the Logge and the Stanza d'Eliodoro and thus on the main route of access to the Pope's private apartments, a room through which he and his court and Raphael and his assistants would have passed almost every day, would not all along have been a matter of concern to Julius II and after him to Leo X.

115. Venus

British Museum 1895–9–15–629
Metalpoint on pink prepared paper. 238 × 100 mm.
 (maximum measurements: the drawing is on two
 irregularly shaped pieces of paper, the one on which are
 the legs of the figure being stuck over the other with an
 overlap of about 25 mm).
Literature: P & G 27; Ruland, p. 127, ii, 2; F, p. 328 n.
 (incorrectly stated to be reproduced in part viii of the
 corpus).

The upper part of the overlapping piece is trimmed on the left to follow the outline of the top of the figure's right leg. This alteration must have been made by Raphael himself in order to modify the pose. The former position of the right hip is indicated to the left of the trimmed contour. There is also a *pentimento* for the right shoulder.

 An almost identical figure occurs in the same direction in an engraving by Marcantonio (B xiv, p. 234, 311) of Venus standing in a niche and reaching down to embrace the head of Cupid who stands on a low plinth to her right. The drawing differs from the engraving in the larger scale of the figure and in the position of the right leg, and also in the absence of

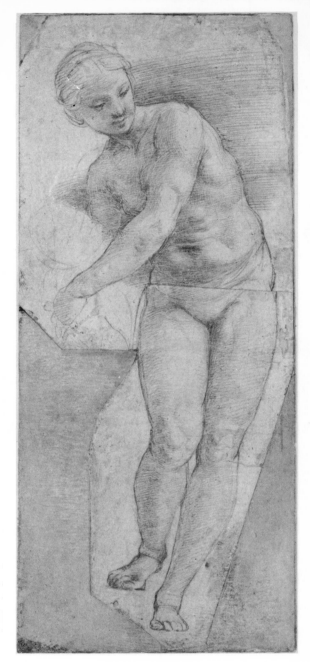

115

Cupid, though the position of his head is indicated by the roughly drawn circular outline above Venus's left forearm. It has been suggested that no. 115 served as basis for Marcantonio's engraving, but he would hardly have been capable of making these additions and subtle adjustments to produce a group as beautifully harmonious as that eventually engraved. Raphael must have supplied him with a drawing complete and explicit in every detail.

 The group of Venus and Cupid cannot be

connected with any known or recorded work by Raphael. The engraving is one of a pair, its *pendant*, representing Apollo (B xiv, p.252, 335), being derived from a lost study for the feigned statue on the left-hand side of *The School of Athens* which has in its turn for *pendant* a statue of Minerva. The figure of Venus would have been so inappropriate to the theme of *The School of Athens* that Raphael could never have intended it to occupy the place of Minerva. The answer may be that he designed the figure expressly for Marcantonio, in the belief that *Apollo and Venus* would make a more attractive pair of engravings than *Apollo and Minerva*.

Whatever its purpose, no. 115 can be dated at the very beginning of Raphael's Roman period. The technique of metalpoint on pink prepared paper is paralleled in studies for *The School of Athens* (nos. 100 and 101) and in the 'Pink Sketchbook' group which is datable about the same time (nos. 116 and 117). Other drawings of a standing Apollo and a standing Venus in the Uffizi (F 264) and at Lille (F 266) appear to be derivations from studies for the Leonardesque youth in the left foreground of the *Disputa*.

116. Sheet of studies for an Infant Christ

British Museum Pp. 1–72
Metalpoint on pink prepared paper. The framing-lines in pen. 168 × 119 mm.
Literature: P & G 23; P 445; Ruland, p. 70, xxix, 3; C & C, ii, p. 110; F 350.

Inscribed in ink, top centre: *22*, and in top right corner: *81*.

This drawing and no. 117 form part of Fischel's· 'Pink Sketchbook' group. Six further sheets of roughly the same size, drawn on in metalpoint on the same-coloured ground, are at Lille (F 345–348 and 351–353; F 347 is the *verso* of F 346), and a seventh, formerly in the Robert von Hirsch Collection, is now in the Cleveland Museum of Art (F 354; Hirsch Sale, Sotheby, 20 June 1978, lot 16). To this well-defined group Fischel, less convincingly, added a tenth drawing, noticeably smaller in size and on a cream-coloured ground, now at Rotterdam (F 355). He claimed to see on them indications – wear on the right-hand edges, old numbering, etc. – that they once formed part of a sketchbook. Neither on no.

116

116 nor on no. 117 is there any trace of such wear, and only three out of the total of ten are inscribed with old numbering; but whether or not these sheets were originally bound up together – and as in the case of his 'Large Florentine Sketchbook' (see no. 37) the question is of little more than academic interest – Fischel was certainly right in grouping them together and in dating them in the first years of Raphael's Roman period. The same themes recur on them and on one (F 353) is a study for a figure in *The School of Athens*. Larger studies for the *Parnassus* and *School of Athens* (nos 100 and 105 and F 306 at Frankfurt) are also in metalpoint on the same pink ground.

The group includes another sheet of studies of a reclining baby (F 351) closely connected with no. 116; of the studies on it, one repeats the pose of the child in the top right-hand corner, while another is in a position very close to that of the Child in the *Madonna di Loreto*, a work of the very beginning of the Roman period. Of the studies on no. 116, the one in the centre of the sheet is hardly less close to the Infant Christ in the *Madonna Bridgewater* (Duke of Sutherland Collection, on loan to Edinburgh), a painting generally dated towards the end of the Florentine period, but which may well be somewhat later and have been developed *pari passu* with the *Madonna di Loreto*.

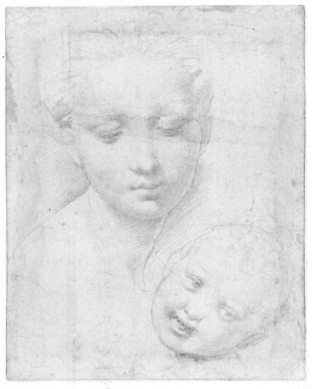

117

117. Heads of the Virgin and Child

British Museum 1866–7–14–79
Metalpoint on pink prepared paper. 143 × 110 mm.
Literature: P & G 24; P 159; Ruland, p. 68, xxiv, 9; C & C,
 i, p. 359; F 349.

Critics have at various times associated this drawing
with a very wide range of compositions of the
Virgin and Child, but Fischel's convincing recon-
struction of his 'Pink Sketchbook' group, datable at
the very beginning of Raphael's Roman period (see
no. 116), enables the possibilities to be narrowed
down. The relation of the two heads resembles in a
general way, though in reverse, that in the
Aldobrandini–Garvagh and Mackintosh *Madonnas*
(both National Gallery); but Raphael's late Floren-
tine and early Roman *Madonnas* are a series of
variations on a theme, and it would be rash to
connect with a particular composition one of a
group of interrelated studies in which Raphael is
working out a series of such motifs, merely on the
grounds of a general resemblance.

118. Two children: after Michelangelo

Christ Church 1949
Red chalk, heightened with white, on pink-tinted paper.
 114 × 169 mm.
Literature: J. Byam Shaw, *Drawings by Old Masters at Christ
 Church, Oxford,* 1976, no. 67.

This pair of figures occurs on the ceiling of the
Sistine Chapel, above and to the left of the *Cumaean
Sibyl*. The attribution of this copy to Raphael,
suggested by J. A. Gere, is conjectural; but to quote
Byam Shaw: 'the rendering of the forms and the
feet, the modelling of the knees, and the "feeling" of
the contours are all distinctly Raphaelesque; and the
pink ground was often used by Raphael.' The
distribution of light and shade and the way the
figures stand out against an area of hatching are
features that might also be adduced in support.

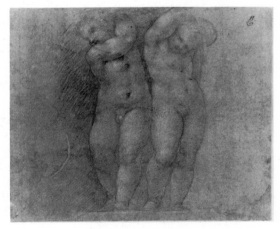

118

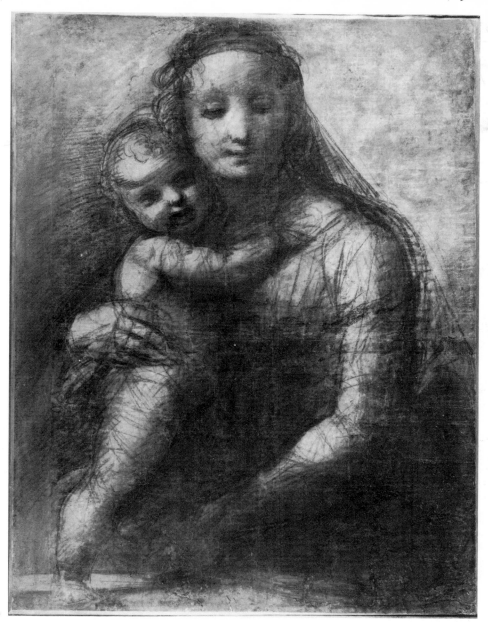

119

119. The Virgin and Child: cartoon for the Mackintosh *Madonna*

British Museum 1894–7–21–1

Black chalk, with a few touches of white heightening.
The outlines pricked for transfer and partly indented.
The sheet is composed of two pieces of paper joined
horizontally. 710 × 535 mm, including a strip about 45
mm wide added to the left-hand edge.

Literature: P & G 26; P 164; Ruland, p. 68, xxiv, 8; C & C,
ii, p. 133; F 362.

The cartoon corresponds exactly in composition
and in scale with the totally repainted picture in the
National Gallery, also known as 'The *Madonna* of
the Tower' or 'The Rogers *Madonna*'. It differs in
showing the Virgin's left arm covered with a simple
sleeve; the prick-holes outline a more elaborately
folded one, as in the painting. The condition of the
painting is such that its correspondence with the
cartoon, which is certainly by Raphael, provides one
of the strongest arguments for its authenticity.

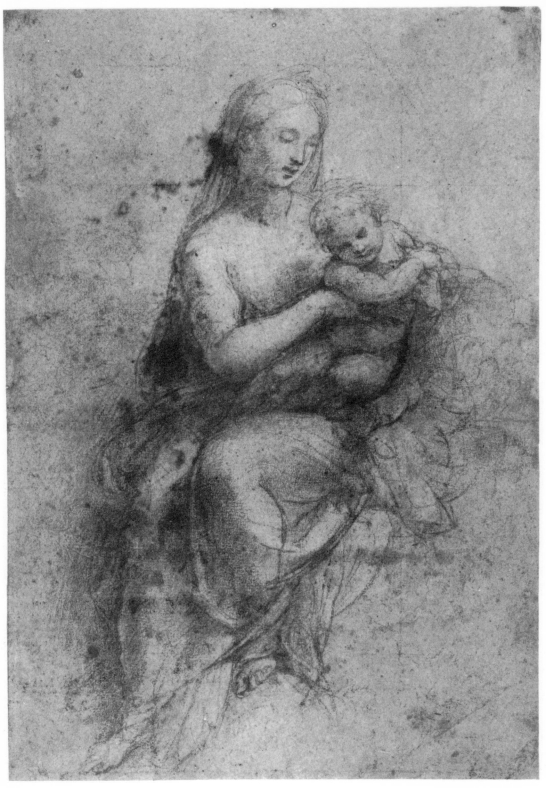

120. The Virgin and Child: study for the
Madonna di Foligno

British Museum 1900–8–24–107
Black chalk on greenish-grey paper. The outline of a halo
 is indicated with the stylus behind the Virgin's head.
 Traces of squaring in black chalk. 402 × 268 mm.
Literature: P & G 25; P, p. 538, *hh;* Ruland, p. 73, 10;
 C & C, ii, p. 167; F 370.

The group corresponds closely with the upper part
of the altarpiece of *The Virgin and Child adored by the
Baptist with St Francis, and by St Jerome with the donor,
Sigismondo de'Conti,* a painting commissioned by the
last-named for the high altar of the church of S.
Maria in Aracoeli and probably completed shortly
before his death on 18 February 1512. In 1565 his
heirs moved the painting from Rome to the church
of S. Francesco in Foligno, from where it derives the
name by which it is commonly known. It is now in
the Vatican Gallery.

No. 120 differs from the painting in the position
of the Child's legs (some lines below his left leg may
be either a *pentimento* for the leg or indicate a
cushion) and in showing the group surrounded by a
mandorla rather than a circular glory; but in spite of
these differences and the squaring and the possible
pentimento, to say nothing of the quality of the
drawing itself, it has not been unanimously accepted
by critics. Passavant dismissed it as a copy of a lost
drawing, and Crowe and Cavalcaselle as a copy of an
engraving by Marcantonio (B xiv, p. 53, 47) which
could well be based on a study for the same picture
but which differs from no. 120 in every possible
detail.

The doubts about Raphael's authorship are prob-
ably due to the unfamiliar appearance of the draw-
ing: this is the only known instance of his using
black chalk on blue paper. But as Sidney Colvin
(*Vasari Society,* i (1905–6), no. 7) observed, 'the
touch and sentiment of the Virgin's head seem
thoroughly Raphael's and not those of any imitator;
and the suggestion of modelling in her shoulder and
arm is very sensitive and full of beauty' – and, he
might have added, equally characteristic of Raphael.
The technique of black chalk on blue paper is a
Venetian one; it is possible that the unfamiliar
appearance of the drawing reflects the moment in
Raphael's development not long after his arrival in

Rome (and thus at about the time when he probably
received Sigismondo de'Conti's commission) when
he was in contact with the Venetian painter Sebas-
tiano del Piombo.

121. The Holy Family with an (?) angel

Fitzwilliam Museum 3103
Red chalk. 159 × 129 mm (lower corners cut).
Literature: Ruland, p.94, xxxii, 1; F 357.

The attribution to Raphael almost certainly goes
back at least as far as Sir Thomas Lawrence, whose
collector's mark is stamped in the lower left corner.
The 'Miss Woodburn' named by Ruland as the then
owner was presumably the daughter of the art dealer
and expert Samuel Woodburn who as Lawrence's
principal creditor took possession of his collection
after his death. The drawing is therefore probably
one of the 180 or so attributed to Raphael in the
Lawrence Collection.

Raphael's authorship was accepted by Ruland;
and without hesitation by Fischel (see also 1948, pp.
130, 361). He pointed out that the pose of the Child
resembles that in the Aldobrandini-Garvagh
Madonna in the National Gallery, a work datable

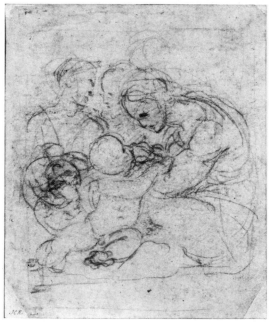

121

*c.*1509-10, and associated the drawing with the Madonna studies of the early Roman period in the 'Pink Sketchbook' (see no. 117) and elsewhere. As Michael Jaffé suggested, the composition seems distantly to reflect knowledge of Florentine sculptured *tondi* of the Virgin and Child with the Infant Baptist (Michelangelo's in Burlington House and the one in the Bargello attributed to Rustici).

The other collector's mark in the lower left corner is that of Sir Charles Robinson, one of the most distinguished authorities on Raphael's drawings and the author of the classic catalogue of the Michelangelo and Raphael drawings in Oxford. In 1902, eleven years before his death, Robinson sold the greater part of his own collection of Old Master drawings (Christie, 12-14 May). No. 121 appears as lot 193 in this sale, where it is described as 'Lombard School, *c.* 1515-20' – an opinion which suggests that Robinson was inclined to place the drawing in the ambit of Correggio. The old attribution to Raphael is not even mentioned.

That a connoisseur as experienced as Robinson should reject so emphatically an attribution to Raphael, especially of a drawing belonging to himself which he would have been in a position to study at leisure, is surely significant. No opinion of Fischel's can ever be lightly disregarded, but without the authority of the old attribution it may be doubted whether the name of Raphael would necessarily have come to mind. The composition is admittedly 'Raphaelesque,' in the widest sense of the word, but it has none of Raphael's clarity: the relationship of the figures in space is ill-defined in a way that seems uncharacteristic of him (cf. e.g. the no less summary composition-sketch, no. 60), and it would be difficult to find parallels to such details as the drawing of the Child's left foot and the Virgin's profile. Raphael seems on the whole not to have used red chalk for his *primi pensieri*. It is true that some of the studies on a sheet in the Albertina (F 110/111) connected with the *Madonna Bridgewater* are in this medium, but comparison with no. 121 hardly helps to support the attribution. Robinson's hint might with advantage be followed up.

122. The Massacre of the Innocents

British Museum 1860-4-14-446
Pen and brown ink. Red chalk underdrawing only in the two figures in the right background. The outlines of all the figures except these two pricked for transfer. 232 × 377 mm.
Literature: P & G 21; P 562; Ruland, p.35, ix, 7; C & C, ii, pp. 118 f.; F 233.

The composition is known in its complete form only in an engraving by Marcantonio (B xiv, p. 19, 18), which includes more figures and shows the women clothed. The drawing corresponds exactly, so far as it goes, with the engraved composition except for the executioner and the mother in the right background. This pair of figures clearly represents an afterthought on Raphael's part, since it is only they that were first sketched in red chalk and one of them is drawn partly over another figure. Raphael abandoned this solution for the right background before proceeding to the next stage of the design, for these two figures are the only ones not pricked for transfer to another sheet – possibly the more elaborated composition study at Windsor (no. 123). The assumption by Crowe and Cavalcaselle that this modification was introduced by Marcantonio argues an altogether exaggerated view of his capacity as a designer: every stage in the working-out of this complex and beautiful composition can only have been due to Raphael himself, who must have provided Marcantonio with a drawing explicit in every detail. Possibly, as Oberhuber has suggested (orally), the final stage is represented by the very carefully finished pen and ink drawing of the whole composition now in Budapest, known to us from an old photograph in the Windsor Raphael Collection (Ruland, p. 36, 10; I. H. Shoemaker and E. Brown, *The Engravings of Marcantonio Raimondi*, exh. Lawrence (Kan.) and Chapel Hill (N. C.), 1981, fig. 23). It has been truly said of Raphael that he never wasted anything: the poses of the two figures discarded from the right background of no. 122 were adapted for a pair of fighting sea-centaurs in the desigh for the border of a dish on the *verso* of the study for the *Massacre of the Innocents* at Windsor (no. 123).

Two sheets in the Albertina (F 231/2 and 236/7) have on one side studies for details of the vault of the

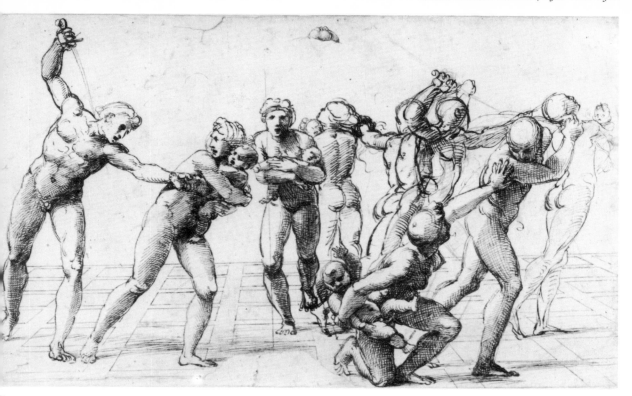

2

Stanza della Segnatura and on the other studies for figures in the *Massacre of the Innocents*. It seems reasonable from the point of view of style to date the latter at about the same time, *c.* 1511 (see no. 109). There is no record of any painting of this subject by Raphael, and it may be that he designed this composition expressly to be engraved.

Fischel considered that no. 122 had been largely reworked by a later hand. He had expressed the same unfounded belief about drawings of a somewhat earlier period (e.g. nos. 58 and 76), which are similarly characterised by dense and regular cross-hatching.

123. The Massacre of the Innocents

Windsor 12737
Red chalk over underdrawing in black chalk and stylus.
248 × 411 mm.
Literature: AEP 793; P 421; Ruland, p. 35, ix, 7; C & C, ii, p. 119; F 234.

A study for the composition engraved by Marcantonio (see no. 122). The dotted contour visible here and there in the black chalk underdrawing shows that this was transferred by pouncing (see no. 25 for

an explanation of this term) from another sheet, possibly even from no. 122 in which the figures correspond exactly in size and the contours are pricked for transfer.

No. 123 comes closer to the final result, though the figures in the centre of the composition in no. 122 are omitted. The women are now clothed and the seated mother on the extreme left and the one behind her who is pursued by an executioner are as in the engraving, as also is the mother on the extreme right. It has been observed by Shearman (1972, p. 105) that Raphael seems to have built up his more intricate compositions by constructing a framework of 'anchor figures' (to adopt Shearman's term), round which the others were in due course fitted.

On the *verso* (F 235) is a study in pen and ink for the decoration of a circular dish or salver with a composition of fighting and embracing sea-monsters. On the right of the group are a sea-centaur and a sea-nymph adapted from the group of the executioner on the right of no. 122 and the mother whom he seizes by the hair, figures which are omitted from no. 123 *recto* and from the engraving.

Apropos of the *verso*, Fischel referred without comment to the fact that the goldsmith Cesarino of

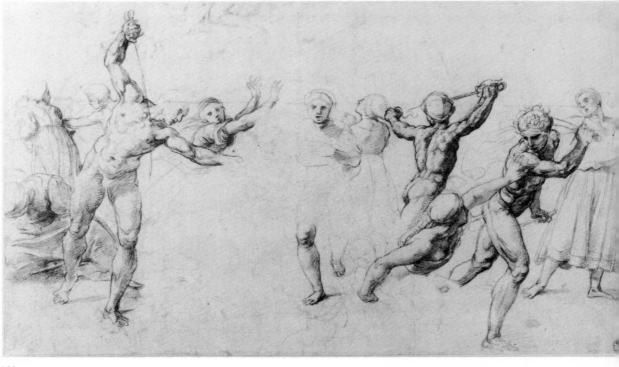

123

Perugia (Cesare Rossetti) agreed to make two bronze dishes on Raphael's designs for Agostino Chigi. The source of this statement is a receipt from Rossetti acknowledging an advance payment for two bronze 'tondi', each about four *palmi* (i.e. about 3 feet or 90 cm) in diameter, decorated in relief 'cum pluribus floribus' after a design to be supplied by Raphael (Golzio, pp. 22 f.). The date of this document, 10 November 1510, fits with the probable date of the *Massacre of the Innocents* (see no. 122), but it specifies a decoration of flowers, not of sea-monsters.

124. Aeneas escorted by Dido

Chatsworth 727 A.
Black and red chalk. Some contours pricked. 78 × 74 mm.
Literature: Ruland, p. 126, i, 6 *(recto)*, 4 *(verso)*.

125. Dido receiving the Trojans in audience

Chatsworth 727 B
Pen and brown ink. Some contours pricked. 77 × 75 mm.
Literature: Ruland, p. 126 ,i, 5.

It is evidence of Ruland's thoroughness that until very recently his was the only reference in the Raphael literature to these studies for two of the subsidiary compositions on the right-hand side of the engraving by Marcantonio known as the *'Quos Ego'* (B xiv, p. 264, 352). They are mentioned in recent studies of Marcantonio, notably by Oberhuber in the catalogue of the exhibition *Rome and Venice: Prints of the High Renaissance* held at the Fogg Museum, Harvard, in 1974 (under no. 32).

The engraving illustrates part of the first book of Virgil's *Aeneid*: in the large central compartment Neptune is shown calming the storm which drove Aeneas's ships on to the coast of Africa, while the subsidiary scenes represent incidents of the Trojans' arrival and their reception by Queen Dido of Carthage. The words 'Quos Ego –' (*Aeneid*, i, 135) are the aposiopetic threat uttered by Neptune to the Winds which raised the storm without his permission.

Both drawings agree exactly in scale with the corresponding details of the engraving, and each is partly pricked for transfer. No. 124 is in reverse to the engraving, and has been traced through from a pen and ink drawing on the *verso* (Chatsworth 727 C) which must have resembled no. 125, and in which the group consists of all four figures with their architectural setting, as in the engraving. Only the two outside figures of the group on the *verso* are

pricked, and they have been rubbed over and almost obliterated with powdered black chalk in the course of transferring the outlines to another sheet. In no. 125 which like no. 124 *verso* is in the same direction as the engraving, the pricking is confined to the figure in the left foreground. The two drawings must have been treated in this way during the process of transferring the design to the copper plate.

It seems to have been Raphael's usual practice to supply Marcantonio with drawings made for other purposes than to be engraved, but the *Massacre of the Innocents* (see nos. 122 and 123) is an instance of a composition that seems to have been produced expressly for engraving. The *'Quos Ego'* must be another, but nos. 124 and 125 in no way resemble the two studies for the *Massacre of the Innocents* here exhibited, and clearly represent a much later stage in the working out of the design.

The authorship of nos. 124 and 125 is something of a puzzle. No. 124 *verso* is so badly defaced that no conclusion is possible, but comparison of no. 125 with the engraving reveals a much greater degree of liveliness and intelligence in the draughtsman than in the engraver. The theoretical possibility of an attribution to Marcantonio can therefore be ruled out. In the study in Frankfurt (F-O 471) for *God showing the Rainbow to Noah* in the *basamento* of the Logge, there is something of the same intricate web of pen lines and the same tendency to organise drapery into long serpentine folds. Oberhuber attributed the Frankfurt drawing to Penni, in spite of the presence of 'some especially beautiful and very Raphaelesque passages'. (It should be added that the partial oxidisation of the white heightening and the now much rubbed condition of the sheet seem, paradoxically, to have improved it by imparting a more mysterious and 'malerisch' quality than is apparent in the old photograph taken in the 1850s, in the Windsor Raphael Collection, which goes far to support the attribution to Penni.)

An even closer parallel, to judge from another old photograph in the same collection, is with the carefully detailed pen and ink drawing of the *Massacre of the Innocents*, in Budapest, which appears to be of very high quality and possibly even the finished drawing made by Raphael for Marcantonio to work from (see no. 122). It may well be that nos.

124

125

125 and 124 *verso* will prove to be Raphael himself, but the possibility of Penni cannot be entirely excluded. The facial type and psychology of the two heads immediately to the left of Dido in no. 125 are suggestive of him, and rather the same fold-system and the same web of cross-hatched lines are found, though in a more stylised and cruder form, in his

126

drawing of *Tarquin and Lucretia* (no. 202) which further resembles nos 124 and 125 in having probably been made for engraving.

126. A *putto* embracing an eagle

British Museum 1868–8–8–3180
Red chalk. The outlines of the *putto* indented, and the *verso* blackened for transfer. 120 × 142 mm.
Literature: P & G 35.

A rough outline of the *putto* is drawn immediately to the left of the eagle.

Inscribed in lower left corner, in ink in an old hand: *di tiziano.* The old attribution to Titian is out of the question, and probably also the more reasoned later attempt to put the drawing into an Emilian or Lombard context. The names of Correggio, Anselmi, Parmigianino and Camillo Boccaccino have all been suggested, but it seems to us that Fischel's attribution to Raphael (1948, p.163) is

likely to be correct. His attempt to connect no. 126 with the decoration of the facade of the long-since demolished Palazzo dell'Aquila, which according to Vasari was designed by Raphael, is an unverifiable hypothesis. Only slightly less hypothetical is the suggestion that this may be a study for a fountain intended for the garden of the Villa Farnesina, put forward by Oberhuber who pointed out that there are studies of *putti*, some embracing eagles and others dolphins, on a sheet in the Uffizi on which is also a ground-plan identified by him as for the stables of the Villa (1474ᴱ; repr. Pierluigi de Vecchi, *I disegni di Raffaello nel Gabinetto dei Disegni degli Uffizi,* 1982, no. 17, where the argument, first stated in P & G, p. xvi, is expanded). A third possibility that might perhaps be taken into account is that this drawing may have been made in connection with the Psyche Loggia of the Farnesina (see no. 159), where the window-spandrels are decorated with *putti* holding a variety of emblems and attributes. The eagle is one of the attributes of Jupiter.

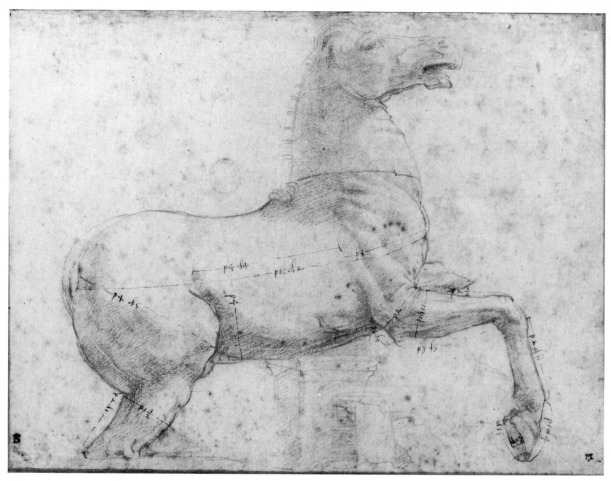

127

127. One of the Marble Horses of the Quirinal

Chatsworth 657
Red chalk over stylus underdrawing. Notes of
 measurement inscribed in brown ink. 218 × 272 mm.

A careful, measured drawing of one of the horses in
the famous colossal Antique group – the so-called
'Castor and Pollux' – which has stood on the
Quirinal Hill in Rome since ancient times. The
monument is generally explained as a Roman replica
of a Greek original of the fifth or sixth century BC.
The horse copied is the one inscribed OPVS PRAX-
ITELIS. The drawing shows most of the left foreleg
broken off.

Raphael's interest in Antique sculpture and
architecture was recognised by his appointment in
1515 as official inspector of all Antiquities in Rome
and within a radius of ten miles of the city; but no.
127 is unusual, if not unique, in being a correct and
carefully measured drawing by him of a piece of
Antique sculpture. Like no. 114 it has been kept in

the Devonshire Collection under the name of
Raphael since the early eighteenth century, and like
no. 114 it is nowhere referred to in the Raphael
literature. Recently, J. A. Gere, John Shearman and
James Byam Shaw have all independently recog-
nised that it must be by Raphael. It was first
published by the last-named in the catalogue of the
exhibition of drawings from Chatsworth circulated
in the United States by the International Exhibitions
Foundation in 1969–70 (no. 56 in the catalogue).

In the opinion of Arnold Nesselrath (*Burlington
Magazine,* cxxiv (1982), p. 357) the measurements
are not inscribed in Raphael's hand. It does seem
reasonable to suppose that Raphael would have
delegated to an assistant the mechanical task of
measuring the statue.

128

128. Two studies of the Belvedere Torso

Ashmolean Museum P II 625
Red chalk over stylus underdrawing. 240 × 401 mm.
Literature: KTP 625; P 529 b; R 164; Ruland, p. 346, viii, 1.

Copies, taken from two slightly different points of view, of the fragment of an over-lifesize Antique marble statue of a seated man, perhaps a *Hercules*, which has been in the Belvedere of the Vatican since the very early years of the sixteenth century. During the High Renaissance it was one of the most prized of all Antique works of sculpture, and the name by which it is sometimes known, 'the Torso of Michelangelo', reflects his particular admiration for it.

No. 128 was one of Lawrence's Raphael drawings selected by Samuel Woodburn for exhibition in the Lawrence Gallery in 1836. It was no. 11 in the catalogue of the Ninth (Raphael) Exhibition, where it was described in enthusiastic terms: 'this most admirable drawing ... is one of the finest studies by this great master'. Passavant nevertheless dismissed the attribution to Raphael out of hand; Ruland, for what his opinion on this point is worth (see no. 129), accepted it; Robinson again rejected it, but with the comment 'apparently by one of the ablest of Raffaello's scholars, perhaps Polidoro da Caravaggio'; Parker included it under Raphael's name, but relegated to a section of copies after the Antique traditionally connected with him 'only a few (of which) can claim to belong even to the master's remoter following'.

Robinson's suggestion of Polidoro cannot be sustained once the drawing is compared with the copy in Berlin, also in red chalk, of a detail of a battle-sarcophagus in the Museo delle Terme, in which his highly individual graphic style is unmistakably apparent (*Zeichner sehen die Antike,* exh. Berlin-Dahlem, 1967, no. 72, pl. 41). It seems to us that the old attribution to Raphael of this most impressive drawing deserves serious reconsideration. The present exhibition provides an opportunity of making direct comparisons with a study after the Antique in the same medium, now generally accepted as being by him (no. 127), and with such red chalk figure-studies as no. 102. The masterly freedom of the stylus underdrawing, the streaky hatching, the fall of light on the chest of the right-hand figure and the incisive accent with which the outline of the stomach is emphasised, and the way in which the surface of the marble has been brought to life and transformed into something almost suggestive of flesh and blood, are all features that suggest the possibility of Raphael's authorship.

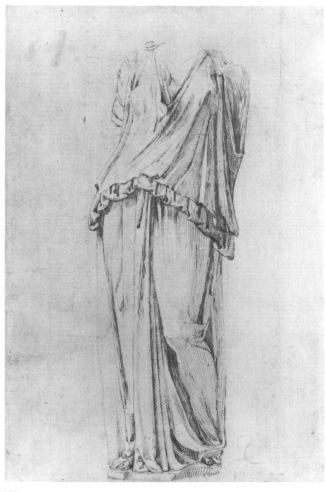

129

Parker referred to a drawing in the sketchbook of Marten van Heemskerck of the torso 'as it then actually appeared, lying on its back' (C. Huelsen and H. Egger, *Die Römischen Skizzenbücher von Marten van Heemskerck,* Berlin, 1913, i, fol. 63; Fischel, 1948, pl. 213 b.). Since the sketchbook is datable 1532–35, this would seem to establish a dating for no. 128, in which the torso is upright, later than the lifetime of Raphael, were it not that on fol. 73 of the sketchbook the torso is also drawn in an upright position. Huelsen and Egger pointed out that the drawing on fol. 63 should not necessarily be taken as a factual record, since the torso is shown in conjunction with part of an Egyptian obelisk never in the Vatican collection; there are several examples in the sketchbook of the fanciful juxtaposition of objects, and this drawing too may be in the nature of a *capriccio.*

129. A standing, headless female figure: after the Antique

Ashmolean Museum P II 466
Pen and brown ink. 380 × 246 mm.
Literature: KTP 466; P 529, *i*; R 161; Ruland, p. 346, vii, 1.

Parker cited Phyllis Pray Bober's authority for the identification of the Antique original as a statue of a type derived ultimately from the Caryatids of the Erechteum, once in the Della Valle-Capranica Collection and now in the Villa Medici (M. Cagiano de Azvedo, *Le Antichità di Villa Medici,* 1951, p. 38, no. 4 and pl. xiii, 19).

The drawing was part of Lawrence's Raphael series. The attribution to Raphael was rejected by Passavant; Ruland accepted it, but along with a number of other copies after the Antique that plainly have nothing to do with Raphael; Robinson again rejected it, though with the comment that the drawing was 'masterly' and 'evidently of the Raffaellesque technic and period'; Dollmayr grouped it with the similarly detailed pen and ink copies of two of the figures of *Victory* on the Arch of Titus (KTP 465 and no. 145 *verso*) and gave them all to Peruzzi; the attribution to Peruzzi was adopted by Parker but was rejected by Frommel (p. 73).

The copy on no. 145 *verso* could well be by the same hand as no. 129; and since there seems good reason for attributing no. 145 *recto* to Raphael, the

traditional attribution of no. 129 should at least be re-examined. The technique is tight, but in no way laborious, and the quality and intelligence are unusually high for a copy of this kind. Raphael's tendency in his drawings to simplify the structure of forms is parallelled in the division of the left knee of the figure (as of the fingers in no. 145 *verso*) into flat facets.

On the *verso* of no. 129 is an inscription, which Parker transcribed. It is not in the hand of Raphael; nor, as Parker claimed, is it in Peruzzi's. An example of the latter's handwriting is the five-line inscription on a drawing in the British Museum (P & G 240 *recto*).

130. Profile of the interior entablature of the Pantheon

British Architectural Library/RIBA, Pall. XIII, fol. 1.
Pen and brown ink. 220 × 180 mm.

This profile of the main entablature of the interior of the Pantheon had somehow found its way into one of the volumes of the Burlington–Devonshire Collection of drawings by Palladio, deposited on permanent loan in the library of the Royal Institute of British Architects. R. Lanciani was the first to recognise it as by Raphael (*Rendiconti dell'Accademia dei Lincei,* 1895, p. 15); it has also been discussed by G. Zorzi (*Palladio,* N.S., i–ii (1952), pp. 171 ff.) and H. Burns (*Andrea Palladio,* exh. London, 1975, no. 489).

The Pantheon was one of the most frequently studied of all ancient Roman monuments. It would have been natural for Raphael, increasingly occupied as he was by architectural interests, to have made a detailed drawing of a feature of so well-known a building. The inscriptions recording the measurements of the elements of the entablature are in his hand. Others, in various hands, record attributions to him and also to Giulio Romano and Giovanni da Udine.

130

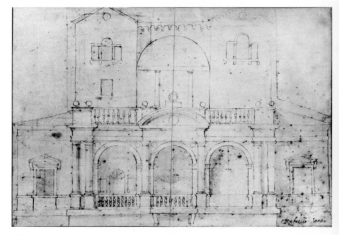

131

131. Elevation of the facade of a villa

Ashmolean Museum P II 579
Pen and brown wash over stylus underdrawing partly
 drawn with a ruler. The sheet much faded as a result of
 'restoration'. 250 × 362 mm (maximum measurements:
 the sheet has been irregularly trimmed).
Literature: KTP 579; P 560; R 165; Ruland, p. 300, i, 1.

Inscribed in ink in lower right corner: *Rafaello
Santio*. On the *verso* are some roughly drawn
ground-plans inscribed with measurements, etc.
 Passavant and Ruland accepted the old attribu-
tion, but it was rejected by Robinson, who thought
the drawing a product of the studio – 'the technical
execution, although to a certain extent resembling
that of the great master, seems to reveal a heavier and
feebler hand' – and denied that Raphael was respons-
ible for any of the inscriptions. Parker, who included
it under the heading 'School of Raphael', was the
first to suggest the possibility of a connexion with
the Villa Madama, begun *c.* 1518 on Raphael's
designs for Cardinal Giulio de' Medici. He pointed
out a feature of the design that had not previously
been remarked, that the pediment over the central
arch is surmounted by the Medici device of a ring set
with a pointed diamond.
 Shearman (*Studies in Renaissance and Baroque Art
presented to Anthony Blunt,* 1967, pp. 12 ff.) gave the
drawing without hesitation to Raphael, and claimed
that the dimensions, etc. inscribed on the *verso* are in
his hand. He took up Parker's suggestion that the
recto design is for the Villa Madama and connected it,
more specifically, with the east façade of the house
looking towards the Tiber; he compared the
ground-plans on the *verso* with those by Antonio da
San Gallo the younger, who succeeded Raphael as
architect of the Villa. He also noted another possible
allusion to the Medici in 'the six *palle* ... laid out
punningly along the balustrade'.
 He subsequently revised this opinion. In the
Supplement to Parker's catalogue Macandrew
records (p.279): 'in a lecture given in Oxford during
November 1977 Shearman withdrew the suggestion
of a possible association with the Villa Madama; he
now believes that the drawing represents Raphael's
adaptation of the previous villa (belonging to a
Sienese doctor called Arcangelo) which stood on the
same site, and for which he has documentation'.

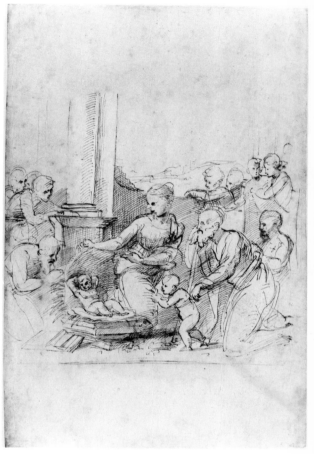

132

132. The Adoration of the Shepherds

Ashmolean Museum P II 564
Pen and brown ink. 405 × 266 mm.
Literature: KTP 564; P, p. 513, *cc*; R 76; Ruland, p. 35,
 viii, 1; C & C, i, pp. 353 f.; F 361.

We agree with Robinson and Fischel in dating this
drawing towards the end of the period of Raphael's
activity in the Stanza della Segnatura, *c.* 1510–11.
Parker seems to disagree, in so far as his opinion is
implied by his inclusion of no. 132 in a section
headed 'Later Roman Period', which he defines as
from *c.* 1514 onwards.
 The purpose of no. 132 is not known. A crude

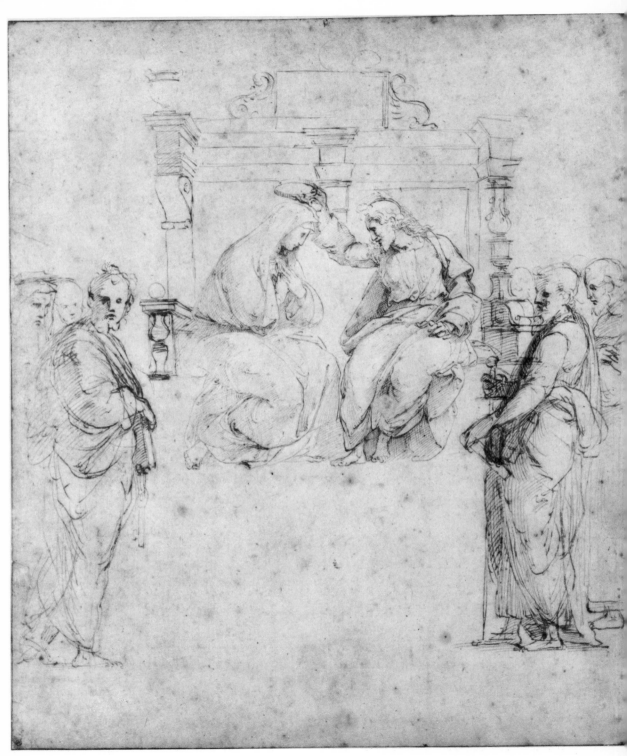

133

adaptation of the design, in the Louvre (F, fig. 288), appears to be by the hand generally identified as that of Tommaso Vincidor, Raphael's Bolognese associate who was especially involved with his activity as a tapestry designer (see P & G, pp. 87 ff.). It includes portraits of Leo X and two prelates and has been connected by Fischel with a project for tapestry hangings for the Pope's bed described in a letter from Vincidor dated 20 July 1521. There is no reason to suppose that no. 132 itself was necessarily made in connexion with tapestry.

133. The coronation of the Virgin

Ashmolean Museum P II 565

Pen and brown ink over stylus underdrawing. 353 × 289 mm.

Literature: KTP 565; P 492; R 121; Ruland, p. 254,6; C & C, ii, pp. 460 ff.; F.384.

The stylus underdrawing includes at least one figure, apparently of an angel, in front of the base of the throne to the right.

Two variants of the composition are known. In an engraving by the Master of the Die (B xv, p. 189, 9: copy, B xiv, p. 64, 56) the throne is in the form of a shallow curved recess closed at the top by a simple horizontal moulding. In front of the high base stand two child-angels examining a scroll, and on the left of it is the standing figure of the Baptist and on the right that of St Jerome. Above are the Holy Ghost and a half-figure of God the Father emerging from clouds.

The second variant is a drawing by G. F. Penni in the Louvre (3883; F, fig. 305), which must repeat faithfully an alternative design by Raphael himself. St Jerome is accompanied by St Francis in place of the Baptist, and both are kneeling at the foot of the throne. Behind Jerome stand the Baptist and St Peter; and behind Francis, St Paul and an unidentified saint. The back of the throne is flat, and over it is a flat rectangular canopy supported on turned posts.

Passavant found the engraving by the Master of the Die listed in a mid-eighteenth-century catalogue of the papal *Calcografia* with a note stating that it reproduced a tapestry in the Sistine Chapel. He concluded from this that the series of ten tapestries

illustrating the *Acts of the Apostles* woven for the chapel on designs by Raphael (see nos. 155 to 158) had been supplemented by an eleventh, intended for the altar-wall. This precariously based hypothesis was accepted without question by Robinson, Ruland and, in his 1898 volume (no. 258), by Fischel; while Crowe and Cavalcaselle with even less justification connected no. 133 with the second series of tapestries, the so-called *Scuola Nuova*, woven after Raphael's death on designs by Giulio Romano. Passavant's explanation seemed to be confirmed by the discovery in 1873 in a store-room in the Vatican of a panel of tapestry corresponding exactly in composition with the engraving by the Master of the Die (F, fig. 307), but critics were quick to point out that since the design embodies the arms of Pope Paul III the panel cannot be earlier than 1534 (see *Art Bulletin*, xl (1958), p. 216, n.72). The tradition that no. 133 is in some way connected with tapestry has nevertheless tended to persist, but it should be observed that the Sistine Chapel tapestries were woven from the back from a cartoon in the reverse direction to the final result. All the known preliminary studies for them are in the same direction as the cartoons, so that the action of the figures is back to front. This is not so in no. 133, in which the Virgin is seated in the traditional position on the right of Christ who is crowning her with his right hand. This drawing is therefore unlikely to be a preliminary study for a tapestry cartoon.

A more satisfactory clue to its purpose is provided by some very rough sketches on a badly damaged sheet in the Musée Bonnat at Bayonne (F 382/3). Drawn in isolation on the *recto* is the group of Christ crowning the Virgin; on the *verso* the group appears, enthroned and flanked by standing figures as in no. 133, in the upper part of a monumental composition with an arched top. In his 1898 volume, in which he described only the *recto* (the *verso* had not then been uncovered), Fischel referred briefly to the altarpiece known as the Monteluce *Coronation,* now in the Vatican Gallery (Shearman 1961, pl. 24c.). In his *corpus* he did not return to this suggestion, but it has recently been convincingly restated and elaborated by Shearman.

In December 1505 Raphael contracted to paint an altarpiece for the nuns of the convent of Monteluce, just outside Perugia. He was required to take as his

model, for size, degree of finish, colour, and number of figures ('perfectione, proportione, qualità et conditione ... et omne de colore et figure numero') and, implicity, for subject, Domenico Ghirlandaio's *Coronation of the Virgin* then in the church of S. Girolamo at Narni. This is an arched-top altarpiece divided horizontally into two sections with the Coronation taking place above and a group of saints below. Raphael negotiated a fresh agreement with the nuns in 1516, but the picture was still not begun when he died in 1520. Three years later the nuns returned to the attack and approached Giulio Romano and G. F. Penni, the joint inheritors of the business and goodwill of the Raphael studio. The altarpiece which they eventually received, in June 1525, is remarkable in being made up of two distinct panels painted by two distinct hands, the upper panel being clearly by Giulio and the lower by Penni. It follows the Ghirlandaio model only in the upper part, in which the Coronation of the Virgin is represented; the lower part shows the Apostles gathered round her empty tomb – a motif more appropriate to the lower part of an *Assumption*. Shearman put forward the ingenious theory that after Giulio's departure from Rome in the late summer or autumn of 1524 his collaborator, remembering the nuns' stipulation that any money paid in advance must be refunded if the painting was not completed within a year, concocted an 'instant' altarpiece by sawing off the upper part of the hypothetical *Assumption* postulated by Shearman as having been commissioned from Raphael for the Chigi Chapel in S. Maria del Popolo (see no. 109) and executed posthumously on his design by Penni, and substituting as much of the altarpiece intended for Monteluce as Guilio had had time to complete.

It seems very likely that the lower part of the Monteluce altarpiece is based on a design by Raphael. Shearman claims that the upper part also 'follows Raphael's preliminary drawings', but its resemblance to the principal group in no. 133 is of the most general kind; and of the three sketches on the Bayonne sheet, two differ from the picture in showing the Virgin kneeling while the third is so slight and so damaged that it is impossible to tell more than that she is seated. In their relative position and in their poses and gestures the two principal figures in any *Coronation of the Virgin* offer only the

narrowest scope for variety: in no. 133 and in the upper part of the painting they are both seated, and there the resemblance ends. On the other hand, Shearman's contention that the sketches on the Bayonne sheet, and thus also no. 133, are early ideas for the Monteluce altarpiece is most convincing. Raphael seems to have practised a rigorous intellectual economy: he was not given to doodling, and even his slightest scribbles were made for a definite purpose. These sketches are for a large-scale altarpiece, and from their style cannot be earlier than the very end of the Florentine period. Apart from the Oddi *Coronation* of 1502–3 (see no. 20), which is altogether too early, the only recorded commission for a painting of this subject is that from Monteluce. Furthermore, there are positive indications in the Bayonne sketches that when drawing them Raphael had the Ghirlandaio prototype in mind. The drawing on the *recto* and the larger of the two on the *verso* resemble the Narni *Coronation* in showing the Virgin kneeling and Christ holding the crown with both arms extended; in the smaller study on the *verso*, as Shearman pointed out, the top of the composition is occupied, exactly as at Narni, by a circular canopy with a conical upper part.

The two composition-sketches at Bayonne show Raphael departing from Ghirlandaio's old-fashioned two-tier arrangement in favour of one in which the figures of Christ and the Virgin and those of the attendant saints could be integrated into a single monumental group. To achieve this within a picture-area of the given shape and proportion it was necessary to bring the Coronation group lower down, and the sketches show two solutions to the problem of filling the gap thus produced at the top of the composition: in one, the back of the throne is enlarged into a shallow round-headed niche by the imposition of a vertical semi-circular moulding; in the other, the simple curve of the back of the throne echoes that of the base of the circular canopy above.

Neither solution, nor indeed any other way that might be imagined of filling the semi circular space above the throne, would seem to be appropriate in combination with no. 133, in which the back of the throne culminates in an elaborate superstructure of vases and a tablet supported by volutes or dolphins, which has the effect of emphatically closing the composition. The group would fit satisfactorily into

an arched top only if the arch were to begin on about the level of the heads of Christ and the Virgin; not only is no such arch indicated in the drawing, but such a solution applied to a panel of the shape of the Monteluce altarpiece would leave a no less awkwardly large blank area in the foreground. Everything about no. 133, and also the variant in Louvre 3883 in which the composition is closed even more emphatically by the flat rectangular canopy, suggests that it was conceived in in the form of a squarish rectangle and that it is complete in that form. It is true that the variant engraved by the Master of the Die is higher in proportion to its width in order to accommodate the figure of God the Father, but this is a clumsy addition made with no attempt to integrate it with the lower part, the composition of which, like that of the other two variants, has every appearance of being complete in itself. If, as seems possible, no. 133 is a study for the Monteluce commission, it is perhaps worth suggesting that Raphael may have considered the traditional Umbrian expedient of a separate lunette, as in his *Pala Colonna* of c. 1504 (New York); and that the apparently extraneous addition to the engraved variant may reflect – however remotely – Raphael's solution for such a lunette.

The date of no. 133 is a matter of conjecture. Obviously it cannot be as early as 1505, the time of the original commission; equally, its style suggests an earlier date than 1516, when the nuns reopened negotiations. In handling the drawing resembles some of the studies for the *Parnassus* (e.g. nos. 103, 104 and 106), and it has often been observed that the structure of the composition resembles that of the *Madonna del Baldacchino* on which Raphael was working shortly before his departure from Florence at the end of 1508 (see no. 63).

134. The angel appearing to Joachim

Ashmolean Museum P II 563

Pen and brown ink and yellowish-brown wash over black chalk, heightened with white. 314 × 276 mm.

Literature: KTP 563, P, p. 513, ii; R 167; Ruland, p. 108, C, ii, 1; F 386.

On the *verso* (F, fig. 308; repr. in reverse) is a drawing in pen and ink of Joachim and Anna meeting at the Golden Gate.

The traditional attribution to Raphael was rejected by Passavant and by Robinson. Passavant put forward no alternative, but Robinson catalogued the drawing under the heading 'Florentine or Sienese School' with the suggestion that it might prove to be by Sodoma. Ruland also rejected the attribution, as also, *ex silentio*, did Crowe and Cavalcaselle. Fischel similarly omitted no. 134 altogether from his 1898 volume, but in his *corpus* he emphatically argued the case for Raphael's authorship, pointing out the stylistic affinities with drawings of the early Roman period. Parker likewise accepted the attribution to Raphael.

Fischel's further suggestion that both studies on the sheet may have been made in connexion with the predella of the Monteluce *Coronation of the Virgin* (see no. 133), though conjectural, deserves consideration. Raphael, who seems rarely, if ever, to have made drawings without some definite project in mind, may have been concerning himself with the Monteluce commission in about 1510–11 (see no. 133). The four panels composing the actual predella of the altarpiece are of roughly the same shape as no. 134. They were executed in 1525 by his Umbrian collaborator Berto di Giovanni and represent the *Birth, Presentation, Sposalizio* and *Death of the Virgin*, but the *Annunciation to Joachim* and *The Meeting at the Golden Gate* also form part of the cycle of the life of the Virgin and could have been considered as subjects for the predella. They occur, treated in a wholly different way, on the *sottarco* of the chapel in S. Maria Assunta at Trevignano referred to under no. 185, together with the *Birth, Presentation* and *Sposalizio*.

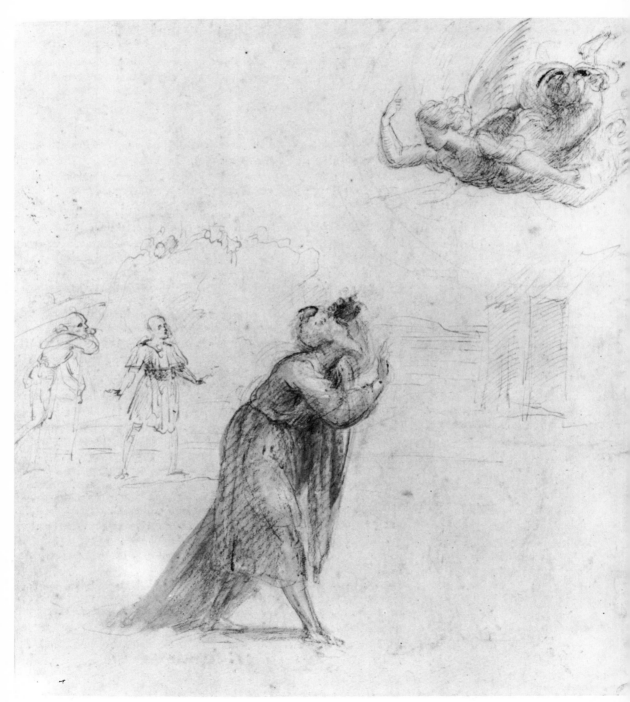

134

4 LATER ROMAN PERIOD, c. 1512 to 1520
Nos. 135–184

The death of Julius II in 1513 made no difference to Raphael's position, for his services were welcomed with equal enthusiasm by the new Pope, Leo X. His most important work for Leo was the series of cartoons for the tapestries intended for the Sistine Chapel (see nos. 155–8), on which Raphael was working from 1515 to 1516. Whether or not the cartoons are necessarily 'the Parthenon Sculptures of Modern Art' – as they were once described – in them Raphael established the canon of classical figure-composition from which the rules of the 'Grand Style' were ultimately derived. The decoration of the papal apartment continued with the completion of the Stanza d'Eliodoro in 1514, with some help from assistants in the subsidiary details; the Stanza dell'Incendio was carried out, with considerable help from studio assistants, between 1514 and 1517; the 'gioveni di Raffaello' were paid in 1517 for work in the Sala dei Palafrenieri (see no. 190), and between 1518 and 1519 they also executed the cycle of biblical scenes in the Logge – the arcaded loggia designed by Raphael which constitutes the entire second floor of the west side of the Cortile di San Damaso, and which was originally the main way of access to the Sala di Costantino into which it opens directly, and to the three *stanze* beyond. After Raphael's death in April 1520 such designs as he had made for the Sala di Costantino (see no. 181), the last room in the apartment to be decorated, were carried out with considerable modifications by his studio assistants under the supervision of Giulio Romano.

The paintings in the Stanza della Segnatura could be seen as the culmination of Raphael's Florentine experience, enriched and enlarged by the scale on which he was required to work and by the ambience of Rome itself. A decisive stylistic break occurs between this room and the adjacent Stanza d'Eliodoro. The lighting is more dramatic, the compositions and the figures in them are more animated, and the colour darker and more intense, the figure groups more tightly knit. Some of this change of style must be due to the effect on Raphael of Michelangelo's Sistine Ceiling. The ceiling was completed and unveiled in October 1512, but the first half had been finished two years earlier and it was no doubt then that Bramante, according to the tradition recorded by Vasari, surreptitiously introduced Raphael into the chapel. Such a drawing as no. 143, for a figure in the *Expulsion of Heliodorus*, reflects the tendency towards a freer and more vigorous style of drawing. This 'Baroque' phase in Raphael's development was followed in the tapestry cartoons by a return to the more measured style of the Stanza della Segnatura, but with a much greater degree of academic idealisation.

The Pope was always Raphael's principal patron, but he found time to carry out commissions for highly placed individuals at and around the papal court, especially for Leo's nephew, Cardinal Giulio de'Medici (later Pope Clement VII), and for his banker Agostino Chigi. For Chigi, Raphael designed and partly decorated one family chapel, in S. Maria del Popolo (see nos. 153–54), and decorated another, in S. Maria della Pace (see nos. 149–52); in the Chigi villa, now the Farnesina, he painted the fresco of *Galatea* and later planned the decoration of the Psyche loggia (see nos. 159–64). Commissions for Giulio de'Medici included Raphael's last, unfinished painting, of the *Transfiguration* (see nos. 174–80).

Raphael's large output was achieved only with the help of a highly organised team of

studio assistants. This expedient was forced on him by pressure of work and the ever-increasing importunities of his patrons. (In 1514, for example, Leo X appointed him chief architect of St Peter's in succession to Bramante, and in the following year made him responsible for inspecting, and if necessary acquiring, all antiquities discovered in or near Rome.) As commissions multiplied, his analytical intelligence enabled him to 'break down' a complex project into a sequence of stages which could mainly be entrusted to individual assistants; his early experience as a pupil in the studio of Perugino would have taught him the value of this systematic procedure. Raphael himself must have conceived the initial design in some form or other, but his assistant Giovanni Francesco Penni, an artist totally lacking in original creative talent but whose *rapport* with him was clearly very close, seems to have been able to elaborate his ideas into *modello* drawings explicit enough to serve as the basis for detailed cartoons. Examples of such drawings are the Logge *modelli* (nos. 191–6). Of the studies for separate figures or groups of figures in such late commissions as the Farnesina loggia, the *Transfiguration* and the *Battle of Constantine*, some are clearly by Raphael himself while others seem inferior in quality and therefore more likely to be the work of assistants. But only a very small fraction has survived of the enormous number of preparatory drawings that such projects must have involved, and the evidence is too scanty to enable any exact picture of the working procedure of the studio to be formed. The difficulty of distinguishing the master's hand from those of his pupils is that they were expected as a matter of course to model their style as closely as possible on his. Raphael's genius as a teacher is shown by the fidelity with which his pupils emulated his style while he was alive, and by the success with which some of them used this foundation to develop into independent artistic personalities.

Though Raphael was only thirty-seven when he died, his development was so prodigiously rapid that it seems to have followed the usual parabola of youth, maturity and age. Nevertheless, it is misleading to describe his last works as 'late' in the sense in which the word is applied to the productions of an artist's declining years. The *Transfiguration* is not to be seen as the equivalent of Michelangelo's *Crucifixion* drawings or Titian's *Entombment*. If Raphael had lived the normal span of life, he would have died in the 1540s or even 1550s; how his style might have evolved is an interesting subject of speculation. Whether or not his capacity for assimilation could have been sustained at the same rate, it is unlikely that his exceptionally sensitive response to current tendencies would have diminished. He might have evolved in the direction of the Mannerism already implicit in his later work, the elements of which were extended so fruitfully, and in quite different directions, by his pupils, Giulio Romano, Perino del Vaga and Polidoro da Caravaggio. But exactly what form that tendency would have taken if followed by an artist of Raphael's stature is impossible to imagine. On the other hand, it can be claimed that such late compositions of his as the tapestry cartoons, the *Spasimo di Sicilia* and the *Transfiguration,* with their tendency towards a systematised and rhetorical vocabulary of gesture and facial expression, anticipate in some respects the idealised academic classicism of the seventeenth century.

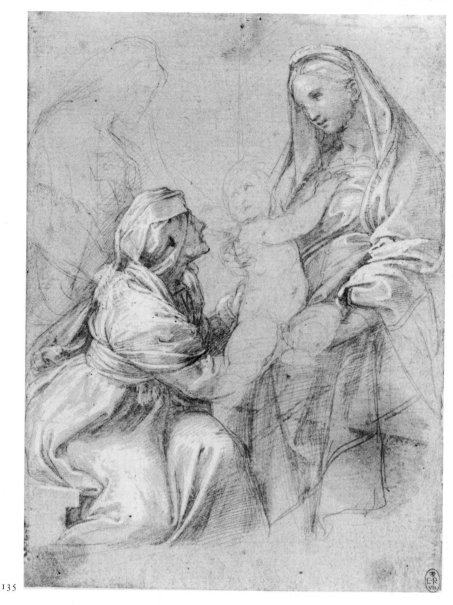

135

135. The Virgin and Child with St Elizabeth and a female saint (St Catherine?): the *Madonna dell'Impannata*

Windsor 12742
Metalpoint, heightened with white, on pale brown
 prepared paper. 210 × 145 mm.
Literature: AEP 800; P 426; Ruland, p. 81, xli, 4; C & C, ii,
 p. 171, n.; F 373.

The *Madonna dell'Impannata* in the Palazzo Pitti in
Florence (so-called from the blind on the window in
the right background, the panel being considerably

wider than the drawing in proportion to its height)
was executed in Raphael's studio on his design. The
date *c.* 1513–14, on which all critics seem to agree, is
consistent with the style of the two related draw-
ings.

No. 135 corresponds with the principal group,
consisting of the Virgin and Child with St Elizabeth
and a younger female saint usually identified as St
Catherine. It does not include, and does not seem
necessarily to have been designed with a view to
including, either the full-length seated figure of the
youthful Baptist in the lower right corner, or the

half-length figure of St Joseph seated in profile to left with behind him a youthful head, evidently the Baptist's, which an X-Ray photograph has revealed underneath the full-length Baptist (see P. Sanpaolesi, *Bollettino d'arte,* xxxi (1938), pp. 495 ff.). That Raphael himself was responsible for this change of plan is established by a sheet of studies in Berlin (F 374), like no. 135 in metalpoint and likewise certainly from his hand, on which is a drawing for the Infant Christ as in the painting and another for the Baptist as eventually represented.

136. The Virgin and Child with Tobias and the Angel and St Jerome: the *Madonna del Pesce*

Private Collection
Brush drawing in brown, heightened with white, over
 black chalk. 258 × 213 mm.
Literature: P, p. 538, *jj*; Ruland, p. 74, ii, 10; F 372.

The altarpiece now in the Prado for which this drawing is a study is generally dated *c.* 1513–14. With the exception of Fischel (1948, p. 140) recent critics have attributed its execution partly or wholly to studio assistants.

An earlier stage in the design is represented by F 371 (Uffizi), a life study in red chalk from models posed in the studio. The attitudes of the three attendant figures are there more explicit than in no. 136 or indeed in the painting itself. Tobias is clearly kneeling on his left knee; the right leg and left foot of the angel are visible; and the indication of St Jerome's left leg shows that he is kneeling against the base of the throne.

The painting differs from no. 136 in certain details. The step of the throne is seen from directly in front; the sides of the throne itself are in the form of flat-fronted balusters, whereas in the drawing they are curved and the throne apparently an elaboration of the plain 'Savonarola' chair in the Uffizi sketch, which was no doubt a piece of studio furniture; the St Jerome in the drawing is an altogether more ascetic-looking type than in the painting, and appears to be bare-chested.

An alternative position for the head of St Jerome in the space between his head and the left arm of the Infant Christ enables the apparently meaningless jumble of lines on the saint's chest to be explained as

an indication of the left shoulder and upper arm in the rejected position in which he is craning forward with his head and the upper part of his body.

Fischel (1948, p. 140) claimed that no. 136 is squared and therefore the definitive *modello* from which the full-scale cartoon for the painting was enlarged. The details in which the drawing differs from the final result are not such that they could not, in theory, have been adjusted on the cartoon itself, but we can see no trace of the squaring which would have been essential for enlargement. Exactly where this drawing belongs in the sequence of preparatory studies is not immediately obvious. There can surely be no doubt about Raphael's authorship. Dussler (p. 38) is the only recent critic to follow Passavant in rejecting it, but he proposed no alternative. To do so convincingly would be difficult, for though Raphael's composition studies for paintings are not usually so highly finished, and though he seems rarely to have taken such trouble to establish so exactly every gradation of tone, the high quality and intelligence of the drawing, to say nothing of the beauty and psychological intensity of the facial expressions, seem far above the level of Penni or even Giulio Romano, the two studio assistants most likely to have been involved in the execution of the painting.

No. 136 corresponds exactly with the crudely executed Marcantonio School engraving attributed by Bartsch to Marco da Ravenna (B xiv, p. 61,54), but it was not necessarily made on purpose for the engraver: Raphael would hardly have gone to such trouble even for Marcantonio himself. One explanation of the unusually – and, for a working drawing, perhaps even unnecessarily – high degree of finish in no. 136, is that it was a *modello* intended for submission to the patron who had commissioned the altarpiece; alternatively, Raphael might have felt obliged to be particularly explicit when making a design for an important commission that was to be executed by studio assistants.

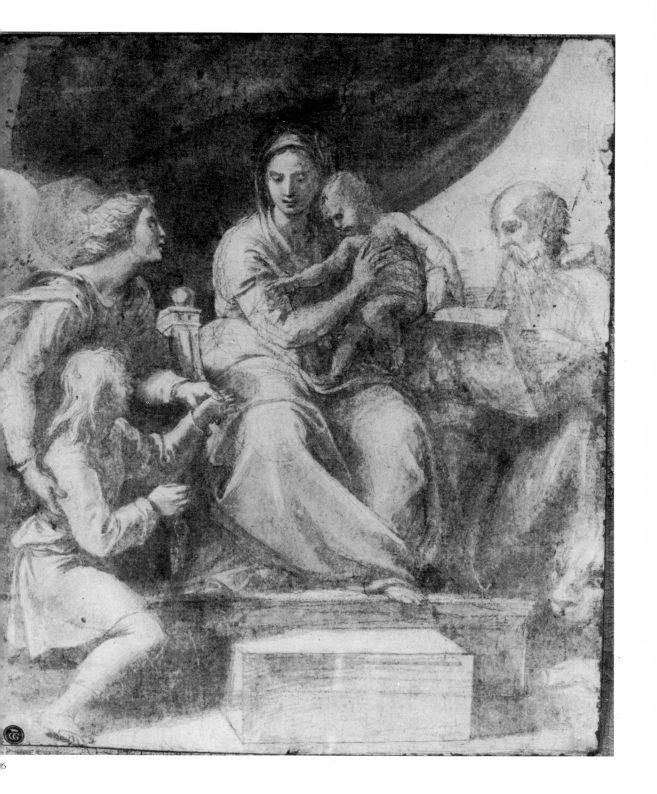

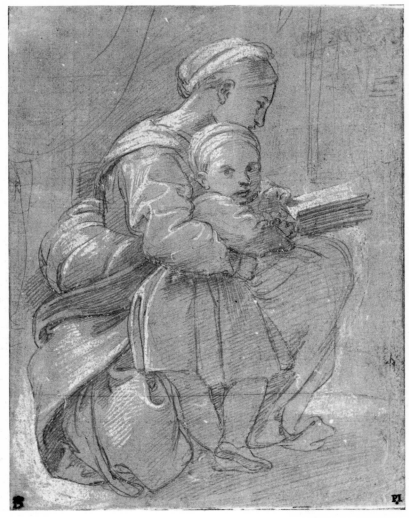

137

137. A seated woman reading, embracing a child standing at her side

Chatsworth 728

Metalpoint, heightened with white, on grey prepared
 paper. 191 × 141 mm.
Literature: P 565; Ruland, p. 97, xlvii, 2; F 375.

Nos 137 and 138 resemble one another so closely in
technique, subject, treatment and spirit that they are
more conveniently discussed together. Both com-
positions are engraved in the manner of Marcan-
tonio, in the same direction as the drawings: Bartsch
attributed the engraving of no. 138 to a follower of
Marcantonio (B xv, p. 20, 11) and that of no. 137 to
Marco da Ravenna (B xiv, p. 54, 48). The traditional
attribution of the drawings to Raphael seems never
to have been questioned.

The parallel that Robinson drew between no. 138
and the metalpoint studies for *The School of Athens* is
solely one of technique. Fischel, more acutely,
stressed the resemblance between both drawings
and the group of women and children in the left
foreground of *The Miracle of Bolsena* in the Stanza
d'Eliodoro. This fresco is dated 1512, and the two
drawings can reasonably be placed at about the same
period. Raphael's purpose in making them remains a
matter of speculation: the high degree of finish, the
absence of *pentimenti* and the apparent completeness
of both compositions suggest that they were made
either as ends in themselves or – and perhaps more
likely – expressly with a view to their being
engraved. The usual interpretation of the subject as
The Virgin and Child may well be correct, but the
possibility that Raphael was here trying his hand at a

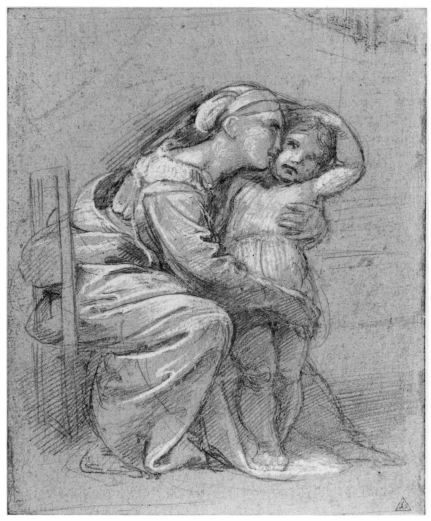

138

scene of domestic *genre* cannot be excluded. Robin-son entitled no. 138 'A study for the Virgin and Child' but went on to say that it has every appear-ance of being 'a study or reminiscence from nature of a young mother and child', and it is unusual to find the Christ Child so fully dressed as in no. 137, in a cap and shoes and even leggings. On the other hand, the figure of a man, who might have been intended as St Joseph, is very lightly drawn in the window top right in no. 137, but has been scratched out in metalpoint, apparently by the draughtsman. In the engraving the window is covered by shutters.

Fischel, ever on the look-out for signs of later reworking, claimed that the white heightening on both drawings is largely the work of a later hand. Parker doubted this in the case of no. 138 and we agree with him: there is surely no trace of any later

reworking on either drawing. Whether they formed part of one of the two hypothetical 'Early Roman Metalpoint Sketchbooks' which Fischel claimed to have in part reconstructed (see *Burlington Magazine,* lxxxiv (1939), pp.81 f.) seems to us a question of slight importance.

138. A seated woman embracing a standing child (The Virgin and Child?)

Ashmolean Museum P II 561
Metalpoint, heightened with white, on grey prepared
 paper. 161 × 128 mm.
Literature: KTP 561; P 489; R 79; Ruland, p. 97, xlvi, 2;
 F 376.

See no. 137.

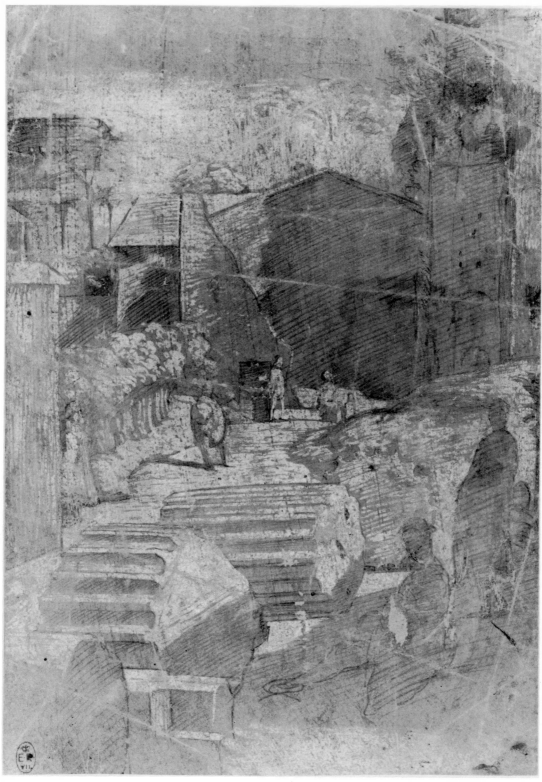

139

139. Landscape with ruins

Windsor 0117
Metalpoint, heightened with white, on pale brown
 prepared paper. Somewhat rubbed. 270 × 355 mm.
Literature: AEP 801.

Discovered in about 1930, without attribution, by
Sir Owen Morshead, the then Librarian at Windsor
Castle, who observed its correspondence in reverse
with the landscape in the right background of the
composition of a scene of plague known as '*Il
Morbetto*', engraved by Marcantonio after a design
by Raphael (B xiv, p. 314, 417). The figures in the
right foreground of the drawing are omitted in the
print as are the two foreground drums of the fallen
column, while in the background a dead horse is
substituted for the obese personage standing in the
roadway.

 Kenneth Clark, who first published the drawing
(*Vasari Society,* 2nd series, xii (1931), no. 6), argued
that it was not necessarily drawn with the engraved
composition in mind, and that Raphael may have
adapted a landscape sketch originally made with no
definite end in view. Such a sketch would have no
parallel in Raphael's surviving work, but it is
certainly true that the way in which the composition
is fitted into the rectangle suggests that it was
intended to be complete in itself. Clark's suggestion
that the place represented might be in the neigh-
bourhood of the Forum of Trajan may well be
correct, but we have been unable to find confirma-
tion in any of the views of that part of Rome
published by H. Egger in his *Römische Veduten,*
Vienna, 1932.

140. Head of Pope Julius II

Chatsworth 50
Red chalk on brownish paper. 360 × 253 mm.
Literature: Ruland, p. 150, xiii, 9 (giving the medium as
 black chalk); C & C, ii, p. 103; F 257.

No. 140 is something of a puzzle, for there is no
drawing by Raphael with which it can be effectively
compared. It corresponds exactly in size, in outline,
and in lighting, with the head of the portrait in the
National Gallery which Oberhuber has convin-
cingly established as Raphael's original painting (see

Burlington Magazine, cxiii (1971), pp. 124 ff.). The
exact correspondence with the head as painted, the
regular and unaccented handling of the chalk, the
schematic breaking down of the structure of the
head into its component elements, and finally what
in our view can only be described as a certain
dullness and lack of charm, combine to produce an
effect that has led some critics – for example, Crowe
and Cavalcaselle, and Popham in an annotation in
the Chatsworth catalogue – to dismiss the drawing
as no more than a copy of the painted portrait. This
conclusion was eloquently challenged by Fischel
(1948, p. 93): 'in spite of all that complacent or
petty-minded doubters may say, the mark of
genuineness is set – or enthroned – on this forehead,
with its rock-like structure, and around the eyes
with their bushy brows there lurks something of the

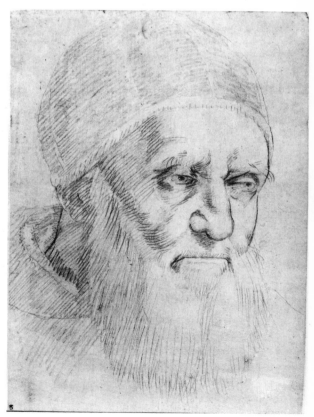

140

vital character of an heroic landscape – steeps and chasms overhung by storm-beaten trees'. The same view was expressed more succinctly by Oberhuber with the word 'superb' (op.cit., p. 128). In his *corpus* Fischel sought to explain the sketchy character of the drawing on the grounds that it was made directly from life and probably – in view of the Pope's notoriously impatient temperament – in a hurry.

No proper comparison between no. 140 and the final painting had been possible until the latter was cleaned. This has revealed a very much more powerful degree of psychological intensity than is apparent in the drawing. In the painting the Pope's brooding, abstracted gaze and the baleful set of his lips reflect an alarmingly formidable personality; in the drawing, by contrast, there is something amost benign about his grimness. It seems improbable that one should have served as basis for the other. The drawing lacks the spontaneity and vividness normally characteristic of a portrait-study from life. There is an element of contrivance about the simplification of the forms and their reduction to an almost abstract pattern that suggests that if this is a working drawing it is one made at a more advanced stage in the evolution of the portrait. The scale, too, seems unduly large for a study from life. The exact correspondence with the painted head – a material fact not hitherto remarked – is surely significant; and the hesitant outlines of the cap and shoulders reinforce the impression that no. 140 is based on a tracing, the contours of which were strengthened in such passages as needed to be more explicit, like the neck, eyes, nose, mouth and left cheek. The thinness of the paper and its unusual colour are consistent with its having been oiled, a means of making tracings used before the invention of tracing-paper. But whether the original tracing – assuming that this explanation is correct – was made from the cartoon which presumably preceded the painting or from the painting itself, why it was made, and who made it, remain matters of conjecture.

141. Portrait-drawing of an ecclesiastic

The Earl of Pembroke and Montgomery
Black, red and white chalk. 300 × 239 mm.
Literature: Sidney, 16th Earl of Pembroke, *A Catalogue of the Paintings and Drawings in the Collection at Wilton House,* 1968, p. 95, no. 26.; F-O, p. 74.

Inscribed in gold on the seventeenth-century mount: *R.URB.PI: P.LEO.X.*

Though this drawing has been at Wilton House since the early eighteenth century, if not before (it bears Sir Peter Lely's stamp, and may have been bought by the eighth Earl of Pembroke at his sale in 1688), it is only in very recent years that the traditional attribution to Raphael has been taken seriously. It was even overlooked by Ruland, who on the whole missed very little; it was not included by Arthur Strong in his selection of the best drawings in the Wilton House collection published in 1900; and for some reason it escaped being sold with the bulk of the collection in 1917. The attribution to Raphael was endorsed in about 1966, when the late Lord Pembroke, then engaged on the catalogue of his collection, brought the drawing to the British Museum. He disclosed that it had been seen by Fischel, who had suggested an attribution to Jacopo Bassano.

Raphael's authorship was accepted unquestioningly by Oberhuber, who saw a resemblance between this head and some of those in the *Transfiguration* and accordingly dated the drawing in Raphael's very last years. The resemblance does not seem to us so striking that the drawing could not date from earlier in the artist's Roman period: in our opinion it could have been drawn at any time from about 1513 onwards, but its unusual character and technique make the question of its date one that cannot be answered with any certainty.

Raphael has here engaged with the personality of his sitter in a way more usually characteristic of his painted portraits. With the exception of the Chatsworth head of Leo X (no. 183), his authorship of which is by no means certain, the Wilton drawing suggests an altogether more intense degree of psychological insight than we find in other drawings by him that might be described as portraits (e.g., nos. 34 and 68). It is also remarkable for its unusual technique, which was no doubt responsible for

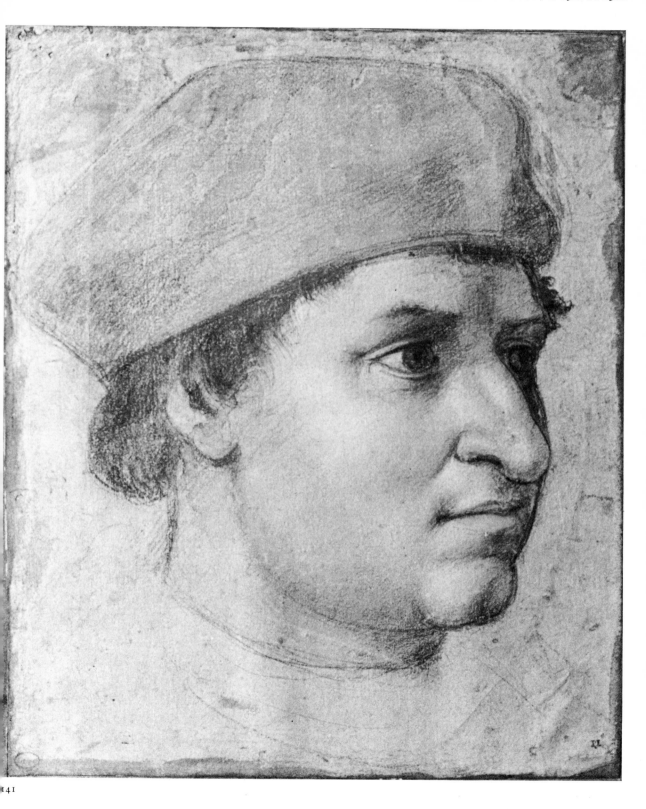

141

misleading Fischel in the direction of Jacopo Bassano, whose drawings often are in coloured chalks. So far as Raphael is concerned the only comparable instance is the sketch at Fenway Court of a Pope in the *sedia gestatoria* surrounded by his entourage (F-O 490; repr. in colour as frontispiece in R. van N. Hadley, *Drawings [in the] Isabella Stuart Gardner Museum,* Boston, 1968), in which black, red and yellow chalks are combined together with a few touches of white heightening; and which Oberhuber and other recent critics are no doubt right in attributing to Raphael himself and explaining as a sketch for an unexecuted project for the Sala di Costantino.

The old inscription identifies the portrait as that of Leo X, which is of course out of the question. The red *berretta* suggests that the personage represented is a Cardinal, but so far we have not been able to identify him.

142. Portrait of Valerio Belli

The Hon. Alan Clark
Oil on panel. Circular:120 mm diameter.

The identification of the subject as the Vicentine medallist and gem-engraver Valerio Belli (1468–1546) is confirmed by comparison with the woodcut in the 1568 edition of Vasari, based on a drawing attributed to Parmigianino in Rotterdam (A. E. Popham, *Catalogue of the Drawings of Parmigianino,* 1971, no. 569), and with two portrait medals (G. F. Hill, *Portrait Medals of Italian Artists of the Renaissance,* 1912, pl. xxiii, nos. 24 and 25). All these likenesses show the head in profile to left, as in no. 142.

The painted portrait was acquired by Lord Clark in the 1930s together with a companion portrait by another hand, which was later stolen. This pair of portraits has been plausibly identified with the two

142

described in about 1650 by Girolamo Gualdo in his catalogue of the family collection of works of art in Vicenza, known as the 'giardino di Chà Gualdo' (see *Nuovo archivio vento,* viii (1894), pp. 207 f. and 388): one was a portrait of Valerio Belli said to be by Raphael and to have been painted on the occasion when Belli acted as godfather to a daughter of his, on a box-wood roundel two *palmi* in circumference on which the artist inscribed his name F. R., for *fecit Raphael* ('Questo [Belli] essendo suo [Raphael's] compare per una figlia, che li tenne, gli fece il suo ritratto in un tondo di bosso di giro di due palmi, dove pose il suo nome F. R. fecit Raphael'); the other was a small portrait on panel by the Vicentine painter Giovanni Antonio Fasolo (*c.*1530–72) of Valerio Belli's son, the physician Elio Belli (d. 1576), which made into a box together with Raphael's portrait of the father ('un ritrattino in tavola d'Elio medico, figlio di Valerio Belli, che si unisce come un bossolo con quello fatto al suddetto Valerio da Raffaello'). The two portraits were evidently contained in a shallow turned wooden box, one in the body of the box and the other inside the lid. Miniatures and small portraits were often kept in this way in the sixteenth and seventeenth centuries.

The *palmo* was a unit of measurement equivalent to about 22 cm. The diameter of a circle 44 cm in circumference is about 14 cm, which fits well enough with the size of no. 142. It should be noted, however, that there is no sign of the signature 'F. R.' described by Girolamo Gualdo. The attribution to Raphael was accepted by Fischel (1948, p. 122), Popham (loc.cit.) and Dussler (p.42).

G. Zorzi (*L'arte,* xxiii (1920), p. 184) claimed that documentary evidence exists establishing that Valerio Belli came to Rome in the 'early months' of 1520. Popham, on the other hand, states that the portrait was probably painted in 1517, and Dussler dates it 1516–17. The question could probably be settled if we knew the date of the christening of Raphael's daughter – if she ever existed: we have been unable to find any other reference to her, and Gualdo's has the flavour of the kind of romantic embellishment indulged in by some seventeenth - century biographers.

143. A kneeling woman with two children; a separate study for her head

Ashmolean Museum P II 557 *verso*
Black chalk. 395 × 259 mm.
Literature: KTP 557; P 512; R 85; Ruland, p. 200, 33;
 C & C, ii, p. 140; F-O 399.

A study for the kneeling woman holding two children close to her immediately to the right of the *sedia gestatoria* in the group on the left of *The Expulsion of Heliodorus* in the Stanza d'Eliodoro. Another study for the figure, in the Kunsthaus in Zurich (F-O 397), shows her standing, as she appears in the copy of an early study for the whole composition in the Albertina (F-O 396). Shearman (1965, p. 168) pointed out that the standing pose is derived from an Antique figure of Niobe protecting one of her children. The prototype would seem to have been a variant or version of the statue in the Uffizi, which was not unearthed until 1583 (see F. Haskell and N. Penny, *Taste and the Antique,* 1981, p. 274).

Shearman was also the first to observe (cf. Hirst 1961, p. 168) that the rough sketch in the lower right corner of the sheet, of a seated and a standing figure in the left-hand side of a lunette, is a very early, and in the event discarded, idea for the pair of Prophets on the left of the window in the upper part of the Chigi Chapel in S. Maria della Pace. The figures are not as painted, but they correspond in reverse, as far as they go, with the pair intended for the other side of the lunette in the early sketch for the right half of the entire decoration (no. 143). The presence of this sketch on the same sheet as studies for *The Expulsion of Heliodorus,* which cannot be datable later than 1512, is an important piece of evidence for the dating of the Pace commission.

On the *recto* (F-O 398) is a more carefully finished drawing for the woman kneeling conspicuously by herself in front of the group of onlookers on the left of the composition. Unlike the *verso* drawing, this seems to have been drawn from a model, for there are separate detail studies of the head and shoulders, hands and feet.

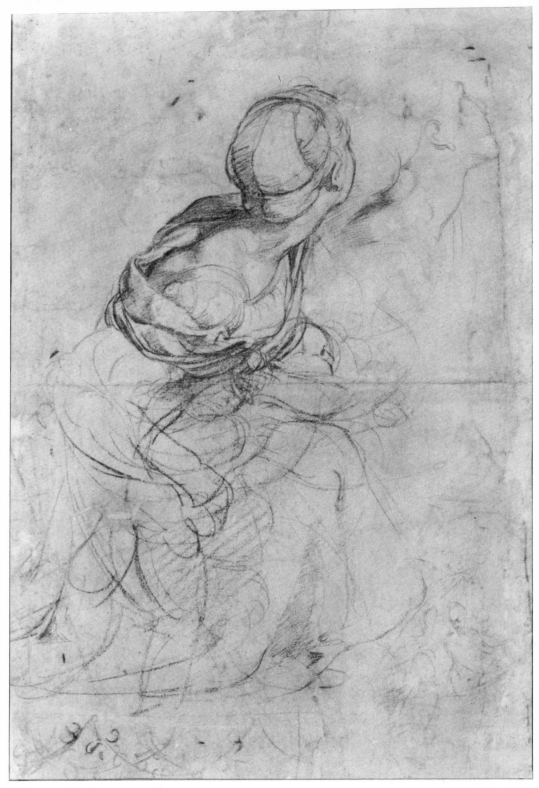

143

144

144. A horse's head

Ashmolean Museum P II 556

Black chalk. Somewhat rubbed and damaged. The
 outlines pricked for transfer. 682 × 533 mm. The sheet
 made up of more than one piece of paper.

Literature: KTP 556; P 513; R 86; Ruland, p. 201, 40;
 C & C, ii, p. 140; F-O 402.

A fragment of the cartoon for *The Expulsion of
Heliodorus* in the Stanza d'Eliodoro, corresponding
with the head of the horse ridden by the Avenging
Angel in the right foreground.

145

145. God the Father with angels, in a flaming cloud

Ashmolean Museum P II 462

Pen and brown ink. Some stylus underdrawing. (Oberhuber claims that there are traces of squaring at an oblique angle to the edge of the sheet, which he explains by the sheet having been trimmed in order to shift the angle of the group. We can see no sign of any squaring. The short vertical strokes near the lower edge, just to left of centre, are freehand and appear to be part of the drawing.) 271 × 401 mm.

Literature: KTP 462; P 516; R 91; Ruland, p. 205, iv, 5; C & C, ii, p. 138; F-O 410.

Related to the fresco of *Moses and the Burning Bush*, one of the four subjects from the Old Testament represented in the four compartments of the cross-vaulted ceiling of the Stanza d'Eliodoro. The drawing differs from the finished work in many respects, notably in showing the figure of God the Father unclothed and in the presence of two additional angels at the base of the group. The slanting pen line to the right of the upper edge of the sheet corresponds, in relation to the figures, with the oblique side of the trapezoidal ('fan-shaped') area occupied by the fresco. On the *verso* is a careful pen and ink copy of the figure of *Victory* in the right-hand spandrel on the east side of the Arch of Titus (repr. Dollmayr, op. cit. infr., p. 296). A copy of its counterpart, identical in handling but weaker and probably a copy of a copy, is also in the Ashmolean Museum (KTP 465, as Peruzzi).

The obvious explanation of no. 145 as a study by Raphael for the fresco was accepted without question by W. Y. Ottley (who included a facsimile engraving in his *Italian School of Design*, 1823), by Passavant and by Ruland. Robinson, on the other hand, while admitting that its differences from the fresco made the drawing difficult to explain as anything other than a preparatory study, and that it is 'in itself, a powerful and masterly performance', continued, '*but it is not from the hand of Raffaello*, nor can it be regarded as a copy of an original drawing by the great master; in fact, it differs from his work both in style of design and manner of execution, and everything points to the conclusion that it is an original design by one of his eminent scholars'. He went on to attribute it to Giulio Romano, whom he credited with the design and execution of the fresco;

he conceded that Raphael might have made 'the original slight sketch embodying the first invention of the subject', but in his opinion Giulio was responsible for the working out of the composition in all its subsequent stages. This view was faithfully echoed by Crowe and Cavalcaselle.

Even if the four Old Testament scenes were not begun until as late as 1513 or 1514, as Oberhuber and Shearman have independently argued (1962(A), p. 35 and 1965, p. 174 respectively), Giulio would still have been only about fourteen or fifteen years old. Robinson's contention that he was responsible for most of the Raphaelesque part of the vault (see also no. 146 below) depends on the incorrect, but in Robinson's day universally accepted, assumption that he was born in 1492: Hartt (p. 3) summarises the convincing arguments for a birth-date c. 1499.

The name of Baldassare Peruzzi, Raphael's Sienese contemporary and associate in Rome, has also been suggested in connexion with no. 145. The decorative framework surrounding the four Old Testament scenes includes a number of small-scale figure-compositions in *grisaille,* Ripandesque in character and of Antique inspiration. These are a vestige of the original decoration of the room carried out before the advent of Raphael, and were attributed by Crowe and Cavalcaselle to Peruzzi (but see Frommel, pp. 72 f.). Dollmayr *(Zeitschrift für bildenden Kunst,* N. F., i (1890), pp. 292 ff.), following a suggestion thrown out by Wickhoff, went further: he attributed no. 145 to Peruzzi on the strength of a comparison between the copy after the Antique on the *verso* and some of the drawings in the Siena *Taccuino,* which at that time was believed to be the work of Peruzzi himself (see Frommel, p. 151), and he extended the attribution to the four *Old Testament* scenes. Parker, who followed Dollmayr's attribution while at the same time accepting Fischel's view that the invention of the related fresco was due to Raphael, was obliged to explain no. 145 as a free copy by Peruzzi of the fresco. He did not, however, refer to Fischel's opinion (1948, p. 362) that it is by Raphael and a study for the fresco. The attribution to Peruzzi was rejected by Frommel, who dismissed no. 145 as a studio replica of a lost drawing by Raphael.

Oberhuber (see also 1962(A), p. 35, n. 57) admitted that he too found no. 145 something of a puzzle;

but his acceptance of the traditional (and surely correct) view that the fresco on the ceiling is by Raphael, and the fact that the relation of the drawing to it is that of a preliminary study, enabled him to reduce the number of possibilities to two. For him the only difficulty lay in deciding whether the drawing is from Raphael's own hand or whether it is a copy of a lost drawing by him. He studied it together with a closely related drawing for the same composition which he had discovered in the Uffizi under the name of Parmigianino (F-O 409), Raphael's authorship of which is established by the presence on the same sheet of a study for the composition of *The Vision of St Helena* engraved by Marcantonio (B xiv, p. 342, 460), and a sketch of the interior of a barrel-vaulted building related to Raphael's revision of Bramante's design for St Peter's, of which he was provisionally appointed architect in April 1514. In style and handling the related study on the Uffizi sheet comes so close to no. 145 as to make inescapable the conclusion that it too is by Raphael himself.

Nevertheless, it is disturbing to find connoisseurs as sensitive and as experienced as Robinson and – almost a century later – Parker, dismissing so completely the traditional attribution to Raphael. Admittedly, this drawing makes a somewhat unfavourable first impression: there is a certain crudeness in the handling, and the rendering of the flames and smoke out of which the figure is appearing is so schematised as to suggest the hand of a copyist. But there is nothing in it that is inconsistent with Raphael, and much (e.g. the angels' heads, the abbreviated form of the arms, etc.) that seems positively characteristic of him. No. 145 shows his draughtsmanship in an unfamiliar and not altogether attractive light, but Raphael himself, who seems always to have regarded drawing as a utilitarian activity, as merely a means to an end, would probably have found incomprehensible the notion of 'attractiveness' applied to his drawings.

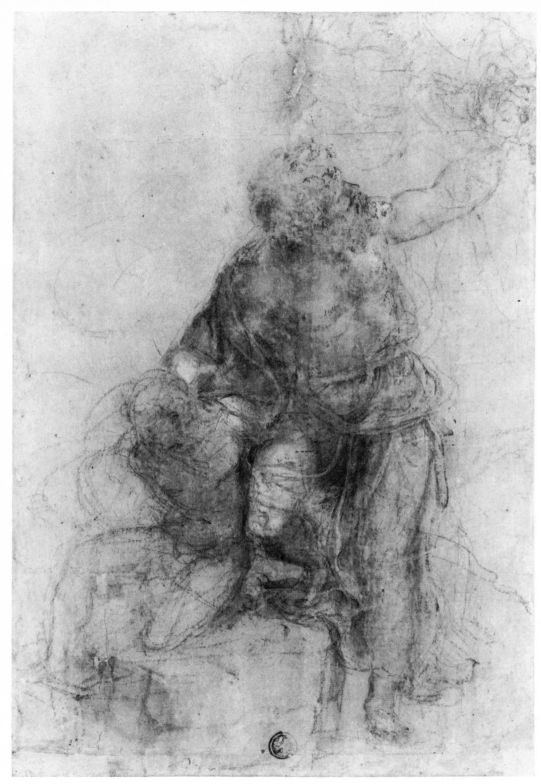

146

146. The Sacrifice of Isaac

Ashmolean Museum P II 583

Black chalk and pen and brown wash, heightened with
white. The outlines indented. Much rubbed and
abraded. 315 × 210 mm.

Literature: KTP 583; P, p. 512, *e;* R 93; Ruland, p. 204, ii,
7; C & C, ii, p. 139.

Though there is no exact correspondence in detail
between this drawing and the fresco of the same
subject on the vault of the Stanza d'Eliodoro, there is
a marked general similarity, in reverse, in the
relative position of the two figures and in their
arrangement in a compact vertical group.

Passavant rejected the traditional attribution to
Raphael, but proposed no alternative. Robinson,
influenced by his erroneous belief that the fresco was
'from first to last the sole work of Giulio Romano'
(see no. 145) attributed the drawing to him. Parker,
without committing himself about the nature of the
connexion with the fresco, catalogued the drawing
under the name of Raphael in a section headed
'Indeterminate', consisting of drawings 'tradition-
ally associated with his name, but which do not in
fact belong even to his closer following'. Pouncey
(annotation in KTP, *c.* 1956) described no. 146,
independently of Robinson, as a 'fine Giulio
Romano' – a view which on recent reconsideration
he does not feel inclined to abandon (Parker's
reference to his opinion that no. 146 is 'connected'
with a drawing ascribed to Polidoro da Caravaggio
in the British Museum appears to be due to a
misunderstanding: the drawing in question, of St
Luke seated on the ox, inv. 1938–6–11–9, is by
Biagio Pupini, to whom it was transferred in 1942,
and plainly has no connexion with no. 146 either in
subject-matter or in style). Shearman, in his article
on unexecuted projects for the Stanze (1965, p. 175),
took the view that no. 146 was a preliminary study
for the fresco by Raphael. Oberhuber, on the other
hand, omitted it altogether from his survey of
drawings connected with the Stanza d'Eliodoro
(F-O 396–419).

The very poor condition of the drawing makes it
hard to judge, but we agree that the attribution to
Raphael himself can hardly be sustained. In favour of
it, admittedly, is the masterly conception of the
group, the subtle *contrapposto* of the principal figure,

the daring fore-shortening of his right leg, and the
sculptural emphasis on the forward-jutting head and
the hollows and protuberances of the drapery.
(Shearman's characterisation of the design as
'unusually relief-like' seems more appropriate to the
fresco: the drawing surely suggests, to an unusual
degree, a group modelled in the round.) On the
other hand, there are certain uncharacteristic
incoherencies and uncertainties in the drawing itself.
Such less fully-realised passages as the angel in the
top right corner are rendered with a schematic,
two-dimensional sense of form that we do not find
in Raphael's drawings, even at their most summary,
while the figure of Isaac has the continuous, empha-
tic and at the same time unaccented but in places
duplicated contour that is one of the features of
Giulio's draughtsmanship. In facial proportion and
type Isaac closely resembles the drawing of *St
Sebastian* in the Pierpont Morgan Library (F-O, fig.
24) in which Pouncey convincingly recognised the
hand of the youthful Giulio.

If no. 146 is by Giulio rather than Raphael, its
relation to the fresco can hardly be that of a
preliminary study (see no. 145). A significant differ-
ence between the drawing and the fresco is in the
reversal of the group: in the drawing Abraham holds
the sword with which he is about to dispatch Isaac in
his left hand, but it is improbable that he was ever
intended to do so in the fresco itself. The most
frequent reasons for reversing a composition are if it
is to be used for tapestry, or for mosaic, or if it is to
be engraved. There is in fact an engraving of the
subject by Agostino Veneziano (B xiv, p. 6, 5) which
corresponds closely in reverse with no. 146 except
that Abraham holds his head at a different angle and
stands with both feet on the ground. It seems to us
that the most likely explanation of no. 146 is that it
was drawn by Giulio expressly for the engraver,
probably on the basis of a discarded design by
Raphael for the Stanza d'Eliodoro fresco. Fischel
seems to have been hinting at the same conclusion
when he observed – without commenting on its
authorship – that the drawing is nearer to the
engraving than to the fresco (1898, no. 182).

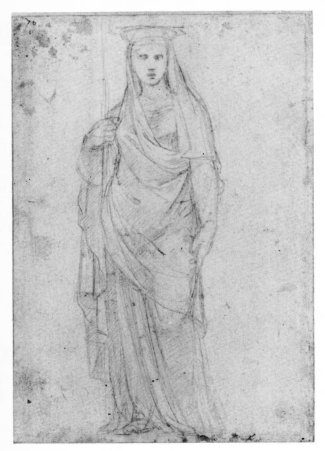

147

147. A caryatid

Ashmolean Museum P II 569B
Metalpoint on grey prepared paper. 146 × 98 mm.
Literature: Macandrew, Suppl. 569B; F-O 413.

The figure supports an *abacus* (that is, the topmost member of a capital) on her head and holds a staff in her right hand. Macandrew saw what might be a branch in the other hand, but this may be only the outline of the thigh.

Acquired in 1965 by the Ashmolean Museum from Messrs Colnaghis' Summer Exhibition (no. 78), in the catalogue of which it was described as 'School of Raphael'. Oberhuber and Shearman (1972, p. 103) independently attributed it to Raphael himself and connected it with the *basamento* of the Stanza d'Eliodoro, in which there are similar Caryatid figures, some holding staves (see no. 148). Macandrew pointed out that the same figure, minus the *abacus* and the staff, corresponds very closely in reverse with the goddess in the niche in the pier on the right of the tapestry of *The Blinding of Elymas*.

This detail of the composition is missing from the tapestry-cartoon (see no. 158), in which the figure would have been in the same direction as the drawing.

On the *verso* (F-O 414, also repr. Shearman, fig. 67) is a very rough sketch in pen and ink of a terminal figure. Shearman is no doubt right in connecting it with the two such figures below the niche containing the goddess, but it should be noted that in the Stanza d'Eliodoro *basamento* the window embrasures are flanked by vertically bisected figures of Terms.

148. A seated female figure, wearing a helmet and holding a staff, with a dog lying at her feet

Ashmolean Museum P II 569A
Red chalk. Some retouching in the area of the right knee.
267 × 154 mm.
Literature: Macandrew, Suppl. 569A; F-O 478.

The significance of the figure has not yet been satisfactorily explained, and the purpose of the drawing is still to some extent a matter of argument. It had been unknown and unrecorded until 1956, when it was acquired by Parker for the Ashmolean Museum.

According to the inscription on the old mount by an eighteenth-century French collector, the figure represents *La Fidelité du Comerce. Raphael. Il a fait ce dessein sans l'executer de même ayant mis cette figure debout sous la réprésentation du Comerce au Vatican a Rome sous forme de support.* The reference is to the *basamento* of the Stanza d'Eliodoro, the cornice of which is supported by eleven Caryatids (two subsequently obliterated in part by the insertion of a fireplace and a door) and two Atlantids, all holding emblems of various kinds which have been variously interpreted. The iconography of the *basamento* has never been studied in detail, but it has been suggested that the figures and the small monochrome scenes between them symbolise the occupations and qualities regarded as the essential basis of good government. They are described in a summary fashion by Passavant (followed by Müntz), but are not mentioned at all by Gronau (*KdK*) or by Dussler. They are referred to briefly by Oberhuber (F-O, p.

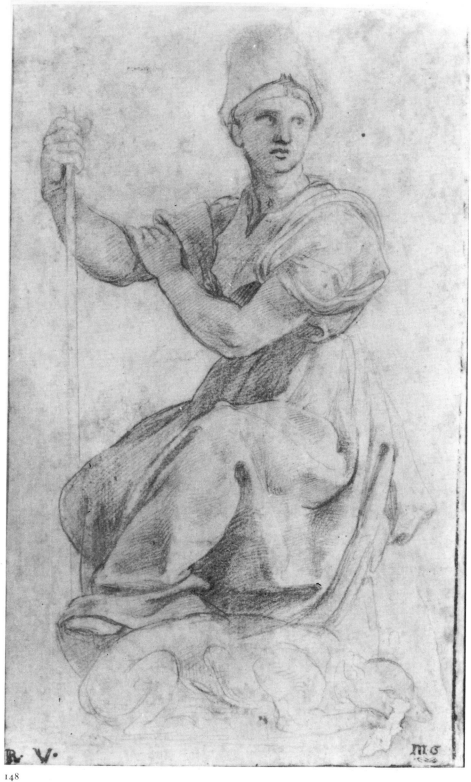

148

83) and more recently, and in more detail, by D. Redig de Campos (*Raffaello nelle Stanze,* Milan, 1973, p. 60), who gives a list of suggested identifications arrived at with the help of Mario Praz and Erwin Panofsky. Some of these differ from the earlier identifications inscribed on the engravings by Gérard Audran (1640–1703) of the separate figures.

All these authorities agree in identifying as *Commerce* the figure on the right below the *Freeing of St Peter,* for which there is a study in the Louvre (F-O 415; corresponding detail of *basamento,* fig. 89). This figure in no way resembles the drawing now under consideration, whereas the one identified as *Navigation* (the second from the left under *The Expulsion of Heliodorus*) holds its arms in the same way, with the left hand supported on the upraised right arm just above the elbow. Parker, who first published no. 148 in the Annual Report of the Ashmolean Museum for 1956 (pp. 55 f.), speculated on the possibility that Raphael may at one stage have planned a row of seated allegorical figures for the *basamento.* He quoted the opinion of Edgar Wind, that the hat is the one worn by *Tyche,* or *Fortuna,* and that the staff held by the figure is her attribute of a 'rudder-oar'.

Shearman (1965, pp. 179 f.) objected that the figure is designed to be seen from below, and cannot therefore have been intended as part of the decoration of the *basamento*; that the hat or helmet is quite unlike any of the headdresses worn by personifications of *Fortuna*; that Wind's indentification of the figure takes no account of the dog, which is obviously an attribute; and that the supposed 'rudder-oar' is nothing more than the stick used by the model to sustain the pose. He argued that the drawing must be a study for one of the seated personifications of Virtues on either side of the enthroned Popes in the Sala di Costantino (see no. 181). These groups are well above the spectator's eye-level, and some of the *Virtues* have animals or birds as attributes. He identified the dog as a symbol of *Fidelity* and suggested that the figure was intended for the place eventually occupied by *Fides,* on the left of the group on the left of the *Battle of Constantine.*

But was the figure in no. 148 necessarily designed to be seen from below? There is no attempt on Raphael's part to create illusionistic effects of perspective in the figures in the Sala di Costantino, as a Baroque artist might have done. The figures there seem to be on the spectator's eye-level, and the same is surely true of the one in the drawing. The connexion with the Sala di Costantino cannot be excluded, but Parker's suggestion deserves more serious consideration than it has received. The few drawings attributable to Raphael himself and connected with the Sala di Costantino (e.g. no. 181) are more developed in style and are in a technique of rather freely handled black chalk; as Oberhuber observed, the style of no. 148 suggests a considerably earlier dating, c. 1514–15: that is, in the period of the Stanza d'Eliodoro. The resemblance between the upper part of the figure and that of *Navigation* in the *basamento* may be significant. Not only are they both holding their arms in the same unusual way, but *Navigation* is likewise grasping in her right hand a staff, which widens at the bottom into what appears to be the blade of an oar. We agree with Shearman's refusal to accept the identification of the figure as *Fortuna,* but not with his explanation of the staff, which must be an essential feature of the design and not a mere studio accessory: not only is the action of the hand grasping it very carefully studied, but the position of the arms, with the right arm supporting the weight of the other, would be unnatural if the right arm were not itself supported.

On balance, however, it seems to us that of the two suggested explanations of the drawing, the Sala di Costantino option is perhaps more likely to be right. The standing Caryatids in the Stanza d'Eliodoro *basamento* are more than nine feet high; a seated figure occupying the same space would have been of unduly colossal proportions. As Oberhuber says, Raphael could well have been considering the problem of the Sala di Costantino by as early as 1514 or 1515. The figure in the drawing seems compatible with Raphael's own ideas for these features of the decoration, to judge from the painted figures of *Justitia* and *Comitas,* both of which have a good claim to be on his design unmodified by the intervention of Giulio Romano, and also the drawing in the Louvre (F-O 478) which seems to be a 'fair copy' by Penni of a design by Raphael for a complete corner section (see no. 181).

149. Sketch for the decoration of the Chigi Chapel in S. Maria del Popolo

Ashmolean Museum P II 553 *verso*
Pen and brown ink. 247 × 326 mm (only a detail of *verso* illustrated).
Literature: KTP 553.

Inscribed in pen in an old hand: *Guido.*

On the *recto* (F 311–312) is a badly rubbed and damaged drawing in metalpoint on greenish-grey prepared paper, for the group in the right fore-ground of *The School of Athens*. It corresponds closely with the final result except that some of the figures are studied from models wearing contemporary dress.

The *verso* of the sheet was not revealed until 1953, and is therefore not discussed in the earlier Raphael literature. Parker described the upper group of figures as 'philosophers in converse' inspired by similar figures in *The School of Athens*. Hirst (1961, p. 167) was the first to point out the significance of the drawing, when he identified it as a sketch for the decoration of the Chigi Chapel in S. Maria della Pace in Rome. The altar of the chapel is in a shallow round-headed niche in the right-hand wall of the nave, and Raphael's decoration is on the flat wall above. In the area surrounding the arch of the niche he painted two pairs of Sibyls, one on each side of the arch, with attendant angels. Above this area and divided from it by a heavy entablature is a lunette divided vertically by a window, on either side of which is a pair of Prophets, one sitting and one standing. In most of the standard Raphael literature, including even Gronau (*KdK*) the Prophets are not illustrated at all, an omission that reflects the generally held (and probably correct) view that Raphael himself did not execute this part of the decoration (see Hirst, p. 167, n. 33). Both parts are, however, illustrated in Dussler, figs. 154 a and b. The evidence of drawings establishes that whether or not Raphael painted the Prophets with his own hand he was certainly responsible for their design.

In no. 149 the essential elements of the right-hand side of the decoration are set down in schematic form. It shows the arch of the altar-niche with its heavy moulding, and on its summit the child-angel who in the fresco holds a torch. The two angels holding inscribed tablets, one sitting on the arch and

one standing between the two Sibyls, and the third angel holding a scroll and hovering in the upper right corner, have not yet made their appearance. The Sibyl nearer the arch, but not her companion, is in a pose close to the final result (see nos. 151 and 152). The entablature dividing the upper and lower parts of the decoration is indicated by a single horizontal line. The upper group of figures in the drawing corresponds fairly closely with the two Prophets on the right of the window, except that the standing figure holds his tablet low down with both arms extended. This pose is repeated, in reverse, in the rapid sketch for the left-hand side of the lunette in the lower right-hand corner of no. 143.

150. The Incredulity of St Thomas

Fitzwilliam Museum PD 125–1961
Pen and brown ink. 231 × 377 mm.
Literature: F-O, p. 56.

A circular variant of the composition exists in the form of a large bronze relief, just under three feet (87 cm) in diameter, in the abbey church at Chiaravalle, near Milan. Christ is standing slightly to right of centre and the figures on the left are moved closer together to fit into the circle; to the right is another group of onlookers, incuding the kneeling Magdalen. The relief has for *pendant* one of *Christ in Limbo,* which corresponds with a drawing by Raphael in the

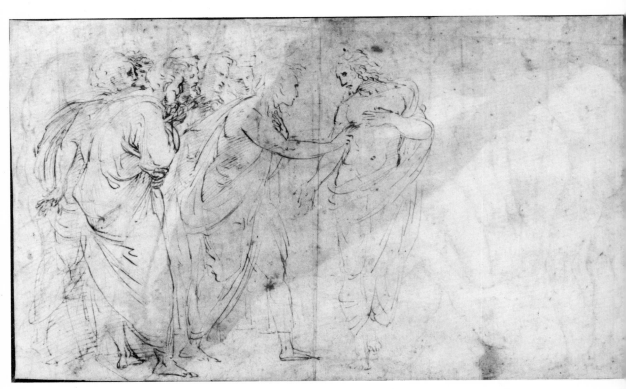

150

Uffizi (1475ᴱ; F-O, fig. 55 and Hirst 1961, pl. 31 b). The two reliefs were first reproduced, and first connected with Raphael, by G. Frizzoni in the text of his 1914 publication of the Raphael drawings in the Uffizi (p. 4; Hirst 1961, pls. 31 c and 32 c), but it was left for Fischel (1948, p. 182; also letter of 1938 to the then owner of no. 150 summarised in catalogue of *European Drawings from the Fitzwilliam,* International Exhibitions Foundation, USA, 1976, under no. 33) to connect them more specifically with the Chigi Chapel in S. Maria della Pace (see no. 149). Fischel suggested that this pair of compositions was intended for the circular spaces indicated on either side of the altar-niche, in the upper part of the *basamento,* in the copy at Stockholm of a lost drawing for the decoration of the entire wall surrounding the niche (1948, pl. 193 and Hirst 1961, pl. 28 c). Both develop the theme of the *Resurrection* which, as Hirst showed, runs through the iconograpy of the whole decoration and which, as he convincingly argued (see no. 167), was to have been the subject of Raphael's never-executed altarpiece. In Hirst's opinion the bronze reliefs now at Chiaravalle are those actually made for the chapel though in the event never placed there. Fischel followed Frizzoni's attribution of them to Caradosso, but Hirst gave them to Lorenzetto, the sculptor who translated designs by Raphael into three-dimensional form for the other Chigi Chapel, in S. Maria del Popolo.

The Uffizi drawing of *Christ in Limbo* is circular, which makes the rectangular format of no. 150 even less easy to explain. It is usually described as a study *for* the relief, but it might be more correct to say that it seems to have been *used* for it. The intermediate stage is perhaps represented by a lost drawing attributed to Raphael, engraved in reverse by Bernard Picart in his *Impostures Innocentes,* 1734 (Hirst 1961, pl. 32 b), in which the composition is compressed into an octagon with alternate short and long sides (in other words, a square with the corners cut off); but no. 150 was clearly not designed with a circular or near-circular format in mind. If, as seems reasonable to assume, the onlookers on the left were to have been complemented on the right by a group corresponding similarly with that on the right in the relief, the composition begun in no. 150 would have been even longer in proportion to its height and

would have fitted even less satisfactorily into the narrow *basamento* of the chapel. The possibility that Raphael at one stage formulated a scheme involving one or more such frieze-shaped compostions cannot be excluded; but equally, it cannot be denied that no. 150 would not have been considered in that connexion without knowledge of the relief or (conceivably) of the octagonal variant engraved by Picart. Instead, there might have been an attempt to explain it by referring to the small-scale *grisaille* scenes from the New Testatment in the *basamenti* of the Logge and the window-embrasures of the Stanze, some of which are of similar frieze-shaped format and not entirely dissimilar in composition. It may, for example, be compared with the study at Windsor for *The Doctrine of the Two Swords* (see under no. 113), in one of the window-embrasures of the Stanza della Segnatura.

151. A Sibyl; a separate study for her left arm and shoulder

Ashmolean Museum P II 562
Red chalk over stylus underdrawing, with some black chalk in the drapery. 363 × 189 mm.
Literature: KTP 562; P 500; R 96; Ruland, p. 272, 23; C & C, ii, p. 218.

A study for the Sibyl, sometimes identified as the Phrygian, on the right of the arch in the Chigi Chapel in S. Maria della Pace (see no. 149). There seems to be no certain basis for identifying any one of the four with a particular Sibyl (see L. Ettlinger, *Journal of the Warburg and Courtauld Institutes,* xxiv (1961), p. 322), with the possible exception of the elderly one on the extreme right who is probably the Cumaean: the tablet next to her is inscribed *iam nova progenies,* the utterance associated with this Sibyl by Virgil (Ecl. iv, 7), and she bears a marked resemblance to Michelangelo's Cumaean Sibyl on the Sistine ceiling.

The final pose of the so-called Phrygian Sibyl in essentials approximates more closely to the corresponding figure in the early sketch for the whole decoration (no. 149) than to the present study, from which it differs radically in the position of head, body and arms: in the painted figure the shoulders are turned to the right, so that the right arm rests on

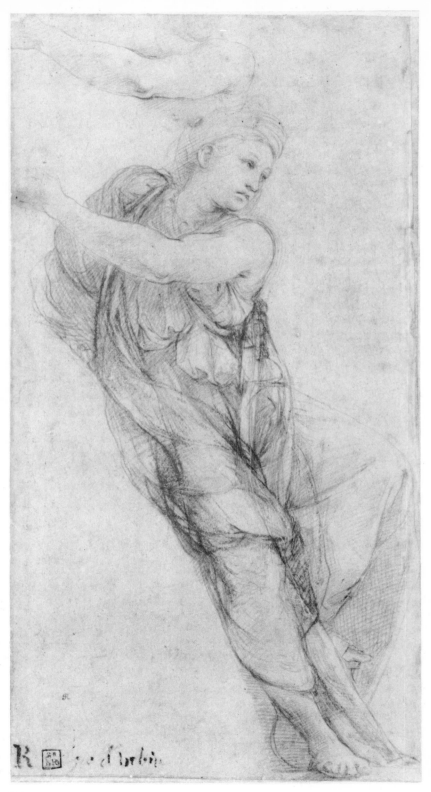

151

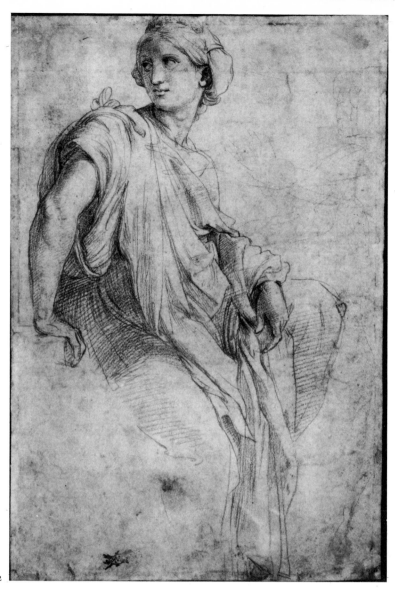

152

the arch and the left hand on the left thigh, while the head is turned to look over the right shoulder towards the tablet held by the angel sitting on top of the arch. No. 152 is a later study for the same figure.

152. A Sibyl

British Museum 1953–10–10–1
Red chalk over stylus underdrawing. 262 × 167 mm.
Literature: P & G 36.

A study for the Sibyl on the right of the arch in the Chigi Chapel. Unlike no. 151, it corresponds closely with the figure as painted. The only differences are in such small details as the elevation of the left knee, the angle of the right arm, and the position of the right hand. In the fresco this hand is resting on the arch, but in the drawing it is supported on a rectangular object, perhaps the end of a thick table-top – a detail that suggests that Raphael was drawing from a model.

We do not share Parker's unfavourable opinion of no. 152, expressed apropos of no. 151, that 'the handling is . . . rather coarse and defective, but whether the drawing is by a scholar of Raphael, a copy, or a retouched original remains problemati-

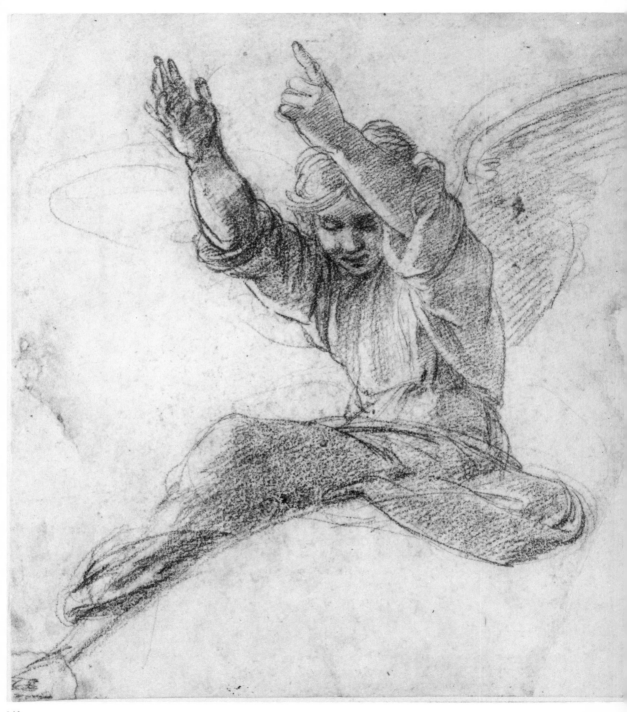

153

cal'. We see no trace of retouching and no indication of any other hand than Raphael's. The worst that can be said of no. 152 is that in such passages as the left shoulder and hand the drawing is unattractively hard and schematic, but Raphael practised a rigorous economy of effort which sometimes led him to concentrate on certain areas of a drawing while paying only perfunctory attention to those parts not his immediate concern at that moment. In no. 152 his attention was devoted above all to the head and right arm and shoulder.

Very lightly sketched to the right of the figure, with several *pentimenti,* are a head and extended arm. The angular profile and indication of a head-dress identify this as an indication of the old Sibyl, probably the Cumaean, who occupies the same relative position in the fresco.

On the *verso* of the sheet is a study, also by Raphael, of the draped legs of a seated figure facing the front, with the left knee raised and the foot resting on a vase. Parker's suggestion that this is for the Cumaean Sibyl is surely correct: there is a vase in the same position in the fresco, but the legs of the figure are crossed so that it is the right foot that is supported.

153. An angel: study for the Chigi Chapel in S. Maria del Popolo

Ashmolean Museum P II 567
Red chalk. 197 × 168 mm.
Literature: KTP 567; P 461; R 129; Ruland, p. 274, 12;
C & C, ii, p. 340.

The angel is the one accompanying the planet *Jupiter* in the mosaic in the cupola of the Chigi Chapel (see no. 154). The figure corresponds closely, in reverse, with the mosaic, except that there both legs are showing, the other being visible through the transparent sphere on which the angel is sitting.

Parker has misrepresented Crowe and Cavalcaselle as saying that the drawing is retouched by a later hand. It was the wings of the angel in the mosaic that they described as 'shorn of their feathers, either by the mosaist or a restorer' – a statement equally reckless, since it was based on comparison with the wings in the drawing which are too sketchily indicated to permit any such conclusion.

154. God the Father: study for the Chigi Chapel in S. Maria del Popolo

Ashmolean Museum P II 566
Red chalk over stylus underdrawing. 214 × 209 mm.
Literature: KTP 566; P 460; R 128; Ruland, p.274, v, 4;
C & C, ii, p. 339.

A study for the figure of God the Father and the two child-angels on either side in the mosaic in the centre of the cupola, dated 1516, of the Chigi Chapel in S. Maria del Popolo. It is in the same direction as the mosaic, whereas the study for the same figure on the *verso* of the sheet, drawn from a model in contemporary dress, is in reverse to it. Cartoons for mosaic had to be designed in reverse. The *tesserae* composing the mosaic were stuck face-downwards to the cartoon, after which the mosaic was affixed to the wall with the back of the cartoon turned outwards. When this was removed the mosaic was revealed with the design in reverse.

Both sides of the sheet were published by Fischel in the *Vasari Society* (2nd series, xi (1930), pls. 4 and 5; *verso* also repr. Shearman 1961, pl. 23d). He argued, from the reversal of the figure, that the *verso* drawing must have been made after the other; but Parker objected that the converse could equally well be true.

The significance of the figure's gesture is not immediately clear. It is not the usual one, of benediction; the generally accepted alternative is that God the Father is here seen in the act of creating the Celestial Universe, represented by the eight Celestial Spheres – the Seven Planets and the Fixed Stars – surrounding the rim of the cupola. Shearman (1961, pp. 140 ff.) objected that this would have been inappropriate in a mortuary chapel, and suggested that the Celestial Spheres, 'christianized' by the addition of the angels, represent the then familiar concept of the Platonic idea of Heaven to which God the Father is welcoming not only the souls of the departed but also the Virgin, whose *Assumption,* according to Shearman's hypothesis, was to have been the subject of Raphael's projected altarpiece (see no. 109).

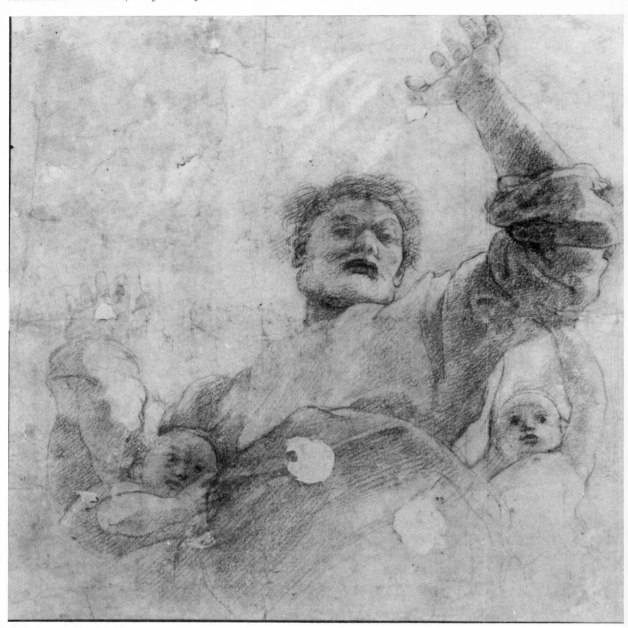

154

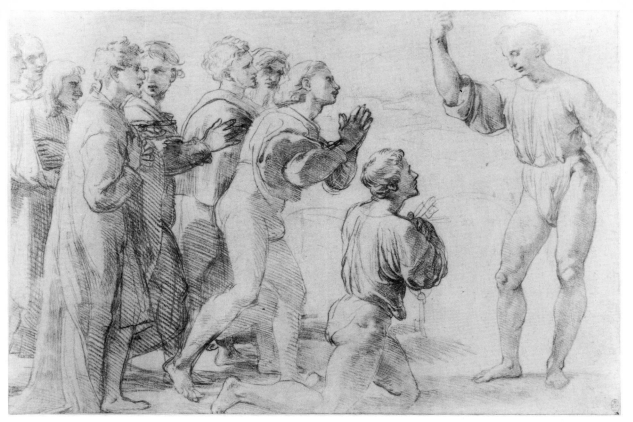

155

155. Christ's Charge to Peter: 'Feed my Sheep'
(offset)

Windsor 12751
Red chalk. 257 × 375 mm.
Literature: AEP 802; P 425; Ruland, p. 245, 12; C & C, ii,
p. 289; F-O 441.

Nos. 155 to 158 are studies for the cartoons commissioned by Leo X for a series of tapestries to decorate the lower part of the walls of the Sistine Chapel. The exact date of the commission is unknown but Raphael is recorded as receiving an interim payment on 15 June 1515 and a final payment on 20 December 1516. There were altogether ten tapestries: six with scenes from the life of St Paul, and four with scenes from the life of St Peter. According to Shearman's reconstruction (1972, p. 25) the episodes involving St Paul were intended to begin on the end wall to the left of the altar and to continue along the left-hand side wall of the Chapel; the others similarly were to have begun on the right of the altar wall and to have continued along the right-hand side wall. The seven surviving cartoons are in the Royal Collection, on indefinite loan to the Victoria and Albert Museum.

The tapestries were woven from the back, so the cartoons had to be designed in reverse to the final result. Raphael presumably made this offset, of a study made from studio assistants in contemporary dress, in order to judge the effect of the composition in its eventual form. Three fragments of the original drawing are known: one with the whole figure of the model posing for Christ, in the Louvre, and two with between them the heads of all eight of the standing figures in the offset, now in the collection of Mr John R. Gaines, of Lexington, Ky., USA (F-O 442–4; Shearman 1972, figs. 46, 48 and 49). Freedberg's claim (1961, p. 274) that the offset has been 'worked over in large part, and perhaps altogether, by Raphael' is unfounded: there is no sign on it of right-handed hatching, as there would be if Raphael had reworked it; and comparison with what is left of the original shows that the two correspond exactly, line for line.

A later stage of the design is represented by a *modello,* also in the Louvre (F-O 445; Shearman, fig. 51), in pen and wash heightened with white. This corresponds with the cartoon and differs from no. 155 in showing the figures draped; in the pose of

Christ, who is pointing downwards with his left hand towards the kneeling figure of St Peter; and in the introduction of an additional figure on the far side of the youthful Apostle (St John) advancing with hands joined behind St Peter. The offset seems to have been trimmed on the left, so that the Apostle at the tail of the group is missing. He is also missing from the corresponding fragment, but this includes slightly more of the figure immediately in front.

The suggestion (Shearman, p. 97) that the original drawing was 'mutilated' by Raphael himself in the course of his revision of the design does not take into account the disfiguringly irregular contour (hardly visible in the reproduction in F-O) of the right side of the Louvre fragment, the trimming of which has in two places even impinged upon the figure, in the left foot and lower part of the left sleeve. If Raphael had dismembered his own drawing, he would surely have made a neater job of trimming the fragments. It is more likely that the lower right-hand area of the sheet was accidentally damaged – perhaps by the spilling of some liquid, which would account for the irregular but apparently deliberate trimming – in such a way that only part of the drawing could be salvaged. Everything that we know about Raphael's working methods reinforces the impression that he regarded drawing from a strictly utilitarian point of view, as a means to an end; he would probably have been surprised to hear his supposed mutilation of the sheet described as a thought 'not pleasant to contemplate'.

156. A group of three soldiers: study for *The Conversion of St Paul*

Chatsworth 905
Red chalk over stylus underdrawing. The edges and
 corners tattered, especially the lower right corner.
 316 × 245 mm.
Literature: Ruland, p. 249, 5; C & C,ii, p. 281; F-O 447.

The group of figures appears, in the reverse direction to the drawing, on the right of the tapestry of *The Conversion of St Paul* (Dussler, fig. 180; Shearman 1972, fig. 20). The drawing is a study for the cartoon, which would have been in reverse to the tapestry. The cartoon was separated from the others within, or very soon after, Raphael's lifetime, for it is

recorded in 1521 in the possession of Cardinal Domenico Grimani in Venice (see Shearman, p. 139). It has long since disappeared.

The traditional attribution of no. 156 to Raphael was accepted by Ruland and by Crowe and Cavalcaselle. Fischel in his 1898 volume (no. 252) followed Dollmayr in giving it to Penni. How accurately the catalogue of Raphael's works appended to his posthumously edited monograph of 1948 reflects the final state of his thought is not always clear, but it is there unequivocally stated (p. 365) that all the known drawings for the Tapestries except nos. 155 and 157 in the present exhibition are products of the Raphael studio. Popham, whose opinion is quoted in the catalogue of the exhibition *Drawings by Old Masters* at the Royal Academy in 1953 (no. 57), seems to have been the first to restate the traditional attribution of no. 156. In this opinion he was followed by Oberhuber and by Shearman (1972, pp. 101 f.).

A nice point of connoisseurship is raised by the existence of a deceptively similar version of no. 156, also in red chalk, in the Teyler Museum in Haarlem (F-O, fig. 133; Shearman, fig. 64). The correspondence between the two drawings is so close that one, at least, must be a copy; but either might plausibly be attributed to Raphael's own hand if considered in isolation. In the catalogue *Le Dessin italien dans les collections hollandaises*, Paris-Rotterdam-Haarlem, 1962 (no. 65) the Haarlem drawing is accepted unquestioningly as by Raphael but without reference to the version at Chatsworth. In the later catalogue of the selection of drawings from the Teyler Museum shown at the Victoria and Albert Museum in 1970 (no. 77), comparison of the two versions led to the conclusion that the one at Haarlem is the original and the other a copy of it. Dussler, on the other hand, took the view (p. 103) that the Chatsworth version is 'considerably superior', but did not commit himself on the question of Raphael's authorship. Both Oberhuber and Shearman are firmly of the opinion, with which we agree, that the Chatsworth version is by Raphael and the Haarlem version a copy of it. As Shearman pointed out, the essential objective difference between the two is the presence on the Chatsworth sheet, but not on the other, of the extensive underdrawing in stylus frequently found in Raphael's

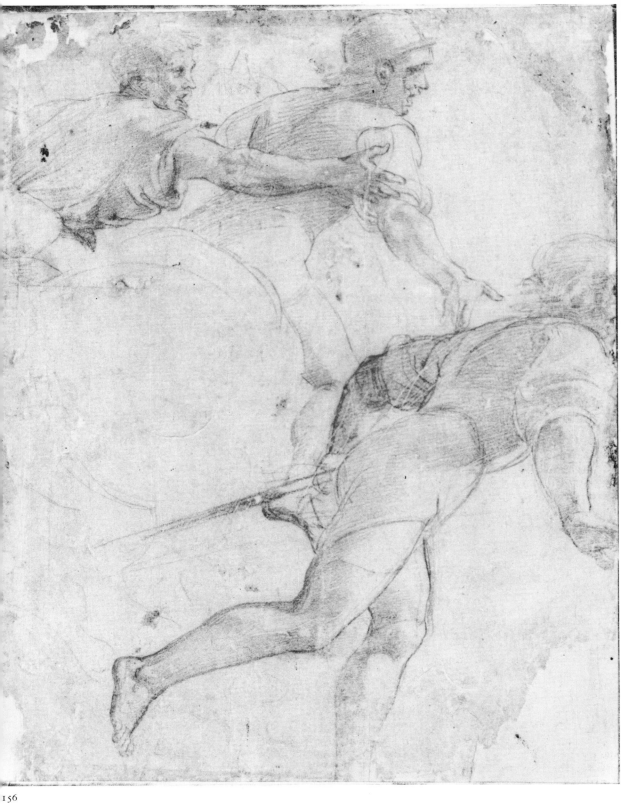

chalk studies, and here handled with a freedom and decision entirely characteristic of him. Oberhuber was inclined to date the Haarlem version as late as the seventeenth century, while Shearman saw it as a product of the Raphael studio, possibly by Giulio Romano.

The problem is complicated by the presence on the *verso* of the Haarlem sheet of a drawing in black chalk and grey wash with white heightening, of Julius II kneeling at his faldstool as in the *Mass of Bolsena* in the Stanza d'Eliodoro (F-O 404). That fresco is dated 1512, and the tapestry commission was probably not initiated earlier than the end of 1514 or the beginning of 1515; but notwithstanding this discrepancy of date the *verso* drawing is accepted without discussion in both Teyler catalogues as a preliminary study by Raphael. This view is shared by Shearman (1972, p. 102, n. 40), in spite of his rejection of the *recto* drawing as a copy. Oberhuber included the *verso* drawing in his *corpus* and illustrated it on a full plate, but in his text he seems somewhat less than whole-hearted in his acceptance, and in the caption to the plate he crystallised his doubts by adding the word 'Kopie?'. Dussler (p. 80) described it as a study *for* the figure in the fresco, while rejecting Raphael's authorship.

It seems to us that the *verso* of the Haarlem sheet is quite unlike any drawing by Raphael of 1512 or earlier. Apart from the summarily indicated head and hands, it corresponds exactly with the figure in the painting and in our opinion is more likely to be a copy of this than of a lost study. Two objective points may be noted: the way in which the pattern on the cushion is indicated roughly but accurately by patches of white body-colour seems as suggestive of a copyist as it is uncharacteristic of Raphael; and the perspective of the faldstool is misunderstood, the arm with the lion-mask to the spectator's right being noticeably higher than the other, whereas in the fresco it is almost imperceptibly lower.

157. St Paul rending his garments: study for *The Sacrifice at Lystra*

Chatsworth 730
Metalpoint, heightened with white, on pale violet-grey prepared paper. 228 × 103 mm.
Literature: P 563; Ruland, p. 251, 8; C & C, ii, p. 306; Fischel 1948, p. 365; F-O 449.

A study for the figure of St Paul on the left of the cartoon. He is shown rending his garments in anger at the intention of the people of Lystra to offer a sacrifice to him and St Barnabas in the belief that they were the gods Mercury and Jupiter 'come down . . . in the likeness of men' (*Acts,* xiv, 6–18). The figure in the cartoon corresponds very closely with the drawing, except that the fold of drapery falling over the right shoulder is omitted; probably, as Shearman (1972, p. 104) suggested, because it would have interfered visually with the robe of Barnabas, who stands behind Paul. Both saints are dressed in rather the same shade of pinkish red.

Raphael no doubt made this study from a model on whom the drapery was arranged, but the features and hair are already idealised, and are those of the figure in the cartoon. As Freedberg put it (1961, p. 274), the figure 'is developed in poetic eloquence of pose in a way more artificial than direct observation of a model would permit'.

An old copy of a study for the entire group of figures on the right of the cartoon, complete with their drapery, is in the Uffizi (F-O 449a, fig. 136; Shearman, fig. 68). The original drawing, which has only very recently come to light and is now in the Louvre (RF 38.813), is in metalpoint on the same-coloured ground as no. 157. The heads in the corresponding part of the cartoon are not idealised so much as caricatured; but those in the drawing seem to be of studio assistants.

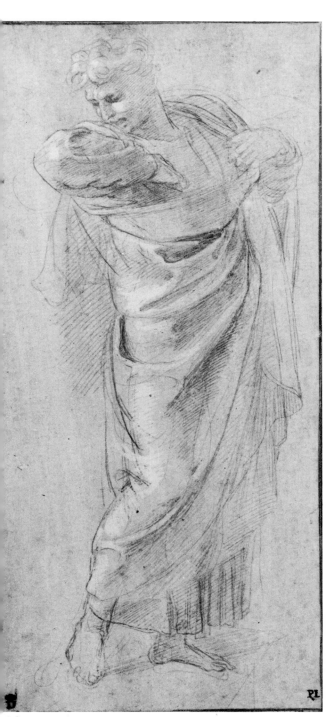

57

158. The Conversion of Sergius Paulus (The Blinding of Elymas)

Windsor 12750
Metalpoint and brown wash, with some pen and ink, heightened with white, on grey prepared paper.
270 × 355 mm.
Literature: AEP 803; Ruland, p. 250, vii, 13; C & C, ii, p. 302; F-O 448.

A study for the tapestry cartoon, in which an identical inscription occurs on the base of the throne: *L. SERGIVS PAVLLVS ASIAE PROCOSS: CHRISTIANAM FIDEM AMPLECTITVR. SAVLI PREDICATIONE.* There seems to be no reason for doubting that Raphael himself inscribed it on the drawing. Though there is no known example of his holograph in capital letters, those composing the inscription seem compatible with his elegant cursive handwriting as we see it for example in the draft of a sonnet on no. 90. The corresponding cartoon is the only one thus identified, and as Shearman pointed out (1972, p. 58) the subject is properly the conversion of the Proconsul Sergius Paulus by St Paul (*Acts*, xiii, 7–12) and not the blinding of the sorcerer Elymas which was the cause of that conversion, by which title the cartoon is more generally known. The drawing served as basis for the engraving by Agostino Veneziano (B xiv, p. 48, 43).

In the past no. 158 has been generally dismissed as a product of the Raphael studio or even a copy of the cartoon. The attribution to Raphael was reaffirmed by Popham, followed by Shearman and by Oberhuber; but Popham's suggestion that the intricate network of ruled lines defining the perspective framework of the composition was the work of a studio assistant was based on the *a priori* and by no means necessarily correct assumption that at this late stage of Raphael's career such a task would have been delegated. Shearman (op. cit., p. 103, n. 45) saw indications of later retouching in the wash, but was inclined to accept the passages that seemed to him unrestored. He also doubted whether Raphael himself was responsible for the pen and ink additions to some of the heads in the background, which he described as clumsy and perhaps the work of an assistant. Oberhuber expressed similar doubts about the authorship of the pen-work. The drawing is

certainly somewhat rubbed, but we can see no signs of later restoration or retouching; and it seems to us that the accents added in pen and ink have sharpened the expressions and brought the faces to life with an economy and intelligence characteristic of Raphael alone.

The exact place of no. 158 in the sequence of studies that must have preceded the execution of the cartoon is far from clear: it can hardly have been intended to be the final *modello*, since it is not squared for enlargement to the scale of the cartoon. What might be interpreted as the remains of squaring is in fact part of the ruled perspective grid. For a discussion of the possible explanations see Shearman, op. cit., pp. 72 f.

In apparent conflict with the symmetry of the composition, in which the figures are evenly balanced on either side of the throne, is the off-centre position of the vanishing-point, as emphasised by the direction of the lines in the pavement which if produced would converge at a spot above the Proconsul's right hand. The vanishing-point is in the same place in the tapestry, but there it is central, for the composition is extended by the addition of a square pier in the extreme right foreground (see no. 147). The perspective of the drawing and the cartoon must have been designed to take this absent feature into account, but it is curious that the cartoon should resemble the drawing in including only the extreme end of the pier.

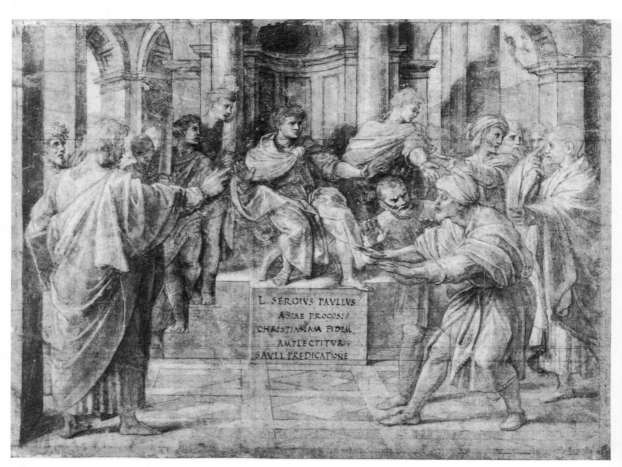

158

159. Venus and Psyche

Ashmolean Museum P II 655
Pen and brown ink over red chalk. 105 × 80 mm.
Literature: KTP 655; P, under 555; R 10(3); Ruland, p. 282,
33; C & C, ii, p. 419.

Inscribed in lower left corner: *Raphaël*, and in lower
right corner: *RAFAELO 104.*

At one time mounted together with four other
drawings: KTP 12 and 13 (now attributed to Filip-
pino Lippi), KTP 512 (no. 23 above) and KTP 644.
No. 555 in Passavant's catalogue comprises all five,
but only KTP 512 was accepted or even described.
Robinson, Ruland, and Crowe and Cavalcaselle all
accepted no. 159 as a first sketch by Raphael for the
pendentive of *Psyche offering the Vase of Proserpine to
Venus* in the loggia of Agostino Chigi's Roman villa,
now known as the Farnesina.

The loggia was decorated by Raphael with the
help of assistants, and was unveiled at the very end of
1518. The centre of the vault is occupied by two
large figure compositions, *The Council of the Gods*
and *The Wedding Feast of Cupid and Psyche,* which
simulate tapestries apparently stretched over the flat
centre of the vault to form an awning. The coved
sides of the vault are pierced by lunettes, two at
either end and five on either side, those on the outer
long wall forming the tops of the arched openings
towards the garden, the others blank but for *trompe-
l'oeil* window-bars. The bases of the lunettes are
almost contiguous, with the result that the sides of
the vault are divided into a sequence of triangular
pendentives which alternate with the inverted
triangles of the subsidiary arched vaults formed by
the intersection of the lunettes with the coving.
These spaces are bordered by swags forming the
framework of the illusionistic arbour which appears
to support the central awning. In the ten pendentives
are episodes from the legend of Psyche involving
either the Gods alone or her dealings with them; in
the fourteen subsidiary vaults (or spandrels) are
amoretti holding trophies and emblems and seen
against a background of sky.

In his 1898 volume (no. 270) Fischel dismissed
no. 159 as 'later, in the manner of Giudo Reni', but
he came to change his mind and in his posthumously
published monograph described it as the only extant
sketch for the Farnesina from Raphael's own hand

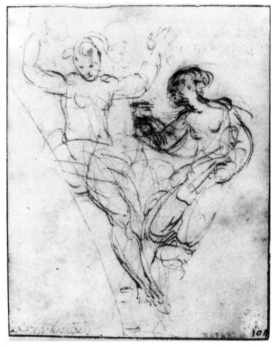

159

(1948, pp. 184, 366). Parker, however, once again
rejected it as probably 'no more than a jotting made
from memory at a good deal later date'. Raphael's
authorship was reaffirmed successively by J. A. Gere
(*Burlington Magazine,* xcix (1957), p. 162),
Oberhuber (1962, p. 124, n. 27) and Shearman (1964,
p. 81), and is now generally accepted.

Apart from the sheet of rapid pen sketches in the
Wallraf-Richartz-Museum in Cologne connected
with the pendentive of *Mercury* at one end of the
loggia and with two adjacent spandrels at the other
end, which Oberhuber (loc. cit. and F-O, p. 58 and
fig. 58) and Shearman (1964, p. 90 and fig. 90) agree
in attributing to Raphael, no. 159 is the only known
surviving sketch for any part of the loggia decora-
tion. The other known drawings are all carefully
finished studies in red chalk for single figures or
groups of figures, like nos. 160–4, the attributions of
which in recent critical literature has tended to
oscillate between Raphael and his two principal
assistants Giulio Romano and Giovanni Francesco

Penni. One such drawing, in the Louvre (3875), is for the pendentive for which no. 159 is a sketch, and is now generally agreed to be by Raphael himself.

It has been suggested that one of the two figures on a sheet in Haarlem (*Drawings from the Teyler Museum,* exh. Victoria and Albert Museum, 1970, no. 78) was used for the figure of Psyche in this composition; but though it resembles Psyche in looking upward over its right shoulder its hands are crossed on its breast, and the other figure on the sheet in no way resembles either Psyche or Venus. On the other hand, the Haarlem drawing is in red chalk and close in style to the studies associated with the Farnesina, and might well prove to be a study for one of the hypothetical unexecuted subjects which Shearman suggested were to have gone in the lunettes of the loggia (see no. 161).

160. A nude woman seated on clouds, attended by *putti* (offset)

Chatsworth 53
Red chalk, showing stylus underdrawing from the
 original. 330 × 246 mm.
Literature: Ruland, p. 320, 56.

No such figure occurs in any surviving work by Raphael, to whom the drawing was traditionally attributed. Doubt was cast on the attribution after Eugenie Strong, who acted as Librarian at Chatsworth after Arthur Strong's death in 1904, had observed that an identical figure, in the same direction as the offset, is on a ceiling in the Villa Bufalini at San Giustino, near Città di Castello, decorated after 1537 by Christofano Gherardi of Borgo San Sepolcro (see Venturi, ix⁵, fig. 361). Popham, the first to publish the drawing (*Old Master Drawings from Chatsworth,* Arts Council Exh., 1949, no. 17), nevertheless refused to abandon the attribution to Raphael: 'Though the connexion is undeniable', he wrote in the catalogue at Chatsworth, 'I cannot believe that this magnificent and very Raphaelesque drawing can be by a second-rate provincial manner-ist like Gherardi.' He pointed out that other echoes of Raphael and the Raphael School can be seen in the paintings in the villa, including at least one penden-

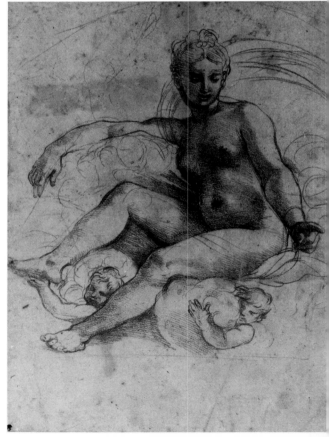

160

tive derived from the Farnesina loggia (see also *Mitteilungen des Kunsthistorischen Institutes in Florenz*, xiii (1968), pp. 366 ff.).

Popham suggested that the offset, which is retouched here and there in a redder chalk evidently by the hand responsible for the original drawing, is in some way connected with the scenes from the legend of Cupid and Psyche painted by Raphael and his assistants on the vault of the loggia of the Farnesina (see no. 159). The horizontal line below the figure and the curving one above show that it was to have been enclosed in a lunette. The lunettes in the loggia were left blank, but there is reason to suppose that Raphael's intention was to fill them. Shearman (1964, pp. 67 f.) adopted Popham's hypothesis, arguing that no. 160 is likely to be a study for one of the lunettes and that it represents Psyche wafted heavenward by the Zephyrs. He quoted the relevant passage from the version of the legend likely to have been known to Raphael, in which Psyche is described 'da il vento zefiro levamente in su levata, il quale ventillando in forma di vella i panni suoi,' and pointed out that the drapery behind the figure in the drawing is blown out exactly in the form of a sail.

161. A nude woman kneeling, with her left arm raised above her head

Chatsworth 56
Red chalk, over faint traces of stylus underdrawing.
279 × 187 mm.
Literature: Ruland, p. 320, lv, 1; C & C, ii, p. 262.

The traditional attribution to Raphael seems never to have been disputed, but no such figure occurs anywhere in his surviving works. Various suggestions have been made about the purpose of this drawing. Crowe and Cavalcaselle thought it might have been an early idea for the kneeling woman seen from behind with both arms raised in the foreground of *The Fire in the Borgo* in the Stanza dell'Incendio. Fischel's suggestion (1898, no. 197) that it is a discarded study for a figure in the left foreground of *The Miracle of Bolsena* in the Stanza

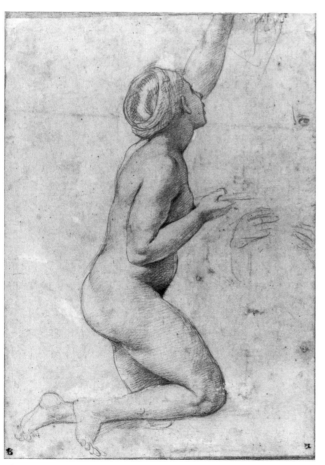

161

d'Eliodoro was repeated in his posthumously published monograph (1948, p. 104). Adolfo Venturi (*Raffaello,* 1920, p. 196) seems to have been the first to point out that no. 161 comes very close in style to the studies for the scenes from the legend of Psyche on the vault of the Psyche Loggia of the Farnesina (see no. 159). Popham (*Vasari Society,* 2nd series, vi (1925), no. 8) came independently to the same conclusion. He saw the pose of the figure as resembling that of Psyche handing the vase to Venus in one of the pendentives. At the same time he pointed out the difficulty of fitting such a figure into the V-shaped space, and as an alternative possibility suggested that this figure might have been intended for a cup-bearer in the *Wedding Feast.* In the fresco that function is performed by Ganymede, but it is not impossible that Hebe, whom Ganymede supplanted, might at one stage have been considered.

From what we know of Raphael's methods it seems unlikely that so highly finished a study would have been made before the composition that was to contain the figure had been worked out in detail. It seems reasonable to assume, as a working hypothesis, that this is a study for a composition in the Psyche Loggia that was never carried out; and in fact it has often been remarked that the cycle in the Loggia is incomplete, since none of the pendentive scenes represent episodes of her activity on Earth. Shearman, whose study of the question (1964) is the most recent, and the most persuasive, observed that figures in two of the pendentives are pointing towards the lunettes below and that these gestures are meaningless with the lunettes blank. He argued that the missing episodes were to have been represented in the lunettes and also perhaps – in view of the awkwardness of juxtaposing indoor scenes with the spandrels and pendentives all of which have the sky as background – on the walls below the cornice. History does not relate why the decoration might have been left incomplete in this way.

Shearman (1964, p. 70) suggested that no. 160 represents Raphael's solution for one complete lunette. His argument for connecting no. 161 with the Psyche cycle is more tenuous. On the *verso* of the study in the Louvre for the pendentive of *Jupiter embracing Cupid* (1120; Shearman, figs. 73 and 83) is a drawing in red chalk of a nude woman standing in profile to left, holding in front of her with both hands at waist level a roughly sketched object of elongated ovoid shape. Whatever the status of the *recto* drawing, which has been attributed to Giulio Romano, the *verso* seems certainly to be by Raphael himself. Shearman pointed out that in an engraving by Giulio Bonasone (B xv, p. 153, 167; Shearman, fig. 69) of three nude women assisting at the toilet of a fourth, the pose of the attendant holding a mirror for her mistress closely resembles that of the woman in the Louvre drawing, whose gesture is entirely compatible with that of holding a mirror up to the face of someone seated. On the right of the group in the engraving is a kneeling woman holding up both hands towards her mistress, with in one a phial and in the other a small cup. This pose, again in reverse, is not unlike that of the figure in no. 161, whose left hand has been trimmed away but who holds in the other a small tray from which she could have just taken whatever toilet accessory she may have been handing to her mistress.

The suggestion that Bonasone may have reproduced, in reverse and probably not very faithfully, a preliminary composition sketch for one of the unexecuted scenes in the Psyche cycle, and that no. 161 and the Louvre drawing may be studies for a more fully worked-out stage of the design, seems to us very plausible. It is perhaps also worth suggesting that the face and hands lightly sketched near the right edge of no. 161 could be those of the third attendant in the group engraved by Bonasone, who is occupied with her mistress's hair.

162. The Three Graces

Windsor 12745

Red chalk. Traces of stylus underdrawing. 203 × 260
 mm. All four corners cut.

Literature: AEP 804; P 433; Ruland, p. 284, 74; C & C, ii,
 p. 418.

These figures occur, exactly as drawn, in the right background of *the Wedding Feast of Cupid and Psyche* on the vault of the loggia of the Farnesina (see no. 159). No. 162 is one of a number of finished studies in red chalk traditionally attributed to Raphael, which modern critics have tended to detach from his *oeuvre* and assign to his principal assistants, Giulio Romano and G. F. Penni. In Fischel's posthumously

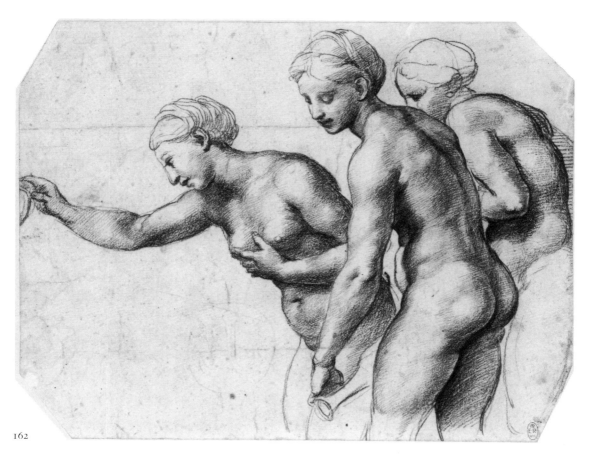

162

published monograph (1948, pp. 184–5 and 366) the view is expressed that the only surviving drawing for the Loggia by Raphael himself is the rough sketch for the pendentive of *Venus and Psyche* (no. 159), and that his contribution to the other related drawings is limited to 'corrections' on the more detailed red chalk study for the same pendentive in the Louvre and on no. 162, both of which Fischel still attributed to Giulio, as he had done in his 1898 volume (nos. 266 and 271).

Fischel stated his conclusions, but did not give his reasons. The first detailed examination of the problem of distinguishing Raphael's late drawings from those of his assistants since the publications of Morelli and Dollmayr at the end of the last century was made by Shearman in his article on the Psyche Loggia (1964). Oberhuber returned to the subject in 1972 in his introduction to vol. ix of the Fischel *corpus*. Shearman considered the drawings related to the Loggia in conjunction with others connected with late works in which the studio was involved, and began by remarking that the criterion must be one of *quality* and not of *style*, since in the Raphael studio the assistants were trained to imitate their master's style as faithfully as possible. He also took into account the underlying artistic personality, for he drew a distinction between Penni, whom he saw as particularly responsive to the soft and delicate aspect of Raphael's draughtsmanship and as more sensitive than Giulio to effects of light, and Giulio whose strength seemed to him to lie rather in his firm definition of form. He divided the drawings into three groups, attributing some to Raphael, some to Giulio and some to Penni, but he concluded his well-weighed and scrupulously cautious assessment of the evidence with the disarming admission that all the attributions put forward could well prove to be incorrect. How very finely balanced these distinctions of hand are, is shown by Oberhuber's attribution of three of the drawings in Shearman's Giulio group and two of those in his Penni group to Raphael, and of two in his Penni group to Giulio. This divergence of opinion is remarked upon here only to underline the point, which Shearman him-

self made, that the available evidence is not always sufficient to permit definite conclusions to be drawn in every case.

We do, however, agree with Shearman and Oberhuber that some drawings of this group can certainly be attributed to Raphael himself. In no. 162, for example, and in the Louvre pendentive study '*le fond* and *la forme* are co-substantiate': there seems to be an intimate organic relation between the conception as it took shape in the draughtsman's mind, and his expression of it on paper. In others, such as nos. 163 and 164, the outward and visible signs of the Raphael style seem by contrast unanimated by any creative intelligence. We prefer to classify these drawings, which are on the borderline – and perhaps likely to remain there – under the more general heading of 'Studio of Raphael'.

No. 162 was catalogued under the name of Raphael himself by Popham, though with some reservations. Previously (1930, p. 142), he had classified it under the heading 'Attributed to Raphael' with the comment 'Study for, or more probably from, the group in the fresco'. In his Windsor catalogue, after quoting Fischel's opinion that the drawing is by Giulio, he went on to describe it as 'less free and masterly' than the offset of the study for one of the tapestry cartoons, also at Windsor (no. 155). He added that there are no signs of preliminary drawing with the stylus, as was usual with Raphael.

The original of no. 155 was a comparatively rapid study made from studio assistants and primarily intended to fix the poses of the figures in the composition. No. 162, on the other hand, seems to represent a later stage in the design when the poses had been established, and to have been drawn more deliberately, with greater emphasis on nuances of modelling and tonal variation. Moreover, careful examination of the sheet reveals unmistakable traces of stylus underdrawing, most clearly visible along the back of the right-hand figure. We agree with Shearman (1964, p. 90) and Oberhuber (F-O, p. 68) that this drawing is certainly by Raphael himself.

We do not, however, agree with Shearman that no. 162 has suffered from repeated offsetting and consequent retouching. The only offset of it known to us (Chatsworth 52) seems likely to have been taken by Raphael himself, and comparison with the

original reveals no discrepancies to indicate that the latter was subsequently reworked. The offset, on the other hand, is retouched in places, apparently by Raphael; this is most obvious on the head of the figure leaning forward. The original sheet has been trimmed below and to the right, for the offset shows the leg of the centre figure to well below the knee and the whole of the back and right arm of the one on the right.

163. Mercury bearing Psyche to Olympus

Chatsworth 54

Red chalk. Traces of stylus underdrawing. Very badly stained, tattered and abraded, especially in the upper part. 308 × 232 mm, measurements of the sheet as made up to a rectangle: the original drawing has been roughly trimmed to the shape of the pendentive.

Literature: Ruland, p. 283, 44; C & C, ii, p. 423.

One of the group of red chalk drawings connected with the Psyche Loggia in the Farnesina (see no. 159). It corresponds exactly with one of the pendentives except that the drapery in the drawing is less voluminous and that Mercury's left foot is visible whereas in the fresco it is covered by the garland of foliage enclosing the figures. The traditional attribution of no. 163 to Raphael was accepted by Ruland; Crowe and Cavalcaselle describe it as 'in the style of Giulio Romano'; Fischel in his 1898 volume (no. 273) dismissed it as a copy; Shearman (1964, p. 87) and Oberhuber (F-O, p. 31, n. 85) gave it to Giulio himself. We prefer the less specific classification 'Studio of Raphael' (see no. 162).

Oberhuber explains no. 163 as a preparatory study for the fresco, Shearman, as a later derivation made for the engraver. The only engraving that he was able to cite, unsigned but attributed by Bartsch to Caraglio (B xv, p. 80, 56), is a coarsely executed and clumsily misunderstood piece of hack-work unlikely to have been based on a drawing made expressly for it under Raphael's own supervision. It is also considerably smaller in scale. A drawing made for such a purpose would normally have been on the same scale as the intended engraving, for there would have been no point in giving the engraver the additional trouble of scaling-down the composition. No other contemporary or even

3

164

near-contemporary engraving of the subect is recorded.

164. Mercury presenting the Ambrosial Cup to Psyche

Chatsworth 55
Red chalk. 269 × 227 mm.
Literature: Ruland, p. 283, 50; C & C, ii, p. 421.

The figures occur, almost exactly as in the drawing, on the extreme left of the fresco of *The Council of the Gods* on the vault of the Psyche Loggia of the Farnesina. The drawing is one of the group of red chalk studies for the Loggia discussed under no. 162.

The traditional attribution to Raphael was followed by Ruland; Crowe and Cavalcaselle gave the drawing to Giulio Romano; Fischel dismissed it as a copy in his 1898 volume (no. 266), but in his posthumously published monograph described it as the work of a pupil (1948, p. 185); Shearman (1964, p. 87), followed by Dussler (p. 97), gave it to Penni, and Oberhuber (F-O, p. 31, n. 85) to Giulio. We prefer, as with no. 163, to classify it as 'Studio of Raphael'.

Shearman considered no. 164 to be the final *modello*, based closely on a design by Raphael. His contention that it was later used for the engraving of the entire composition attributed by Bartsch to Caraglio (B xv, p. 89, 54) overlooks the discrepancy in scale – the figures in the drawing are considerably larger – and the fact that Mercury in the engraving is not wearing the normal shallow winged *petasus* as in the drawing and in the fresco, but a hat of less conventional type with a deep brim turned up all round and a small scroll in front. (A similar hat, with wings on either side, is worn by the figure on the extreme left in the *basamento* under *The Repulse of Attila* in the Stanza d'Eliodoro.)

165

165. Neoptolemus and Andromache

Chatsworth 903
Pen and brown ink. 262 × 408 mm.
Literature: P 569; Ruland, p. 130, xvi, 1; C & C, ii, p. 548;
 F-O, pp. 56 f.

The subject is an incident in the aftermath of the sacking of a city from which the victors are about to depart by sea carrying their spoils in the form of vases, candelabra and the like. Conspicuous among those preparing to embark are an obviously distressed young woman being solicitously urged towards the boat by a young man in armour. The usual interpretation of the subject is *The Rape of Helen*; but it was with no reluctance that Helen eloped with Paris, nor did the Trojans sack the city of Sparta where she had lived with her husband Menelaus. The same doubt evidently occurred to Arthur Strong, the then Librarian at Chatsworth, who in 1902 published the drawing with the hardly more convincing suggestion that it represents Iphigeneia and her brother Orestes escaping from Tauris (*Reproductions of Drawings . . . at Chatsworth*, pl. xix). The more plausible identification of the subject as Neoptolemus and Andromache was put forward independently by Hartt (p. 51) and Profes-

sor Hugh Lloyd-Jones (orally). Neoptolemus was the son of Achilles and one of the leaders of the Greek army; after the fall of Troy he received as part of his share of the spoils, Andromache, the widow of the Trojan prince Hector.

Passavant and Ruland accepted the traditional attribution to Raphael; Crowe and Cavalcaselle were entirely non-committal; Hartt attributed the drawing to Giulio Romano when most strongly under Raphael's influence; Popham's annotation in the catalogue at Chatsworth reads, 'best explained as an old facsimile of a genuine Raphael drawing'; Oberhuber, on the other hand, singled no. 165 out as one of the finest pen drawings of Raphael's late period and dated it *c.* 1516–19. We agree with him that Giulio's authorship is out of the question, but not with his very high estimate of the quality of the drawing itself, in which we see a disquieting resemblance to some of Penni's drawings in pen and ink alone (e.g. nos. 193 and 195). The composition seems too good to be an independent creation by Penni, and Popham and Oberhuber were no doubt right in attributing it to Raphael himself.

The purpose of the drawing is unknown. It might, for the sake of argument, have been designed as an alternative or *pendant* to the *Rape of Helen*

engraved by Marcantonio (B xiv, p. 170, 209) which it resembles in format and scale and in the general arrangement of the composition; but it must be admitted that the principal group in the engraving is suggestive of Giulio Romano rather than of Raphael.

166. Studies for figures in a *Resurrection*

Ashmolean Museum P II 559 *verso*
Pen and brown ink. 345 × 265 mm.
Literature: KTP 559; P 520; R 136; Ruland, p. 40, xxi, 5;
 F 389.

On the *recto* (F 390) is a large-scale drawing in black chalk of the back view of a nude man sitting on a stone in exactly the same pose as the figure in the left foreground of no. 167. There are also separate studies of his head and left arm. This drawing belongs to the same group of studies for single figures of soldiers or groups of soldiers in a *Resurrection* as nos. 168 to 172.

The studies on the *verso* side, here exhibited, show Raphael's creative energy at its most intense, with ideas crowding to the point of his pen faster than he could coherently express them. Of the isolated studies on the upper part of the sheet, the two in the top left corner correspond in pose with the figure in the right foreground of no. 167, for which no. 171 is a finished study. In the backward angle of his body the kneeling man top right resembles the figure sitting on the plinth of the tomb in the centre foreground of the composition-study at Bayonne (see no. 167).

The jumble of figures in the lower right corner of the sheet is not easily disentangled. At the bottom are three (or possibly four) figures which seem to be intentionally grouped together. A vertical framing-line to their right suggests that Raphael intended this group to occupy the right foreground of the composition. (The parallel vertical line to the left seems to have no compositional significance.) The figure at the bottom of the group, wearing Roman armour, grasps a staff or spear in his right hand and is sitting on the ground, falling backwards so that his left leg is in the air. To the right of the framing-line are separate studies, on a larger scale, of his body and head. Immediately above the head of this figure is

the upper part of one seated upright with arms crossed over his head in much the same position as in no. 172. To the left is a standing man in profile to left, with his left leg advanced and his head and body leaning forward. His left arm is lowered and his right arm raised, and he is grasping in both hands the pliant staff of a banner tossed in a gust of wind. The figure is repeated to the left on a larger scale, with an alternative position for the head. Fischel pointed out that the 'Standard Bearer' in Marcantonio's engraving (B xiv, p. 357, 481) is in the same pose, in reverse. The apparently meaningless isolation of Marcantonio's figure could be explained on the hypothesis that he had access to a separate drawing of it. Such a drawing might have been one of the group of black chalk studies: if so, the soldier with the banner would have been retained until the final stage of the design.

To the right of the smaller-scale figure with the banner, which definitely forms part of the group of figures, is the upper part of one in the pose of no. 170, leaning forward to the right with his right arm across his face. It is not certain whether this is intended to be part of the group.

Immediately above, on a larger scale and evidently drawn at the same time as the single figures on the upper part of the sheet and thus not belonging to the group sketched below, is a figure looking over his left shoulder and holding up his shield with both arms extended to his right, evidently to protect his eyes from the supernatural light coming from the Risen Christ.

167. Sketch for the lower part of a *Resurrection*

Ashmolean Museum P II 558
Pen and brown ink. 208 × 262 mm.
Literature: KTP 558; P, p. 513, *t*; R 134; Ruland, p. 40, xxi,
 4; C & C, ii, p. 542; F 388.

A complete composition-study for a *Resurrection* which was evidently to have been a large-scale altarpiece with an arched top is in the Musée Bonnat at Bayonne (F 387). As in no. 167 a sarcophagus occupies the centre of the lower part, on the edge of which sits an angel pointing upward towards the figure of Christ hovering in the sky surrounded by a glory of angels. Around the sarcophagus sprawl the

166

soldiers guarding the tomb, abruptly awakened and dazzled by the apparition and shielding their eyes from the light. No finished study for the whole composition has survived, but Raphael must have brought it to the point at which the disposition of the figures was finally determined. There exists a stylistically homogeneous group of no fewer than six large-scale carefully finished drawings in black chalk (nos. 166 *recto* and 168–172), of a type that it seems to

have been his practice to make only when his design had reached the cartoon stage, of single figures of soldiers or groups of soldiers in a *Resurrection*. A seventh such figure, walking forward with his right arm upraised to clasp the back of his head, is known from two drawings, each on much the same scale as the others of the group: one, in black chalk, at Besançon (2301, as Primaticcio; Gernsheim 12137); the other, in finely cross-hatched pen and ink,

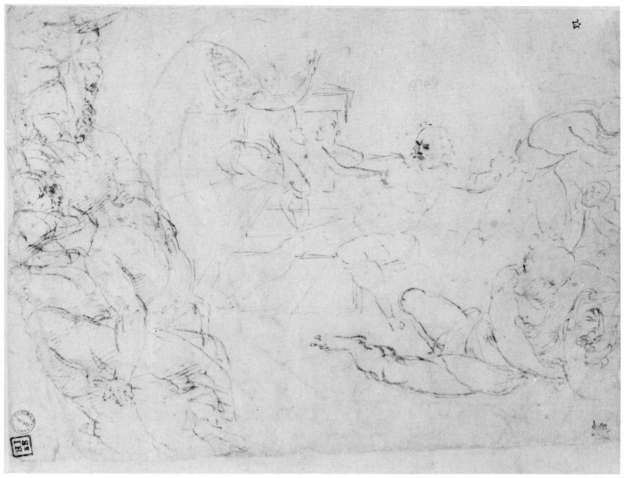

167

showing the figure only as far as the knees, at Frankfurt (F 395a; fig. 309). The direction of the lighting shows that this figure was intended for the left foreground of the *Resurrection*. Both drawings have always been dismissed as old copies of a lost study by Raphael, but it seems to us that in neither case can the possibility of his authorship be excluded. The Frankfurt drawing is of very high quality; its technique is comparable, for example, with that of nos. 76 and 79 in the present exhibition; and it is on the *verso* of a drawing unquestionably by Raphael himself – the study for *Justinian delivering the Pandects* in the Stanza della Segnatura; and the Besançon drawing, if it is a copy, is an exceptionally faithful one. Ruland and Robinson were the first to recognise, independently, that these figure-studies are for the *Resurrection* for which no. 167 and F 387 are composition-sketches. Earlier critics had explained them as discarded studies for figures in *The*

Battle of Ostia in the Stanza dell'Incendio or in *The Battle of Constantine*.

Three of the figure-studies (nos. 166 *recto*, 170 and 171) correspond with figures sketched in no. 167, but only one corresponding figure (also no. 170) occurs in the Bayonne sketch. It would therefore seem to follow that no. 167 represents a somewhat later stage in the evolution of the design, though not the final one, since the figures in nos. 168, 169 and 172 have not yet made their appearance. Two pieces of evidence to be taken into account in any attempt to reconstruct the composition are: (1) the sketch for the group in the right foreground on the sheet of studies no. 166; and (2) an engraving by the Master HFE (B xiv, p. 464, 5; repr. *OMD* (1939–40), p. 41) of a *Bacchanal* composed of four men lying or sitting on the ground, two of whom correspond in reverse, in pose and relative position, with the frontmost figures in no. 169, and a third, in

the same direction, with no. 172 with the right leg in the alternative position as shown. (For the fourth see under no. 102.) In Raffaellino dal Colle's *Resurrection* in the cathedral at Borgo San Sepolcro (Hirst 1961, pl. 29, fig. f) there is a figure corresponding exactly with the one in the left foreground of no. 167, for which no. 166 *recto* is a finished study; but the pastiche nature of the composition is shown by the soldier in the centre foreground, who is a faithful copy of the fallen Heliodorus in the *Expulsion of Heliodorus* in the Stanza d'Eliodoro.

It is surprising that no record should survive of any commission for a painting of this subject by Raphael, and especially surprising since the drawings show that the project was one to which he devoted unusual care. Both Robinson and Fischel suggested that Raphael had at one stage proposed a *Resurrection* as the subject of the large-scale altarpiece commissioned *c.* 1517 by Cardinal Giulio de'Medici, and that only later did this become the *Transfiguration* (see no. 174); but it is unnecessary to discuss the arguments for and against this explanation – for which, indeed, there is no evidence whatever – since the publication of the entirely convincing demonstration by Hirst (1961), that Raphael intended his *Resurrection* for the altarpiece of the Chigi Chapel in S. Maria della Pace. Raphael's *Sibyls* and *Prophets* are on the exterior wall of this chapel (see no. 149), but the altar-niche is decorated with seventeenth-century sculptures.

Hirst's argument may be briefly summarised as follows. All the tablets and scrolls which play a conspicuous part in the design of the *Sibyls* and *Prophets* are inscribed with texts alluding specifically to the Resurrection, and that event was either prefigured or foretold by each of the four Prophets; but the significance of these allusions is fully apparent only in conjunction with a representation of the subject. The obvious place for such a representation would be above the altar. That an altarpiece for the chapel was in fact contemplated within Raphael's lifetime, and thus presumably by Raphael himself, is established by a record of payment for a frame 'per la tauola daltar che andava alla pace' made on behalf of Agostino Chigi, Raphael's patron and the owner of the chapel, who died only five days after he did. In December 1520, less than a year after Raphael's death, his rival, Sebastiano del Piombo, is reported

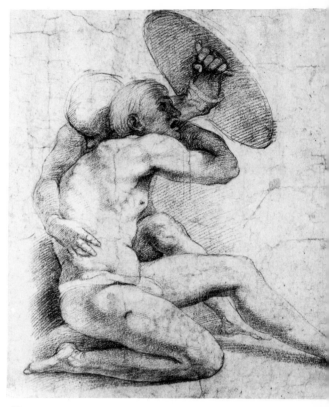

168

to have announced his intention of carrying out 'la tavola alla Pace sotto le fighure di Raffaello', but it was not until ten years later, on 1 August 1530, that he signed a contract to do so. In this document, discovered by Hirst in the Chigi archives, the subject of the altarpiece is specified as the *Resurrection*.

The style of the *Resurrection* studies suggests a dating in the period of the Stanza d'Eliodoro (1511–14), when the full impact of Michelangelo's Sistine ceiling first made itself felt. (One of the figure-studies, no. 169, had indeed been traditionally attributed to Michelangelo.) Hirst suggested that something of the effect of Raphael's final design, in whatever form it eventually attained, might be reflected in the altarpiece of the *Resurrection* painted in about 1519 by his friend and fellow-countryman Girolamo Genga for the oratory of St Catherine of Siena in Rome, in which, as in the altarpiece by Raffaellino dal Colle referred to above, the scene is set at night with dramatic contrasts of light and shade (Hirst 1961, pl. 29, fig. e; *Paragone* 177 (1964),

pl. 54). If Raphael had had a night scene in mind, the effect might also have been not unlike the *Freeing of Peter* in the Stanza d'Eliodoro, in which, it may be noted, a figure in the pose of that in no. 170 occurs, in reverse.

168. Two nude men crouching on the ground, protecting their eyes with a shield: study for figures in a *Resurrection*

Windsor 12736
Black chalk. 266 × 233 mm.
Literature: AEP 798; P 436; R, p. 276, no. 7; Ruland, p. 40, xxi, 9; C & C, ii, p. 542; F 392.

Raphael must have intended this pair of figures to occupy the extreme left foreground of the *Resurrection* (see no. 167). As Popham suggested, they could be a development from the pair in the corresponding position in the Bayonne composition-study (F 387).

169. A group of three nude men: study for figures in a *Resurrection*

Chatsworth 20
Black chalk. 233 × 364 mm.
Literature: F 394.

The absence of any reference to this drawing in the earlier Raphael literature (Passavant, Robinson, Ruland, etc.) is due to its having been attributed to Michelangelo until 1925, when Fischel restored it to Raphael and grouped it with the other *Resurrection* studies (1925(A), p. 198).

The three figures appear to have been designed as a single group, though it is not clear where the body and left leg of the figure with its back turned are meant to be, nor how its right leg is attached to the body. The figure at the back seems to be reclining on its side in a position of some discomfort, with his right knee drawn so far up that it is resting on the shoulder of the figure in front. As Fischel observed, a

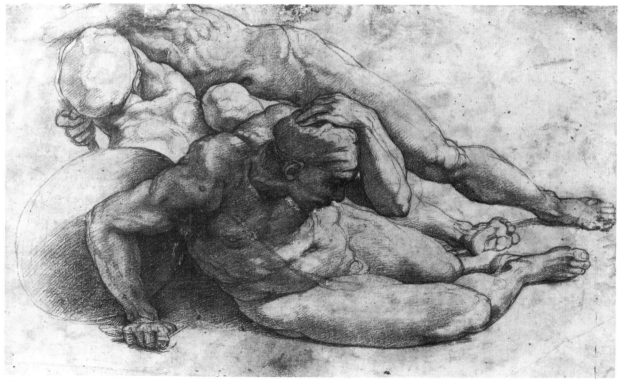
169

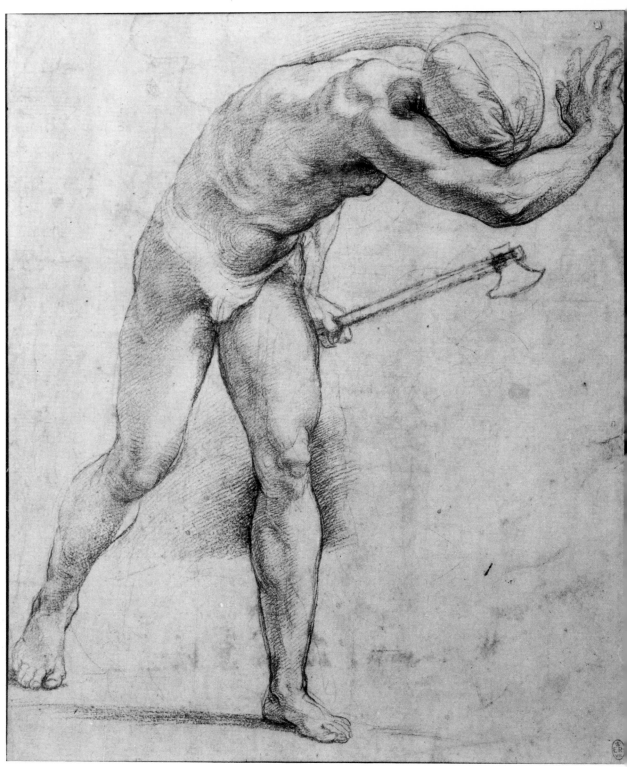

170

reclining soldier in much the same pose occurs in the group on the left of the *grisaille* fresco of the *Resurrection* in the Logge for which no. 196 is a study.

170. A nude man walking to the right with an axe in his left hand, shielding his eyes with his right arm: study for a figure in a *Resurrection*

Windsor 12735
Black chalk. 322 × 256 mm.
Literature: AEP 799; P 437; R, p. 276, no. 8; Ruland, p. 40, xxi, 8; F 393; C & C, ii, pp. 142, 542; F 393.

This is the only one of the six black chalk studies for soldiers in the foreground of the *Resurrection* that corresponds in pose with a figure in both of the known composition-studies, no. 167 and F 387, in each case on the extreme right and towards the back of the foreground group. A figure in what could well be the same pose, and in much the same position, can also be made out in the sketch for the right foreground group on no. 166. Raphael used the pose in reverse for one of the guards on the left-hand side of the *Freeing of Peter* in the Stanza d'Eliodoro, a figure for which some critics even considered no. 170 a study.

On the *verso* (AEP, pl. 51) is a rapid pen and ink sketch, evidently drawn directly from nature, of a group of cattle lying on the ground. Popham observed that it would be difficult to find anything at all comparable among Raphael's drawings; but he was surely right to accept it, in spite of the contrary opinion of both Ruland (p. 340, iv, 1) and Fischel.

171. A reclining nude man: study for a figure in a *Resurrection*

Ashmolean Museum P II 560
Black chalk. 184 × 316 mm. Top corners cut.
Literature: KTP 560; P 521; R 135; Ruland, p. 40, xxi, 7; C & C, ii, p. 542; F 391.

The pose of the figure corresponds with that of one

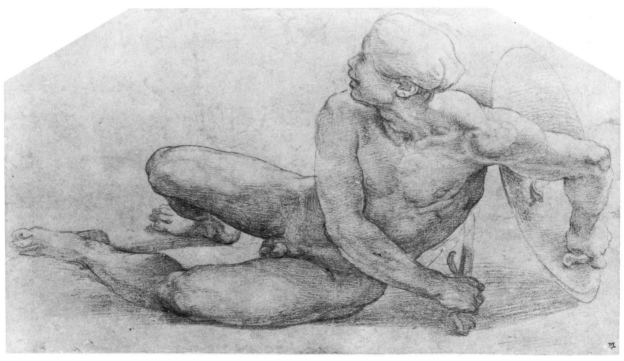

171

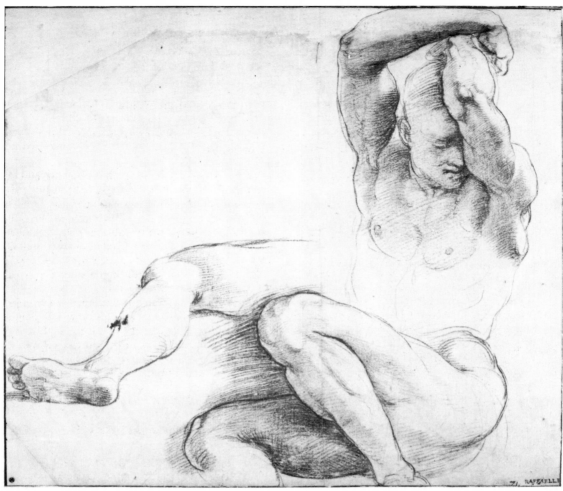

172

in the right foreground of the composition-study for the *Resurrection*, no. 167. Apart from the position of the head and arms, it is also that of the fallen Heliodorus in the *Expulsion of Heliodorus* in the Stanza d'Eliodoro.

172. A nude man seated with his arms above his head; an alternative position for his right leg: study for a figure in a *Resurrection*

British Museum 1854–5–13–11

Black chalk. 293 × 327 mm (including a strip added to the top, on which the right arm is completed. The style of this addition is characteristic of the French eighteenth-century collector P.–J. Mariette, whose collector's mark is on the made-up lower left corner).

Literature: P & G 34; Ruland, p. 321, lviii, 1; F 395.

Inscribed in ink in the lower right corner, in an old hand: *RAFFAELLE* and, in another hand: 71. The inscription on Mariette's mount shows that he connected the drawing with the *Battle of Ostia* in the Stanza dell'Incendio. Robinson unaccountably omitted it from his group of *Resurrection* studies (pp. 275 f.); Ruland included it in the section of his catalogue headed 'General Studies' but with the comment 'perhaps for the Resurrection'. Fischel restored it to the group, with which it fits perfectly in character, style and technique. The rough sketch for the right foreground of the composition on no. 166 includes a figure in rather the same position, apparently seated upright with his arms above his head. The figure on no. 172 is repeated exactly, with his right leg in the alternative position, in the *Bacchanal* engraved by the Master H F E and discussed under nos. 102 and 167.

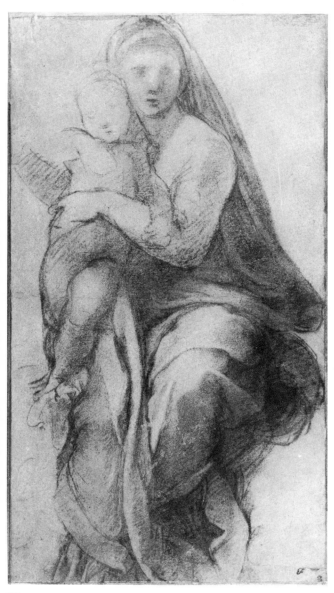

173

173. The Virgin and Child

Chatsworth 902
Black chalk and charcoal. 410 × 223 mm.
Literature: F 369.

Fischel saw no. 173 as a stage in the train of thought that led up to the *Madonna di Foligno* (see no. 120). Without describing it in so many words as a study for that painting, he placed it in his *corpus* immediately after a sketch at Frankfurt (F 368) of a seated Virgin seen from directly in front, holding the Child against her right side so that their heads are touching; and immediately before the drawing in the British Museum (no. 120) which closely resembles the group in the painting, especially in the transference of the Child to the Virgin's other side, and is undoubtedly a preliminary study for it. No. 173 gives the impression of being more developed in style than no. 120: whether it is necessarily as early as 1511–12 – the probable date of the *Madonna di Foligno* – seems to us an open question.

174. Study for the upper part of *The Transfiguration*

Chatsworth 904
Red chalk over stylus underdrawing. Squared in red chalk. 246 × 350 mm.
Literature: Ruland, p. 30, 85.

The large altarpiece of *The Transfiguration*, now in the Vatican Gallery, was commissioned from Raphael by Cardinal Giulio de'Medici, later Pope Clement VII, for his cathedral at Narbonne in Southern France. The date of the commission is not recorded, but the earliest known reference to it is in a letter of 17 January 1517 to Michelangelo from Raphael's unfriendly rival in Rome, Sebastiano del Piombo, from whom the Cardinal had also commissioned a similarly large-scale altarpiece, of *The Raising of Lazarus,* for the same cathedral. Raphael probably began work on the painting itself in 1519, for it was still unfinished at his death in April 1520. It was completed by Giulio Romano and in 1523 was placed above the high altar of the church of S. Pietro in Montorio in Rome.

Oberhuber (1962(B), pp. 116 ff.) has shown that Raphael's first solution was to represent only the

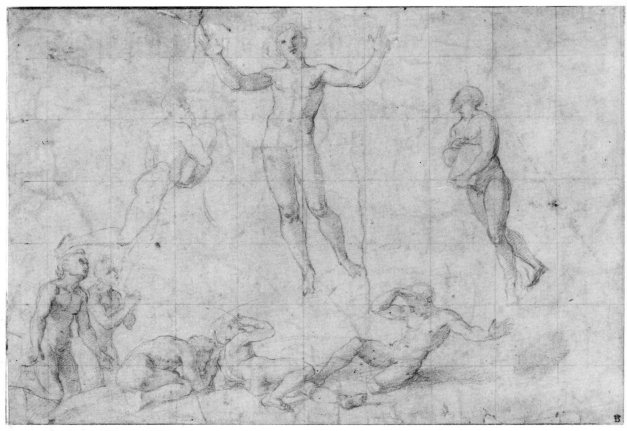

174

episode of the Transfiguration itself: copies of a lost *modello* in the Louvre and in the Albertina (op. cit., figs. 1 and 2; Pope-Hennessy, fig. 59) show Christ standing in the centre of the composition, with Moses and Elijah hovering on either side and the chosen disciples, Peter, James and John, kneeling in the foreground; in the upper part is a half-figure of God the Father surrounded by angels. In the eventual solution the scene of the Transfiguration is moved to the background where it occupies the upper part of the panel; in the foreground is represented the episode of the disciples who had not been chosen to accompany Christ, trying unsuccessfully to heal the demoniac boy who was later healed by Christ after his descent from the mountain. Dussler (p.53) states that the two episodes are not 'factually connected' in the Gospels, and argues that Raphael would hardly have dared to combine them without being instructed to do so by his patron; but it is clear from the narratives of St Matthew and St Mark that they took place on the same occasion and simultaneously – as they are indeed represented. In the words of Crowe and Cavalcaselle, 'the two

incidents thus combined have the sanction of scripture, and Raphael cannot be accused of caprice in attempting to unite them in one composition'. His motive in making the composition more crowded by the introduction of the second theme may simply have been the practical one of reducing the scale of the figures: those in the earlier solution might well have seemed unduly large in a painting that was to measure about thirteen feet by nine (405 × 278 cm). As it is, their scale in relation to the picture area agrees well enough with that of the figures in Sebastiano del Piombo's rival altarpiece of *The Raising of Lazarus* which had been completed by May 1519 and which Raphael may have seen before beginning work on the painting of his own picture.

The upper part of *The Transfiguration* and the group of figures in the left foreground are largely the work of Raphael himself; the figures in the right foreground are clearly executed by another hand, which has every indication of being Giulio Romano's. As Pope-Hennessy observed (p.75) the existence of auxiliary cartoons by Raphael himself for seven of the eight heads in the lower part of the

composition (see nos. 176–180) suggests that he had prepared the full-scale cartoon. The design on the right-hand side of the lower part must therefore be substantially his, however much Giulio's execution may have transformed it superficially.

The figures in no. 174 correspond exactly with the group in the upper part, except that they are nude and that in the painting there is a bigger gap between the pair kneeling on the extreme left and the group of recumbent disciples. There is also a *pentimento* in the drawing for the left leg of the hovering figure of Elijah.

Surprisingly enough, in view of its evident connexion with the picture and its unmistakable character as a squared working drawing, and in spite of the fact that it has been in the Devonshire Collection under the name of Raphael since the eighteenth century, there is only one reference to no. 174 in the whole of the earlier Raphael literature. Ruland accepted the traditional attribution, but the hint was not followed up either by Crowe and Cavalcaselle or by Fischel in his 1898 volume. In his posthumously published monograph Fischel attributed the drawing to Penni (1948, p. 367), and the compilers of the catalogue of the Royal Academy exhibition of *Drawings by Old Masters* in 1953 (no. 44) were inclined to give it to one of Raphael's 'abler assistants'. Oberhuber, on the other hand, argued convincingly in favour of Raphael's authorship (1962(B), pp. 127 ff.), adducing the oral support of van Regteren Altena and Shearman. In the course of his career Raphael must have made innumerable working drawings of this rather schematic and at first sight not strikingly attractive type, but this is one of the very few to have survived.

175. Two seated nude men

Chatsworth 51
Red chalk, with traces of stylus underdrawing. 329 × 232 mm.
Literature: Ruland, p.28, 61; C & C, ii, p. 488.

A study from nude models for the figures of the so-called St Andrew and his companion in the left foreground of *The Transfiguration*. In their relation to one another and in their poses they correspond exactly with the figures as painted.

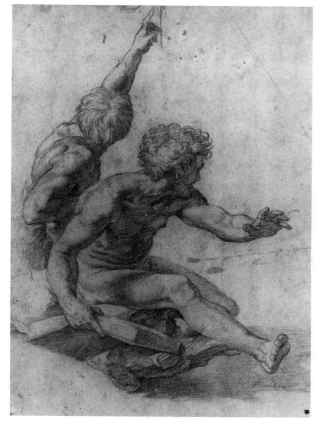

175

The critical history of this drawing has been confused by the existence of an old replica, also in red chalk, in the Albertina (Stix-Bum Cat. iii, no. 115, where the drawing is said to be squared; examination of the excellent old photograph in the Windsor Raphael Collection reveals no trace of this). Ruland listed no. 175 as an original drawing by Raphael and the Albertina version as a copy. Crowe and Cavalcaselle, on the other hand, attributed the Albertina drawing to Raphael and described no. 175 as 'a very fine replica ... apparently by Penni and probably traced for the purpose of adding the draperies'. Fischel (1898, nos. 335 and 336) likewise took the view that no. 175 is the copy, but gave the other drawing to Penni. In his posthumously published monograph (1948, p.367) the wording is too

confused for his exact opinion to be ascertained, but it seems clear that he attributed neither drawing to Raphael. Oberhuber (1962(B), p. 134) repeated Ruland's opinion, which now seems self-evident, that the Albertina drawing is a copy of no. 175; he also took the view that no. 175 is by Raphael himself.

It seems to us that this is one of the late red chalk drawings that still hang in the balance between Raphael and Giulio. There are features of it that we find disturbing and difficult to reconcile with the attribution to Raphael: for example, the unconvincing relationship between the left arm, left shoulder, and head of the pointing figure, and the failure to convey the form of the left leg of the other. The possibility that no. 175 is by Giulio should not be excluded.

AUXILIARY CARTOONS FOR *THE TRANSFIGURATION* (Nos. 176–80)

Six 'auxiliary cartoons' (see under no. 25 above for an explanation of the term) are known for seven of the nine heads in the group of disciples in the left foreground of *The Transfiguration* (the head of the ninth disciple is turned completely away from the spectator). One cartoon, for the head of the disciple at the back of the group who is pointing towards the demoniac boy, is in the Albertina (Stix-Bum Cat., iii, no. 79; Oberhuber 1962(B), fig. 23), but the other five are here exhibited.

Ruland listed all six cartoons as studies for *The Transfiguration,* by Raphael; but Fischel in his 1898 volume (nos. 341–6) gave them all to Penni except for no. 180, which critics have always agreed is by Raphael himself. In the article in which he first pointed out the distinctive function of the auxiliary cartoon in Raphael's work (1937) and in his posthumous monograph (1948, p. 367) he maintained this view in respect of all but no. 176, which he had by then come to think was also by Raphael. Nos. 177 and 178 were first reproduced by F. Hartt (*Art Bulletin*, xxvi (1944), p. 87) who convincingly put the case for Raphael's authorship. Ruland's view that all six are by Raphael was repeated in the British Museum catalogue (P & G, under no. 38) and also by Oberhuber (1962(B), pp. 142ff.), though he observed that the condition of no. 179 and the Albertina drawing makes them difficult to judge.

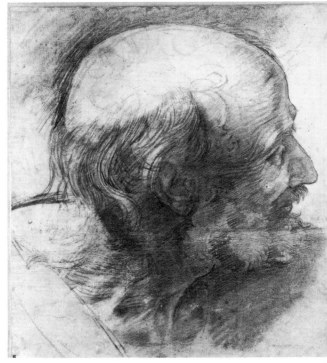

176

176. Head of a bald, bearded old man

British Museum 1860–6–16–96
Black chalk, over pounced-through underdrawing.
 399 × 350 mm.
Literature: P & G 37; P, p. 294, *f* and p. 536, *t*; Ruland, p. 29, 78; C & C, ii, p. 488.

The head is that of the figure seated in the left foreground, usually identified as St Andrew. The auxiliary cartoon reflects a temporary change of mind on Raphael's part: in it the top of the head is completely bald, but the underdrawing pounced through from the full-size cartoon shows locks of hair as in the finished painting. In the full-length study at Chatsworth (no. 175 above) the figure has a luxuriant head of hair.

Fischel's opinion (1937, pp. 167 f. and 1948, pp. 285 and 367) that no. 176 has been reworked by a later hand was repeated in the British Museum catalogue. It now seems to us that Oberhuber is right in his view that this is not so (1962(B), p. 142).

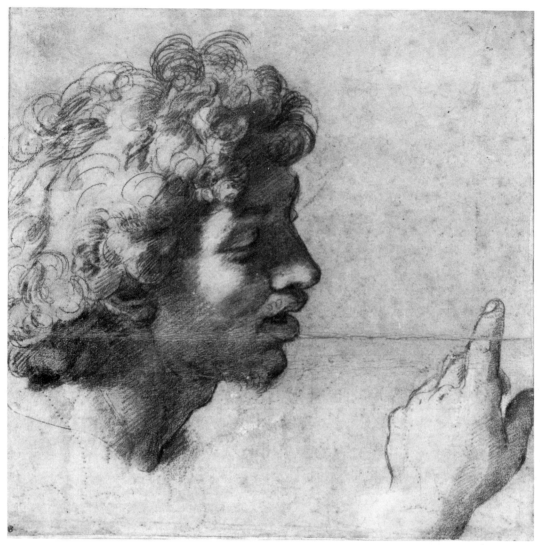

177

This drawing was once part of the Devonshire Collection along with nos. 177 and 178: an inscription formerly on the mount records that it was given to Sir Thomas Lawrence by the sixth Duke of Devonshire in 1823.

177. Head of a young man with curly hair; a left hand pointing upwards

Chatsworth 66
Black chalk over pounced-through underdrawing.
363 × 346 mm.
Literature: Ruland, p. 29, 76; C & C, ii, p. 489.

The head and hand are those of the figure pointing upwards in the centre of the group of disciples. Crowe and Cavalcaselle implied that in their opinion the drawing was originally made for the tapestry cartoon of *The Sacrifice at Lystra* and that it was later used for *The Transfiguration*; but the previous reference to their own book that they quote is to the full-length study, also at Chatsworth, for the figure of St Paul (no. 157). The head in no. 177 is not unlike that of St Barnabas on the extreme left of the tapestry cartoon, but it is held at a different angle and there is no corresponding hand.

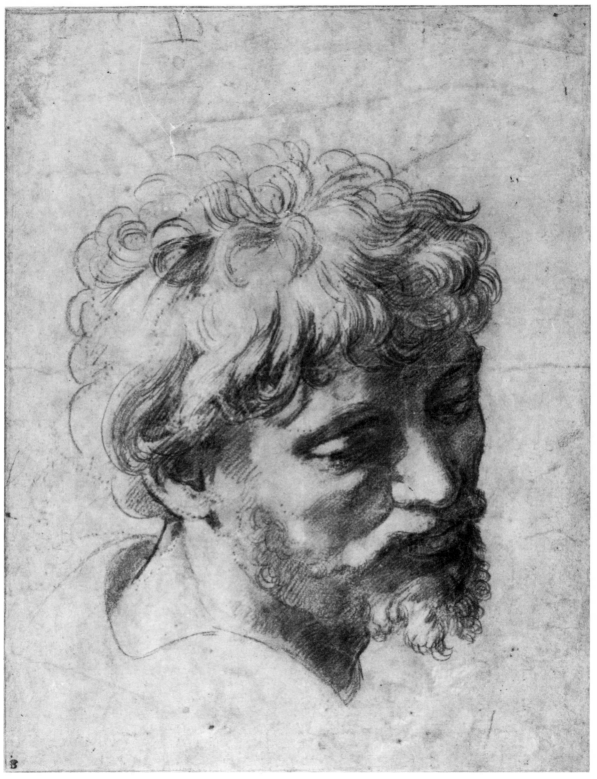

178

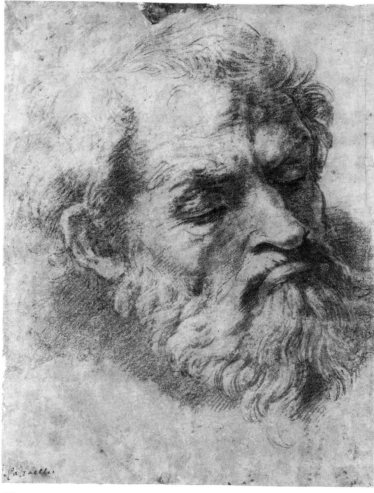

179

178. Head of a youthful bearded man looking downwards over his right shoulder

Chatsworth 67
Black chalk over pounced-through underdrawing.
 375 × 278 mm.
Literature: Ruland, p. 29, 77.

The head is that of the disciple standing on the extreme left of the group.

179. Head of a bearded man

British Museum 1895–9–15–634
Black chalk over traces of pounced-through
 underdrawing. 265 × 198 mm.
Literature: P & G 38; Ruland, p. 29, 73.

The head is that of the disciple at the back of the group who peers over the shoulder of the one

pointing towards the demoniac boy. It differs from the other disciples' heads in facial type and in psychology. Fischel's identification of this figure as Judas Iscariot (1948, p. 282), 'who with protruded lower lip shows himself to be incapable of being affected by what is taking place either on high or in the depths', was followed by Oberhuber (1962(B), p. 145). This head may be a belated reflection of Raphael's Florentine experience: a rather similar grotesque head of an old man is peering over the right shoulder of the Virgin in Leonardo's *Adoration of the Magi*.

Alongside the other drawings for heads in *The Transfiguration* no. 179 makes an unfavourable first impression, but this is due to its having been badly rubbed and discoloured; there are faint traces of pounced-through underdrawing which establish that this was likewise an auxiliary cartoon.

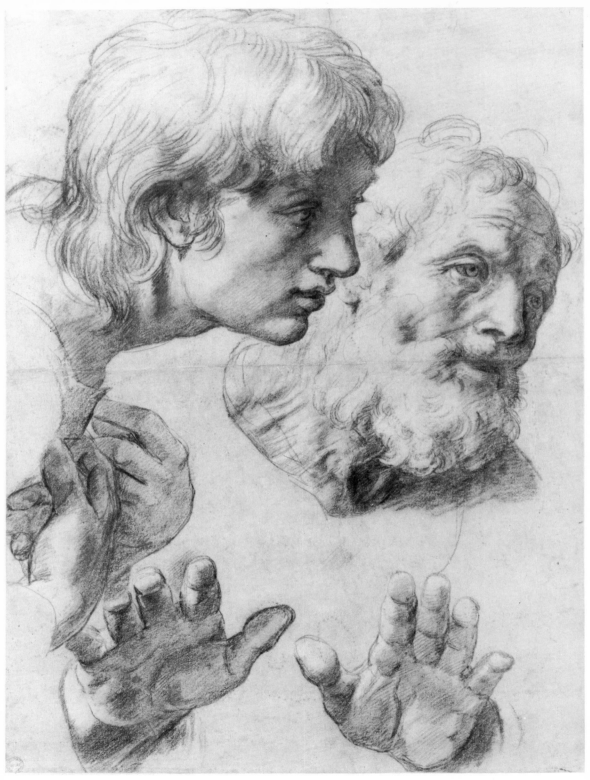

180

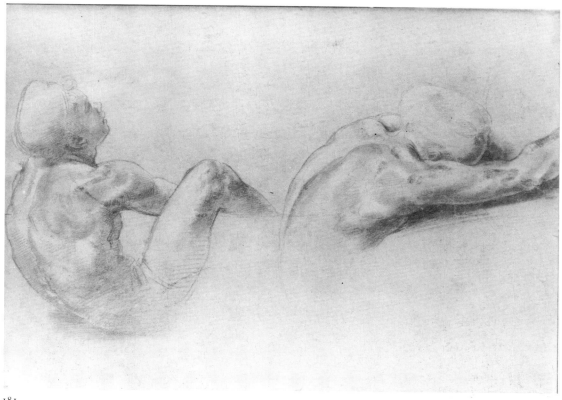

181

180. Heads and hands of a young clean-shaven man and an old bearded man

Ashmolean Museum P II 568
Black chalk over pounced-through underdrawing.
 499 × 364 mm.
Literature: KTP 568; P 473; R 137; Ruland, p. 29, 71;
 C & C, ii, p. 489.

The heads and hands in the same relative positions are those of the pair of figures in the centre of the group of disciples on the right. The traditional identification as John and Peter does not conform to the Gospel narrative, where these are named as two of the three chosen by Christ as witnesses of his Transfiguration. In the painting three disciples are shown with Christ on the mountain, and nine below.

181. Two studies of a nude model

Ashmolean Musuem P II 569
Black chalk, heightened with white. 257 × 362 mm.
Literature: KTP 569; P 519; R 143; Ruland, p. 236, 17;
 C & C, ii, p. 455; F-O 487.

Both studies are for figures in the fresco of *The Battle of Constantine* in the Sala di Costantino, which lies between the Stanza d'Eliodoro and the Logge and was the last of that suite of rooms to be decorated. The cross-vaulted construction of the three *Stanze* makes the upper part of their walls lunette-shaped, but the Sala di Costantino is a very much larger room which in Raphael's time had a flat wooden ceiling. In the centre of each wall is an episode from the history of Constantine represented as a simulated tapestry; on either side of these, also at dado

height, are figures of early Popes enthroned in niches attended by personifications of Virtues.

Constantine's victory over Maxentius at the Milvian Bridge, usually called *The Battle of Constantine,* the largest and most complex of the four historical scenes, is on the long wall opposite the windows; on the facing wall, above the fireplace between the windows, is *The Donation of Constantine;* on one end wall is Constantine addressing his troops before the battle and the miraculous apparition of the Cross in the sky, usually called *The Allocution of Constantine;* on the end wall opposite is *The Baptism of Constantine.*

The decoration as executed bears the unmistakable stamp of Giulio Romano, but work had already begun in this room within Raphael's lifetime, for a payment for scaffolding there is recorded in October 1519. After Raphael's death his studio assistants, headed by Giulio Romano, are reported to have claimed the commission on the grounds that they were in possession of his designs, and Vasari, whose source of information would presumably have been Giulio, is emphatic that 'le invenzioni e gli schizzi delle storie' were partly by Raphael and that 'era il partimento di questa sala, perchè era bassa, stato con molto giudizio disegnato da Raffaello, il quale aveva messo ne' canti ... alcune nicchie ... e dentro ... alcuni papi'. From the evidence available, analysed in detail by Shearman (1965, pp. 177 ff.) and Dussler (pp. 86 ff.), the problem is to determine how much of the decoration as we now see it can be credited to Raphael himself.

Vasari's statement that it was Raphael who devised the partitioning of the wall surfaces is confirmed by a drawing in the Louvre (F-O 477) for a complete end-section composed of the same elements as in the final result, disposed in the same way but with greater restraint and structural clarity. The drawing is a characteristic 'fair copy' *modello* by Penni, but Penni himself can be ruled out, *ex hypothesi,* as the author of the design; so too, once the design is compared with the end sections as executed, can Giulio. This leaves only Raphael. The effectiveness of his scheme is now hard to judge, even when allowance is made for the transformation brought about by Giulio's independent and uncontrolled interpretation of it: Vasari emphasises that it was designed to take into account the low ceiling,

but in the 1580s the flat wooden ceiling at cornice height was removed to make way for the present high coved vault embellished with paintings by Tommaso Laureti, which destroys the effect of Raphael's carefully worked-out solution.

Of the four historical scenes, the *Donation* and the *Baptism* are independent creations of the studio, in which Raphael had no part (see no. 199). On the other hand, the *Battle* and the *Allocution* (see no. 197) come into consideration as being possibly designed by him. In this connexion no. 181 is a crucial piece of evidence.

Both studies on the sheet are from life, from a model posed in the studio, wearing a loincloth and with his hair tied up exactly as in the figure-studies for the *Resurrection* (nos. 168 to 172). They are, with their position transposed, for the pair of figures struggling in the water in the right foreground of the *Battle:* the study on the left is for the soldier trying to pull himself into the boat, and the other is for the partly submerged soldier who is clasping him round the waist. They are closer to the corresponding figures in Penni's 'fair copy' *modello* for the whole composition in the Louvre (F-O 485) than to those in the fresco: in the *modello* they are both unclad, whereas in the fresco the soldier partly in the boat is wearing a helmet and a coat of mail. Studies of this sort, for figures in their final poses, would not have been made until the composition itself had reached its final form. The authorship of no. 181 is thus a question of crucial importance: is it by Raphael, as was traditionally supposed, or by Giulio? It seems to us that Giulio can be ruled out absolutely on grounds of style and quality. The combined delicacy and breadth with which the structure of the knee is suggested, and the beautiful rendering of the fall of light across it, are surely far outside his range, as is the subtle element of pathos which the draughtsman has even imparted to the figure. Oberhuber pointed out that Penni is an unknown quantity as a draughtsman in chalk, but this possibility can be excluded *a fortiori.* If this drawing is by Raphael himself – and no alternative attribution seems possible – then it follows that he was responsible for the composition of *The Battle of Constantine,* however much his conception was transformed by Giulio's execution. Parker, while not committing himself entirely to the attribution to Raphael, acutely

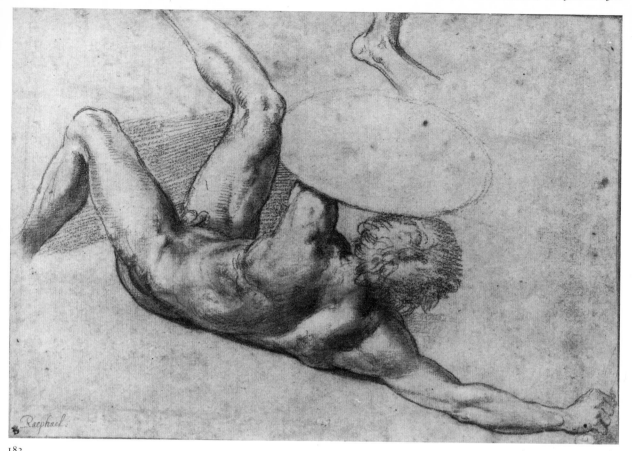

182

emphasised the resemblance between no. 181 and the figure-studies for a *Resurrection* (nos. 168 to 172).

182. A nude man sprawling on the ground, holding a shield on his left arm; a separate study for his right foot and ankle

Chatsworth 59
Black chalk, with touches of white heightening.
 221 × 302 mm.
Literature: Ruland, p. 236, 19; Crowe and Cavalcaselle, ii,
 p. 455; F-O 486.

Inscribed in ink in the lower left corner, in a sixteenth- or seventeenth-century hand: *Raephael*.

 This drawing resembles no. 181 in being a study from the model for one of the soldiers in the water in the right foreground of *The Battle of Constantine*; in the painting the figure is wearing a coat of mail and holds a dagger in his right hand. It poses an even nicer problem of connoisseurship. Ruland accepted the traditional attribution to Raphael, but Crowe

and Cavalcaselle were inclined to see it as a copy of a lost drawing by him. Later critics put forward the name of Giulio; and Parker, while not attributing no. 182 to Giulio in so many words, was emphatic in seeing a distinction between it and no. 181 which he was very much inclined to give to Raphael. The same distinction was made by Shearman (1965, p. 179), who attributed no. 181 to Raphael and no. 182 to Giulio. Oberhuber, on the other hand, gave both drawings to Raphael. The attribution of no. 181 to Raphael is hardly in dispute, but we agree with Parker and Shearman that a distinction can be drawn between it and no. 182. In no. 181, which Parker justly compared with the figure-studies for the *Resurrection* (nos. 168–172), the musculature of the backs of the two figures, especially the one on the left, is rendered by a sequence of delicate tonal modulations; in no. 182, on the other hand, it seems to us that the form of the body lacks organic unity, and that it is broken up crudely into over-emphatic areas of light and dark. No. 182 seems to be the work of a less subtle draughtsman, having many of the

characteristics of Giulio. Comparisons of this sort can never be satisfactorily made on the basis of photographs: the present exhibition will provide the first opportunity of comparing the two drawings themselves.

183. Head of Pope Leo X

Chatsworth 38

Black chalk. The outlines indented. 337 × 268 mm.
(maximum measurements of the irregularly trimmed sheet, laid on a rectangular sheet measuring 480 × 299 mm).
Literature: F-O 482.

An inscription on the old mount in the hand of the late-seventeenth-century collector and 'expert', Padre Sebastiano Resta, describes the drawing as a portrait of Leo X by Michelangelo. The first critic to recognise the connexion with Raphael was Passavant, in a brief reference not in his life of Raphael but in his *Tour of a German Artist in England* (Engl. ed., 1836, ii, p. 145): 'here [at Chatsworth] ascribed to Michelangelo, although from one of Raphael's own paintings'. The attribution to Michelangelo was probably maintained at Chatsworth throughout the nineteenth century, for in 1899 Franz Wickhoff expressed his opinion that the drawing was by Sebastiano del Piombo (*Jahrb. der kgl. Preussischen Kunstsammlungen*, xx (1899), p. 209), an attribution adopted by Berenson in the first edition (1903) of his *Drawings of the Florentine Painters* (no. 2477). It was not until 1935 (*Bollettino d'arte*, xxviii, p. 484) that Fischel spelt out in full what Passavant may already have observed, that the head corresponds with that of the fresco of *Clement I* in the Sala di Costantino, one of the figures of historical Popes who was portrayed with the features of Leo X. Fischel attributed the drawing without hesitation to Giulio Romano. Berenson presumably took note of Fischel's observation, for in the second edition (1938) of his *Florentine Drawings* he abandoned the attribution to Sebastiano in favour of one not to Giulio but to Raphael, with the comment: 'it was used by Giulio for the head of Clement I; it has shrivelled in the process, the conception being far too overpowering for Giulio, and the execution too direct'. Both Hartt (p. 51) and Oberhuber, however, were emphatic in

returning to the Giulio attribution, which they saw as self-evident. Shearman, on the other hand (1972, p. 61) followed Berenson and described the drawing as 'the most intensely realised (and the last) of all Raphael's portraits of Leo'.

Wickhoff's attribution of no. 183 to Sebastiano del Piombo was a consequence of the then fashionable theory, to which Berenson at that time also subscribed, that Sebastiano was Michelangelo's stylistic *alter ego* and that many drawings traditionally attributed to Michelangelo are in fact by Sebastiano. So far as this particular drawing is concerned, it had a certain element of plausibility in that the draughtsman seems to have been a gifted portraitist. This immediately suggests Raphael; and it is difficult to think of any portrait by Giulio that makes so powerful an impact. Hartt supported the attribution to Giulio by a comparison with the heads in the Vatican cartoon for the altarpiece of *The Lapidation of St Stephen* (his figs. 102–3 and 106–7), an independent work by Giulio datable soon after Raphael's death; but these seem looser, less controlled and less concentrated than the head of Leo, without its grasp of the underlying form. A more convincing comparison would have been with the fragment of Giulio's cartoon for the *Battle of Constantine* in the Ambrosiana, especially with the head of the horseman in the detail reproduced by Hartt on fig. 81. The arguments for and against Raphael and Giulio are nicely balanced. The quality of the drawing as a portrait is fully worthy of Raphael and is somewhat unexpected in Giulio; but it must be admitted that the way in which the lips and nose are formalised, and the over-emphatic contrasts of light and shade, make it difficult to deny the correctness of the attribution to Giulio.

The exact relation between no. 183 and the head in the fresco is still a matter of argument. The over-lifesize scale of the head, the technique of the drawing and the incised contours, all proclaim it a fragment of a cartoon. Fischel had no doubt that this was so, and went to some trouble to obtain the measurements of both heads. He claimed that they correspond exactly in scale, but the measurements that he gave for the head in the drawing are significantly smaller. Oberhuber accounted for the discrepancy by quoting the explanation that he thought had been given by Berenson – that the paper

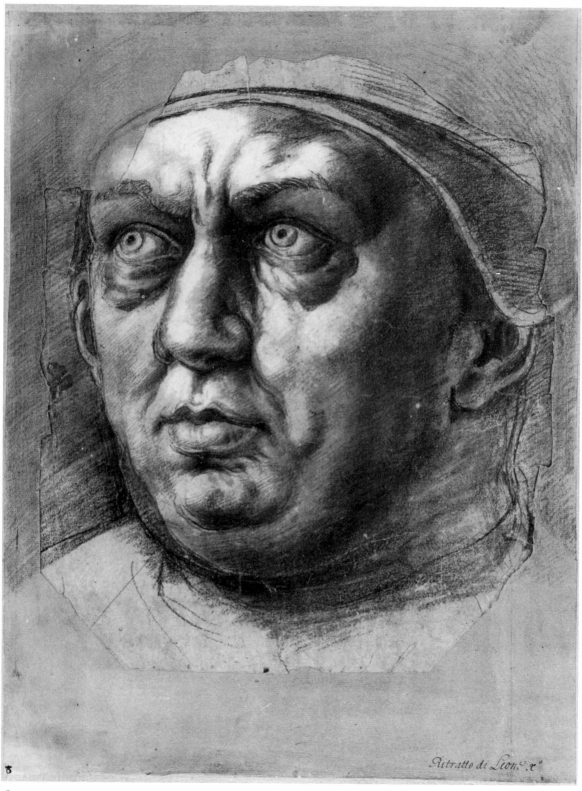

Ritratto di Leon.e x.e

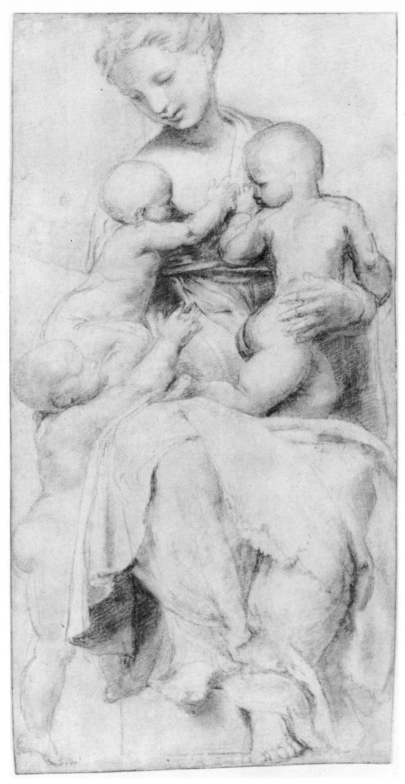

184

had shrunk; but there is no reason why the paper of a cartoon should shrink, and Berenson was clearly using the word 'shrivelled' in a metaphorical sense, to describe the relative inferiority of the painted head.

Shearman (1972, p. 60, n. 88) thought that no. 183 had only been re-used for the head in the Sala di Costantino, and that it had originally been drawn by Raphael in connexion with the colossal statue of Leo by Giovanni Aimo, now in S. Maria in Aracoeli. This suggestion seems to us without substance: not only are the features of the statue distorted to the point of caricature, but there would surely have been no need for a sculptor to work from a larger-than-life cartoon.

184. Charity

Ashmolean Museum P II 665
Black chalk, heightened with white. 313 × 152 mm.
Literature: KTP 665; P, p. 512, *o;* R 144; Ruland, p. 239, iv, 11; C & C, ii, p. 535; F-O 479.

A study for the allegorical figure to the right of *Urban I*, the enthroned Pope on the right of *The Battle of Constantine* in the Sala di Costantino (see no. 181).

Critical opinion of this drawing has varied: Woodburn (Lawrence Gallery, 1836, no. 71) gave it to Raphael; Passavant, Robinson, and Crowe and Cavalcaselle to Penni; Parker dismissed it without hesitation as a copy 'whether from the fresco or from another drawing is uncertain'; Shearman (1965, p. 180, n. 103) considered it 'an exceptionally fine study by Giulio'; Oberhuber reverted to the original attribution to Raphael.

Oberhuber admitted that in dealing with the black chalk figure-studies of this period it is not easy to distinguish those by Raphael himself from those of his studio assistants. He disagreed with the attribution to Giulio, but the two black chalk drawings that he adduced in support of his argument (F-O 481c and 489a) are both fragments of cartoons and thus not strictly comparable. He went on to argue that the absence of any black chalk figure-studies certainly by Penni makes an attribution to him hazardous. Raphael's authorship seemed to him supported by the quality of the drawing and by its superiority to the figure in the fresco which for him excluded the possibility of the drawing being by a studio assistant.

We agree that no. 184 cannot be by Giulio. It is too close to Raphael; and if not by Raphael, it can only be by Penni. The absence of black chalk drawings certainly by Penni does not in itself constitute a positive argument against the attribution. We are unable to share Oberhuber's enthusiasm for no. 184, which seems to us to be characterised not so much by sensitivity of touch and subtlety in the treatment of light and shade, as by an inconsistency of touch – now over-emphatic, now over delicate – and an uncertainty amounting at times to timidity, which in our view are indicative of Penni. The profile of the legs and back of the child standing on the left of the group is rendered with an over-simplified formula identical with that used for the angel in the Louvre drawing for *St Matthew* in the Sala dei Palafrenieri (see no. 190); and in both drawings are the same inexpressive little hands. But the quality of the design of the figure of *Charity* is surely beyond Penni's unaided capacity, and we agree with Robinson's explanation of this drawing as 'an advanced drawing of Penni from Raffaello's first sketch for the cartoon'.

5 SCHOOL DRAWINGS
Nos. 185–202

Raphael had a number of studio assistants, but the two whom he named as his heirs and who were clearly the most important were Giulio Romano and Giovanni Francesco Penni. The assistants also included two younger artists, Perino del Vaga and Polidoro da Caravaggio, who were later to distinguish themselves, but both are on record as having begun their careers in the Logge in 1518–19, when they would have been only about eighteen years old. There is no reason to suppose that either stood in the same confidential relation to Raphael as Giulio and Penni.

The discussion of some of the drawings catalogued above (e.g. nos. 156, 160, 162, 163, 164, 175 and 181 to 184) illustrates the difficulty posed by the chalk figure-studies connected with Raphael's late commissions of *c.* 1515 onwards. The traditional attribution to him of most drawings of this type has at one time or another been challenged on grounds of quality. It is difficult to feel any great certainty about some of the alternative attributions to Giulio and Penni that have been proposed, for the style of the drawings is so entirely Raphaelesque as often to obscure the draughtsman's individual personality.

Another group of drawings that must be from the studio are in pen and wash, sometimes heightened with white, and are the work of a competent but uninspired hand. They clearly emanate from the immediate circle of Raphael, many of them being 'fair copies' of Raphael compositions, often squared for enlargement. Though evidently anterior to the finished works, they reveal few signs of creative thinking and can hardly be described as preliminary studies in the accepted sense of the term. The draughtsman's level when left to his own devices is shown by such a drawing as no. 201, and by the group of three drawings in the Albertina (F-O, figs. 33 and 34) which seem to be stylistically more developed and hardly datable much earlier than *c.* 1530. These are enough to exclude completely the theoretical possibility that this group might be by Giulio, Perino or Polidoro. The attribution to Penni, though arrived at largely by process of elimination, remains the most convincing explanation of this group of 'fair copy' drawings, and is now generally accepted. Penni's nickname of 'Il Fattore' suggests that he may have been responsible for the practical organisation of the studio. Such routine tasks as the reduction of Raphael's ideas to a neat and communicable form could well have been delegated to him.

The group includes a number of drawings connected with the biblical scenes in the Vatican Logge. The compositions agree closely with the frescoes but the drawings do not seem to be copies. Almost all are squared, and in one instance (no. 194) the composition has a shallow arched top, as do some of the frescoes but not the corresponding one, which is rectangular, a discrepancy that must mean that these drawings are part of the preparatory material. It seems on grounds of general probability unreasonable to suppose that anyone other than Raphael was responsible for the general invention of the Logge scenes, but exactly how his ideas for them were formulated is uncertain. No compositional sketches by him are known, but the preservation of drawings is a matter of chance and no conclusions can safely be based on the accident of their survival or non-survival. More ingenious than convincing is the theory that Raphael expressed his ideas in the form of the rough black chalk underdrawing, which an assistant then elaborated in pen and wash (see no. 191).

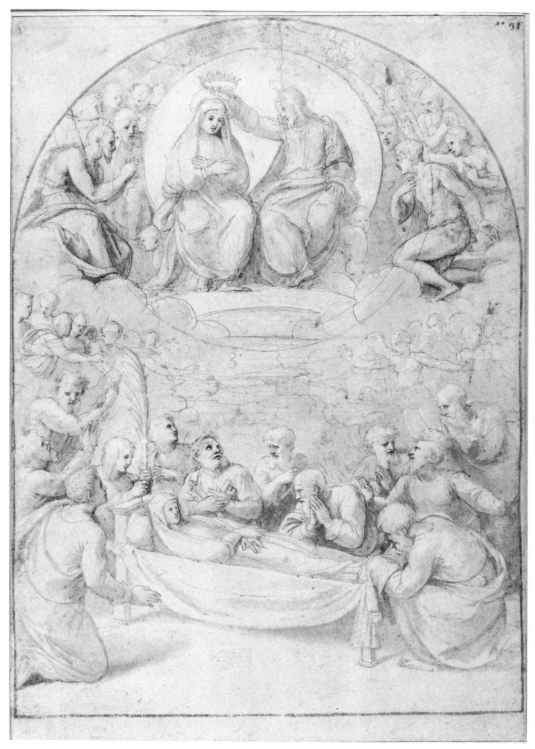

185

185. The Dormition and Coronation of the Virgin

British Museum 1860–6–16–84
Pen and brown wash, heightened with white. Traces of
 underdrawing in black chalk. 379 × 260 mm.
Literature: P & G 68; P, p. 539, *ll*; Ruland, p. 106, iii, 4; F,
 under 384.

The drawing, traditionally attributed to Raphael
himself, is by the neat but characterless hand now
identified as that of his principal studio assistant
Giovanni Francesco Penni. It is a typical 'fair copy' of
what was presumably a composition by Raphael.
Passavant, who was the first to see that it was the
work of a pupil, concluded that it could not be a study
for the Monteluce *Coronation* (see no. 133) as had been
suggested, since in his opinion Raphael himself
would have been responsible for any preliminary
drawings. That suggestion, repeated by Ruland and,
in his 1898 volume (no. 352), by Fischel, seems to us
very plausible, in spite of the difference in subject
between the lower part and that of Domenico
Ghirlandaio's *Coronation of the Virgin* at Narni which
Raphael in 1505 had agreed to take as a model, and in
which the lower part is occupied by a crowd of some
twenty saints. This combination and this arrange-
ment of figures was much favoured in Umbria by the
Observant branch of the Franciscan Order, to which
the convent of Monteluce belonged; but Umberto
Gnoli, who reproduced several such Umbrian altar-
pieces, by Lo Spagna and others, pointed out that this
pattern of *Coronation* seems to have been developed
from another of which there are also many examples
in Umbria, in which the lower part is occupied by the
Dormition of the Virgin (see *Bollettino d'arte*, xi
(1917), p. 138, n. 5). To an artist of Raphael's capacity
for rapid development it cannot have been long
before the Ghirlandaio prototype would have come
to seem impossibly old-fashioned. He might well
have prepared a *modello* of an alternative treatment of
the subject that would still have been likely to appeal
to the conservative taste of his patrons. In shape and
proportion of height to width the composition in the
drawing exactly corresponds with the Ghirlandaio
altarpiece.

In some features, particularly the circular Glory
behind the Coronation group and the void in the
centre of the lower part through which a distant
landscape is visible, this composition resembles the
Madonna di Foligno of *c*. 1511–12 (see no. 120), and can
reasonably be dated about the same time. This seems
also to be the most likely date for no. 133, which may
likewise be connected with the Monteluce altarpiece,
and of which a variant is preserved in a similar 'fair
copy' *modello* by Penni.

The same combination of subjects occurs in a
Raphaelesque fresco, dated 1517, decorating the apse
of a chapel in the church of S. Maria Assunta at
Trevignano, north of Rome (Venturi ix², fig. 339).
The composition is hardly more than a clumsy
pastiche of motifs taken from Raphael, executed by a
clumsy hand; but its existence should not be over-
looked in any discussion of the history of the
Monteluce commission.

186. Design for part of the border of a circular dish

Ashmolean Museum P II 572
Pen and brown ink. The concentric circles drawn with
 compasses. 232 × 369 mm.
Literature: KTP 572; P 522; R 83; Ruland, p. 308, iii, 2; C
 & C, ii, p. 354.

The traditional attribution to Raphael – the drawing
had formed part of Lawrence's series – was accepted
by Passavant and Ruland, but rejected by Robinson,
who saw no. 186 rather as a copy by a pupil of a
design by the master. Crowe and Cavalcaselle
compared it with a similar design, also in the
Ashmolean Museum (KTP 245), which they and
Parker followed Robinson in attributing to Giulio
Romano; no. 186 they described as 'executed with a
softer line, and probably by Penni'. Parker was
inclined to agree with this attribution, though he
catalogued the drawing under 'School of Raphael'.
In our opinion both drawings are probably by
Penni, but we agree with Robinson that the design
of no. 186 (though not necessarily that of the other)
seems to have been due to Raphael. A drawing by
Raphael himself for part of a circular border simi-
larly composed of sea-monsters, etc. is on the *verso*
of the study at Windsor for the *Massacre of the
Innocents* (no. 123). A complete design for another
border of the same kind, said by Passavant to be in
the Dresden Printroom and attributed by him to

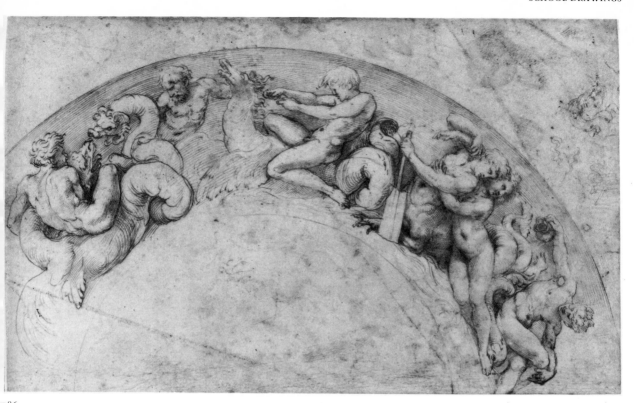

186

Raphael himself, (Ruland, p. 308, iii, 1), is very much more crudely executed than no. 186 and KTP 245: it seems to be a copy, probably after a design by Raphael, but not necessarily even a studio work.

Maiolica was sometimes in the past known as 'Raphael Ware'. Many pieces are decorated with compositions derived from engravings after him, but there is no basis for the tradition that he made designs expressly for the decoration of maiolica. No. 186 and the other drawings referred to above are more likely to be designs for metalwork. Critics have tended to connect them with the pair of bronze dishes commissioned from the goldsmith Cesare Rossetti by Agostino Chigi, for which Raphael supplied the designs, but these were to have been decorated with a pattern of flowers (see no. 123).

187. The Miraculous Draught of Fishes

Windsor 12749
Pen and brown wash over black chalk, heightened with
 white. 203 × 340 mm.
Literature: AEP 808; Ruland, p. 243, 8; C & C, ii, p. 275;
 F-O 440.

The composition corresponds very closely with that of the tapestry cartoon (see no. 155). The final result differs from the drawing in the addition of the fish in the boats and the birds in the foreground; in the compression of the group in the right-hand boat by moving the reclining oarsman closer to the other figures; and in the omission of the oar lying across the left-hand boat between the feet of the standing figure usually identified as St Andrew.

The drawing cannot be by Raphael himself, as was once supposed. It seems to be by the hand now generally agreed to be that of his studio assistant G. F. Penni. This attribution, suggested independently by Crowe and Cavalcaselle and in the British Museum catalogue (P & G, p. 56), is accepted by Oberhuber and by Shearman (1972, p. 94). Penni presumably based his drawing on some sort of sketch by Raphael; and the *pentimenti* in the draperies of Christ and St Andrew suggest a close degree of collaboration between the master and his assistant.

The oar lying across the left-hand boat is a vestige of an earlier solution shown on both sides of a sheet in the Albertina (F-O 438–439), in which St Andrew is propelling the boat with it and not, as in no. 187 and the final version, advancing forward with his hand held out in a gesture of astonishment. On the *recto* of the Albertina sheet the boat-group is rele-

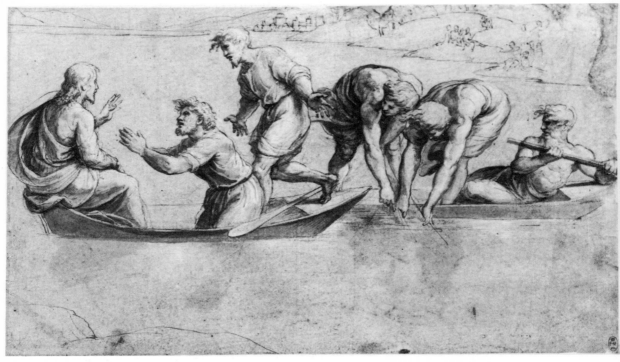

187

gated to the background, the foreground being occupied by a group of men, women and children representing the crowd which had gathered by the lake to listen to Christ's preaching. On the *verso* the boat-group occupies the foreground as in no. 187 and the final version. As Oberhuber observed, the action of St Andrew in propelling the boat is appropriate when this is out in deep water, but once close to the shore it was no less appropriate for him to drop his oar and assume the more expressive gesture of worshipping amazement. The significance of the *verso* drawing is that it represents a transition between the two; and we agree with Oberhuber that a change of this sort suggests the working of a creative imagination. The Albertina drawings are certainly not by Raphael, and are now generally agreed to be by Giulio. It seems to us, however, that Freedberg's attribution to Penni (p. 294) deserves serious consideration. Neither Oberhuber nor Shearman entirely rejects the possibility that they may record a discarded solution by Raphael himself.

188. Venus Anadyomene (offset)

British Museum 1939–2–1–1
Red chalk over stylus. 228 × 116 mm.
Literature: P & G 282; Ruland, p. 276, i, 3; C & C, ii, p. 335; F-O 453.

Inscribed in ink in lower left corner, in a sixteenth-century hand: *Raphael*.

The original of this offset corresponded with one of the now much damaged frescoes of mythological subjects in the Bathroom of Cardinal Bibbiena in the Vatican (repr. *L'Arte,* xxix (1926), p. 205), the decoration of which was completed on or shortly before 20 June 1516.(see F-O, pp. 143 ff.).

Raphael was a close friend of the Cardinal, and the style of the decorations in the Bathroom and in the adjoining *Loggetta* leaves no doubt that it was carried out by him and/or his studio. The execution of the Bathroom frescoes is generally agreed to be by Giulio on the basis of designs supplied by Raphael. With one exception Oberhuber has attributed to

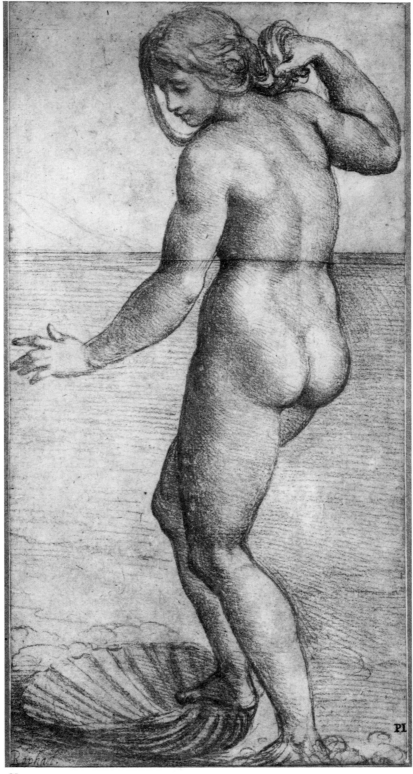

188

Giulio such related drawings as have survived, all finished studies in red chalk of figures or groups of figures (e.g. no. 189). The exception is no. 188, regarded by him as an offset of a lost drawing by Raphael himself which would have resembled the lost original of the offset at Chatsworth (no. 160) possibly connected with the slightly later decoration of the Psyche Loggia of the Farnesina.

189. Venus and Cupid

Windsor 12757
Red chalk over stylus. Much rubbed with several holes.
 209 × 170 mm.
Literature: AEP 810; P 434; Ruland, p. 277, iii, 5; C & C, ii,
 p. 335; F-O 454.

The composition is that of one of the now much damaged frescoes in the Bathroom of Cardinal Bibbiena in the Vatican (see no. 188). An engraving of it, in the same direction, by Agostino Veneziano (B xiv, p. 218, 286) is dated 1516, the year when the decoration was executed. Oberhuber may well be right in attributing this drawing to Giulio Romano, on the strength of the combination which he saw in it of hardness of line and lack of precision in such details as foreshortening. He claimed the support of Crowe and Cavalcaselle and Popham for the attribution. Crowe and Cavalcaselle in fact describe no. 189 as 'a good drawing, in the manner of Giulio Romano'; and Popham, even more cautiously and without invoking Giulio's name at all, as belonging 'to a series of copies from Raphael compositions (which) are extremely delicate, almost dainty, in touch, very near to Raphael himself in style, but without his decisiveness'.

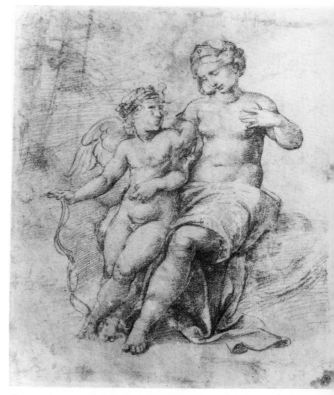

189

190. St Luke

British Museum 1959–7–11–1
Pen and brown wash over black chalk, heightened with
 white. Squared in black chalk. 257 × 189 mm.
Literature: P & G 63; F-O 475.

Inscribed in ink in the so-called 'deceptive hand' (see AEP, p. 379): *Scuola Rafaele*; and in lower right corner, in another hand: *R.*

The figure in the drawing corresponds with one of the large-scale figures in niches painted in *grisaille* round the walls of the Sala dei Chiaroscuri (also sometimes called the Sala dei Palafrenieri) in the Vatican (F-O, fig. 200). In this room, which immediately adjoins the Sala di Costantino, Vasari says that Raphael painted 'in certi tabernacoli alcuni Apostoli di chairoscuro, grandi come il vivo'; a payment to the 'Gioveni di Raffaello' for painting carried out there is recorded on 1 July 1517. A similar drawing in the Louvre (F-O 476) corresponds with the *grisaille* of *St John the Evangelist* (F-O, fig. 201), and another drawing in the same collection, of *St Matthew* (F-O 474), clearly belongs to the series though there is now no corresponding *grisaille*. All three drawings are by the hand identified as that of G. F. Penni; but the quality of the design suggests that all three are based on indications furnished by Raphael himself.

Vasari goes on to say that the frescoes were destroyed when this part of the papal apartment was rearranged by Pope Paul IV (1555–59), and that they were then restored by Taddeo Zuccaro. The older critics such as Passavant and Ruland had assumed that the figures now to be seen in the Sala dei Chiaroscuri had no connexion with the earlier series, and that the appearance of these is preserved in the engravings of the Twelve Apostles by Marcantonio (B xiv, p. 74, 65 to 76) based on drawings at Chatsworth probably by Giulio Romano; but two of the present *grisailles* correspond with Raphael School drawings and it has also been pointed out by Frommel (p. 88, n. 395) that there are *graffiti* on two others which include dates earlier than the pontificate of Paul IV: on *St Lawrence* are the dates 1518, 1519 and 1540, and on *St Matthias* the date 1541. Paul IV's remodelling of the room was therefore less destructive than Vasari implies, and some of the present figures are actually those painted in Raphael's lifetime.

It seems unlikely that there is any connexion between the series of Apostles engraved by Marcantonio and those in the Sala dei Chiaroscuri: of the figures in the latter that are derived from Raphael School drawings, *St John* differs completely from his engraved counterpart (as also does the Louvre *St Matthew*) while *St Luke*, who was not an Apostle, is omitted altogether from the engraved series.

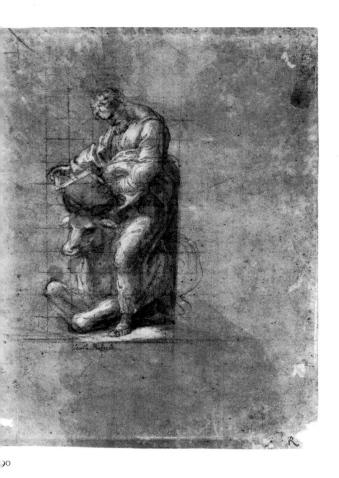

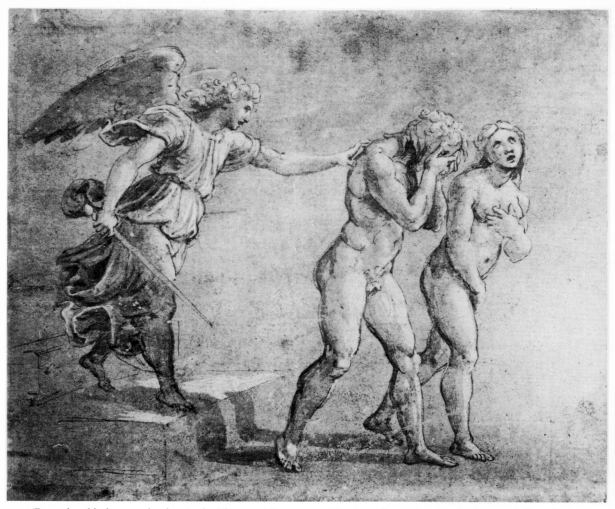

191a (From the old photograph taken in the Thurston Thompson publication of 1857 showing the drawing before the removal of the wash)

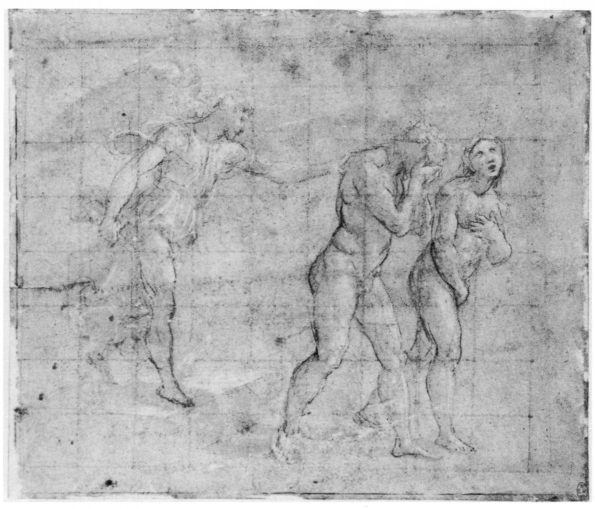

191b (The drawing in its present state)

191. The Expulsion from Paradise

Windsor 12739

Black chalk, heightened with white. Some traces of
 brown wash (see below). Squared in black chalk.
 243 × 278 mm.
Literature: AEP 806; P 418; Ruland, p. 214, vii, 6 and 7;
 C & C, ii, p. 503; F-O 457.

The composition is one of those in the second arcade
of the Logge. An old photograph of no. 191 in the
Thurston Thompson publication of the Raphael
drawings at Windsor shows that it originally resem-
bled the majority of the surviving studies for the
Logge frescoes in having been executed in pen and
brown wash, heightened with white, over black
chalk. The wash was 'cleaned off' at some point
between 1857, the date of the Thurston Thompson
publication, and 1876, the date of Ruland's catalogue
of the Windsor Raphael Collection in which two
photographs of no. 191 are listed: one of it as it had
been, the other of it in its present state 'showing the
first sketch, in black chalk, by Raphael's own hand'.
It seems therefore to have been Ruland who first
evolved the theory that the Logge studies are works
of collaboration in the literal sense of the word, in
which Raphael provided a rapid sketch in chalk
which was then elaborated by an assistant into a
finished *modello*. This explanation was adopted, for
no. 191 at least, by Oberhuber (1962(A), p. 59). He
later modified his position and admitted that the
black chalk underdrawing could be by Penni; but
that if so, to judge from comparison between it and
the generally less expressive fresco, he must have
been closely following a sketch of some sort by
Raphael. To us the underdrawing seems entirely
consistent with Penni.

192. Esau claiming Isaac's blessing

Ashmolean Museum P II 574
Pen and brown wash, heightened with white. Squared in
 black chalk. 254 × 283 mm.
Literature: KTP 574; P 139; Ruland, p. 217, xix, 5;
 F-O 459 b.

The corresponding fresco is in the fifth bay of the
Logge. Oberhuber has pointed out slight differences
between the black chalk underdrawing and the later
pen and wash in the position of some of the heads,
etc.

The Logge drawings vary widely in their degree
of finish: no. 192 has been carried so far that it could
be described as a true *modello*, in which the
draughtsman has used the wash and white heighten-
ing to suggest variations of tone and so convey the
pictorial effect of the composition as a whole. The
traditional attribution was to Raphael himself; that
to Penni was first suggested by Parker.

192

93

193. The Allotment of the Promised Land

Windsor 12728

Pen and brown ink, squared in black chalk. 203 × 297 mm.

Literature: AEP 807; P 420; Ruland, p. 223, xl, 6; C & C, ii, p. 521; F-O 467.

Vasari (ed. Milanesi, v, p. 594) implied that the corresponding fresco, in the tenth bay of the Logge, was executed by Perino del Vaga. No. 193 has been variously attributed: to Raphael by Passavant and Ruland, to Giulio Romano by Crowe and Cavalcaselle, and by Fischel (1898, no. 232) to the member of Raphael's immediate *entourage* responsible for the Louvre drawing of part of a papal procession (F-O,

fig. 232, as Giulio). Popham limited himself to the comment that 'the mannerisms of drawing come very close indeed to Raphael himself, and I suspect that it is a copy of his original design. The drawing is much too sloppy to be actually him'. He went on to point out that it is by the same hand as no. 195. The attribution to Penni of both drawings, first put forward in the British Museum catalogue, is accepted by Oberhuber, who went further than Popham in his suggestion that the draughtsman of no. 193 had worked up a slight pen and ink sketch by Raphael himself. Though there are a few *pentimenti*, we can see no trace of underdrawing by another hand.

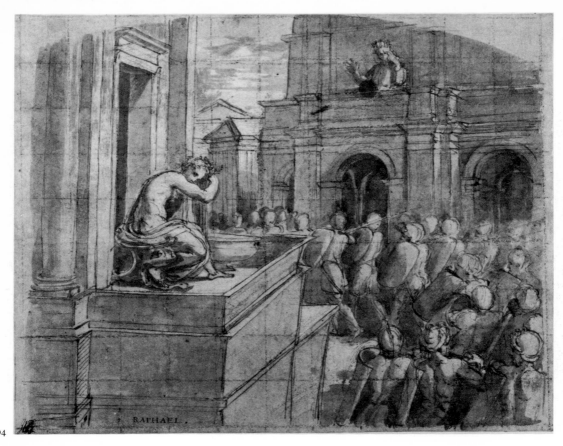

194

194. David and Bathsheba

British Museum 1900–6–11–2
Pen and brown wash over black chalk, heightened with
white. 215 × 267 mm.
Literature: P & G 66; P, p. 535, *l*; Ruland, p. 224, xliv, 4;
F-O 469.

Inscribed in pen along lower edge: *RAPHAEL*.

The corresponding fresco, in the eleventh bay of
the Logge, is rectangular in shape, but in the
drawing the composition has a shallow arched top
like the frescoes in the fourth and tenth bays. An
arched top is similarly indicated in another drawing
(F-O 464) connected with a rectangular fresco,
Moses striking the Rock in the eighth bay. It has
sometimes been suggested that the series of draw-
ings of which these form part are copies of the
frescoes or of the cartoons for them; but such
discrepancies of shape constitute an objective point
in favour of their being part of the preparatory
material. The fresco of *David and Bathsheba* is one of
those that Vasari attributes to Perino del Vaga, to
whom Freedberg (p. 415) attributed the drawing, as
he did no. 195.

195. The Baptism of Christ

British Museum 1861–6–8–150
Pen and brown ink. 198 × 385 mm (the lower edge
irregularly trimmed and made up).
Literature: P & G 67; P, p. 536, *q*; Ruland, p. 226, li, 6;
C & C, ii, p. 527; F-O 470.

The composition is that of one of the four *New
Testament* scenes in the thirteenth bay of the Logge.

An exact copy, reproducing even the irregularly
cut and made-up lower edge, is at Windsor (AEP
860). Passavant attributed both drawings to Raphael
himself, though in his discussion of the fresco (ii, p.
184) he referred to the Windsor drawing as the
original. In this opinion he was followed by Ruland.
Crowe and Cavalcaselle said, of the Windsor draw-
ing, that if it is of the period at all the most that it
could be is a 'weak production of Perino': a judg-
ment evidently inspired by Vasari's attribution to
him of the related fresco. Freedberg (p. 415) attri-
buted no. 195 emphatically to Perino; Hartt (p. 28),
no less emphatically, to Giulio.

The attribution to Penni was first put forward in

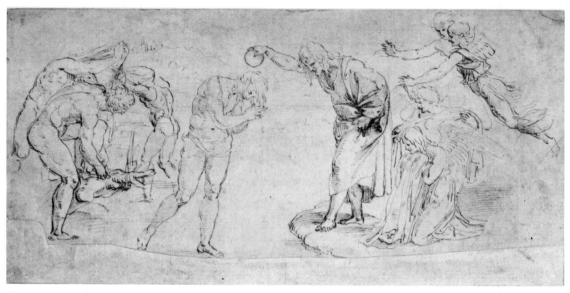

195

the British Museum catalogue. Popham had already pointed out that no. 195 seems to be by the same hand as no. 193. These two drawings, together with the study in the Uffizi for *Moses and the Burning Bush* (F-O 462), stand apart from the other Logge drawings (e.g. nos. 192 and 194) in being in pen alone. The technique gives them a superficial resemblance to a certain kind of drawing by Giulio, but they have all the stylistic and morphological peculiarities that have come to be associated with Penni. Oberhuber, while accepting the attribution to Penni, argued that the drawing itself is too careless and in some passages too ill-defined to be any sort of preliminary study. His suggested explanation, that it is a copy by Penni after a lost drawing by Raphael, seems somewhat over-subtle, but the absence of squaring (in which no. 195 differs from the other Logge studies attributable to Penni) is an anomaly that certainly calls for comment.

196. The Resurrection

Chatsworth 150

Pen and brown wash, heightened with white. Traces of black chalk underdrawing, especially on the left. Squared in black chalk. The sheet is made up of two pieces of paper, that on the right including only the three Holy Women. The squaring on them does not exactly agree, which suggests that two already squared drawings were combined. 147 × 415 mm.

Literature: P 292; Ruland, p. 230, lxiv, 5; C & C, ii, p. 529; F-O 473.

The composition is that of one of the now almost wholly effaced monochrome frescoes in the *basamento* of the Logge underneath the window openings. Vasari (v, p. 594) attributes some of these to Perino del Vaga, to whom the drawing has in consequence been given; but it is certainly by Penni. The piled-up group of recumbent guards on the left seems to be a remote echo of the group of three designed by Raphael himself apparently for the left foreground of his own, never-executed, *Resurrection* (see no. 169).

The chiaroscuro woodcut of the composition by

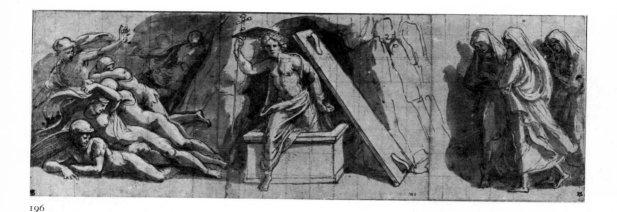

196

Ugo da Carpi (B xii, p. 45, 26) was probably based on no. 196.

197. The Allocution of Constantine

Chatsworth 175
Pen and brown wash, heightened with white. Squared in
black chalk. 232 × 415 mm.
Literature: Ruland, p. 235, i, 4; F-O 483.

A study for the painting executed after Raphael's death by Giulio Romano and his assistants in the Sala di Costantino (see no. 181). The figures are pointing in the direction of the miraculous apparition of the Cross, which does not feature in the drawing. The sheet may have been trimmed, or the draughtsman was perhaps concerned solely with the figural part of the composition.

This drawing was the sensation of the sale of Sir Peter Lely's collection of drawings in 1688. Lely's executor, Roger North, who was responsible for organising the sale, says in his account of it: 'I shall give only one instance to show the prodigious value set upon some of these papers. There was half a sheet that Raphael had drawn upon with umber and white, that we call washed and heightened, a tumult of a Roman soldiery, and Caesar upon a suggestum with officers appeasing them. This was rallied at first, and some said 6d., knowing what it would come to; but then £10, £30, £50, and my quarrelsome lord bit £70, and Sommius £100 for it, and had it. The lord held up his eyes and hands to heaven, and prayed to God he might never eat bread cheaper. There is no play, spectacle, shew or entertainment that ever I saw where people's souls were so engaged in expectation and surprise as at the sale of that drawing. Some painters said they would go a hundred miles to see such another. Whereby one may perceive how much opinion is predominant in the estimate of things. If all the good and evil in the world that depend on mere fancy and opinion were retrenched, a little business would be left for mankind to be diverted with; but Providence hath so ordained it that as children they shall not want baubles to pass their time innocently with.' (*The Autobiography of the Hon. Roger North,* ed. Augustus Jessop, 1887, p. 200). His scepticism about the value of opinion has been fully vindicated: the attribution of this drawing to Raphael himself was long ago discarded, and that to Penni, first proposed in the British Museum catalogue (P & G, p. 51), is now generally accepted. Oberhuber's analysis of the differences between the drawing and the fresco led him to the conclusion that no. 197 is a 'fair copy' *modello* by Penni which followed faithfully a design by Raphael himself. In the coherence and lucidity of the grouping of the figures and in the clarity of the spatial organisation he saw a parallel to Raphael's *Battle of Ostia* in the Stanza dell'Incendio – a composition of a not dissimilar subject only a year or two earlier in date. The qualities that Oberhuber singled out as being characteristic of Raphael are not found in the painting, where the composition was transformed by Giulio in accordance with his fundamen-

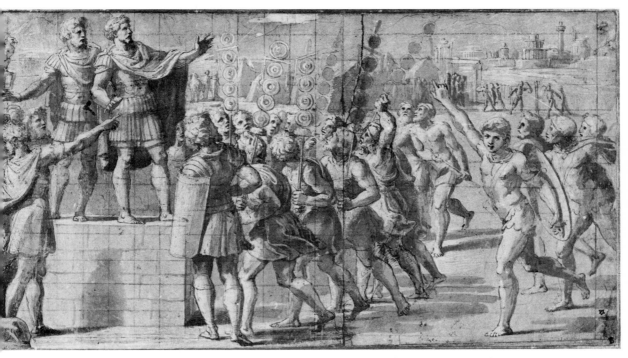

97

tally anti-classical bias. Giulio was prepared to take liberties with Raphael's design for the *Allocution*, but not with the *Battle of Constantine*, which faithfully follows Penni's similar 'fair copy' *modello* (F-O 485): he no doubt realised that the *Battle* composition was so tightly woven and so complex that no modification was possible that would not adversely affect the whole.

198. Head of Giovanni Francesco Penni: auxiliary cartoon for *The Allocution of Constantine*

British Museum 1949–2–12–3
Black chalk over pounced-through underdrawing.
 393 × 241 mm.
Literature: P & G 72; P, p. 543, *rrr*; Ruland, p. 160, x, 1;
 F-O 484b.

The pounced-through underdrawing shows that this is an auxiliary cartoon (see no. 25 for an explanation of the term) for the head of the figure standing immediately behind Constantine in *The Allocution* in the Sala di Costantino (see no. 197). The underdrawing indicates locks of hair as in the fresco, where the figure is bare-headed. Otherwise the correspondence is exact: comparison of a tracing of no. 198 with the painted head revealed that the main contours of the drawing agree exactly with the incised outlines in the plaster which had been transferred from the full-scale cartoon.

The model for this figure was G. F. Penni. In the woodcut portrait of him in Vasari's 1568 edition the head is identical, even to the hat, and it seems very likely that this drawing was the one used by Vasari.

No. 198 was in the past attributed to Raphael. The attribution to Giulio Romano, put forward in the British Museum catalogue, is followed by Oberhuber. As the executant of the fresco, Giulio is the most likely candidate for the authorship of a working drawing of this kind; and allowing for the difference in scale and medium, the line-work seems

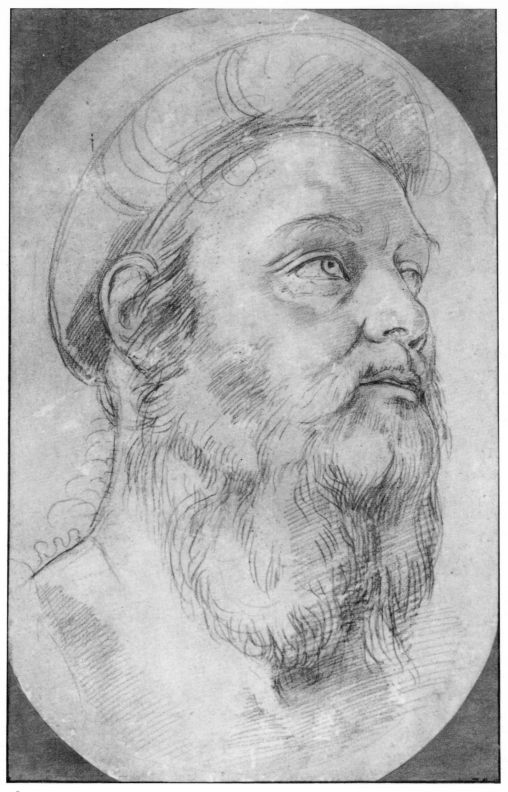

198

compatible with that of his pen drawings. We now agree with Oberhuber that the drawing is entirely by Giulio, and that there is no sign of reworking by a clumsy later hand. The passages of apparently rather coarse tonal hatching resemble those in Raphael's auxiliary cartoon for the head of St Andrew in *The Transfiguration* (no. 176).

199. Figures standing and kneeling in a pillared hall: study for part of *The Donation of Constantine*

Ashmolean Museum P II 248
Pen and greyish brown and brown ink and wash, heightened with white, over black chalk. Some touches of red chalk. The outlines indented and the verso blackened. Squared in black chalk. 273 × 247 mm.
Literature: KTP 248; F-O, p. 189.

Acquired for the Ashmolean Museum in 1939 by Parker, who recognised its importance as an undoubted preparatory study for the right-hand side of *The Donation of Constantine* in the Sala di Costantino (see no. 181). It corresponds with the painting in the design of the architectural setting and, in essentials, with the figure composition, though here there are considerable differences, notably the eventual introduction of a kneeling cripple next to the standing figure in the foreground. Raphael had no share in this composition nor in that of the fourth historical scene, *The Baptism of Constantine*: a letter dated 6 September 1520, five months after Raphael's death, from Sebastiano del Piombo to Michelangelo describes the four historical subjects then proposed for the Sala, only two of which, the *Battle* and the *Allocution,* were executed.

Parker catalogued no. 199 as 'Giulio Romano?'. He quoted Hartt's attribution to Giulio, but added 'this seems hard to believe on the evidence of style, unless indeed the artist is here seen in a passing and unfamiliar phase... the drawing, rather insipid in character, remains problematical in regard to its authorship'. The puzzling character of the sheet is due to its being one of the rare instances of a drawing demonstrably the work of two distinct hands. This fact was first recognised by Hartt (p. 50), who attributed the drawing of the architecture to Giulio and that of the figures to Giulio's assistant Penni. An

exactly converse opinion was put forward in a review of the Ashmolean Catalogue in the *Burlington Magazine* (xcix (1959), p. 161), where it was argued that the original drawing, architecture and figures alike, seemed to be by a timid hand, using a greyish-brown ink; and that this drawing had been reworked and revitalised – in rather the same way as Rubens retouched and brought to life drawings by other masters – by a stronger, more impatient and more vigorous hand using a browner ink. The personality of the first, insipid draughtsman goes well with the group of drawings attributable to Penni (see p. 230), while the hand responsible for the reworking has every indication of being Giulio's. The reworking process did not extend to the languid youth in the right foreground of the drawing; curiously enough, the same distinction is apparent in the fresco, where the figures, like those in the drawing, are obviously by Giulio with the exception of the languid youth's counterpart in the right foreground, a foppish young man in contemporary dress – presumably a portrait – who takes no interest in the proceedings and might have sauntered in from the adjacent, and altogether less Giuliesque, *Baptism of Constantine*.

200. The Holy Family

Windsor 12740
Red chalk over stylus. Extensively damaged, especially at the sides. 268 × 222 mm.
Literature: AEP 833; P, p.493, *f*; Ruland, p.80, xxxix, 6; C&C, ii, p.553; F 379a.

The composition is that of the '*Small Holy Family'* in the Louvre, a variant of two others of the same subject now both in the Prado, the '*Perla'* and the '*Madonna of the Oak'*. All three are products of the Raphael studio and are generally dated *c*. 1518.

Ruland attributed no. 200 to Raphael himself. Passavant, Crowe and Cavalcaselle and Fischel (1898, no. 327) dismissed it as a copy. Fischel later revised this view. In his *corpus* he pointed out one or two *pentimenti* (for example, in the Baptist's leg and the profile of St Elizabeth), where the chalk drawing diverges from the preliminary stylus sketch, and also a few differences from the painting, notably in the position of the Baptist's right arm. He described

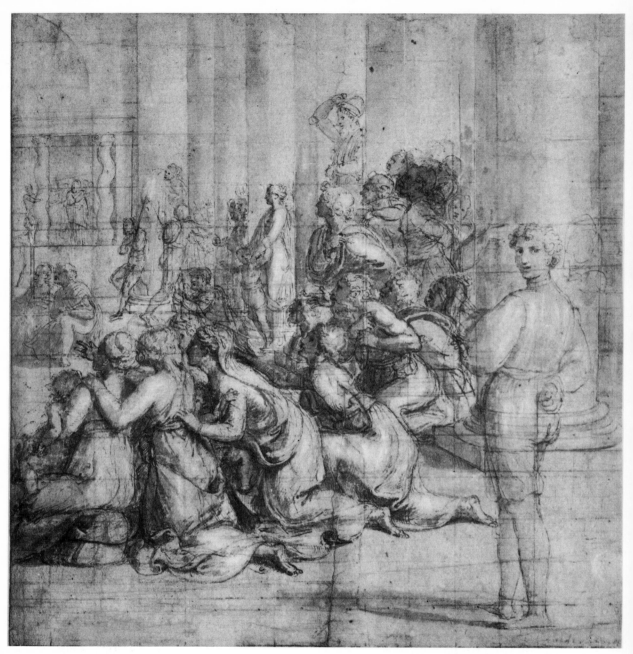

199

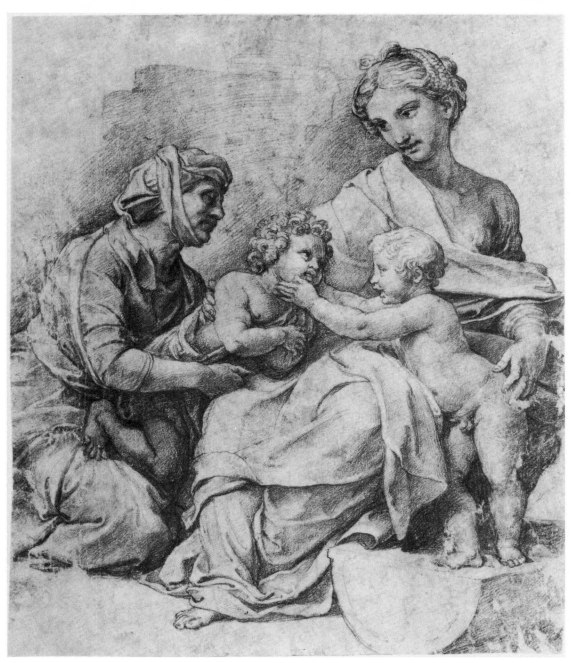

200

no. 200 as 'uninteresting and phlegmatic' ('tem-
peramentlos'), and grouped it with a number of
other drawings, including the studies in the Uffizi
for the *Madonna of Francis I* (F 377, 378), that he was
inclined to give to Giulio Romano. In his posthum-
ously published monograph (1948, p. 366) the
execution of the painting is attributed to a pupil
'probably Penni', and the drawing to an artist 'close
to Giulio'. Popham nevertheless described no. 200 as
a copy, though a careful and sensitive one in the style
of the red chalk drawings connected with the Psyche
loggia of the Farnesina. Dussler (p. 50) described it as
a copy with variations of the painting.

 The attribution to Giulio is accepted without
qualification by Oberhuber, and is surely correct,
but there is no reason to suppose that the invention

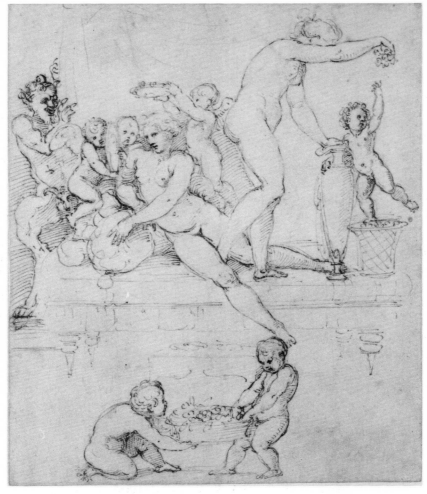

201

of the composition was due to anyone but Raphael.

The scale of the figures in the drawing is very close (perhaps even identical) to that in the painting, but there is no indication on the drawing itself that it was used as a cartoon.

201. The Toilet of Venus

British Museum 1895-9-15-630
Pen and brown ink. 253 × 208 mm.
Literature: P & G 69; Ruland, p. 127, iii, 1.

The traditional attribution to Raphael was accepted by Ruland and also by Robinson in his privately printed catalogue of the Malcolm Collection (1876, no. 191); no. 201 was kept under that name until the publication in 1962 of the British Museum catalogue in which it was given to Penni. The attribution to

Penni had been suggested as long ago as 1897 by Charles Loeser (*Archivio storico dell'arte*, ser. 2, iii (1897), p. 348), who seems to have arrived at it largely by a process of elimination. It can be defended on more positive grounds: the handling is exactly comparable with that of the Logge study no. 195, and in the general incoherence of the composition and the absurd stage-properties – the grotesquely top-heavy vase and the *amorino* balanced in defiance of gravity on one side of a tall basket – this drawing resembles the three in the Albertina (see above, p. 230) which reveal Penni in a phase when he was no longer subject to, and supported by, the immediate influence of Raphael. The still Raphaelesque technique and graphic mannerisms in no. 201 suggest that this is an earlier, but hardly less unsuccessful, attempt at an independent composition.

202. Tarquin and Lucretia

Windsor 0506

Pen and brown ink over black chalk, heightened with
white. 251 × 168 mm.

Literature: AEP 812; P, p. 494, *t*; Ruland, p. 163 , i, 3; F-O,
p. 41.

The left-hand half of an engraving by Agostino
Veneziano (B xiv, p. 169, 208) corresponds exactly
in the same direction with no. 202, which was either
made on purpose for the engraver or used by him.
Popham rightly ruled out the possibility of its
having been copied from the print. Though he
catalogued no. 202 under 'School of Raphael' with-
out reference to Penni, he had observed that it is by
the same hand as no. 193 and a drawing of the *Birth of
the Virgin* at Stockholm of which a better version,
certainly by Penni, is in the Bibliothèque Royale in
Brussels (see F-O, p. 40, n. 113).

Oberhuber attributed no. 202 to Penni, and
grouped it with a number of other drawings includ-
ing two in the same technique and probably of about
the same date which have every appearance of being
the draughtsman's unaided efforts: a *Feast of the Gods*
in the Ecole des Beaux-Arts in Paris and a composi-
tion of a *Prisoner brought before a Judge* at Chatsworth
(F-O, figs. 44 and 45). In no. 202 the quality of the
composition is altogether superior: the erotic
flavour of the subject, the muscular, rubbery little
figure of Tarquin, and the facial type of Lucretia, all
suggest the possibility that Penni's drawing was
based on an 'invention' by Giulio, to whom indeed
Passavant attributed no. 202. Agostino Veneziano's
engraving is dated 1524, four years after Raphael's
death and in the last year of Penni's partnership with
Giulio in Rome.

202

CONCORDANCES

AEP	Cat.		KTP	Cat.		KTP	Cat.		P & G	Cat.		Chatsworth	Cat.
788	24		28	10		538	51		1	1		20	169
789	40		29	12		539	75		2	8		38	183
790	58		30	5		540	67		3	18		50	140
791	66		32	2		541	104		4	22		51	175
792	110		33	3		542	87		5	25		53	160
793	123		34	19		543	93		6	26		54	163
794	85		40	7		544	94		7	41		55	164
795	86		44	35		545	92		8	32		56	161
796	106		248	199		546	95		9	33		57	114
797	113		462	145		547	96		10	73		59	182
798	168		463	64		548	97		11	80		66	177
799	170		466	129		549	98		12	78		67	178
800	135		501	9		550	100		13	68		150	196
801	139		502	6		551	101		14	38		175	197
802	155		503	4		552	102		15	39		657	127
803	158		504	11		553	149		16	48		723	54
804	162		505	13		554	109		17	49		727 A	124
806	191		506	14		555	108		18	60		727 B	125
807	193		507	28		556	144		19	84		728	137
808	187		508(a)	16		557	143		20	83		730	157
810	189		508(b)	17		558	167		21	122		733	63
812	202		509	30		559	166		22	65		902	173
833	200		510	29		560	171		23	116		903	165
			511(a)	20		561	138		24	117		904	174
			511(b)	21		562	151		25	120		905	156
			512	23		563	134		26	119			
			513	27		564	132		27	115			
			514	31		565	133		28	111			
			515	34		566	154		29	103			
			516	56		567	153		30	91			
			517	57		568	180		31	99			
			518	55		569	181		32	90			
			519	52		569 A	148		33	88			
			521	61		569 B	147		34	172			
			522	37		570	112		35	126			
			523	46		572	186		36	152			
			524	45		574	192		37	176			
			525	47		579	131		38	179			
			526	43		583	146		44	105			
			527	44		625	128		63	190			
			528	42		655	159		66	194			
			529	72		665	184		67	195			
			530	74					68	185			
			531	76					69	201			
			532	79					72	198			
			533	70					282	188			
			534	71									
			535	69									
			536	82									
			537	50									

F(ZdU)	Cat.	F	Cat.	F	Cat.	F	Cat.	F-O	Cat.
8	2	1	34	169	76	372	136	399	143
72	3	2	9	170	77	373	135	402	144
73	4	8	11	171	78	375	137	410	145
74	13	11	8	173	79	376	138	413	147
75	14	18	20	178	80	379a	200	417	112
76	19	19	21	187	39	384	133	419	113
78	7	22	22	189	65	386	134	440	187
80	5	23	25	190	66	388	167	441	155
86	12	24	23	191	67	389	166	447	156
92	10	30	27	193	50	391	171	448	158
		31	26	194	51	392	168	449	157
		33	68	197	49	393	170	453	188
		34	33	200	75	394	169	454	189
		35	31	205	82	395	172	457	191
		37	32	210	69			459b	192
		38	1	225	109			467	193
		40	15	228	110			469	194
		41	30	229	111			470	195
		46	16	230	108			473	196
		48	17	233	122			475	190
		51	18	234	123			478	148
		55	41	240	103			479	184
		63	29	246	106			482	183
		67	70	249	104			483	197
		79	40	253	107			484b	198
		82	37	257	140			486	182
		85	38	258	85			487	181
		87	46	259	87				
		88	45	261	86				
		89	47	267	88				
		90	48	271	89				
		91	83	274	93				
		99	44	275	94				
		100	42	276	96				
		102	81	278	95				
		109	84	281	92				
		112	56	286	90				
		114	57	296	97				
		117	54	298	99				
		118	55	299	98				
		121	61	307	100				
		123	62	308	101				
		128	52	309	102				
		130	58	310a	43				
		134	60	349	117				
		143	63	350	116				
		149	71	357	121				
		157	59	361	132				
		164	72	362	119				
		165	73	369	173				
		166	74	370	120				